THINKING THE ANTIPODES

THINKING THE
ANTIPODES

Australian Essays

PETER BEILHARZ

MONASH University
Publishing

Monash University Publishing
Building 4, Monash University
Clayton, Victoria 3800, Australia
www.publishing.monash.edu

Monash University Publishing brings to the world publications which advance the best traditions of humane and enlightened thought.

Monash University Publishing titles pass through a rigorous process of independent peer review.

http://www.publishing.monash.edu/books/ta-9781922235558.html

Series: Philosophy

Design: Les Thomas

Cover image: Ian North, *Seasons. Australia. Kongouro.* 1987
Acrylic on Type C photographs, four panels, each c, 38.5 x 48.5 cm
Courtesy the artist and Greenaway Art Gallery, Adelaide

National Library of Australia Cataloguing-in-Publication entry:

Creator:	Beilharz, Peter, author.
Title:	Thinking the antipodes : Australian essays / Peter Beilharz.
ISBN:	9781922235558 (paperback)
Notes:	Includes index.
Subjects:	Social sciences--Philosophy.
	Culture.
Dewey Number:	300.1

Printed in Australia by Griffin Press an Accredited ISO AS/NZS 14001:2004 Environmental Management System printer.

The paper this book is printed on is certified against the Forest Stewardship Council ® Standards. Griffin Press holds FSC chain of custody certification SGS-COC-005088. FSC promotes environmentally responsible, socially beneficial and economically viable management of the world's forests.

Contents

CONTENTS

Contents

A Christmas Letter

(for Peter Beilharz)

Dear Peter, I quite often think
Of the odd strands of life that link
Your thinking to my own, although
I've become crusty, gruff and slow,
My wit defending a wary self
With old-style books upon my shelf
Which I still try to read my way,
Not in the Information Highway,
Cyborgs are not a buzz for me,
Nor *virtual reality*
And younger colleagues fail to cure
My lifelong taste for Literature,
Now it is more than just – god knows –
Seduction of your suasive prose
That gives a shock of pleasure when
I read something of yours again.
Good old beliefs like socialism
You twine through many a quirk and schism
(Cats' cradles made with finest cotton)
And weave a pattern that's postmodern;
You shed your light on thought as hard as
The ideas of Castoriadis,
And now, for my nostalgic good
You take me back to Collingwood.
Never have I got off that hook:
I've read his every single book –
Almost – but, despite that plan,
When it came to *The New Leviathan*
Somehow I had lost my zing
And couldn't read the whole damn thing,
Specially the part where he got his thrills
By savaging the Bogomils.
His *Nature, Art* and *History*
Have surely been as dear to me
As that fierce *Autobiography*

In which he was shaken to the core
By the Spanish Civil War:
Perhaps for him the worst offence
Was England's polite indifference.
Peter, write on. Divert, renew us,
Ignore the indifference of reviewers
And keep your ardent readers thinking
Amid a world that's stale and stinking
At (or so it seems to me)
The arse-end of the century
When Labor's largely sold us out
To what the fiscal markets shout
And what the bankers tell them should
Be medicine for the public good.
Managerial universities
Bring Matthew Arnold to his knees;
A Newman or a Kant would have
To be the RAGS Committee's salve,
Gaining a Large ARC Grant
For some conceptual elephant:
Each critic's just an aneurism
In multinational capitalism.
(Peter, I think I'll eat my hat
If you can find a worse line that that!)
At all events, we battle on
Another year has clumped and gone,
The papers have been put away
So we can have a holiday
With surf and pudding and champagne,
Recharging batteries again
With intellect and natural wit.
No doubt you'll soon get on with it,
Crossing some critical defile
With trenchant prose and lucent style
Good luck then, Peter. See you soon.
I'm off to the cricket this afternoon.

Chris Wallace-Crabbe

Acknowledgements

The author and publisher would like to acknowledge and thank the original publishers for permission to reproduce the chapters within this book, as follows:

Wallace-Crabbe, C. 1994. A Christmas Letter (for Peter Beilharz). *Overland* 141 (Summer):28.

Chapter 1
 2001. Australian Civilization and Its Discontents, *Thesis Eleven* 64:65–76.

Chapter 2
 2001. Tocqueville in the Antipodes? Middling Through in Australia, Then and Now. *Thesis Eleven* 65:51–64.

Chapter 3
 2005. Australia: The Unhappy Country, or, a Tale of Two Nations. *Thesis Eleven* 82:73–87.

Chapter 4
 2006. Two New Britannias: Modernism and Modernity across the Antipodes, *ACH: The Journal of the History of Culture in Australia* 25:143–156.

Chapter 5
 2006. Nations and Nationalism in Australia and New Zealand. With L. Cox. In *The Sage Handbook of Nations and Nationalism*, edited by Delanty and Kumar. London: Sage.

Chapter 6
 2007. Australia and New Zealand – Looking Backward, Looking Forward and the Parting of Ways. *New Zealand Sociology* 22:315–324.

Chapter 7
 2008. Australian Settlements. *Thesis Eleven* 95:58–67.

Chapter 8
 1989. Elegies of Australian Communism. *Australian Historical Studies* 23 (92):293–306.

Chapter 9
> 1996. Revisioning Labor? In *ISTP Occasional Papers*. Perth: Murdoch University.

Chapter 10
> 1993. John Anderson and the Syndicalist Movement. *Political Theory Newsletter* 5:5–13.

Chapter 11
> 1993. The Young Evatt – Labor's New Liberal. *Australian Journal of Politics and History* 39(2):160–170.

Chapter 12
> 1995. Vere Gordon Childe and Social Theory. In *Childe and Australia: Archaeology, Politics and Ideas*, edited by T. Irving, G. Melleuish and P. Gathercole. St Lucia: Queensland University Press.

Chapter 13
> 1994. Bernard Smith – Imagining the Antipodes. *Thesis Eleven* 38:93–103.

Chapter 14
> 1996. On the Importance of Being Antipodean and the Consistency of Being Bernard. *Voices* 6 (4):8–13.

Chapter 15
> 1996. Place, Taste and Identity. *Art Monthly Australia* 92:7–10.

Chapter 16
> 2002. Portrait of the Art Historian as a Young Man. *Meanjin* 62(2):36–40.

Chapter 17
> 2013. Bernard Smith: Taking a Distance. *Eyeline* 78/79:59–63.

Chapter 18
> 2006. Robert Hughes and the Provincialism Problem. In *Reflected Light: La Trobe Essays*, edited by P. Beilharz and R. Manne. Melbourne: Black Inc.

Chapter 19
> 2013. Placing Robert Hughes: A Promissory Note. *Thesis Eleven* 117(1):117–126.

Chapter 20
> 2003. George Seddon and Karl Marx: Nature and Second Nature. *Thesis Eleven* 74:21–34.

Chapter 21
> 1994. Hugh Stretton: Social Democracy in Australia. Paper presented to the Australian Political Studies Association, Wollongong.

Chapter 22
 2008. Jean Craig and the Factory Girls. Paper presented to the American Sociological Association Annual Meeting, Boston Mass, 2 August.

Chapter 23
 2009. Miss Craig Goes to Chicago. Paper presented at the annual meeting of the American Sociological Association, 8 August, San Francisco, CA.

Chapter 24
 2009. From Sociology to Culture, via Media – Some Thoughts from the Antipodes. *The American Sociologist* 40:228–232.

Preface

Ever since I first met the idea, I have been taken by Montaigne's sensibility that the essay is an attempt. Even my books seem to be attempts; but I am still tempted to think that the best of my work takes the essay form, more conventionally defined: somewhere between ten and thirty pages, one idea, one paper. In 2009 I was fortunate to be able to publish one volume of my best essays, *Socialism and Modernity*, with Minnesota University Press, via the good offices of Craig Calhoun. These essays addressed the transatlantic labour experience, and to a lesser extent the antipodean equivalent. But I knew that some of my best writing was more local, addressing thinkers like John Anderson and HV Evatt, and beginning to explore the work of Bernard Smith and others. Some, like those essays on Jean Martin and Hugh Stretton, were never published. I was keen to publish these antipodean essays, but was unable to find a publisher, which reminded me of those stories about Stretton's work, rejected repeatedly, but finally able with the Owl of Minerva to see light of day. For I then discovered Nathan Hollier and his crew at Monash University Publishing, surfing a new wave at the place where my lights were turned on in the middle seventies. Nathan has given these essays the chance to breathe again, and has given me the opportunity to sense something of the circle that has taken me back symbolically to Monash nearing the end of my long career at La Trobe, where all of these essays were written. For this, I am grateful, as I am for the splendid choreography of Jo Mullins and the indexing of Rachel Salmond.

Some of these essays were written under the canopies of ARC Discovery Projects. Essays 4 to 7 were researched as part of DP 0450983, Social Division and the Pursuit Of Harmony Across the Antipodes in the Twentieth Century. Essays 17 and 18 were researched as part of DP 0450974, Jean Martin and the Social Sciences in Australia.

Around the same time that I made Nathan's acquaintance, I became friends with Ian North, whose visuals now announce something of the contents of this book. And I was able to renew my friendship with Chris Wallace-Crabbe, whose poem heralds it. Who else should I thank? At this time I am reminded of the influence of my teachers, from NW Saffin and Alastair Davidson to Zygmunt Bauman, Jeffrey Alexander, Agnes Heller, Craig Calhoun. In Australia, I have been much supported over the years by Trevor Hogan and my colleagues at La Trobe, and by my friends on *Thesis*

Eleven. My mentors at Harvard helped me to open the optic, and my older friends, John Murphy, Ian Britain, Graeme Davison, Nikos Papastergiadis and Ghassan Hage offered stimulants and friendship along the way. Reading the proofs of this book reminded me of the debt I owe to Robert Dessaix, who helped me to find a voice all those years ago. Across the Tasman, I developed lasting relationships with Brennon Wood, Chamsy El-Ojeili, Ian Carter, David Pearson, Nick Perry, Philippa Mein-Smith and Peter Hempenstall. Peter Newman and Lloyd Cox helped me bring particular projects here to fruition.

Then there are the things so deeply felt that they are difficult to name. Across the path of my life it has been my great good fortune to love, and to be loved twice, by Dor and by Sian. I am deeply grateful to them both, as I am to Nikolai, Rhea, and to Savannah.

Finally, two intellectual presences tower over these pages: these are the figures of Stuart Macintyre and Bernard Smith. Theirs are footprints to follow, for they lead by example, and in so doing make so many other things possible. To all these folk, I am deeply grateful.

Peter Beilharz, October 2014

Introduction: Being Antipodean

Being antipodean literally means having the feet elsewhere; coming from the other side of the earth, being elsewhere, outside the centres, displaced, implicitly disadvantaged. This is the metropolitan view of the Antipodes, historically. The antipodean view is that we are the centres, that they are our Antipodes, logically. Politically, the Antipodes have been seen as places too distant, inferior, too far away, culturally, as derivative of the centres, or else, by local inversion, as their superior. All of this was already evident by the time of D.H. Lawrence's *Kangaroo*; and it was already well exercised in Stephensen's *Foundations of Culture in Australia*. Into the sixties, Bernard Smith began to put a different spin on the issues by suggesting that rather than dividing the world into two, and presuming a simple relation of subordination between north and south, or centre and periphery, it might be necessary to think of them as necessarily interconnected. Centres and Antipodes were mutually constituted, and worked through patterns of cultural traffic which could never be one-directional. There was only one world, and each sphere depended on the other.

As a young Marxist, growing up in Melbourne, it never really occurred to me that I should have to choose between these worlds, between centre and periphery. For being antipodean meant carrying a kind of dual passport, belonging to Europe and America and Australia or the Pacific all at the same time. My folks had come from Germany via Palestine via Fremantle via Tatura via Carlton to Melbourne; their Carlton room was just up the road from where Bernard Smith spent most of his Melbourne life, though I wasn't to know that until much later. Of course, I knew that Australians were little fish globally, but I had no reason to imagine that our culture was necessarily inferior. My formative culture in Melbourne, in the rock music scene in my teens, was vibrant, sharp, mod, creative, even wacky, goony. I was later to realise, or at least to imagine, that my good fortune as a Croydon boy was to discover early on who I was; I was a musician, and a hippie, or at least that was my pretence, so that I suffered no early identity crisis (that came rather later). And then I discovered that I really wanted to be something else: a teacher, and a writer, or at least someone who worked with words. I liked words, and sounds. I knew a bit about images, but let them grow on me.

Like many writers, I suppose, I began with reviews, for journals like *Nation Review* and *Australian Left Review*. In the same year, 1976, I wrote my first major overseas publication, a theoretical survey of the Australian Left for the Hoover Institute's *Yearbook On International Communist Affairs*. I was 22; these worlds looked beckoning to me. It simply made sense that the Left was international, as well as local, and that the two sets of stories would need to be connected if they were to be told intelligibly. My earlier outlet for expression in music gave way to writing, to seeking to influence the radical culture which I had now come to identify with in Melbourne. Instead of hanging around the Thumpin Tum, I hung around Exploration Lane. Reviews, being little, manageable things, might lead to articles, articles to essays and books. So I began to publish overseas as well as locally, in *Telos* as well as in *Thesis Eleven* and took it for granted that you should. Then I wrote theses, another genre altogether, and started to write books. I learned a way to blitz books, such as *Transforming Labor* and *Postmodern Socialism*; and I learned that while it was all damned hard exertion, there was also a magic place and moment in which writing would sort of happen to you, set upon you; that sometimes books could almost write themselves, and that you could resolve major challenges in the process of writing rather than thinking it all out immaculately beforehand.

When I substituted Marxism for music, slowly into the seventies, it all seemed much of a muchness. You didn't have to be in Chicago to play the blues with a feeling, and you didn't need to write for *New Left Review* to participate vicariously in its lifeworld. At the same time, as I began to publish and to learn to write, from 1976, and to edit, from 1980 via *Thesis Eleven*, I came to accept that there were bifurcated audiences, here and there, and that being antipodean meant writing for two different audiences. I could write about Australia; or I could write about social theory, or Marxism. Sometimes you could connect; but being antipodean meant having feet in different places. What I wrote for one audience would not necessarily interest or make sense to another. If I wrote about Zygmunt Bauman, most readers would be elsewhere; about Bernard Smith, mostly here. There was always a price to pay; there were always consequences for following one enthusiasm, or the other. Whatever I wrote about Europe I didn't write about Australia. Books, in any case, or essays were messages in bottles. You never knew if they would be received by their imaginary addressees.

So I have spent my life changing feet, sometimes feeling giddy in the process, often weary. But what you hold before you are some of the essays written across these years about Australia, and being antipodean. They are

divided into two parts: themes and thinkers. Themes, begins with three papers which emerged from my time as Professor of Australian Studies at Harvard, 1999–2000. It seemed like a good time to be away. These were strange times, for while I imagined I knew America, which I had begun to visit annually from 1993, being in Cambridge for a year and then again in 2002 was both privilege and challenge. I decided that I would go with the flow, immerse myself intellectually in that moment, read about America, not about Australia; and that I should be open to that experience, rather than take some big Australian project with me. It was the experience of a lifetime. It afforded me time to think, the rarest of things these days for folks who work in universities, this so much so that I even indulged in auditing a class myself. I decided to make it Patrice Higonnet's on Jacobinism; we became friends, as I did with other remarkable brains and souls like Dan Bell and Orlando Patterson. There was also great music round the corner, at the House of Blues. I taught three courses, one on socialism and sociology, one on public intellectuals, and one on Australia. And, of course, I spent the twelve months there thinking about Australia, not least about its differences with this big brother. For my students, uberbright as they were, had troubles making sense of Australia, which they thought of as like America, and it was difficult to convey the sense of difference. Best of all, this experience confronted me with the ignorance I had of my own place; for that which you know by habit, in one register, you hardly know at all, in another.

The first three essays republished here are all the result of that head-opening exercise. Being away then, I missed both the Republic Referendum and the Sydney Olympics, neither of which caused significant distress. My initial curiosity was simply to puzzle over the nature of Australian modernity and the stories we told ourselves about it. If we were not exceptional, unique, were we then British, or American, creatures of culture or of landscape or environment? The standard options seemed to be just these, that we Australians were either self-generated, immaculate conceptions, or that we were the result of somebody else's labours or influence.

Into the early nineties, I had come to the conclusion that I needed to jump ship. All my previous work and intellectual inspiration was caught up with socialism and the labour movement. The object of my desire was disappearing before my eyes. I registered this politically in *Transforming Labor* and *Postmodern Socialism*, but had not yet understood its intellectual consequences. I would have to write about something new, change my life. And I began to do this with a new lifeline, which I found in the work of Bernard Smith, our most important antipodean. These opening essays, in

the present volume, trace the consequences of that move, opening a process of renegotiation with what it meant to be antipodean.

The figure of Tocqueville came to work here as a carrier. Partly this was to do with the power of his own insight, partly with his stature as a mediator for my American interlocutors. W.K. Hancock, and later Manning Clark had loitered with Tocqueville, but Australian writers were in general less taken by the connection, which I also wanted in my own way to encourage. For like all great thinkers, Tocqueville is good to think with, to use as a foil positively and negatively, to puzzle over like cases and different cases. I remember thinking at some point in this process that you could portray the differences across the Pacific symbolically in the way that Tocqueville might; that while we historically had thought of life as a punter's game, they had constructed it as a running race. Or as Tim Winton had it, while they had losers, we had battlers. I wouldn't bet my life on it, but nevertheless the possibility is worth thinking about. Australian modernity seemed different, at least until recently, because we waited to see what the others did before we bolted off all in the same direction. 'Why are we running?' 'Dunno, the rest of them were'. Australia was slow, or it used to be. There's a lot to be said for a little slowness.

At Harvard I spent a lot of time in the Widener Library and carrying books around. One of them was Max Lerner's *America as a Civilization*. I was much taken by Lerner's distinction between the idea that nations had myths of foundation and myths of mission. Seemed to me that historically we had neither, or at least that we were more complacent or at least less missionary about all this. Coming from German stock after fascism didn't predispose me to an enthusiasm for nationalism, and I was persuaded by Bernard Smith's suggestion that even the nationalism of the subordinate had too much potential to get nasty. In any case, it seemed to me that Australia had a significant plurality of claims to myths of foundation, and that this was an advantage.

Into the nineties I discovered America, practically. Into the new century I discovered Aotearoa/New Zealand and this opened my head some more. I was surprised that while my book on Bernard Smith, *Imagining the Antipodes*, had received its share of stick, no one had taken me to task on the question, *which* Antipodes? What were the local refractions of the category? What of the experience of Perth, or New Zealand? I began to explore both these places and experiences more carefully than I had before. This resulted in curiosities, such as those in 'Two New Britannias', which sought to connect Smith, Humphrey McQueen, and great works of New Zealand

scholarship such as Fairburn's *The Ideal Society and its Enemies*. Australia and New Zealand, after all, were caught up in terms of earlier arguments about utopia and the social laboratory, which my interest in Fabianism had taken me to. The trans-Tasman was a cultural and economic circuit; you couldn't really understand one without the other, even if this meant in turn that New Zealand was also our Antipodes, in a different sense.

If Australian modernity was peculiar, at least historically, what about New Zealand's modernity? For some time I had been playing with notions like Fordism, out of the work of Antonio Gramsci. Fordism, it now occurred to me, might also have non-American models. There might be a kind of agrarian Fordism, an agricultural model of industrialism, which might set the trans-Tasman experience apart from other, more conventionally European or American models. This possibility would also necessarily connect back to the concept of settler capitalism, which others had used to align the experiences of Australia, New Zealand, South Africa and Canada.

Somewhere Bernard Smith says that all thinking is comparative. I think he is right. Comparison of like cases – New Zealand and Australia, for example – indicates as much about similarity as about differences. And then there are the exaggerated interpretations of small differences. Arbitration is sometimes claimed, as by Paul Kelly in *The End of Certainty*, to be an attribute of what he, in a cribbed version of Hancock's 1930 *Australia*, dubbed the Australian Settlement. As scholars from the other side were quick to observe, this was in fact an Australasian Settlement. Arbitration resulted from processes of cultural traffic between Kingston, in Adelaide, Pember Reeves, in Wellington, and Higgins, in Melbourne. In any case, as I argue in 'Australian Settlements', the fact and the metaphor of settlement has many more meanings than the singular idea of 'Australian Settlement' allows. If there is not quite a clear and finally agreed myth of origin, this even despite the contrived revival of Gallipoli, then there might be even more to talk and to disagree about.

There are always important foreigners here, from Tocqueville to Edward Bellamy; for culture is constituted through cultural traffic. Consider the path of William Lane, one of 'our' greatest radicals; from the UK, to the US, to Canada, to Australia, to Paraguay, to New Zealand. Warts and all, he belonged to all of us, to all of these places. Intellectuals, in this way, might best be seen as carriers of culture. They move, and their ideas with them; their ideas more, even when they stay at home.

Cultural and political forms like communism represented both European and vernacular forms and ways of thinking and being. Ironically enough,

the only significantly insignificant culture here was that of the Soviet Union. Identified after 1917 and especially after 1920 by its enthusiasts as the only way, its lessons were, as Alastair Davidson long ago showed in his history of the Communist Party, irrelevant. Communism never quite implanted successfully in Australian culture. To the extent that it did, it came to mimic and enthuse for labourism, the socially dominant culture of the Left here. And this was, finally, the fate of communism in Australia, to liquidate back into the dominant culture of labourism, this at the very moment that Labor transformed into the party of state. Two related essays take up these themes. The first resulted from the enthusiasm of Stuart Macintyre for the period phenomenon of what he called these 'elegies of communism', mostly literary or biographical in form, which traced this trend before the fall of the Wall. Communists were good at organising, in their own way; when I first went to CPA Headquarters in Lonsdale Street in 1975, to research my Hoover essay, it felt like I had walked into the CWA: men in short-sleeved check shirts, women busying themselves with cups of tea, nothing vaguely revolutionary here (and few other longhairs like me). Communists were also good at writing, as these books showed. They showed lives sad, and funny. One example: in Oriel Gray's *Exit Left* an Australian novelist returns needing to convince some waterside workers that everything is so good in the Soviet paradise, even intercourse is wonderful. To which the antipodeans reply, it ain't too bad here, either.

Those who follow us, chronologically, will necessarily understand the world differently to us. For our students, universities will always seem to have been this way; and the patterns of everyday life will always seem to have had this frenzy. The idea that the Labor Party was different, or had different dreams and hopes, will also be difficult to grasp for those who come lately. If to write about culture here, meant always knowing also about there, then there was also a different sense in which knowing about the Left meant knowing about the Labor Party, and the other way around. This was a wisdom which people like Alastair Davidson taught me via Marx and Freud, with the idea that the truth of an object might not be in itself, but rather somewhere else. We were not masters in our own house. I wrote *Transforming Labor* to try and get some of these matters out of my head, not least because the transformation of the Left and the transformation of Labor had its own peculiar dynamic or hypertrophy. In 1996 I was invited west, to discuss these issues in the company of Carmen Lawrence and Geoff Gallop. *Transforming Labor* was a good book, attempting as it did to combine political economy and culture, to make sense of the ALP as the object and subject of

this transformation into the state, or what Gramsci called *trasformismo*. The argument effectively fell on deaf ears. Perhaps it was articulated too early, for the rosy blush of power had yet really to wash out. Another way of shooting the messenger is to ignore him, or her. These days, the way I would describe this process would be to say that it involved modernisation, which is itself unavoidable, but with a global template which left little room to move.

Some interesting issues emerge, nevertheless, within the reach of the cultural autonomy afforded us. One is that Australia's small population historically has meant that its intellectual divisions of labour are less inflamed than those, say, in the United States. In the Antipodes intellectuals like Bernard Smith and James Belich take the license to roam widely; nothing human is alien to us, more or less. A discipline like sociology, if we are lucky, ends up being a kind of refuge for misfits, folks from various disciplines, training and background. But this also means that social theory, for example, is often the victim of misrecognition. As Bernard Smith explains of those poor Britons who could make neither head nor tail of kangaroo or platypus, so could antipodeans and others misrecognise the fields of endeavour which they confronted. You could, in fact, find a vibrant social theory at work in the art history or cultural history of a thinker like Smith.

More, the Antipodes also led. Its peculiar blend of Fabianism, labourism, new liberalism and progressivism led a hundred years ago to the description of the Antipodes, trans-Tasman, as the social laboratory of the world. Having spent my early career working on other people's socialisms, after a false start on a project on the history of Australian Trotskyism, I had essayed some of the ideas involved in my contribution to the book I published in 1992 with Mark Considine and Rob Watts – *Arguing About the Welfare State – The Australian Experience*. It's a book which, according to the lending right authorities, people still read, which is interesting, because the object of its analysis has gone, in that form. The point, among other things, was that contrary to the cultural cringe, Australians and New Zealanders were actually good at ideas, good at innovation; consider Arbitration, again.

Intellectual work from the Antipodes only occasionally gets its hearing in the centres; and even then, it is inserted into the pre-existing disciplinary categories. But there were always boundary riders, as I discovered to my pleasure in sharing enthusiasms for Bernard Smith with Martin Jay, Paul Hirst, Marshall Sahlins, George Steinmetz and others. The connections are always there. (I remember meeting an Italian in Amsterdam in the 1990s whose eyes lit up – Ah, Melbourne. Agnes Heller!) But it is always hard for the locals to be heard elsewhere, and not only because of professional

credentialing. All intellectual cultures seem to work through microclimates, so that even in a city like Melbourne what's read on one side of town will be invisible on the other. Figures like Smith, or Seddon, would always be hard to place; in Seddon's case, partly because of a shared path across geography, geology and English literature that would simply demand too much of many readers, especially in the northern proliferation of specialisations. The irony then, finally, was that captured in the now declining image of the expatriate – that if you really wanted to be heard in the north, then you had to be there, which would mean transforming the project as well as the self.

In other times, this did not prevent outstanding intellectuals from reversing the direction, and shifting to the periphery. In my lifetime, alongside the assorted exodus of the Thatcherite diaspora to Australia, the most outstanding single example was the immigration of the almost entire Budapest School to Australia in the eighties. But others had done this before, and one was the Glasgow radical John Anderson, later to give his name to a phenomenon and a significant Sydney culture.

The second part of this book gathers my best essays on Australian intellectuals (and here, so far, they are all Australians, with the exception in two essays of New Zealanders Miles Fairburn and Nick Perry).

Ideas are always interesting, this in the Antipodes as well as anywhere else. This is not because of what is in the water, but because of the way that culture works, through processes of cultural traffic, via the work of cultural carriers who drink deep at the source but also have the capacity to respond sufficiently to place, to their own immediate location and habitus. Innovation is certainly the work of actors, but perhaps especially of those who imbibe as they travel. The outstandingly clear examples happen in fields like rock music, where, as say Jonathon Gould shows in his superb study *Can't Buy Me Love – The Beatles, Britain and America* (with Germany thrown in too), the phenomenon we call 'the Beatles' emerged, among other things, from the processes of cultural traffic between Liverpool, Hamburg and the US. Not that you necessarily needed to leave home in the process, as the contrasting case of H.V. Evatt shows.

The figure of John Anderson remains elusive in the Australian landscape. A little like Bauman, or Smith later, everybody knew Anderson, which meant that nobody knew him at all. Having been trained in philological Marxism by Alastair Davidson and Zawar Hanfi and by Harry Redner, my approach to Australian thinkers was to seek to read them as we would Marx or Gramsci, serially, all the work, usually the published or public work first, then the archives and private papers. This had been my habit

since my earliest work on Trotskyism, and then Bolshevism, Fabianism and Social Democracy for *Labour's Utopias*. For I had been taught, even earlier, by historians, historians of labour and of ideas like N.W. Saffin at Croydon High School – half my luck. And my teachers at Rusden, a small college near Monash which is now apartments, led me on. With historians like Don Gibb I pushed into invasion literature and devoured William Lane. Australian thinkers were invariably, in my experience, at least as interesting in this way of reading as the Big Animals Elsewhere.

Anderson's project was essayistic and contrarian. Like the work of many other leading Australian radicals, it had a significant connection to Marxism and, in Anderson's case, syndicalism, the ethic of the producers. He rejected the doctrine of harmonism, or solidarism; his view of the good or necessary society was agonistic. In this way of thinking, the state and the Labor Party, are part of the problem. In this Anderson was sympathetic with Vere Gordon Childe, even though they had different paths, with Childe's leading out, to Europe, rather than in, to the Antipodes. While Childe became best known as an archaeologist, he also left a major contribution to social theory, in *How Labour Governs* (1923). This was a significant curiosity for me, because as in the case of Anderson, many of the theoretical coordinates in Childe's book were European. The mass political party form had been pioneered by the German Social Democrats, which called out the work of great critics such as Roberto Michels. The ALP became an Anglo pioneer of the process in which the party became the end rather than the means.

Childe's was the first great critique of Australian labourism; invariably, it influenced later work, including my own attempt to make sense of the contemporary form in *Transforming Labor*. The problem of labourism, Childe understood, was not local; it was modern, European or Western, even if its Anglo form had distinct markings and flaws. His own argument, like that of Lloyd Ross, showed stronger sympathies with the socialism of G.D.H. Cole. None of these issues deterred Labor's period intellectual champion, H.V. Evatt. Evatt's thought emerged under the influence of Glasgow idealism in its earlier version, via not John but Francis Anderson. Evatt was Labor's new liberal, not a labourist but broadly sympathetic rather to the kind of thinking we associate with Deakin and Higgins. Liberalism, here, is concerned with providing the external means for the inner moral development of individuals; the sensibilities are as German as they are British, idealist as much as liberal. Evatt had been close to Childe, early on; his historic image, into the forties, took him rather in the direction

of Roosevelt, where the state is part of the solution rather than the problem. And with the passing of time, Evatt's vista shrinks from the pursuit of a more robust social democracy, to the necessary vigilance against the injustices which mar liberal democracy. Bernard Smith, meantime, chose communism, not labourism, even though he got on well with the Evatts in Sydney.

As I look back over these essays, some of my own mannerisms became apparent. One is to begin with biography. Who was John Anderson? Who is Bernard Smith? For the personal is always significant. But in this case, remarkably for me, my subject was alive and well and living a few suburbs away, so that I could go and visit. As I have mentioned, my relationship with Bernard Smith was life changing. It taught me that I was capable of intellectual risk, as might befit an actor in a small place with a less well policed division of labour. I will not rehearse again here the themes of Antipodes as relationship, or the centrality of cultural traffic which I learned from Bernard: they are central axes of all these essays collected here, in different ways. From the period of my second book, *Labour's Utopias*, I had developed the strategy of writing an essay on a field, as a floater. So I began my project on Bernard's work with a survey in *Thesis Eleven*, like a kind of feasibility study. Later I did the same with Bauman. This put me in an interesting situation, as interpreter. I accepted the hermeneutic position, for which the author is not the final authority on his or her work: it needs to be assembled, read for coordinates, continuities and ruptures by another party, in this case me.

This was to result in some amusing blurring of identities, as when Randolph Stow accused me of putting ugly new words in Bernard's mouth, or when Boris Frankel reviewed 'us' as Bauman/Beilharz. There is a sense in which the interpreter should know the work better than the original author. It takes a lot of work, as you need then to read what they read, to teach yourself to listen for echoes, quotations, resources in the cultures which they made their own. One striking difference between Smith and Bauman is that Smith sketches out much of his life's work in his 1948 Courtauld and Warburg journal essay, and follows it, where Bauman's trajectory takes some unexpected shifts and changes over the years, via the Holocaust and then the postmodern and liquid modernity. For Smith, in contrast, the postmodern is but the tail to the kite of modernity.

Having had such a good time working with Bernard Smith, I knew that I would also have to write about Robert Hughes (and there will still be more to come, I hope). Hughes is a fascinating writer and critic, the significance

of whose contribution has never quite been recognised for flurry, controversy and tragedy. Two necessities beckon, for me: first, that while Bernard's contribution includes significant work on modern and international art, his main legacy concerns the eighteenth century, where Hughes' work focuses powerfully upon the modern; second, that while Smith's work focuses on Europe, Hughes takes on the carrier of high modernism, America: perhaps his most striking work is *American Visions*, his 'love letter' to America. Hughes is the brilliant synthesiser, a critic of sharp eye and astonishing power to condense an image, a visual moment and its context. And he has other adopted Antipodes, not least those of Barcelona, the great enchantress. Beyond all the fuss about Hughes, the quality of his intellectual achievement still has to be sufficiently recognised.

Much of George Seddon's impact was felt via Western Australia, as has Hugh Stretton's been via Adelaide. These are internal Antipodes. The extraordinary quality of Seddon's work has to do with the lightness of his own landprints, his prose and presence mischievous, the ambit of his vision sufficiently broad to take in both nature and culture. Stretton's work, similarly liberal in character, always managed to add something which was not there before, as in the highly innovative platform provided by *Capitalism, Socialism and the Environment*. These are Australian thinkers who were always a step ahead.

Two papers follow on the work of Jean Craig, as she was known until she married Allan Martin. Craig was an exemplary carrier of cultural traffic, starting with the influence of A.P. Elkin at Sydney, travelling to the University of Chicago at its peak, and home to pioneer industrial sociology before turning to immigration and multiculturalism. These were years of optimism, after the devastation of the Second World War; this was a period when sociologists really believed that they could change the world, and they did. The volume closes with a more tentative excursion into the Tasman zone, via Peter Carey's *Unusual Life of Tristan Smith* and Nick Perry's cheeky notion of 'antipodean camp'. Literature, from W.C. Wentworth's 'New Britannia', through Lawrence's *Kangaroo*, up to and including Carey's phantasmic antipodean world, and art, from Stubbs' kangaroo to Ian North's cover visuals, on this book has always provided a portal into what we are, where we have come from. Where are we going? Read on; write on. These are some of the byways of my thinking over recent years. I am grateful for the opportunity to share them, again, and thankful to find myself in a place where there are so many good thinkers to work with.

PART ONE:

THEMES

Chapter 1

Australian Civilisation and Its Discontents (2001)

Australia used to be the Lucky Country, or that at least was the image that we grew up with. Something has changed, upsetting that image of well-fed complacency, sunshine and surf, endless summer; of course this life was never universally shared, in any case. You could call this process of change globalisation, or postmodernisation, or even modernisation. Whatever you call it, Australia today is an unhappy country, neither relaxed nor comfortable except in the most immediate sense. I want to suggest some reasons why; or how at least we might begin to make sense of this situation.

Let me begin with a recent controversy, if you could call it that – with the recent scuffle across the pages of the *Times Literary Supplement* between the humourist and critic Clive James and his own critic, the Australian historian Stephen Alomes. What's changed, when it comes to argument about Australia and identity? Not much, at least in terms of public, Anglo debate. Australians, we are often told, suffer from identity crises. It is a condition of being antipodean, apparently, that we have to be told this. Clive James' major review of Alomes' book, *When London Calls: The Expatriation of Australian Creative Artists to Britain* (Alomes 1999), was itself entitled 'All over the world like a rash' (*Times Literary Supplement* 28 January 2000, and see *Times Literary Supplement* 4 February, 11 February 2000). Actually, Clive James has come out, and come out in a rash, but on the most tired of turf, that of this very obsession or beat-up concerning the question of national identity. Who are we? Alomes comes out of James' review looking like a swaggie; Clive James, of course, himself emerges as the very figure of the absent cosmopolitan, smelling of Harrods or the Galleries Lafayette. The feelings and arguments involved are intense and personally felt. Partly this has to do with anxieties, resentment, senses of betrayal and the need for recognition. Sometimes Australians need to leave, and to stay away. Those

who remain feel that they suffer for this absence, although they also benefit from the replenishing of metropolitan culture at its centres. Having just two options, to stay or to leave, increasingly these days looks like a poor choice, one anyway upset by the jumbo. We are, to twist the animal metaphor, already migratory birds, as the art historian Bernard Smith put it in 1955, on the occasion of an earlier Olympics.

So what is at risk in this well-publicised spat in the pages of the greatest literary institution afforded us by empire, the *Times Literary Supplement*? Clive James is evidently pissed with the intellectual paparazzi. He resorts to wicked, dead words with which to whip us, *Savants*! Yet the discursive opening thus suggested is wonderful, for Clive James shares with us hereby his own considerable intellectual capacities, and not only his televised wit. And the sense of relief is evident, as Australia is – remarkably – dealt with in the pages of the *Times Literary Supplement* increasingly in a still subordinate but ongoing manner, in contrast to the single bitter pill of a Special Issue every three years, that precedent locked into a compulsorily triennial time capsule which ends up looking the same every time, even if there is life after Manning Clark and we do actually change over time. All of which goes to show that, in the old established routine, and contra Clive James, we are still colonials for the British establishment; for if we were marked by our voices, and yet heard for our arguments, as Clive James implies we already are, then we would be treated more like Peter Carey or Robert Hughes in the *New York Review of Books*, and less like the proverbial antipodean dancing dog.

Clive James cannot agree with Stephen Alomes that we have changed since, say, 1972. In a sense James wants to have it both ways, as though we in the Antipodes have always contributed to world culture, and yet as though the pond remains too stiflingly small, the cultural desert too overwhelmingly large. My own sense is that we have changed, are changing, are always changing, although perhaps as Claudio Veliz puts it, we share with Latin American culture something of a sense of boredom with the past as well as a fear of the future, of change (Veliz 2000). But to renew an old observation, this 'we' in any case changes differentially, and this is true for each of us, psychologically and not only in sociological terms of demographics. While the moves in Clive James' review are familiar to us, we might get further on afield the other side of the compulsory obsession with colonial or national identity. It is a good time to ask not who we are, but where Australia is, and what it might mean to be antipodean today. This would mean shifting away from more directly personal references concerning identity, to seek out some corresponding sense of distance or detachment via sociology or

history, political economy or geography, before returning to those personal preferences and to contemporary anxieties.

In this spirit I offer six theses, under the heading Australian Civilisation and Its Discontents. The first three are negative, the second three positive. I have no idea what chemistry ensues when you put them together, whether they explode or just cancel each other out. I am aware that the idea of theses sounds pretentious, like something a young Marxist would have for breakfast; indeed, this was exactly the kind of intellectual diet on which I was raised. I can do no other but anticipate results yet to be developed.

Thesis 1: When it comes to making sense of Australia today, neither imperial nor nativist mythology will do. What we call Australia is neither simply the echo of imperial voice, nor just the plaintive bleat of the lonely kangaroo, its own proud or pathetic immaculate conception. We need finally to let go of ideas that what we call Australia is the accumulation of response to imperial stimuli, whether British or subsequently American. Australia is not a second-class version of America, for better or worse. Nor can we sustain the alternative view, or inversion of this perspective in the tradition that is national-chauvinist, where Australia is Godzone, immaculate conception, culture grown of salt and desert. There are various permutations of this split, which have kept critics locked into bipolarised clichés and guaranteed markets for far too long: noble Australian nature against decadent European civilisation; authentic Australian culture versus decadent European civilisation; superior metropolitan culture versus provincial vulgarity, and so … Paris or the Bush, Paris or the Beach, Boston or the Backyard.

This simple split between 'here' and 'there' is unhelpful, because the pairing is usually understood in terms of causal relations of explanation. Whether this is an imaginary split between origin and result, seed and fruit, culture and nature, or civilisation and culture, the logic of environment and implant is distracting, not least because it makes of environment a metaphor. We need now more than ever to talk about environment or landscape, in realist as well as in symbolic terms. More, this cultural divide between culture and periphery cannot be overcome by mere juxtaposition, or addition. Australia, our Antipodes, is not just the sum of these parts, but the result of shifting processes of human and cultural traffic. Place matters, but it is constructed in traffic.

Thesis 2: In the process of rewriting history, or of revisioning the Antipodes, it is time to transcend teleological stories of the Australians as an emerging national popular subject. My sometime predecessor in the Harvard Chair of Australian Studies, Professor Blainey, in the *Times Literary Supplement* of all places,

recently made the telling observation that whereas other folks have culture wars, we in Australia have history wars. Of course we also have generational spats over culture and media, and who speaks; of course history writing cannot be other than political, but there is a point at which the fusion of politics and history writing means that we can no longer tell the difference and get both wrong in result, just as when we are unable any longer to think about nature as a material process that is independent of us, because we have second-naturalised nature as though it were only a social construction.

Plainly, recent historiography in Australia has been multiculturalised; we are shifting, implicitly away from the idea of culture toward that of civilisation. But another split emerges here, between a commemorative, monocultural Old Australianism and a critical, but in its own way also celebrative, new multiculturalism. Both these old and new histories are too angry, which is one thing that unites them; the old, about the survival of the old Australia, under threat, the new, about its continued persistence.

In narrative terms these battles involve disputes over foundational values and the actors taken to represent them – Anzacs, if you like, versus democrats. The figure of the Australian is changing, or better, the cast in its story is becoming pluralised. As elsewhere, we are witness here to the writing in of labour, women, indigenous and ethnic stories, as in the significant volume by Patricia Grimshaw, Marilyn Lake, Ann McGrath and Marian Quartly, *Creating a Nation*. A broader, more representative personnel results, still within the conventional narrative of the emerging national popular subject – only now she looks different (Grimshaw et al. 1994). A book that in my view more closely registers the awkward nature of our moment, a more transitional book for this most transitional period, is Stuart Macintyre's *Concise Cambridge History of Australia* (Macintyre 1999). Macintyre combines this period left-liberal concern with the emerging national, multicultural subject, with a longer view, including the old Australia back through Terra Incognita, Sahul and Gondwanaland, this together with a practical scepticism about the predictive value of history. We have come a long way, into a new world indeed, when our leading mid-career historian acknowledges that we have no idea what the future might be; that the best we might achieve is a longer view, a civilisational and ecological view of the Antipodes within world history. Yet we need, together with Macintyre, to be open to the possibility that all this, once achieved, would tell us little directly of our future. We cannot claim any longer to call the future of our country in terms of our favoured social actors or social movement. Our futures may, indeed, be elsewhere.

Thesis 3: When it comes to making sense of Australian civilisation, none of the following will get us there: the idea of the frontier; the idea of the cultural fragment; or the idea of Australia as a neo-Europe. First, not the frontier: not Frederick Jackson Turner. Americans, in the imagery of tradition conquered a continent. Australian modernity has failed to conquer nature. Nature still confronts us, as a fact. Seventy percent of our continent is arid; eighty percent of our peoples live in the fertile south-eastern crescent. The cultural, or imaginary, effects of this contrast are substantial. Australia never had a strong boosterist, or progressivist culture. The honorary antipodean who best expresses our kind of experience is not Henry Ford, but Albert Camus. Put differently, via Max Lerner's pattern of thinking in *America as a Civilization*, Australia has myths of origin – Eureka, The Great Strikes, Gallipoli, Postwar Reconstruction, Whitlam, The Family Law Act, Mabo – what we lack is *myths of mission*. As Lerner puts it, the American experience rests upon the coincidence of the frontier and capitalist revolution. Australia lacks both of these revolutions, remaining instead a permanent metropolis and a permanent hinterland (Lerner 1987, 39). America is permanent revolution; Australia, in contrast, has never had a Faustian culture like this. Australia had a working class before it had industrial capitalism; we are still sorting out the effects of this, especially after the more recent invention of capitalism without labour.

Second, not the fragment – not Louis Hartz. Australia was never just the implanted fragment of Europe far flung. The problem here, again, is the proclivity of the centres to a kind of causal narcissism, first, in their own thinking, therefore apparently generative of the other. The logic of cultural diffusionism is unilateral – the centres throw up, or out; the peripheries receive. Louis Hartz understood this, at least in the longer historical view, though the pattern of his own thinking also looks Hegelian; the centres of world history lead, even if they also decline, and the peripheral results are distinct, paradoxical (Hartz 1955; 1964). The point lost here is that the centres need the peripheries culturally, perhaps more even than they do in terms of political economy. The fragment – in this case, Australia – influences the centre – here, say, Great Britain – more than we might at first imagine. Think only of Paul Keating and Tony Blair, for it was in the Antipodes that New Labour was pioneered, or of the earlier global effect of the social laboratory in the Antipodes (Coleman 1987; Scott 1999). Who today remembers Henry Demarest Lloyd's American campaign for the 'New Zealandisation of the Rest of the World'? In the age of great power chauvinism we forget far too quickly that size is not everything, whether in

social policy or in aesthetics. Cultural traffic also flows uphill. If we were to pursue the organic metaphor on the other hand, better to think together with Australian feminist Sue Sheridan of grafts than of transplants. The result of cultural traffic is difference, creation, and then feedback.

Third, not neo-Europe. Australia cannot sufficiently be explained in Alfred Crosby's terms in *Ecological Imperialism*, even though both the cultural argument and its environmental inflection are appealing (Crosby 1986). In making sense of the Antipodes we need to hold onto this ecological sensibility regarding the impact of biological imperialism throughout the new world, without losing the analytical insight associated with the sharper category of settler capitalism. But the idea of neo-Europe will only help culturally if we once again pluralise internally the concept of Europe. Closer points of comparison in Canada, and in South America, might well get us further within the larger optic of civilisational history.

The negative theses now give way to the positive. *Thesis 4: What we can call the Antipodes – a sharper focus than the idea of Australia because it refers to a relationship as well as a place – results from processes of cultural imperialism and cultural traffic; these processes are provisional, and always shifting.* The centres depend culturally upon the peripheries. Imperial cultures cannot reproduce or develop by internal means alone. The idea of neat, modular national cultures is as fictive as it is ideologically redundant. Herder is dead. Tocqueville lives. The objects of our analysis are always changing and in tension. The solidarist imperatives, for example, of Edward Bellamy come to the Antipodes in the 1890s to be reformed and returned, rerouted via associated enthusiasms for institutions such as arbitration, which themselves emerged in cultural traffic between Australia and New Zealand. The paths of cross-movement in social policy, as in high culture, are not only transatlantic, as Daniel Rodgers displays in *Atlantic Crossings*, but also transpacific, and more (Rodgers 1998). The same is true of feminism. Think only of Spence, Alice Henry or Stead; more recently of Carole Pateman, Elizabeth Grosz, Desley Deacon, Judith Allen, Hazel Rowley. Or of art criticism, where our greatest export remains Robert Hughes – even if *Beyond the Fatal Shore* disappoints, *American Visions* remains magisterial. Empires always talk back, as do outsiders. The point concerns not only individuals and their particular ways of geographical or social mobility. Patterns of cultural traffic, as Bernard Smith has shown in a life of writing from smaller rooms in Glebe and Fitzroy, not only supply the peripheries locally but also renew jaded hearts of empire through various waves of modernism, romanticism and primitivism.

Those who have read Russel Ward's *The Australian Legend* (1957), and not only its title, will have met this theme at the end of his book, where he turns in closing to what came to be Smith's (1960) book, *European Vision and the South Pacific*, expanding his civilisational perspective. The two drank together in the late 1950s at the Wellington in Canberra as middle-aged doctoral students at a new Australian National University, in a moment itself significant in Australian intellectual history, for Ward was subsequently to be viewed as the advocate of environmental nationalism, where Smith in *European Vision and the South Pacific* became our most insightful theorist of cultural traffic, Antipodes as relation rather than place, culture as movement more than ethnos. Smith ran the gauntlet, the line in between, in *The Antipodean Manifesto* in 1959 (Beilharz 1997). In the closing passages of *The Australian Legend*, Ward steps outside the analytical framework of nationalism to entertain the possibility that the heroic frontiersman, in our case bushman, is a belated reconfiguration of the noble savage. Ward's case is not a simple nativism, for he thus makes plain that in his own usage myth-making is a creative and civilisational process (Ward 1957; cf. Nile 2000). The Australian bushman as cultural hero emerges not from the deserts, but from the cities of 'empire', and in both cases the mythology is held up practically not by drovers or artists but by their wives. Crocodile Dundee, then, is at least as much Californian as antipodean, for even a new world modernity like American civilisation needs to refresh its culture with nostalgia whether local or exotic, the more so for the progress of progressivism, or boosterism. Ward knew that his subjects in *The Australian Legend* had been assembled and recruited for the project of nation building, so that 'national culture' could in consequence be neither neatly imperial nor provincial in origin, but would only be the result of processes of trafficking between those places, habits and ways of thinking. In result, Australian critics of various stripes may have been looking for identity – or love, or recognition – in all the wrong places. As in Freud's suggestion concerning symptom and structure in the unconscious, our history in the Antipodes will always be elsewhere and shifting, thus elusive. Like total history, antipodean history is in this sense impossible to write; but that will not prevent us from attempting it.

Thesis 5: Australia, or the Antipodes, can usefully be viewed not only as a country or culture but as a civilisation. Australia and New Zealand really need to be co-written, not least because to an outsider, New Zealand is more interesting. They do things differently there, even though at the very same time the experiences are similar. Why civilisation? The category of culture is not big enough, or else these days it is too big, too ubiquitous; if anthropologists

have lost control over culture, management theorists have made of it a way of life. The word 'country', in contrast, is too casual, even if it has the merit of reminding us that, in a moment analytically obsessed with urbanism, most of our global fellows still inhabit the country, or else that what is left of the countryside after the effects of civilisation is not especially cheering. The idea of civilisation, I suggest, should be used in its strong tense, not as a term of self-congratulation but as a way to hold together the dimensions of culture and power. Civilisation is based upon violence against other humans and against nature. As Walter Benjamin understood, progress is dependent upon violence, and this is why we feel ambivalent about it. To think in this way, then, is to think with Benjamin and with Simmel, through the pertinent coordinates in Freud and Norbert Elias and through critical theory to the work of Zygmunt Bauman. The practical theorists of civilisational theory, alongside paranoiac rascals such as Spengler, Sorokin and Toynbee, include in the American case Max Lerner, C.L.R. James in *American Civilization* (James 1995); in Australia Bernard Smith; and crossing over Australia and America, Lloyd Warner in his classic *Black Civilization* (Warner 1937). In the Australian intellectual context we also have two books called *Australian Civilization*, the first representing the old new Australia (Coleman 1962), the second getting closer to the present, especially in the hands of its editor, Richard Nile, where civilisation is understood less in terms of conventional institutional habitus and more in terms of provisional balances between gains and losses whether in aesthetic or harder resources (Nile 1996).

The idea of civilisation points to a long view, and to an ecological history; it sets colonisation against dispossession, masters against slaves, and re-thinks those relations in their asymmetrical reciprocity. The reference here, however, is not only European, colonial or postcolonial, but also continental, and oceanic. Australia's imagination is caught up not only with red desert or Sydney sails, but also with the presence of the Pacific, the Indian and Tasman oceans, differently with Antarctica. Perth or Hobart is as much a symbol of Australia as Sydney is, Olympic guff notwithstanding, not least because of their heightened peripheral visibilities and the ways in which they, Australian peripheries, also supply Australian centres. For there is a kind of internal colonialism that is intellectual, as well as the more sordid kind. Sydney, like New York, is as much a result or point of arrival as it is an origin or point of departure.

The idea of Australian civilisation in this way indicates the presence of an edge culture, a particular kind of modernity built both on the edge of the world-system and upon the edge of a specific form of nature. This is

a matter of substance as well as form. Australian modernity, however we value it, is a pimple on the arse of world history. In contrast to the United States, with the Midwest, East, West and South, Australian built space is a western blot and an eastern crescent, in sum a concrete smudge on a longer landscape. Australian civilisation is fragile, notwithstanding this concrete edge. Our achievements might be considerable, yet viewed from a distance Australian modernity looks like a Christo wrapping. Like the Maya, perhaps; or as in *Mad Max*, Australian civilisation has an impact sufficiently light to imagine its disappearance. As a thought experiment, more perhaps than as a politics, we might indeed imagine what it would mean to vacate it, to give it back.

Thesis 6: To think of Australia as a civilisation, as both grounded and changing, is potentially to get closer to the immediate problem of Australian civilisation and its discontents. Australia used to be imagined as the Lucky Country; now it is the unhappy country. I do not mean to suggest by this word that we are all terminally miserable. In terms of the rituals and habits of everyday life, Australians are likely as happy as they were in the 1960s, with some people's happiness being the misery of others, just as the freedom of some always rests on the dependence of others. Perhaps it would be more precise to say that Australians are chronically anxious, unhappy less about their immediate everyday lives than they are anxious about the remainder of their own lives and the prospects for their children. For we are caught, today, in a liminal phase, between the old Australia and the new, or between the new Australia which we grew up in, and the newly emerging postmodern or globalising Australia. For the Sardinian Marxist Antonio Gramsci, in a different moment of transition in Italy in the 1930s, the problem seemed to be that the old was dying and the new would not yet emerge. For us in Australia, the problem is rather that the new is emerging and the old will not die, or else that we are reluctant to part with it. This is unlikely to change into the foreseeable future. We have, many of us, yearned for a New Australia; now, we may be less sure. A great many morbid symptoms appear at least in the form of conservative populism or economic nationalism in the north, as an imaginary seccessionism revives among sectors of those who feel that political elites represent nobody but themselves, that we are led by a new class ready to jump at any moment.

One lineage in the critical literature tracks this malaise. Hancock captured the image of the old story in *Australia* in 1930; this image of a political economy living on borrowed time is relayed through the premonition of Donald Horne, in *The Lucky Country* in 1964, and finally issues in the

apocalyptic diagnosis of Paul Kelly in *The End of Certainty* (1992) where the ultimatum is too simple, but clear: change the way we live, change the way we make our living, transform our political economy and culture, or die: American republic or banana republic (Kelly 1992; Hancock 1930; Horne 1964). The problem with this diagnosis and its consequent prognosis is that we cannot simply shed the old Australia, nor should we; for its civilisation contained certain patterns of civility built into particular institutions like arbitration, the living wage, the more formal institutions of health care provision and education and the less formalised sensibilities carried in notions like a practical egalitarianism, all of which conferred some kinds of solidarity, even if in the old labourist or protectionist, forms.

Now the old civilisation (or culture?) can no longer pay its way. Never aggressively capitalist in the Marxian, industrial sense its political economy was perhaps physiocratic, naturalist or agricultural, with an egalitarian distributive ethic or a kind of distributist utopia tacked like a flag on top. The old political economy was like the platypus, only half capitalist, and we got the weaker half: for ours was a bourgeois superstructure without a substantial bourgeois or capitalist base, which meant that the old economic culture was never vigorously bourgeois in the puritan or entrepreneurial sense either. Ergo the early popularity in the labour movement of Bellamy or Henry George, rather than Karl Marx. Marx, of course, rejected the ideal of capitalism without capitalists for different reasons, but Australia's fate was to be a variation on this theme. Marxism then became an indirect political presence in the labour mainstream only into the 1980s, when Labor's smart boys out of the New Left discover an absence in the national engine room and divine industry development policy as the solution (Beilharz 1994).

So what's new in this story? Not the process of globalisation, for the Antipodes has always been globalised – but its content. Our lives in Australia coincide with the deconstruction of a state-centred tradition, its civic culture, and the dispersion of its users or employees. Who, then, are our discontents? Obviously those whose life chances have been connected to the state, those working in or dependent upon health care and education. Most truly, in contrast, the outsiders, the excluded, primarily indigenous peoples, who all along have felt the bite of the state which has sought to protect aboriginal people from everybody but the state itself. But also, more generally, those who inhabit, by choice or circumstance, the old Australia; and then, differently, those who have only recently been written into the new, multicultural, national script, some of whom have already slipped out of it. These are all our discontents, in different ways.

Whatever the legitimacy of their relative discontent, categories of actors such as women and labour can at least in principle claim in this context the right to be heard. As actors with some claims internal to the logic of the social system, their interests potentially can be mobilised by social movements. Indigenous peoples have access less to a social, than a political movement. Their plight, as victims of internal colonialism in the strong sense, is to resort to the language of international rights talk, precisely because in a civilisation dominated historically by producer groups there is no systemic or economic interest upon which they can claim recognition, or even against which they can register discrimination.

This means, among other things, that, to connect here back to Bauman, we encounter in Australia the effects of both partial assimilation, the symbolic swallowing up of difference in aboriginality and its practical expulsion or marginalisation; black is allowed to be beautiful in the aesthetic terms of glossy globalisation, yet blacks are incarcerated across the country. Locals regardless of colour are trapped whether firmly or metaphorically, while globals escape at will (Beilharz 2000). Those who escape most often are also those whose voices are authorised to tell us or others from outside, what or who we are. Social ventriloquism rules.

Who then are these discontents of Australian civilisation? Evidently those systemic actors – labour, women, some primary producers or local manufacturers, those allied to the declining state system – who can claim political rights on the basis of rising or falling economic interests. More stigmatically, there are those who watch all this with contempt, or else turn their backs on it from the margins of the desert or in Redfern. More generally, *all of us*, for we are all torn between the old and the new Australia, between local origins, loyalties and solidarities, and futures that beckon elsewhere. The sense of good fortune, undeserved, which Donald Horne tried to capture in *The Lucky Country* has been replaced by a fundamental sense of unease, of ambivalence.

This is not a predicament that will evaporate, not for some generations; and it is this kind of problem I suggest which really lies behind the spat between Clive James and Stephen Alomes. We cannot easily choose between the glossy globalisation offered by our political and cultural elites and the selectively applied if muscular egalitarianism of the old Australia. There is more ambivalence here than you could poke a stick at: between the gains and losses of an old world some of us are leaving and a new world where bravura borders on folly ... and we are all caught between. Those of us sufficiently privileged may feel most at home in movement, in flight. This will be of

little consolation to those frozen into the life chances of the old, declining world. But this is the Australia we are entering, less directly perhaps one of two nations than of two cultures, where the challenges of cultural traffic and political identity will remain continental as well as imperial or global.

If I have to choose between empty cosmopolitanism and national chauvinism, then like Karl Kraus, and following the local example of Bernard Smith, I choose neither. The jumbo opens us to new worlds. Speed and movement become leading postmodern stimulants. We still need to learn how to slow down, how to value the old as well as to recognise its shackles. As far as historiography or criticism is concerned, this means that it is again time to revise the revisionists. We should be driven on by our discontents, actual and symbolic.

Acknowledgements

For Janet Hatch, with thanks, and to Bernard Bailyn, with respect. The present article was delivered as a keynote address to the Annual Convention of ACSANA in Ottawa, 25 February 2000 (thanks to Kim Nossal), to the Committee on Australian Studies at Harvard, 27 April 2000, and to the postgraduate theory seminar at La Trobe on 28 August 2000. Thanks to all, but especially to Harvard for giving me space and distance within which to think.

References

Alomes, S. 1999. *When London Calls: The Expatriation of Australian Creative Artists to Britain*. Sydney: Cambridge University Press.
Beilharz, P. 1994. *Transforming Labor – Labour Tradition and the Labor Decade in Australia*. Melbourne: Cambridge University Press.
Beilharz, P. 1997. *Imagining the Antipodes: Theory, Culture and the Visual in the Work of Bernard Smith*. Melbourne: Cambridge University Press.
Beilharz, P. 2000. *Zygmunt Bauman – Dialectic of Modernity*. London: Sage.
Coleman, J.P. 1987. *Progressivism and the World of Reform. New Zealand and the Origins of the American Welfare State*. Kansas: Kansas University Press.
Coleman, P. 1962. *Australian Civilization*. Melbourne: Cheshire.
Crosby, A. 1986. *Ecological Imperialism*. Cambridge: Cambridge University Press.
Grimshaw, P., M. Lake, A. McGrath, and M. Quartly. 1994. *Creating a Nation*. Ringwood: Penguin.
Hancock, W.K. 1930. *Australia*. Brisbane: Jacaranda.
Hartz, L. 1955. *The Liberal Tradition in America*. New York: Harcourt Brace.
Hartz, L., ed. 1964. *The Founding of New Societies*. New York: Harcourt Brace.
Horne, D. 1964. *The Lucky Country*. Ringwood: Penguin.
James, C.L.R. 1996. *American Civilization*. Cambridge, MA: Blackwell.
Kelly, P. 1992. *The End of Certainty*. Sydney: Allen & Unwin.

Lerner, M. 1987. *America as a Civilization*. New York: Henry Holt.

Macintyre, S. 1999. *Concise Cambridge History of Australia*. Melbourne: Cambridge University Press.

Nile, R., ed. 1996. *Australian Civilization*. Melbourne: Oxford University Press.

Nile, R., ed. 2000. *The Australian legend and its Discontents*. Brisbane: University of Queensland Press.

Scott, A. 1999. *Running on Empty: 'Modernising' The British and Australian Labour Parties*. Sydney: Pluto.

Smith, B. 1960. *European Vision and the South Pacific*. Melbourne: Oxford University Press.

Veliz, C. 2000. *Globalisms, Nationalisms, Republicanisms, and the Devastating Sanity of the Australian People*. Boston: Boston University.

Ward, R. 1957. *The Australian Legend*. Melbourne: Melbourne University Press.

Warner, W.L. 1937. *A Black Civilization: A Social Study of an Australian Tribe*. New York: Harper.

Chapter 2

Tocqueville in the Antipodes?
Middling through in Australia, Then and Now
(2001)

Alexis de Tocqueville never set foot on Terra Australis; the Antipodes did not interrupt his gaze. Yet his presence is everywhere, in modern Australian attempts to understand where we have come from, and where we might be going. Tocqueville himself has become something of a sacred thinker; American social critics seem perhaps especially glued to *Democracy in America*, which after all is more sympathetic than most German or later cultural criticism of the American odyssey. Tocqueville's American reception plainly has something to do with the positivity of recognition, which is less surprising perhaps, than the prophetic sense that Tocqueville was describing America today. Yet the presence is powerful and provocative, and it permeates Australian discussion as well, a fact that is as surprising as it is persistent.

What would Tocqueville have said about Australia? This might be any-one's guess, though it is apparent, on consideration, that it is indeed the case that Australians both read and used Tocqueville to help explain their own situation, and more generally it is also true that the so-to-say Tocquevillian critique of new world egalitarianism and its potential result, in mediocrity, has become a major theme in the internal cultural analysis of the Antipodes ever since.

What a loss, then, that Tocqueville never visited the Antipodes, for the contrasts and convergences between the two new world experiences are substantial. What a loss for Tocqueville, for the one thing antipodeans were good at in his moment was prisons, then his subject of special interest. The differences between America and Australia are striking, notwithstanding ongoing cultural traffic and apparent similarities. Apart from prisons, to which we now defer to others in leadership, Australia now specialises in

cities, seawater, dust and sand, not all in the same places. Our world is global and in some senses American, some colonial or European, but it is also oceanic, and at the same time two-thirds arid. Eighty percent of our people inhabit the fertile eastern crescent or the larger edge of concrete, facing out, curious and cosmopolitan as well as parochial or provincial in our own way. Ours is a modern story begun not in the image of the glory of God but on the more sombre note of the punishment of evil; its originary, white spirit is melancholy at best. Through the 1960s the place came to be known as the Lucky Country, because of its relative material affluence, civility and stability; but it also became known or constructed as mediocre, because fortunate, and the newer response to our situation has older precedents, many of them to be found in documents kindly bequeathed to us by visitors from superior lands. Luckily for us in the Antipodes Teddy Adorno stopped at Santa Monica. For there are all kinds of intriguing puzzles here about how the old world reads the new world, and how the younger, in this case Australian, experience follows, fails to live up to American dreams, and yet still offers some of the nostalgic warmth of older images, whether of Manhattan in the 1950s or the west after the frontier is closed and the Frontier Thesis lapses.

The visitors were numerous and eminent, even if Tocqueville was not among them. I can find three references in *Democracy in America* to our place, one to Australia, two to the Antipodes, one of which seems to indicate that Tocqueville anticipated full well the difference between the antipodean state-centred culture and the American predilection for associative democracy (Tocqueville 1966, 513). Let us scan in passing the views of some of these others. Charles Darwin in 1836 – quite close, chronologically – indeed liked what he saw in Australia, was astonished at how successfully recidivist convict genes had been rechannelled into the new climes of a gentler civility (Ward 1958, 31). The absences from the visitors' view are, to us, as striking as the presences. Here, for Darwin, was appropriate societal evidence that evolution could recommence at such a higher stage via such rupture. And this came, in fact, to be a recurring theme among visitors, that Australian convictism had failed, but that what had developed instead, miraculously, was what Darwin called 'a grand centre of civilization'. Later eminences such as Froude and Trollope both worried about the mother country's hold on the colony, in a kind of premature separation anxiety, and both fretted about the evils of alcohol and gambling, which Australians were also good at. But no-one in the 19th century offered the kind of sustained sociological interpretation of Australia that Tocqueville achieved in *Democracy in America*. Visitors like the Webbs, following Trollope and Froude, sniffed at

local vulgarity even as they were struck by the degree of progress in social experimentation afforded by new world culture.

Other visitors came in abundance. Visiting Americans left books that were hymns, as in E. C. Buley's *Australian Life in Town and Country* (1905), or visitations to hell, as offered in Thomas Diven's *Diseased Communities Australia, New Zealand and* – (1911) – who's next? the spreading bacillus of course being socialism, which had already infected Chicago as well on this account. Frenchmen came too, if not Tocqueville, then after La Perouse and Baudin, most famously Albert Métin, whose views were left in 1901 as *Socialism without Doctrines*. Focusing upon the peculiarities of labour legislation rather than of manners or civil society, Métin's conclusion was that Australian socialists were even more pragmatic than the English (Métin 1977). When he asked a local radical proletarian for his programme, his inquiry was met with the answer 'ten bob a day' – a dollar a day – though controversy has since raged whether this confession was in earnest or just a matter of local humour at the expense of tourists, an antipodean pulling a frog's leg. Métin's work became a kind of landmark for the sober socialism that took its distance from Marxism. Its ambit was more like Sombart's, in *Why is there No Socialism in the United States*, than Tocqueville's, even though Métin's comparativist credentials were substantial – Métin also wrote books about Egypt, India and Canada before becoming French Minister for Labour in 1913.

Into the new century, the American Victor S. Clark visited and sub-sequently assembled his insights in *The Labour Movement in Australasia* (1907). Clark clearly understood the distinction between America and Australia in Tocquevillian terms, establishing the contrast between a culture of local government through townships and a system of labour pursuit of cooperation through union branches instead of towns. This distinction indicated both the relative weakness in Australia of local government and the ambivalence of a form of political corralling that worked well so long as it worked, but where politics would begin and stay adversarial at best and tribal at worst. Victor S. Clark also understood that while the ALP was a great success its example was not generalisable. Visiting a century ago, we can already intuit in his work the sense that Australian labour would become contained within its historic moment, a pre-Fordist capsule like Fordism, based on import substitution, agricultural exports, a high wage, high-cost economy with high employment and protection all round.

Australians also registered some of their claims in America, we can note in passing. In the same moment H.B. Higgins, founding figure of arbitration

in Australia, and Clarence Northcott, a Sydneysider, WEA enthusiast who came to Columbia to work with Giddings, registered their antipodean views in the United States. Higgins published a book significantly entitled *A New Province for Law and Order* in 1922; its core content was a series of articles published in the *Harvard Law Review* across the period 1915 to 1920 (Higgins 1922). Higgins returns later in my story; a kind of mild-mannered cross between Brandeis and Bolshevism, he remains one of the central actors in establishing the institutions that characterise the social laboratory. Northcott's *Australian Social Development* (1918) captured more of the specificity of the path followed in the Antipodes, and the formative presence of labour in that process. Let us note, as a single symbolic instance, that when the eight hour day was won in the Melbourne building trades in 1856 its political expression was 8/8/8, expressing the masculine proletarian right not only to a working day of eight hours, but to equal measures of leisure and sleep. Leisure was to become a key to images of Australian culture, indicating by our own time both something of its remaining charm and something of its ambivalence about modernity or modernism in its dominant, American model. For the images evoked, as Northcott observes, were more often to do with free time for the cultivation of the self than for recreation (Northcott 1918, 90). Leisure might, in the period trade union sensibilities, refer as readily to education as we today might connect it to the cultivation of the body or the pursuit of stimulants. What others call state socialism might here into the 1920s be recognised as the project of social democracy, its imaginary subjects were boys, but they were not only workers.

For sociologists such as Northcott, the challenge was to channel social democracy into the cause of social efficiency. The problem with democracy here was not that it was culturally mediocre, but that it risked productive inefficiency. This contradiction, among other things, was what saw the younger Elton Mayo leave Brisbane for America. Australia had its progressives, but they lacked an audience or constituency. The wage-working inhabitants of the social laboratory were more receptive to the needs-talk of Justice Higgins than to postwar images of a new social order. The labour culture of egalitarianism favoured neither distinction in social manners nor differentiation per skilling in the workforce. Industrial unionism itself was a leveller. Northcott's politics were those of the WEA rather than Marxism; perhaps he was unable to make sense from within of the bizarre local combination of zero-sum thinking with the naturalism or natural physiocracy of labour, which reinforced labour's distributive rather

than productivist ethos. Here the logic of cooperation could not be extended horizontally positive-sum models of labour-capital collaboration. For if earlier Australian political economy presumed abundance, this abundance was imagined as natural or agricultural rather than new or manufactured, artificial; its thinking was closer to John Stuart Mill's steady-state economy than to Adam Smith's pin factory. Perhaps it was even closer to John Locke and Marxist mainly in its populism. For Northcott, this was nothing that a programme of social efficiency could not fix. Some of the fundamental problems of dealing with progress are nonetheless posed by Northcott in this way of thinking.

But these voices, those of Higgins and Northcott and the like, were, as my own in this article, those of insiders taking advantage of an external perspective from which to make sense of their own culture. If we return to the company of those who visited the southern hemisphere from the north, the only apparent parallel to Tocqueville's great work is something much more diaristic, in the book by Richard Twopeny, whose *Town Life in Australia* was published in 1883. Twopeny's survey of Melbourne, Sydney, Adelaide; Houses, Furniture, Servants, Food, Dress, Youth, Social Relations, Religion and Morals, Education, Politics, Business, Shops, Amusements, Newspapers, Literature, Language and Art reads today like a tourist guide for the well-to-do British middle class, which is what it was. It is less clear whether Twopeny's focus on material life indicates his own journalistic habits or whether it reflects a culture where the emphasis and achievement are indeed material rather than spiritual. Certainly Twopeny revisits two familiar themes: men in Australia drink and gamble to excess; and, more generally, as he worries it, 'the great tendency of Australian life is democratic, i.e. levelling' (Twopeny 1883, 90). Twopeny had French connections of his own, but plainly the stronger claims of theoretical inquiry implied by Tocqueville's work are missing here. What was the basis of civil society in Australia? Both capitalism and civil society came later in the Antipodes, where, in the most recent beginning, was the state. Modern Australia was founded on a state tradition, and until very recently this has remained the case. Our democratic ethos, in consequence, has likely been weaker, or more passive, because by comparison it was unearned; there is no foundational spirit of revolution here, neither capitalist nor democratic. Citizenship was never fully disentangled from subjection. Yet for many of us who grew up in this culture, the democratic impulse in everyday life was not obviously weaker than elsewhere among comparable cases, and the state was less a hero good or evil than a support for collective action, whether as

of infrastructure, education, public transport or health care, or more broadly of the economy and culture itself. Home, the street, beach and backyard here offer the loci of everyday activity, in a kind of suburban or backyard socialism of smallholders, cooperative yet independent. There would have been an interpretative challenge here for Tocqueville, indeed.

Tocqueville's work retains its brilliance and even to an outsider what makes *Democracy in America* so fine, is its sense of balance. Tocqueville is happy both to praise and to worry; in the Antipodes, as elsewhere, most of us tend to focus upon one or the other. The worry, of course, concerns the long-term negative consequences of material progress, equality and democracy in America. Tocqueville remains a democrat, in that he trusts common sense. As a sociological critic of modernity, however, he worries over an emergent tendency to modern despotism, and the mediocrity and conformism that might hold it up. Where would all this end? Life may well become less glamorous, but nevertheless be extremely comfortable and peaceable. I do not suggest that this is the sum total of Tocqueville's concerns, but it is one of them, and this aspect of the so-to-speak nostalgic imperial critique of modernity was to become the leitmotif of Australian self-criticism, if we allow as its pioneer or emblem another imperial visitor, our last, in this story.

His name was D.H. Lawrence. He touched land in Western Australia and in New South Wales, and left books in different ways in both places. The more significant title was *Kangaroo*, and it was published in 1923 (Lawrence 1950). Now Lawrence was not Tocqueville in the Antipodes, not even in delay, not least because where Tocqueville's ambivalence was between past and future, Lawrence's was between two places, a declining Europe and a primeval but somnolent colonial world, neither of which, parvenu nor pariah, could satisfy him. Lawrence's *Kangaroo* became canonical in Australian literature. Until the 1950s, university courses on Australian literature began with *Kangaroo*, a symptomatic marker of colonial attitudes and perhaps especially of the cultural cringe, of great power chauvinism in provincial universities. Lawrence's optic was one in which nature attracted, while Australian society – artifice – repelled, except in as much as society reflected nature, for there was an 'absence of any inner meaning: and at the same time, the great sense of vacant spaces' (Lawrence 1950, 33). Sometimes, for this great modernist writer, even the air, nature itself is debilitating; Australian nature is represented as featureless or contrary, upside down, as generations of Englishmen in the Antipodes before him had also imagined. 'Everything is outward', superficial; its people at the

same time are too democratic, and too well inclined to authoritarianism, relaxed and at the same time too careless, herd like, reptilian even, too violent and too conformist (Lawrence 1950, 146). Lawrence manages to hold together vitalism and nihilism in this representation of the Antipodes; all these splits animate *Kangaroo*, yet their passions are too strong to be mistaken for Tocqueville's.

When Tocqueville really arrives, in a sense, in Australia is in W.K. Hancock's modest 1930 masterpiece, *Australia* (Hancock 1965). Hancock's *Australia* becomes Australian historiography in the same way that Lawrence becomes formative of our literature, only Hancock's presence persists, for the arguments are more appropriately measured. Where Lawrence leaves nothing standing except perhaps nature, Hancock leaves us wondering how the statist culture of the Antipodes is maintained. And it is across the pages of Hancock's *Australia* that Tocqueville is summoned as interlocutor across horizons. And over the ages, in order to begin to address the peculiarities of the Australians, Hancock's book deserves its foundational status in Australian historiography; like *Democracy in America*, we ought also claim it as a major work of sociology, for it establishes or expresses some of the major questions of its time, and ours. What kind of society or civilisation have we built, and what kind of political economy might sustain it? Beginning from the rather contemporary confession that modern Australia was indeed the result of an invasion by 'transplanted British', Hancock also observed, in sympathy with Darwin, that the results of this invasion include an inward civility, not, however, extended towards indigenes or Asians (Hancock 1965, 26). The Australian state or its colonial authorities refused the latter; in the case of the former, it awaited expiry or extinction, and later stole a generation of aboriginal children from their families to follow the newer imperative of hard assimilation. But nature had its determining influence too; as Hancock put it, 'collective action is indispensable if an obstinate environment is to be mastered', and the natural agent of such action in a state-founded civilisation was the local state. Simple comparisons with American experience missed the point; Australia was never a frontier civilisation, partly because there was nothing comparable to the Midwest, and the slogan 'go west' could only be achieved by sea, or else later by state-provided train services.

As Hancock famously summarised it, then, 'Australian democracy has come to look upon the state as a vast public utility, whose duty it is to provide the greatest happiness of the greatest number' (p. 55). Australian civilisation was based on a kind of practical collectivism, which afforded a

mutual protection, of the economy externally against the vicissitudes of the world market, and of the people internally against the possible shocks of the life cycle and externally against enemies and competitors real or imaginary. Protection itself became a culture, and its instruments, tariffs, arbitration, the idea of a living wage became the institutions of a civil society. What becomes more readily apparent reading Hancock 70 years later is how the particular configuration of Australian modernity rested not only on this oddity of capitalist superstructure *sans* substantial industrial base, but also on the reinvention of certain medieval sensibilities such as the just wage, enshrined in Justice Higgins' 1907 Harvester Act in the form of the living family wage. Little wonder that Harvester looked paternalistic then, or patriarchal later. The local political economy of modern Australian civilisation was, as Hancock understood, constructed against the logic of the capitalist world system. The rights of organised labour, here, were not only legally recognised but favoured, in principle and via unionism, over the unconstrained rights of capital, at least if the state in the form of the Arbitration could have anything to do with it. The institutional result of such biases into the interwar period was often called state socialism, though it might better have been called a kind of state capitalism, or even at a stretch, an agrarian socialism. Hancock settles for his part on the nomenclature 'Australian paternalism', a category later to be revived in the influential work of Paul Kelly (p. 116). The real problem Hancock detected here was the prospect of milch cow dependency, this notwithstanding a remarkable cultural capacity to both innovate and cooperate, born of adversity. As if dependency or interdependency was a feminine weakness, rather than a social fact.

Enter Tocqueville. Hancock first introduces Tocqueville in worrying about the effect of equality upon the prospects for Australian democracy. Hancock's sense is that, unlike Americans, Australians do not stop at the attack on privilege or the removal of handicaps or advantages of birth; Australians also tend, according to Hancock, to ignore capacities in their preoccupation with needs, as the notion of a just wage suggests (p. 155). If we take this to mean that the Australian labour ethos is, or was, more radical in its distributive impulse than in its productivism, then this is, or was, almost certainly true. Yet the encounter with Tocqueville here is more systematic yet. Tocqueville returns to the centre of Hancock's stage in chapter 13 of *Australia*, where *Democracy in America* offers the frame of comparison and assessment of this even newer world experience. So this *urtext* of Australian modernity bases itself directly on Tocqueville's *urtext*: and Hancock writes,

Australians could attempt no more useful exercise than to read through *Democracy in America*, asking themselves: Is this true of Australia? To what extent is it irrelevant? (p. 231)

Recognising the differences, Hancock wants to inquire into the possible parallels, not least the question of whether a 'middling standard' comes to dominate manners, morals, knowledge and the arts. Hancock's response is that the same 'middling standard' is indeed characteristic of democracy in Australia, but with two peculiar complications. First, white Australia has never known a tradition or practice of effective local government. The habit of free or civic association characteristic of Tocqueville's America is, in Australia, a field colonised into the 20th century by the two-party system and its attendant tribalism. Australia has known one great voluntary society, according to Hancock, the Australian Natives Association, which of course excluded Australian *aborigines*; white Australians claimed themselves as natives, *terra nullius*, or as independent Australian Britons, whereas Anglos in New Zealand in contrast referred to themselves as British and to the Maori alone as New Zealanders until after the Second World War. According to Hancock, whose generation viewed all this as *fait accompli* more than as the subject of controversy, with the exception of the ANA, the women's organisations and temperance societies, most evidently the WCTU, the organs of the press, and those political parties, there were no special political associations that were to dominate the landscape (he views as non-political the RSL and the churches). Where Americans might do business or civics, on this account, Australians would rather work in their own fashion in order to secure livelihood and leisure. Second, if the private pursuit of leisure and the public political pattern of two-party tribalism fills in the space taken up in America by civic activity, the Australian configuration of modernity also develops rights-claims which confirm leisure over civics. As in America, Hancock claims, there are no paupers in the European sense, yet the antipodean air is rent by the complaints of those who have less against those who have more. Why the distinction? He writes that

The explanation is to be sought in the circumstances of time and place. Australia was settled in the age of the Rights of Man and of the Communist Manifesto. Most of the early settlers had been sweated and soured by Industrialism (p. 236)

and sought release from it, rather than to become industrialists themselves. Why establish a sweatshop when you could go to the beach, or do something

useful in the backyard? As Max Lerner put it, comparing America and Australia in *America as a Civilization* (1987), where modern American civilisation combined myths of origin and myths of mission and arrived on the coincidental waves of the frontier and capitalist revolution, Australia remained a permanent metropolis and a permanent hinterland rather than permanent revolution (Lerner 1987, 39, 76). The immediate difference emerges, then, that the dominant ethic is more like existentialism than progressivism, while at the same time politics has been dominated by a distributive orientation wherein its actors have in the main been representatives of the major producer groups in labour, manufacturing and agriculture. Whether Hancock was sufficiently open to an Australian tradition of localism and mutual support is less apparent. Even if leisure was privileged, and politics came to be channelled through the tribalism of party politics, the history of everyday life in modem Australia is also a story of cooperation and localism as risk management, whether in fire fighting, mothers' clubs or lifesaving. But Hancock's book was written in haste and it was not meant to be comprehensive. More might reasonably have been expected of Manning Clark, whose turn to Australian historiography as a field of tragic drama was pre-empted by something like an immersion in a Tocqueville cult; only the two, Tocqueville and the Antipodes, were never to meet frontally in his six-volume magnum opus, *A History of Australia*.

How long could this peculiar antipodean configuration established into the 20th century then last? Hancock already felt the winds of global change, writing as he was in 1929. Depression led to long boom, in Australia as elsewhere, to our collective surprise. In Australia primary exports and the development of import substitution led to the proverbial golden years of the 1960s. In 1964 Donald Horne published his book, *The Lucky Country*. Its slogan was widely misunderstood, as was the earlier slogan of the Workingman's Paradise, which was also ironic in intention yet was held to be emblematic in reception. Horne's case was that the racket was all but up. Our good fortune was to be blessed by this idiosyncratic political economy of primary commodity exports which continued to work, and an attendant culture which was relatively relaxed and comfortable, yet entirely contingent on this political economy. Horne's concern was that our apparent good fortune meant that we were 'a dependent, second-rate "western" nation *that happens, strategically, to be part of Asia*'. Not that mediocrity in itself was a bad thing; after all, life was a beach, if you were lucky; and as others like George Seddon were later to argue, the beach was the closest Australians got to the agora. For Horne did not want to damn, but rather to celebrate popular

Australian achievement. On his account, it was not the people who were mediocre, but their leaders. It was not the case that the mediocrity of the elite merely expressed popular mediocrity. Rather, the culture was mediocre because of the provincial nature of the elites. The problem, for Horne, was not that Australian culture was egalitarian, rather this was a virtue, for it made its relations inhabitable. Australians were natural existentialists rather than puritans; pagans or hedonists rather than protestants. As Lawrence had noted, they put cryptic, punning names on their homes, like Torestin or Wyework. But here, by the 1960s, the critical emphasis has shifted, in accordance with generalised western academic anxiety about the mass society. Leisure is slowly being revalued, as time wasting, and the educative ambitions of social liberals and social democrats are giving way to worries about the corrupting forces of T-bones and television – the mid-century antipodean equivalent of Sombart's ruinous reefs of roast beef and apple pie.

Where, then, was the prospect of associative democracy in the Antipodes in the 1960s? Horne found its residues in masculine domains like the working men's clubs. The suburb here takes the place of the city, the home or club takes the place of the public meeting. The availability of cheap, bottled beer changes everything. Yet some things persist. Until recently, for example, Australians had thought of the less well-off as 'battlers', rather than 'losers'. If the animating theme of American mythology is freedom, ours in Australia has been equality. Ours is, or was, a culture of protection or cooperation, against risk, against a nature greater than us. If the mentality of the American dream is something like a race, then ours is more like a punt, or a lottery. Life is a gamble, it happens within limits, fate matters; battlers might be more deserving than those to whom it comes easy. And so we gamble, and drink, and are happy to watch the world go by, innovating when need be – and this is the face, with elements both real and imaginary, of an old cultural regime which we are now leaving. No longer is it possible to be so mediocre or contemplative. We are learning to chase the American Dream, to run faster and faster regardless of any sense to where we are running or why we should do so, except for the paralytic fear of missing out. So that we, too, now fear that there is no choice other than that between distinction and extinction. Donald Horne left the balance sheet staring us in the face into the 1960s:

> Australia is a lucky country run mainly by second-rate people who share
> its luck. It lives on other people's ideas, and, although its ordinary people

are adaptable, most of its leaders (in all fields) so lack curiosity about the events that surround them that they are often taken by surprise. A nation more concerned with styles of life than with achievement has managed to achieve what may be the most evenly prosperous society in the world. It has done this in a social climate largely inimical to originality and the desire for excellence (except in sport) and in which there is less and less acclamation of hard work. According to the rules Australia has not deserved its good fortune. (Horne 1964, 239)

Recognising that these rules might nevertheless be wrong, the power of the ultimatum is as clear as is its tenor, the populist language of the intellectuals knocking at the door of power. Yet the message is also powerful, regardless of whose interests speak here. The Lucky Country was established as a culture of protection, against risk, against nature, against indigenous peoples, against Asia, against the tsunami of the world market. Critics like Hancock already detected the fragility of these arrangements in the 1930s, and others, like Frederick Eggleston, turned the problem into a collective psychodrama. Liberals and masculinists, whether liberals or not, became easily agitated over this particular question of paternalism: when would Australians grow up? From the hard edge of the economic perspective of the centres, did not Australian culture and political economy produce or at least reproduce a dangerous infantilism? By the 1980s the Labor Party made its mark by evacuating the culture it had formed, by deregulating social and especially economic policy across the long period of its hegemony, 1983–96. Labor transformed itself and Australia in that process, though at the cost of leaving us in limbo between a protectionist past and a more fully globalised future. Many were those in the political elite who, like Trotsky in 1905, urged on history, to do it faster. Their most articulate spokesman was Paul Kelly, editor of the national daily *Australian*, who assembled his modernising manifesto in 1992 as *The End of Certainty*. This is the typically hyperbolic stuff of exaggeration – who *us*, certain? – indicating both economic sclerosis and the necessary fix, now – as though we really thought we were certain, when we were really just creatures of habit.

Reading history backwards, Kelly interprets the period following Federation in 1901, often otherwise known as the period of the social laboratory, as the moment of the Australian Settlement. According to Kelly that settlement, or historic compromise, which held together a workable political economy into the 1960s, consisted of five institutional categories or legs: the White Australia Policy, Industry Protection, Arbitration, State

Paternalism and Imperial Benevolence. This compromise of nation building stuck, not least because it worked but also because it secured bipartisan support, this even though it was steered practically neither by the agents of labour nor capital, but by the social engineering project of the new liberals. Now all these features are those already essayed by Hancock, only lacking in his 1930 text the fixity or broad agreement indicated by Kelly.

The logic in Kelly's case is hard and fast. Australia in effect created its own world in order to keep a larger world out; both its culture and political economy across the 20th century were closed, and like other glossy globalisers Kelly plays on the rhetorical attraction of the contrast in the word 'open'. The White Australia Policy was the first to go, internally eroded by the cultural effect of mass postwar immigration. Protection was always controversial and contested. Arbitration was internally undermined because of the perceived sense that Australia could not remain a high-wage, low-manufacturing export economy into the 1980s. The Empire also dissolved after the Second World War, and state benevolence was gradually replaced by privatised indifference. The key symbolic institution in terms of the conditions of life was Arbitration, because it contained the possibility of a higher wage economy in precedents concerning the basic or living wage, a medieval, part-solidaristic or Catholic tradition invented per the 1891 Papal Encyclical *Rerum Novarum* in a never-quite-high industrial capitalist economy. This was a symbol of labour's right to exist decently. As Justice Higgins put it, as head of the Arbitration Court, if an industrial giant like Broken Hill Proprietary could not pay decent wages, it should shut down. Plainly this was controversial language in 1909, but then it was still less than controversial to argue that political and economic sovereignty should match up. The changes instituted first by Labor in the 1980s loosened all this up, to the evident relief of critics like Kelly, for whom this was a winter's dip in icy waters: bracing, good for others at least. As Kelly put it, Australia today 'is a paradox – a young nation with geriatric arteries' (Kelly 1992, 13), only now with various surgeons aspirant in the Canberra wings.

Historically insular, afraid of Asia – so the argument went – we had been outpaced by developments in Asian capitalism and throughout the world system. Only Kelly also understood, though he here underplayed and has subsequently focused in his journalism more directly upon, the negative effects of modernisation, not least for the Labor Party, which was grounded historically in what he constructed as the Australian Settlement. For here there are antipodean monsters on the political map of contemporary

Australia. As the Labor Party turned away from its traditional constituency, those older Australians, feeling betrayed, turned hard right, embracing both the racism and also the old economic nationalism of new conservative populist parties like One Nation. Politically speaking, deregulation hurt the inhabitants of the old Australia, or those connected to or reliant on the state; culturally, it eroded those institutions like arbitration, state education, health care and public transport provision which had mediated the old patterns of civility, But at this point, Kelly's own rhetoric was hard, like a broker's: as he concluded,

> The 1990's will answer the fundamental question raised by the 1980's – whether this decade laid the foundations of a new settlement or was merely a misguided aberration. It will resolve the battle between the reformers and the traditionalists: between those looking to a new social order and those merely tinkering with the old. It will determine whether Australia has the courage and insight to remake its political tradition or whether it buckles before the challenge and succumbs to an economic and social mediocrity. (Kelly 1992, 16)

So many questions are begged here: like who are the social partners to this new settlement which reaches outwards, between local political elites and metropolitan centres? How will we now, in the present decade, assess the gains and losses of this process? How might we begin to explain how our lacklustre leaders (Horne) have become Wall Street Bolsheviks?

So the Tocqueville theme in any case returns, now in postmodern times, to the threat of mediocrity, bred like other such demons from the sleep of economic reason. And again Australians find themselves middling through, only perhaps in a different spatial or temporal sense than before. Through the larger part of the 20th century, our middling was of a relatively egalitarian kind, working a way to a white civility between extremes of wealth and poverty; now, we are caught between an old Australia which is as alluring as it is repulsive, in differing parts, and a new future which beckons those who better fit the empty, cosmopolitan silhouette of the global symbolic analysts. If we have until recently laboured in the Antipodes as children of Sisyphus rather than Prometheus, with different gods and differing visions, then our social alternatives today are less clear, There could be a worse fate than middling through in the Antipodes, in a world where otherwise harsher extremities of excess and deprivation rule. A world still struggling to learn about limits may yet find something of value in a civilisation built upon ordinary habits and hopes.

Acknowledgements

This article was first presented to the Sociology Department at Harvard in May 2000. My thanks to Chris Winship, Orlando Patterson, Peter Marsden, Mary Waters, Libby Schweber and Patrice Higonnet. I owe the connection to Twopeny to the suggestion of Alastair Davidson, and enthusiasm for Tocqueville to Nathan Glazer. I thank Daniel Bell for discussion of his world and mine. I thank my colleagues at La Trobe for their responses to a later presentation back home in September 2000, and Stuart Macintyre for advice.

References

Buley, E.C. 1905. *Australian Life in Town and Country*. London: George Newnes.

Clark, V.S. 1907. *The Labour Movement in Australasia*. New York: Burt Franklin.

Diven, T. 1911. *Diseased Communities – Australian, New Zealand and –* Chicago: Antiquarian.

Hancock, W.K. 1965. *Australia*. Brisbane: Jacaranda.

Higgins, H.B. 1922. *A New Province for Law and Order*. Sydney: WEA.

Horne, D. 1964. *The Lucky Country*. Ringwood: Penguin.

Kelly, P. 1992. *The End of Certainty*. Sydney: Allen & Unwin.

Lawrence, D.H. 1950. *Kangaroo*. Harmondsworth: Penguin.

Lerner, M. 1987. *America as a Civilization*. New York: Henry Holt.

Métin, A. 1977. *Socialism without Doctrine*. Sydney: APCOL.

Northcott, C.H. 1918. *Australian Social Development*. New York: Columbia.

Tocqueville, A. 1966. *Democracy in America*, trans. G. Lawrence. New York: Harper & Row.

Twopeny, R. 1883. *Town Life in Australia*. London: Elliott Stock.

Ward, R. 1958. *The Australian Legend*. Melbourne: Melbourne University Press.

Chapter 3

Australia:
The Unhappy Country, or, a Tale of Two Nations
(2005)

What is Australia, where has it come from and where is it going? It is a very great honour to stand here before you, to share this time and place with you, to offer you my diagnosis of Australia today. There are two alternative attitudes for Australians to take, in situations like these, where we speak to outsiders. One is pride, and the other is denial, or self-denigration. Following my teacher, Zygmunt Bauman, I want to seek to combine these, or rather to transcend them. We need a lot more ambivalence in this world, and it is ambivalence which I feel towards the country of my citizenship, the country of my birth. What this means intellectually is that the challenge is both to register the bright and dark sides of this modernity. These are matters I have been trying to write on since the academic year 1999–2000, when it was my honour to act as Professor of Australian Studies at Harvard. There I began a project still in the sleeping, the working title of which was 'Australian Civilisation and its Discontents'. When I described this project to Bauman, he said, as he would, that it sounded global, universal, not specifically antipodean at all. When I described it to Hal Bolitho, the Head of the Australian Studies Program at Harvard and himself a lapsed Australian, he raised an eyebrow, sighed, and said, 'ah! The Unhappy Country' – unhappy because caught between two worlds, and ambivalent about both of them, the old, protected Australia, and the new, globalising Australia; unhappy at home, and unhappy away. Since then, the working title of my project has been The Unhappy Country. My own unhappiness in this is that the time I need to relearn about Australia eludes me. For one other thing I learned at Harvard was that, when challenged by my good students who knew nothing at all about Australia, I in turn realised how little I know. The advantage of being a native, an insider is deceptive; we

know much, but can articulate little. And what we do learn, when we are young, needs revisitation and replenishment. This, then, is a promissory note. Here I am reporting in this spirit on the Unhappy Country, or Australia: a Tale of Two Nations.

What is Australia, anyway? The Lucky Country; a land down under. Terra Australis Incognita. Australia, I want to suggest, is an accidental nation. Its sense of nation is weak except on instruction in response to the pressing demands of our superiors; its senses of region and colony, in the pre-Federation sense, remain strong. The argument I have put in a book called *Imagining the Antipodes*, a study of the work of Bernard Smith is, indeed, that the image of the Antipodes is much more suggestive than that of an imaginary nation mapped over the land space now called Australia (Beilharz 1997). Australia remains, in a sense, an empty signifier for an empty or uninhabited land mass. We live on its edge, not in its heart. Europeans in Australia do feel at home, but not without ambivalence. The image of the Antipodes, having the feet elsewhere from the centres of metropolitan civilisation, suggests that identity results from relationship between places and cultures rather than emerging from place, or ground. We, in the Antipodes, do have practical as well as romantic connection to or affection for our place; but we are placed in it by the movements of empire and world system, migration and cultural traffic. We feel, in Australia, or at least many of us do, that we are simultaneously here, and there, home and away. The image of hybridity or grafting appeals, however clumsily. But the image of the Antipodes captures our predicament better, as it suggests movement rather than fixity, as the hard physiological metaphor of hybridity does.

The image of the Antipodes has other utilities, some of them ironic and rhetorical. While some early French thinkers, such as de Foigny (de Foigny 1676) or later Lémontey (Smith 1988) located their post-European utopias and hopes in the south, others, like Charles de Brosses – he who also inspired Marx's image of commodity fetishism with his 1767 study of the fetish – famously imagined the Antipodes as a sewer through which metropolitan effluent could conveniently be evacuated (De Brosses, in Friederich 1967, 44; and see Fausett 1993, 1995; Beaglehole 1974, 120). The Antipodes are the dirty bits, the ribald parts which occasionally, unexpectedly speak back. We live in what then Prime Minister Keating – a Europeanist, but also an Asianist – in the nineties called the arse-end of the earth. But our global posterior is also the place Jeremy Bentham used as the prompt for the Panopticon. Australia, or its first colony, in New South Wales, was established indeed as a sewer, more literally, as a prison. The prospective

prison society was a sewer, for Bentham, a great experiment indeed but one whose peoples were 'a set of *animae viles*, a sort of excrementitious mass that could be projected as far out of sight as possible' (Bentham 1843).

So where did we come from? There are many narratives or myths of foundation concerning Australia. I want to enter this labyrinth by telling two alternative tales of foundation. Then I shall proceed to tell a second tale, or set of stories, about social division in Australia, about the two – or more nations that make up what we call Australia today. All this adds up to something like what Hegel called the 'unhappy consciousness', the consciousness of self (or nation) as dual-natured, contradictory being, both unable to change and unable to contemplate being without change, both aware of possibility and yet afraid of its impossibility. The point is to change it; how?

The narratives or foundational myths I begin with are those of the prison society, to which I have already alluded, and the later, new age, new world social laboratory which emerges with Federation into the twentieth century. These are, respectively, negative and positive stories of the foundation of Australia as first, global effluvia or white trash, and second, as the civilisational blossoming of a New Britannia in the Southern Seas.

I begin with the prison story of foundation. The durability and appeal of the prison story is extraordinary. Convictism was transformed from a stain to a badge of honour in postwar social development; only the valuation of convictism changed, not its presence as allegedly formative of national character. The most influential retelling of the story in recent times is Robert Hughes' book *The Fatal Shore*, published to coincide with the Bicentennial in 1987 (Hughes 1987). Hughes does not refer to Foucault, though *Discipline and Punish* was certainly in the air, to the extent that many of our students came to identify the Panopticon with Foucault rather than with Bentham (Foucault 1975; Bentham 1843). It pleases us to remind them that here the usual pattern of dependency is reversed – Foucault depends upon Bentham who here depends on us, in the Antipodes, as his prompt or pretext.

Hughes' book is a blockbuster, a work as brilliant as its author. The presenting problem was obvious, two centuries on: the legacy of convictism puzzles. Not only was Australian culture derivative of its British implant, it was manured by the worst of its dregs. This resulted in the dread 'cultural cringe', whereby Australians first devalued all that was local and loved all that was European and then, in a fit of so to say maoist nationalism into the 1960s sought to reverse all this, to love all that was local and to spurn the empty gifts of the cosmopolitans, to embrace the wattle and to shun the rose

and its imperial sting. Yet as Hughes observes in opening his story (and we will return to this) the dregs came surprisingly good – already by the mid nineteenth century the Australian colonies exemplified growth, democracy and progress. But Hughes chooses to play a strong hand – he compares the prison society with the Gulag Archipelago. Like the Gulag, the antipodean prison society was formative, foundational. Could we ever escape it?

A more suggestive line of interpretation came from the cultural historian Bernard Smith, who set out to track the tension between mentality and experience in his classic work *European Vision and the South Pacific* (Smith 1960). Hughes' work, in *The Fatal Shore*, though itself constructed in the wake of Smith's pioneering work in art history, here connects more to the tradition of English social history in the manner of Stedman-Jones' *Outcast London* (Stedman-Jones 1980). The slums of London were another country; the other could be cast anywhere, from the East End to Africa, or the Antipodes. The Irish, as Hughes says, were Australia's first white minority. Hughes does not resile from telling the attendant story, of the displacement of indigenous peoples, though his main narrative is one of British victims in exile rather than aborigines in internal exile. Convicts could be made to look like slaves; aborigines were first cast as noble, then ignoble savages. The hopes of freeborn Australians, nevertheless, were for a New Britannia, in another world. Somehow the great transformation of the nineteenth century changed all this. From kakotopia emerged utopia. The new Australia, or the emerging Australia, was carried by the discovery of gold. Gold made us rich, lucky, complacent, and democratic. This was the beginning of the Lucky Country. With prosperity, however, came mediocrity. This was the fear articulated most famously in 1930, by W.K. Hancock in his classic study *Australia* (Hancock 1930), or later by the Sydney libertarian philosopher John Anderson, in his own local version of Hilaire Belloc's *Servile State* (Anderson 1962; Belloc 1927).

The background influence in Hancock's book was the most eminent of French tourists, Alexis de Tocqueville. Here Tocqueville was read as an anticipatory critic of new world modernity, where democracy and prosperity combined would result in a kind of universal dumbing-down. This retroactive adaptation of Tocqueville is perhaps more suggestive of interwar anxieties about mass democracy and mass society than it is of Tocqueville's own curiosities. Tocqueville is indeed a fascinating thinker, but I sometimes suspect that he is used as a substitute for thinking – kneel, move your lips, and you will believe. There is, in fact, a more direct connection between Tocqueville and the Antipodes, and it is via Bentham, for Tocqueville agreed with Bentham

that the transportation of convicts to the Antipodes could only be a disaster. The prospects of panopticon reform at home were much more promising for Tocqueville; convictism could only increase problems of the moral vacuum. In the Antipodes, Tocqueville feared, vice would become popular opinion.

Let me dwell here for a moment, for the Tocqueville connection to the Antipodes has long been forgotten. We know that Marx knew the Antipodes, not least in terms of Wakefield colonisation, in Chapter 33 of *Das Kapital*, and in the realisation of the significance of gold and the New World in California and Australia. Durkheim, of course, also recognised Australia, this time in its earliest foundational, aboriginal register in *The Elementary Forms of the Religious Life*. Until recently the dominant understanding has been that Tocqueville, the great ambivalent observer of democracy in America, said nothing about the Antipodes. I myself argued convincingly – mistakenly – in a paper called 'Tocqueville in the Antipodes', in *Thesis Eleven*, that Tocqueville said nothing much at all about the Antipodes (Beilharz 2002). I think there are two passing references to us in *Democracy in America*. What was missed by everyone, myself included, is the 1833 Appendix on Penal Colonies to the essay *On the Penitentiary System in the United States and its Application to France*, published in 1833 and never republished, and now brought forcefully to our attention by Colin Forster in *France and Botany Bay* (2000). There, Tocqueville writes that

Society, in our days, is in a state of disquiet, owing, in our opinion, to two causes:

The first is of an entirely moral character; there is in the minds of men an activity which knows not where to find an object; an energy deprived of its proper element; and which consumes society for want of other prey.

The other is of an entirely material character; it is the unhappy condition of the working classes who are in want of labour and bread; and whose corruption, beginning in misery, is completed in the prison.

The first evil is owing to the progress of intellectual improvement; the second, to the misery of the poor.

How is the first of these evils to be obviated? (Tocqueville 1833, xllvi).

Tocqueville proceeds to argue that transportation fails as a penal system: rather it becomes a method of colonisation. The most odious result, fittingly for Tocqueville, would be moral:

That which is essentially wanting in Australian society, is good morals. And how can it be otherwise? The force of example and the influence of public opinion are hardly able, in a society composed of pure elements, to restrain human passions; of 36,000 inhabitants, which Australia had in 1828, 23,000, or nearly two-thirds, belonged to the class of convicts. Australia, therefore, was in the rare situation where vice receives the support of the majority …

It will be acknowledged, that transportation may contribute to peopling rapidly an uninhabited country; it may form free colonists, but not strong and peaceful societies. The vices which we thus ship from Europe are not destroyed; they are but transplanted to another soil, and England only frees herself of a past of her misery, to assign it to the children of Australia (Tocqueville 1833, 144–5).

Yet again, this was 1833, when Tocqueville wrote about Australia; by the latter half of the nineteenth century, the report cards for Australia were rather bristling with enthusiasm, and this opens the context for the later, Federation, foundation story of social experiment, the social laboratory, the new beginning. This is my second story, or the story of a second, different variation, also called Australia, this time made in promise rather than despair.

By the 1880s Australia, more often Australasia – Australia and New Zealand – were known as the Workingman's Paradise. The phrase became popularised as the ironic title of a socialist parody by William Lane published in 1892, as Lane set off to Paraguay to establish a utopian colony called New Australia – he was already convinced that the old new Australia had failed (Lane 1892). Others were less certain, and indeed the Antipodes subsequently became known as a social policy beacon for European and American progressives.

Visitors to the Southland there had always been, after Botany Bay. From Darwin via Froude and Trollope through D.H. Lawrence, they came and cleared their throats. Around the turn of the last century, these visitors were often socialists or radicals, who brought hope that Terra Australis Incognita would yield up the political secrets of the new world. Many left books, or diaries, most famously Albert Métin's *Socialism Without Doctrines* (1901), and Victor S. Clark's *Labour Movement in Australasia* (1906). The diarists included the Webbs, who of course also left Indian deposits (B. & S. Webb 1898a, 1898b, 1912). Some highly influential books appeared in the North, left by Australasians who had travelled there, such as William

Pember Reeves' *State Experiments in Australia and New Zealand* (1902) and H.B. Higgins' evocatively titled *A New Province for Law and Order* (1922). You could routinely expect to read about antipodean experiment in the pages of the German Socialist Press, for example in *Die Neue Zeit*. As with Clark's book, many surveys covered Australia and New Zealand, Australasia, together. Other significant studies covered New Zealand alone, as in Rossignol's *State Socialism in New Zealand* (1910) and Siegfried's *Democracy in New Zealand* (1914). The literature of, and on colonial socialism carried through into the interwar period, when a liberal like F. W. Eggleston could still and innocently call his study *State Socialism in Victoria* (1932). There was nothing controversial about the program of national development of settler capitalism, or rural socialism. Socialism was common sense, or at least collectivism was.

The influence of the New Zealand example was especially evident among American progressivists, most famously Henry Demarest Lloyd, who wrote two books on New Zealand, *A Country Without Strikes* and *Newest England*, and began a personal political campaign in California for what he called 'The New Zealandisation of the World' after a tour of Australasia in 1899 (Lloyd 1900a, 1900b; cf. Coleman 1987). Many enthusiasms for the national development project were borrowed by Americans from Australia, including plans for irrigation and land reclamation, though this traffic also went the other way round. But the key policy interest, typically, was in Arbitration, that which Higgins, First Justice of the Australian Conciliation and Arbitration Court signalled in the title of his book as containing the hope for *A New Province for Law and Order*, which turned into a beacon what Demarest Lloyd expressed negatively, the dream of a country without strikes. These were widely influential views, first floated by Higgins from 1914 in the *Harvard Business Review*.

Plainly these are new liberal middle class reconstructionist motifs, where law, like engineering is less an interest than a civic vocation. Arbitration was to become more a symbolic than an actually central institution, but its power was nevertheless significant. Higgins argued famously, in the 1907 Harvester Judgement, that the producer of local agricultural implements should pay a decent living family wage, or else capitalists should desist, pack up and go home, if they were unable to pay a just wage. Australian industrial law, just into the period of Federation, established the principle if not the practice that markets should not rule, that the voice of the third party, the mediator, should judge instead what was fair and reasonable in terms of standards of living. This was to institutionalise something like

the Fabian national minimum. Neither markets, nor class struggle, should rule. Social peace was high on this agenda, but so was the dream of relative equality as one precondition of a civil society. Australians, on this account, needed to be protected from cheap imports and cheap labour, but also from the vagaries of unbridled international capitalism, in order that they might build democracy. Australians needed also, in this fin de siecle optic, to be protected from the development of plantation capitalism in our tropics, for this would threaten to institutionalise slavery and divide Australia even more powerfully between a liberal south and a sometimes radical, often racist north. The tropics of the north presented a consistent challenge for the early, racial sociology of Australia. Here the shadow figure would be Montesquieu rather than Tocqueville, with the idea that climate was the key indicator of culture and political regime (see Anderson 2002).

The image of the Antipodes as a social laboratory, a place of new world social experiment persisted, blipped on through the period of postwar labour reconstruction and was crowned, momentarily, by the short history of social democracy in Australia in the period of the Whitlam Governments, 1972–5. For our purposes, here, today, the interesting question is not how was this possible, but rather how does this narrative sit with the prison-society narrative? From a Foucauldian or libertarian perspective one theme of continuity is apparent – that which indicates that ours in Australia is a statist tradition. The belligerent powers of the imperial state build a prison, here, which is reconstructed a century later, perhaps, in the image of the aviary, an open cage or a prison without walls. The view of Foucault, or more acutely Bauman, which looks out for the excluded would also have its claim here. Australians are institution-builders, indeed, and their institutions have often been designed to be racially exclusive. Ours was a new world Bestiarium, on this negative account. On a more radical reading, however, the results of the regime could themselves be held to account against the values of democracy and equality.

The dream of the New Britannia, of a white or imperial labourism also however looks like a new little England, though postwar mass migration from Southern Europe begins to end that (Hyslop 1999; Bonnett 2003). Combined with the postwar boom and the emergence of local Fordism, the preconditions of Donald Horne's famous book *The Lucky Country* (Horne 1964) are set. For Horne, as for William Lane and *The Workingman's Paradise*, the idea of the lucky country is ironic. Riding on the wave of primary export commodities, wool, wheat, then minerals Australia's good fortune now has a use-by date, as does its indifferent Anglo Europeanism in Asia. The

luckiness of material wealth, by now, makes the prison momentarily look like a fun park for its cheerful inmates.

So we now sneer at the postwar period, philistine, provincial, satisfied, smug. But this is in retrospect, and from the comfort of the period that follows, that which sometimes is hilariously mistitled as the post-materialist present. To look back into the postwar period is to see something else. It was a modest project, by contemporary standards of mass consumption, where the logic of that national project in-the-making was that material sufficiency – decent standards of living widely shared – was the precondition of the possibility of the good society. Two small examples. First, in 1939 Barnard Eldershaw published *My Australia*. It began with *their* Australia, i.e. with the drama of the other, of indigenous life, and proceeded to focus on the project of social experiment and development. As they put it, there had been in this country a genuine organic democratic growth towards that national fruiting of democracy which is, quite simply, the highest possible standard of living secured to every citizen and the door open to opportunity. The imagery is characteristic – arcadian, agricultural, the politics of what we now call the national developmental model expressed symbolically in the wheatsheaf and the golden fleece.

Second example. The visitors who began to head south in the 1890s continued into this period. One of the most significant into the postwar period was the American C. Hartley Grattan. Grattan's most widely read book was *Introducing Australia* (1942). Grattan starts from the proposition that what is striking about the Australian path of development is its rapid evolution from the absolute autocracy of the penal colony to the freedom of a modern social democracy. To anticipate my later argument, however, Grattan also already follows the suggestion that there is a fundamental divide in Australia, here between urban and rural life. There is an urban edge, not in its general silhouette different to that of a metropolis anywhere else, and a rural heart – there really are two Australias, each of which of course insists that the other is parasitic upon it. Put differently, this is also to anticipate George Seddon's more recent quip that Australia is actually a small country, or at least it is a small country connected by large distances. Grattan for his part clearly detects the consensus in the period of postwar reconstruction over the issue of consolidating standards of living. His view is that the differences emerge when it comes to proposed approaches, where he discerns four alternatives: procapitalist; more strongly collectivist; more labour gradualist; and the social justice politics of the Catholic Church, which strikes a resonance back to the medieval idea of arbitration and the just wage.

So the question emerges, what went wrong? Evidently the strategy of protection, import substitution, of the project of national development or organised capitalism was supplanted by the model of globalisation in Australia as elsewhere from the 1980s. Into the postwar period, something went unexpectedly right – the long boom of national, international capitalist development. What also went right was the unintended consequence of the postwar program of mass immigration from Southern Europe, which resulted in multiculturalism. What went wrong domestically in a different register coincided with the Cold War. The Catholic politics of social justice so central to the labour tradition shifted its axis from its own kind of anti-capitalism to a more conventional kind of anti-communism.

As elsewhere, the extraordinary success of the postwar capitalist 'miracles' meant that capital, rather than the State, was reconfirmed as the central social agency. The long State-centred tradition of Australasia began to decline. The ideological association of markets and freedom was also confirmed. The emphasis on State, or imperial foundation in 1788, and on the state support of the social laboratory or tradition of State experiment began to come unstuck.

Alongside questions of the continuity of antipodean experience, state-founded and then state protected, however, another question arises. Is it not possible that there are two or more narratives of foundation here, because there is a plurality of groups or constituencies who license or seek them out? Is it not indeed possible that Australian nationhood is a myth, an essentialism or an ideology in the more conventional sense, whereby something is concealed in order for something else to be revealed, or where the particular interest is represented as the general?

To this point I have been concerned to introduce the idea of competing or alternative myths of foundation for Australia. The point, I suggest, is that, to use the language of Max Lerner, unlike the USA, Australia has neither a singular myth of foundation nor a singular or unifying myth of mission (Lerner 1987). Ours is an accidental nation, where it is often problems of *existence* rather than *essence* that matter. If we leave aside the question of that which is, or is not, essential, what we may instead then confront is differences of *existence* that are surprising, though on reflection they should not be. If there are fundamental divisions in Australia – two nations, or more – then the resulting question might not be, why should this be so, but why have we – and others – dreamed of a false unity, a singularity of identity and national purpose, framed within the model of a singular and representative nation State?

The idea of national identity is as traditionalistic as it is modern, for it usually indicates a populist conception of sovereignty, where people are identified with language, ground, place, the primordial, as in Herder. The nation is the greatest of the invented traditions: if the Germans popularise this idea, then the French modernise it. Renan articulates this with a solidaristic twist when he adds the necessity of renewed consensus to the defining attribute of the nation, in its shared origins. Nationalism depends on the daily plebiscite of endorsement, which in turn replaces Hegel's post-christian daily ritual of reading the newspapers instead of going to church. The question today is, who does this? – who consents daily not just to the local habitus, but to the great ark of the Nation? The fallacy of the early modern solidaristic mentality, as in Renan, through to Durkheim is to presume that without the daily rituals of national affirmation we will fall into chaos, that our grand national world will fall apart, whereas it is actually more likely that we will simply continue to go about our business in difference.

Nation-building does occur in Australia, most conspicuously around Federation and then even more energetically with postwar reconstruction, which coincides with local Fordism (or Holdenism) (Davison 2004). The nation-building project has an especial impetus in Canberra; there is a sense in which Canberra is indeed the nation, in civics and education, which might help to explain why both the nation and the capital are practically irrelevant to the everyday lives of the major cities, which are still largely colonial and local in their complexion. Australia's externally projected image is nevertheless that it is a nation for a continent, a modular as well as continental unit in the globalising world of nations that begat the United Nations, in the moment of western universalism which followed the collapse of Nazism. The period after the Second World War confirmed Australia as a nation in a world of nations, all modernising, some decolonising, in that moment of modernisation theory where development reigned and area studies was to prevail.

Yet Australia is a land mass, more than a sharp political unit. A different way to conceive of Terra Australis, if you look at the maps, is as an accidental nation where the outer perimeter is geographical rather than political, the division into states arbitrary, and the striking attributes are to do with cities and regions or hinterlands which are predominant and a red centre which dominates part of the psyche and popular imagination but is again outside the main habitus, which is suburban, grey, asphalt and concrete rather than sand and spinifex.

Could this then be more than one nation? There are numerous candidates for division, and various analytical precedents which might help to name

them. The idea of two nations we connect to Disraeli, in *Sybil*, 1845, a parallel text of social polarisation to the images of class and military camps in *The Communist Manifesto*, 1848. Disraeli called his two categories the Privileged and the People. The problem of the other, more generally, was the problem of the poor, which exercised various writers from Cobbett through to Carlyle, Gaskell, Kingsley and Dickens to take up the condition of England question (Smith 1980). These images of an underground, or nether world called out by modernity are pervasive. Bauman revives the image of the two nations for Thatcher's Britain in *Legislators and Interpreters* (1987). For Bauman, Disraeli's nations were divided into employers and employees, exploiters and exploited, which may be a little more Marxian an image than Disraeli intended. Bauman's postmodern update is to differentiate between two nations or cultures and economies as the seduced and the repressed. The logic of his argument is that the shift from productivism to consumerism results in the division which he later calls that between tourists and vagabonds, where mobility is the norm and the difference is in the means. Some choose to move; others are compelled to do so. Bauman's innovation was not peculiar – Michael Harrington had built his book on poverty, *The Other America* (1962), on the image of two nations, and likely it was poverty which was the greatest divide. The USA has always been deeply divided. Harrington's own reforming enthusiasm was not racist, even if it can be argued that the war on poverty helped supplant civil rights on the Washington agenda. Yet the division into two nations also reminds of earlier philanthropic condescension, as in Colonel Booth's advocacy of the London poor in his 1890 study *In Darkest England, and the Way Out*. In the case of the dominant Australian historical narratives, populism was central, though poverty less so. The rhetoric of class struggle likely threw larger shadows than its realities, compared to Europe or to North America. The original divide, in Australia, of course, is racial, between those initially in the prison and those outside, though the history of race relations also saw this reversed across the centuries. The inmates came to be aborigines. A powerful, though undeveloped category here is the idea of internal colonialism. The great experiment of the New Britannia was based on the dream of imperial brotherhood or racial purity, even if it was never achieved. Australian nationalism was, from its inception, racially exclusive, though at this point, again, we have to wonder who the nationalists were, and how this nationalism actually worked or was played out locally. Labour nationalism, for example, was more consistently anti-Asian than anti-indigenous. Its expression was as often Australasian or colonial as national. Sometimes

it was internationalist. Populist racism, as in the recent phenomenon of One Nation Party, was old labourist in its policies of economic and social protection, and assimilationist rather than exclusivist, closer to the mentality of drawing up the ladders than shooting the messengers (Beilharz 2004).

The momentary popularity of the One Nation Party, and the corralling of its sentiments by the Howard Government, express a newly apparent divide, between an Old Australia and a New Australia, or rather between a more protected national-development project and a new phase of globalised relations and their respective constituencies and interests. What is being hankered after here as the old Australia is *also* global – it is the image not only of an old Australia, but of the postwar transatlantic settlement, the postwar boom, Fordism, the Keynesian Welfare State, nuclear family and full male employment, the lost utopia of the American, and the Australian Dream. In a culture where material progress and security are central, only some of us will be looking beyond, sideways, or at the stars. And those of us who are middle class, intellectually trained and potentially mobile are bound to be attracted to the image of the New Australia, which may also carry us to Bangkok, Toronto, London or Delhi. Cosmopolitanism also has its interests, just as postmaterialism does.

The division between the two dominant political parties in Australia here expresses but does not reflect these differences. In a two-party dominant system where class and religion were fundamental dividers until the sixties, the two major parties now act as catch-all parties, targeting marginal seats, following the Hollywood version of politics, where leadership is more often reactive and managerial rather than innovative or creative. Yet the split of basic loyalties and world views indicated by the electoral divide of support between the two parties is fundamental. The nuances compound. The absence of a strong modernising bourgeoisie has given the labour movement some significant room to move, historically, and historically labour has taken the intellectuals with it. Yet the conservatives have dominated Federal politics hands down since Federation in 1901, and Labor's transformative long decade in office 1983–1996 might now, after the recent re-election of the Howard Government, be seen as an aberration rather than a stronger bid to convert Labor into a viable party of State. What remains, beneath this, is a sense of cultural divide which is easy to caricature and often actually transgressed but nevertheless active, between a rural and regional culture of survival, mateship and adversity and an urban and suburban proclivity either for civic privatisation and lifestyle ghettoes, or else for cosmopolitanism and alternative values in alternative lifestyle ghettoes.

Are these, then, two nations? The lines of division and of difference in opinion are too varied and fine, too shifting to fit this template. There do seem to be fundamental differences, now, less in myths of foundation than in myths of mission, or to put it more gently, of futures imagined possible. One version, to simplify, calls on the sixties image of the Lucky Country, and asks that its values orient the future possible. Another responds to the claustrophobia and provincialism of that old world, and dreams of something, in today's setting, more European than old Australian or even Anglo-American. The problem with beginning this line of thought is that it has no ending. For the competing spirits or souls in the Australian breast were also old. A hundred, yet even fifty years ago Australian cosmopolitanism was metropolitan, and London, which in turn loved Paris, was home. If Australians now feel more at home in the Antipodes than they did a hundred years ago then the British Empire takes a backseat. Our cultural bubbles are increasingly American, but also significantly multicultural; the fantasies of our children might indeed be anywhere, or remain virtual, and at home.

I have told you two stories about doubling, or split and divided consciousness. I began with two narratives of arrival or establishment, the first of Australia as the prison society, the second of the Antipodes as the world's social laboratory. My second performance of the splits was to pick up the idea of the fictive, singular nation and of the two nations as a limited corrective. The latter opens the idea of multiple divisions in the present, and it implies their transhistorical continuity. And this is the logical outcome of my argument: not that there are two nations, but that to begin pluralising the concept is to truly set the cat amongst the pigeons. The modular image of the single nation has always contained and subsumed within it more than this. None of which means that nation-states do not rule, not least when it comes to the legitimate monopoly of power as violence, but rather that the populist image of the nation is a construction, a project, a task which the dominant historic bloc has to recast anew each day, or in each crisis, through each manoeuvred threat to our safety. And this, finally, is why we in Australia (and elsewhere, I venture) are bound to be the unhappy country, for this is a situation without a solution. The dream of new world, new start, structured by British imperial consciousness was a dream of oneness that is empirically unsustainable and ethically undesirable. That dream of a new world is now a dream for an old world. We now inhabit a brave new world, all of us, where the challenge is to exercise a hermeneutics of suspicion towards the historic values which inform our cultures, and to clarify and radicalise the immanent values in them which open to democracy and equality. Unhappiness, after

all, is one precondition of the idea of future possible progress. If the Lucky Country was an ambit for complacency, then the idea of the Unhappy Country makes clear the challenge, and this, indeed, remains a global and not only an antipodean issue. The problem lies less in our values than in the fact that we do not share them.

Where might this leave us? Likely Bauman is right, that these are universal problems, but the ways in which they are played out is highly contingent and historically specific. If Australia is indeed a small country connected by large distances, then its peculiarities may have little to connect obviously to India. The case of small countries nevertheless remains exemplary, as political sociologists like Peter Katzenstein and Frank Castles have argued (Katzenstein 1985; Castles 1988). They can often experiment in ways that larger and older polities cannot. But the mentality of the social laboratory is gone, and globalisation can be blamed for everything. History, or histories may not be reversible, but we might nevertheless still learn from them, and the nations or experiences and hopes that they describe.

Acknowledgements

This paper was originally delivered as a lecture in New Delhi, 6 December 2004, hosted by the Thesis Eleven Centre for Critical Theory, the Indian Association for the Study of Australia and Australian Education International, Australian High Commission, New Delhi. My thanks to all, but especially to Trevor Hogan, who made it possible.

References

Anderson, J. 1962. The Servile State. In *Studies in Empirical Philosophy*. Sydney: Angus & Robertson. First published in *Australasian Journal of Philosophy* 21 (2 & 3, 1943): 115–132.

Barnard Eldershaw, M. 1939. *My Australia*, London: Jarrolds.

Bauman, Z. 1987. *Legislators and Interpreters*, Oxford: Polity.

Beaglehole, J.C. 1974. *The Life of Captain Cook*, London: A.C. Black.

Beilharz, P. 1997. *Imagining the Antipodes. Culture, Theory and the Visual in the Work of Bernard Smith*. Melbourne: Cambridge University Press.

Beilharz, P. 2001. Tocqueville in the Antipodes? Middling Through in Australia, Then and Now. *Thesis Eleven* 65: 51–64.

Beilharz, P. 2004. Rewriting Australia: The Way We Talk About Hopes and Fears. *Journal of Sociology* 40 (4): 432–445.

Belloc, H. 1927. *The Servile State*. London: Constable.

Bentham, J. 1843. Panopticon versus New South Wales. In *The Works of Jeremy Bentham* Vol. IV, edited by Bowring.

Bonnett, A. 2003. From White to Western – 'Racial Decline' and the Idea of the West in Britain. *Journal of Historical Sociology* 16(3): 320–348.

Booth, C. 1890. *In Darkest England, and the Way Out*. London: Carlyle.

Castles, F. 1988. *Australian Public Policy and Economic Vulnerability*. Sydney: Allen & Unwin.

Coleman, P.J. 1987. *Progressivism and the World of Reform: New Zealand and the Origins of the American Welfare State*. Kansas: Kansas University Press.

Clark, V.S. 1906. *The Labor Movement in Australasia*. New York: Burt Franklin.

Davison, G. 2004. *Car Wars*. Sydney: Allen & Unwin.

de Foigny, G. de. [1676] 1993. *The Southern Land, Known*. New York: Syracuse University Press.

Eggleston, F.W. 1934. *State Socialism in Victoria*. London: P.S. King.

Fausett, D. 1993. *Writing the New World. Imaginary Voyages and Utopias of the Great Southern Land*. New York: Syracuse University Press.

Fausett, D. 1995. *Images of the Antipodes in the Eighteenth Century*. Amsterdam: Rodopi.

Forster, C. 1996. *France and Botany Bay – The Lure of a Penal Colony*. Melbourne: Melbourne University Press.

Foucault, M. 1975. *Discipline and Punish*. London: Allen Lane.

Friederich, W.P. 1967. *Australia in Western Imaginative Prose Writings 1600–1960*. Chapel Hill: University of North Carolina Press.

Grattan, C.H. 1942. *Introducing Australia*. New York: John Day.

Hancock, W.K. 1930. *Australia*. London: Benn.

Harrington, M. 1962. *The Other America*. Harmondsworth: Penguin.

Higgins, H.B. 1922. *A New Province for Law and Order*. Melbourne: WEA.

Hughes, R. 1987. *The Fatal Shore*. Melbourne: Harper Collins.

Hyslop, J. 1999. The Imperial Working Class Makes Itself "White": White Labourism in Britain, Australia and South Africa before the First World War. *Journal of Historical Sociology* 12(4).

Katzenstein, P. 1985. *Small States in World Markets: Industrial Policy in Europe*. Ithaca: Cornell.

Lane, W. [1892] 1948. *The Workingman's Paradis*. Sydney: Worker Trustees.

Lerner, M. 1987. *America as a Civilization*. New York: Henry Holt.

Lloyd, H.D. 1900a. *A Country Without Strikes*. New York: Doubleday.

Lloyd, H.D. 1900b. *Newest England*. New York: Doubleday.

Métin, A. 1977. *Socialism Without Doctrine*. Sydney: APCOL.

Reeves, W.P. [1902] 1969. *State Experiments in Australia and New Zealand*. 2 vols. Melbourne: Macmillan.

Rossignol, J.E. 1910. *State Socialism in New Zealand*. New York: Crowell.

Siegfried, A. [1914] 1982. *Democracy in New Zealand*. Wellington: Victoria University Press.

Smith, B. 1962. *European Vision and the South Pacific*. Oxford: Oxford University Press.

Smith, B. 1988. Lémontey's Prophecy. In *Postscripts. 1988 Boyer Lectures*, edited by M. Long. Sydney: ABC.

Smith, S. 1980. *The Other Nation. The Poor in English Novels of the 1840s and 1850s*. Oxford: Clarendon.

Stedman-Jones, G. 1971. *Outcast London*. Oxford: Clarendon.

Tocqueville, A. and G. de Beaumont. 1833. *On the Penitentiary System in the United States, and its Application in France, with an Appendix on Penal Colonies*. Philadelphia: Carey, Lea and Blanchard.

Webb, B. and S. 1898a. *Australian Diary*. Melbourne: Pitman 1965.

Webb, B. and S. 1898b. *The Webbs in New Zealand*. Wellington: Victoria University Press 1974.

Webb, B. and S. 1912. *Indian Diary*. Delhi: Oxford University Press.

Chapter 4

Two New Britannias:
Modernism and Modernity across the Antipodes
(2006)

What is modernity, and modernism, and what were the trans-Tasman experiences of these forms? Under this horizon, our interest here is in looking for similarities and differences in opening the question of modernism and modernity. For Marxists like us, of course, capitalism and technology are central; but so is culture. For sociologists, or at least for critical theorists, the frame is more often that of modernity, of which capitalism is a subcategory, alongside bureaucracy, state, civil society, culture. Yet the discourse concerning modernism is largely aesthetic, or especially often literary in inflexion. The commonsense is that modernism is the aesthetic dimension of modernity. This view has been the subject of scrutiny not least in Bernard Smith's most recent magnum opus, *Modernism's History* (Smith 1998). The standard query raised in the antipodean context is whether we can have modern without modernity, or more precisely modernist culture without a virile industrialising capitalist base. I have addressed some of these questions in *Transforming Labor* (Beilharz 1994a). The best quick answer is in the positive, though the implication of this is that modernities can be so varied and mixed as to mean, via the principle of uneven development, that the less developed economies of the peripheries (so to say) show the future to those of the centres. As Smith argues, the cultures of the centres suck in the cultures of the peripheries as do cities those of the regions, emblematically in the cases of orientalism, chinoiserie, japonisme, more generally in the way they create and recreate romanticism as the alter ego of enlightenment. Viewed more closely, the ex post facto distinctions between Romanticism and Enlightenment in any case blur, if not collapse. (I have discussed some of these issues in *Postmodern Socialism* (Beilharz 1994b).)

My larger frame of reference relates to ongoing work on the Antipodes and a book in the sleeping, 'The Unhappy Country'. For the purpose of this paper I use two great books as a mainframe. They are Humphrey McQueen's *A New Britannia* (1970) and Miles Fairburn's *The Ideal Society and its Enemies – the Foundations of Modern New Zealand Society 1850– 1900* (1989). The first is as well-known on these shores as the second is invisible. Yet the pertinence of the connection across the Tasman is strong. *A New Britannia* deserves our attention if only for the clarity of its own purpose. The image of the Antipodes as a new Britannia, or as neo-Britons in the southern pacific is as suggestive of the mixed nature of modernity and modernism as you could get. If we think, after Louis Hartz or with Bernard Smith of societal forms as the result of the interaction of environment and culture, then the Antipodes will by definition be mixed modern. For in Australia and in Aotearoa/New Zealand, we encounter the combination of distinct and differing locales, shared imperial cultures, and self-conceptions at once British and stubbornly independent and innovative, new world and old all at once. Australia and New Zealand, Australasia, were one circuit earlier, even if they now pride themselves as culturally distinct. The immediate point of concordance is in the idea of the Antipodes as a petty bourgeois, rather than proletarian utopia, at least when it comes to the mainstream culture of labourists and reformers. Fairburn characterises New Zealand society in this formative period as anomic, or bondless. Community structures are few and weak; isolation is abundant and powerful. The typical New Zealand colonist in the nineteenth century is a 'socially independent individual' (Fairburn 1989, 11). Fairburn writes that petty bourgeois tendencies are visible in other settler or peripheral societies, but argues that New Zealand exemplifies the case. The general image of New Zealand is Arcadia, rather than Cockayne; nature, rather than material abundance without individual labour, is the context. Here natural abundance leads to innate moderation. In the 1890s, the argument goes, the terms of reference shift in the direction of the utopia of the Perfect Moral Commonwealth, which preserves Arcadianism within it. The New Zealand version of Arcadia has a dynamic relationship to abundance, in contrast to the passive classical image. According to Fairburn, 'The difference reflects the incorporation into the New Zealand version of the Victorian imperative of moral progress, the belief that material betterment stimulates more growth which in turn produces moral material growth and so on in an everlasting upward spiral.' (p. 33). Abundance generates independence, or 'competency'. Arguments for home

ownership coincide with claims to the farm as the independent productive unit. The resulting social relations are patriarchal and familial, rather than Fordist or Keynesian, though those latter are also mixed forms. A culture of individualism therefore precedes the moment of the social laboratory, which looks collectivist but underwrites this individual-familial-parochial mode of organisation.

I want to align these two sets of claims, in *A New Britannia* and *The Ideal Society* and gloss them with the discourse of Fordism as a way to read modernity and modernism. The immediate points of connection here are the suggestive themes in Graeme Davison's *Car Wars* (2004) which touches on but does not pursue political economy, and the work of David Craig, who characterises the New Zealand story as pre-Fordist (an economy based on grass and foreign debt). The resulting cultural forms might be characterised as something like Fordism in culture more than economy, in Australia, and a kind of dairy or milkbar modernism in New Zealand, at least in the postwar period.

I

There are two pretexts for this paper. The first is Bernard Smith's *Place, Taste and Tradition* (1945). The second is Humphrey McQueen's *Black Swan of Trespass* (1979). They are links in a formative tradition, that of Marxist cultural history in Australia. While both books have been appraised in detail elsewhere, their purpose here is rather as symbols, statements of intention or markers for a project. What is striking across the two texts is the insistence, implicit or explicit, that the discourse of modernism has to be connected to that of modernity, this often via the political, cultural and economic forms of the thirties through to the forties, and the shared sense in both that culture and technology must always be connected. These forms are cast with especial clarity by McQueen, writing about the forties after the fact. The power of *The Black Swan of Trespass* lies in its organising theme, the four effects of war, mass production, fascism and communism, this matched only by the power of its attendant aesthetic curiosity. *Place, Taste and Tradition*, in comparison, includes a strong programmatic sense of what a Marxist cultural history might look like, but it is part of its own history, or object. Likely this was Bernard Smith's most politically assertive text, finishing in its present. The book has edge, and fire, but it is also a pretext for Bernard's subsequent trajectory and the distance which as an historian he took from the immediate present, at least in his scholarship (see Smith 2005).

The forties is a vital formative moment in Australian modernity. Indeed, my own sense is that this is when modern Australia emerges. It is posited by Federation, the Great War and the earlier reconstruction, but it emerges only with war, planning, federal powers, Postwar Reconstruction, and the latent local Fordism that develops into Holdenism and the Lucky Country, the Australian version of the American Dream. So that these pretexts, in and about the forties, act as curtains for the opening scene. Before the main historic act of modernisation, there is the prologue, which concerns an earlier formative period, into the second half of the nineteenth century. This opens with our two main texts, *A New Britannia* and *The Ideal Society*, seeking to represent the two Antipodes of Australasian experience.

A New Britannia is one of the great works of revisionism in recent Australian historiography. Its critics, by and large, hated it (see Teichmann 1971; Burns 1971; Turner 1971). It may not have changed the world, but it had a radical effect on young readers like me. Famously, *A New Britannia* was a critique and dismissal of Russel Ward's *The Australian Legend* (1958) or at least of the image of that book. Ward's book was taken to be the Australian version of the American Turner thesis. Here it was not Western expansion so much as its absence or impossibility which made Australian character. A hostile environment resulted not in the individualism of the American west, but rather in the cooperative sentiment of Australians, and implicitly of the labour movement as the bearer of this ethos. Ward's thesis was innovative, suggestive, and may have been faulted mainly by its prematurity; forty years later a discourse of cooperation as the social precondition of trust was widely influential in North America. McQueen's ire as a younger Marxist was that Australian native radicalism should be rendered as socialism, and its nationalism as anti-imperialism. If his tenor was strident, then McQueen's greatest period contribution was to establish the centrality of labour racism, even if that view again required revision with the passing of time. To foreground racism before its emerging political salience, and to establish labourism as the core tradition rather than socialism were major shifts in radical historiography in Australia. To open the idea of labourism as collective self-interest, or as petty bourgeois political culture was radical indeed. It pre-empted the later, wider recognition that exclusion was as pertinent a fact as exploitation, painted in the colours of everyday life. As we might say now, it opened the possibility that solidarity is a problem, and not only an achievement, for all kinds of regimes of solidarity are simultaneously based on exclusion.

McQueen's theme, then, is that the ethic of labourism is rather less elevated than its traditions (and its historians) have led us to believe. The

late nineteenth century in Australia, on this account, was less one of the onward march of socialism, and more like one of the dream of individual advancement based on racial exclusion. The prospect of developing this line of argument further was lost, swayed by the Left's reaction to the election of Whitlam in 1972. This becomes, in a sense, a lost chapter on Australian radical historiography. The race theme persists and peaks, after Mabo, but the formative discourse of settler capitalism or agrarian capitalism and its political economy of labour disappears, leaving only the traces of work by Denoon, McMichael, and the earlier promises of the journal *Intervention* (Beilharz and Cox, 2007).

The text I want to juxtapose with *A New Britannia* appears across the Tasman almost two decades later. It is called *The Ideal Society and its Enemies – the Foundations of Modern New Zealand 1850–1950*, by Miles Fairburn, published in 1989. My sense is that the allusion to Karl Popper in the title is incidental to the case or at least to its significant utopian dimensions, though it may signify something of the profound effect that Popper is now taken to have on Pakeha New Zealand intellectual culture. Mannheim's postwar endorsement of the power of the culture of planning far more powerfully captures the spirit of that moment and the triumph of New Zealand collectivism. The more substantial influence, to me, seems to be that of J.C. Davis, in his finely polished 1981 text *Utopia and the Ideal Society*, which Fairburn's book relies on more fundamentally.

By the 1970s, the climate in utopian studies as an emerging discipline was tolerant to the point of promiscuity. The best, and finest illustration of this is in the magnum opus of Frank and Fritzie Manuel, *Utopian Thought in the Western World* (1979) which begins with Plato and finishes with Mao. All possible social alternatives, from the fictive to the fantastic via social engineering here are rested under the term utopia. Against this carry-all definition, Davis insists we must differentiate clearly between types of argument for the ideal society, where utopia alone is scientistic, or modern. Davis argues that there are five distinct types of historical argument for the ideal society, as follows: first, *cockaigne*, which is cornucopian, and hedonistic, and second *arcadia*, which is more moderate than this (though in these first two types, natural abundance abounds, therefore science is irrelevant). Third, is the *perfect moral commonwealth*, the image of the good society which is based not on natural abundance but on exemplary moral or civic behaviour (Adelaide comes to mind); and fourth is *millenarian*, driven by the religious fantasy of supernatural salvation. Fifth is *utopia* proper, the modern regime or model based on the will to knowledge, power and order, bringing

to mind as much its passing enthusiast, H.G. Wells, as its postmodern critic, Zygmunt Bauman (Davis 1981; Beilharz 1992; Beilharz 2000).

Fairburn's broad argument is that there is a discernable shift in New Zealand from arcadian culture, moderate though based on the image of natural abundance, to a combination of elements of arcadia together with those of the Perfect Moral Commonwealth across the path of the nineteenth century. The contrast with Australian stories is evident. Both the image of nature and the actuality of agriculture in New Zealand is distinct. New Zealand is widely imagined and desired in this period as a green and pleasant white land, literally as the place of milk and honey, Godzone, arcadia. Australia, meantime, is red and brown, with the exception of the tropics which are dangerous to white men and especially women, with the fertile crescent of the temperate lands and Tasmania and the irrigated oases of the engineers, like Mildura as the regions worthy of civilising (Griffith 1945; Powell 1988; Anderson 2002).

Attendant aspects of the white New Zealand story are less happy, however, according to Fairburn. They include isolation, anomie, and high levels of drunkenness; antiurbanism, antimodernism or antiindustrialism, or the push for agriculture as an industry over the dynamic of Fordism, or mass industrial production; an ethic of independence, neither class-based nor communitarian; and a sense of geographical and moral superiority (in general? and perhaps with regard to Australians in particular (see *New Zealand Journal of History* 1991). Fairburn hedges on the twentieth century implications of this – how might we then explain the dominant collectivism of the New Zealand state and cooperative tradition, or the social laboratory? The problem is not logically beyond resolution. Even if both labour cultures, on either side of the Tasman are petty bourgeois, they are still compelled to build solidarity, however it excludes.

But clearly the story Fairburn tells of New Zealand sets Australia aside. It is different. Fairburn's sense is that after the 1890s the Australians drop the image of arcadia, in the face of the fearful desert. The result, for Australia, is not arcadia but melancholy; and then, to extrapolate, a parallel moment of the Perfect Moral Commonwealth arrives, when new liberalism indicates the prospect of utopia proper, in Davis' terms. If in New Zealand its hesitant hero is momentarily William Pember Reeves, in Australia it is less King Demos than Deakin and Higgins, knowledge, power, order, state building. Although Fairburn doesn't push the point, the striking resemblance across the Tasman is that his formative New Zealand is petty-bourgeois. It may indeed be the case that *A New Britannia* in this regard fits New Zealand

better than it fits Australia, at least when it comes to the labouring ethic of independent self-sufficiency.

For in New Zealand, on this view, the home or farm is the independent productive unit; the home and family is the unit of cultivation, or productive capital; and the independent home unit depends literally on the family and on the labour of women, not on the safety net of the state or the voluntary associations of civil society. More, the working man in this little utopia enters into independence along the path of the life cycle, step by step into independence. Here the echoes with the logic of labour action in *A New Britannia* resonate. *For the object of labour is not to labour, but to exit the labour market* (Fairburn 1989). Wealth making is the means to independence, understood here more as self-sufficiency than as proletarian or urban independence. There will, of course, always be other stories to be told, like the Marxist stories of hard class struggle not least on the docklands, where internationalism arrives every day by maritime means of conveyance. From the field of stories about modernity, rather than capitalism, this may suggest rather that New Zealand modernism might be less reactionary, in Jeffrey Herf's sense, than provincial, or agrarian. What Herf calls reactionary modernism, in the German case, involves strong and opposed currents of romanticism and technological progressivism (Herf 1984). In New Zealand, that tension is less apparent, though it must also come into play in the Faustian project of the control of nature in the struggle for energy (Blackbourne 2006).

II

Fordism started early, though it was registered later, not least by Gramsci in the thirties. Beynon and his colleagues note that the tomato was one of the forerunners of Fordism, in the mass production of soup (Harvey, Quilley and Beynon 2003). The images are the same as for the Model T or the Volkswagen. Mass production, standardisation, the conveyor belt. Gramsci's contribution was to expand the context and implications of the revolution on the factory floor, out. Gramsci understood that Fordism, or Americanism, was both a mode of production and a mode of consumption, or, like Bernard Smith or Humphrey McQueen, that it combined a technology, a political economy and a culture. Fordism is multiply modular: it indicates a whole way of life (Gramsci 1971). More, by the time it expands and is adapted out into the fifties, it coincides with the momentary glory of the national-developmental or nation building project. Fordism, embodied

in the American dream and its local variants, involves a closed production-consumption loop which depends upon the nation-building project. Its apogee is the political economy of import substitution, symbolically captured by the image of localised automobile production (McMichael 1996).

What happens when Americanism escapes from America? Is it glocalised, hybridised, or are its precedents more mechanically followed? After its major American analysts, Piore and Sabel and then Reich, Fordism becomes identified with America and Americanism, or with the American model of Americanism (Piore and Sabel 1991). The standard logic here is older, the developmental three step, primary, to secondary, to tertiary industry. Yet everything we know about world history tells us that it progresses unevenly, for Marxists, via the principle of uneven development. As Trotsky understood, for example, the movement called futurism took on its most accentuated forms not in the centres but in the peripheries, then in Italy and in Russia (Trotsky 1960, 126–7; cf. Beilharz 1987). And so was there Fordism – or Ford – in Latin America, and in the Soviet Union, where its triumphant bearer was not the symbol of freedom in the passenger vehicle, but that of socialist construction, in the tractor. The study of Fordism, and modernity, could be much advantaged by further work on Latin America, a lost source of parallel experience to the Antipodes, but also by new work on Soviet Fordism, or Fordsonism, which seems to bear the opposite logic to that of the Antipodes, i.e. mass production without mass consumption (Ford 1923, 1926; Buck-Morss 2000).

The clever twist put by David Craig (2003, 42–61) on the New Zealand version of this story is to call it *Trekkaist*, and now *Neotrekkaist*. Craig begins from the premise that New Zealand's is an economy based on grass and debt. This might be a variation in Belich's characterisation of New Zealand as a protein export economy (Belich 2001; see also Denoon and Mein-Smith 2000; Mein-Smith 2005). This comes together, for Craig, with a culture of provincial modernism which looks like the local version of Mickey Mouse (Beilharz 2006). The idea of provincial modernism is catchy, but compromised. New Zealand's cities today do not feel provincial; and if we take an additive approach to the idea of the dairy economy, these days we would have to add that New Zealand exports people, creative capacity and culture as well as protein. This, indeed, is what the provinces have always done, historically speaking – the centres gobble us up, ideas and all. Probably the utility in the idea of provincial modernism is in its aesthetic connection to the regionalism which precedes international style and persists against it, perhaps especially in the representation of landscape,

place writing or place painting. Craig playfully refers to the New Zealand version as Taranaki Gothic, which might fit the postcard image of the forties, but fails to capture the universal in the particular in a representative painter like Colin McCahon (Craig 2003). The local can also be global in its reach.

Craig's puckish response to this predicament is to argue that New Zealand was never Fordist (though it did of course do white goods). Rather, New Zealand can be usefully characterised as a culture and economy of assemblage. Via the metaphor of #8 wire as a universal fix-it culture, something you can fix anything with, the notion of assemblage implies creation more than derivation or mimesis. The major postwar theorist of assemblage was W.B. Sutch, who argued for import substitution such as car assembly but without mass production; for state sponsorship; and who dreamed of a future economy based on the culture industry. The central postwar actor in this story was Noel Turner, the 'commie-capitalist wheeler dealer', literally, who was responsible for the Trekka, the New Zealand hybrid car with Czech Skoda mechanicals and a local boxy ute body (Craig 2003). In result, Craig argues, with the passing of time New Zealand cannot be postfordist, for it was never Fordist. Ergo, it must be neotrekkaist. His argument shows all the adaptability of #8 wire, somewhere between clever and in this case too clever by half.

Was Australia then Fordist? One influential case insists against this. Hampson and Morgan's essay, 'Postfordism, Union Strategy and the Rhetoric of Restructuring: The Case of Australia 1980–1996' claims that the discourse of postfordism is impertinent here, now, as Australia was never Fordist in the first place (Hampson and Morgan 1999). The reservation I have about this case is that it secretly universalises the American model of Americanism. Hampson and Morgan seem to understand Fordism as only the Detroit version of the specifically, provincially American model of the American dream. Fordism, here, means strictly those economies where mass production has come to dominate GNP statistics (which means by definition that there can be no such thing as antipodean Fordism). We might have no dispute with their claim that postfordism is a fantasy, for the dull material demands of factory production still call, from Shanghai to Sao Paulo. But this definition of Fordism is too uniquely American. Was Aotearoa/New Zealand then ever Fordist? Maybe not, though its striving towards other aspects of modernism were plain, in architecture, public housing, in the mixed visual aesthetics which combined images of geographically fixed agriculture with those of mobility, the plane, the locomotive, the steamship.

Like Australia's, this came to be a Fordism of consumption, where the only real problem was paying off the national credit card bills.

A useful point of contrast is provided in Graeme Davison's *Car Wars* (2004). Davison's book is social history at its best – stronger, here, on culture and consumption than on production. Yet Davison's book is expressive of the local condition in this very fact – that ours, in Australia, may seem to have been a Fordism of consumption more than of production. This sense is most powerfully evoked in the photograph Davison reproduces by Wolfgang Sievers, of the Ford plant in Geelong in 1951. Its serried ranks, just like the prize-winning agricultural exhibits in the Royal Shows, go back from Ford Consuls (British) to Ford Mainlines (American), through Commer and what look like International Harvester trucks, to military lines of farming equipment framed, at the edge, by mass-produced Fordist housing. This is also, in a sense, a culture of assemblage – Ford, not General Motors Holden, it suspends the moment of the 1948 Golden Holden, the classic that Chifley launched but couldn't give you petrol for. This is the moment of the Lucky Country about to break out of rationing, hyperplanning and war economy, then to be delivered by the avuncular slim smile of Menzies, where the home, indeed, was the site of utopia, mediated by beach, backyard, car and supermarket. The image of Australian modernity is not quite yet Fordist, in the Detroit sense; it crosses over the agrarian and industrial, its cars could be prize cabbages or cheeses, and its agricultural implements still shout of manmade agrarian abundance, wheatsheaf and sheepsback. Before the sixties, before the Lucky Country, its emblem was the Sunshine Harvester, the pretext for Mr Higgins' basic wage decision. But the frugal comfort he had in mind, in 1907, was exploding by the sixties as the youth market popped. Now Australians and New Zealanders were, for example, also making their own rock and roll, often across the Tasman, often on locally produced instruments, creating as they consumed.

The idea of Fordism, and of Fordism in the Antipodes therefore puts a new and useful spin on the attendant theme of the Americanisation of the Antipodes. As Mark Rolfe argues in 'Faraway Fordism', if Australia looked to American Fordism after World War Two, then New Zealand elites also looked to Australian Fordism as an already mediated model of modernisation (Rolfe 1999). As late industrialisers, antipodean leaders would look to American modernisation rather than to the Industrial Revolution for inspiration. Driven on by the experience of war, militarisation and postwar reconstruction, the image of American modernity made more sense, following Hartz, as the inspiration of the moment of formation

(Rolfe 1999). Postwar images of modernity were shifting away from those of the New Britannias, towards the American Way of Life, Levittown rather than Detroit. By this moment, utopia meant less the prospect of exiting the labour market than entering it securely and matching it to the easy consumption and leisure images of the sixties. In Australia, meantime, the consequence of postwar mass immigration was that Australia would look more like a Neo-Europe than a Neo-Briton.

This leaves us with a final sense, for the moment, that whatever the precise utility of the categories of modernity and modernism, the idea of Fordism flexibly rendered might be useful, at least for Australia, because what we today (or until recently) called Australia arguably emerges not in 1901 or 1915 but in the postwar period, together with the more robust program of national development of the colonies. It may also leave us with an ambit sense that whatever the cultural traffic in statebuilding, fabianism or collectivism, the New Zealand and Australian images of antipodean modernity are more distinct than similar. Australia and New Zealand offer shared histories, imperial and pacific, different local geographies, continuous vocabularies and sometimes shared actors and ideas. To begin to consider these requires a renewed sense of the significance of lateral comparison, not only with reference to the trans-Tasman but also with reference to the US and UK as background images of modernisation and Latin America as a model of parallel cultural creativity, import substitution, the national developmental project and uneven development.

It leaves us with the open question of the nature of cultural traffic between these places and the question of the local sources of modernism. As Humphrey McQueen puts it in *The Black Swan of Trespass*, modernism does not arrive in the Antipodes in European suitcases any more than modernity can be said to arrive in those car crates from Detroit. Americanism is also forged overseas (Coleman 1987; Rodgers 1998; de Grazia 2005). Culture is mediated through the world system of imperialism, but its local emergence and its innovation results from cultural traffic. Modernism does not arrive; it emerges. Alternative modernities persist, even in the provinces.

References

Anderson, W. 2002. *The Cultivation of Whiteness. Science, Health and Racial Destiny in Australia*. Melbourne: Melbourne University Press.

Beilharz, P. 1987. *Trotsky, Trotskyism and the Transition to Socialism*. London: Croom Helm.

Beilharz, P. 1992. *Labour's Utopias – Bolshevism, Fabianism, Social Democracy*. London: Routledge.

Beilharz, P. 1994a. *Transforming Labor. Labour Tradition and the Labor Decade*. Melbourne: Cambridge University Press.

Beilharz, P. 1994b. *Postmodern Socialism – Romanticism, City and State*. Melbourne: Melbourne University Press.

Beilharz, P. 2000. *Zygmunt Bauman – Dialectic of Modernity*. London: Sage.

Beilharz, P. 2006. Robert Hughes and the Provincialism Problem. In *Reflected Light – La Trobe Essays*, edited by Beilharz, Peter and Robert Manne. Melbourne: Black Ink.

Beilharz, P., and Lloyd Cox. 2007. Settler Capitalism Revisited. *Thesis Eleven* 88(1): 112–124.

Belich, J. 2001. *Paradise Reforged. A History of the New Zealanders*. Auckland: Allen Lane.

Blackbourne, D. 2006. *The Conquest of Nature. Water, Landscape and the Making of Modern Germany*. London: Cape.

Buck-Morss, S. 2000. *Dreamworld and Catastrophe. The Passing of Mass Utopia in East and West*. Boston: MIT Press.

Coleman, P.J. 1987. *Progressivism and the World of Reform. New Zealand and the Origins of the American Welfare State*. Lawrence: University of Kansas Press.

Craig, D. 2003. (Post) Fordism, (Neo) Trekkaism. In *This is the Trekka*, edited by Michael Stevenson. Wellington: Creative New Zealand Toi Aotearoa and Frankfurt: Revolver Archiv für aktuelle Kunst.

Davis, J.C. 1981. *Utopia and the Ideal Society: A Study of English Utopian Writing 1516–1700*. Cambridge: Cambridge University Press.

Davison, G. 2004. *Car Wars*. Sydney: Allen & Unwin.

de Grazia, V. 2005. *Irresistible Empire: America's Advance Through Twentieth Century Europe*. Cambridge MA: Harvard University Press.

Fairburn, M. 1989. *The Ideal Society and its Enemies – The Foundations of Modern New Zealand Society 1850–1950*. Auckland: Auckland University Press.

Ford, H. 1923. *My Life and Work*. Sydney: Angus and Robertson.

Ford, H. 1926. *The Great Today and the Greater Future*. Sydney: Cornstalk.

Gramsci, A. 1971. *Selections from the Prison Notebooks*. New York: International.

Hampson, I., and David E. Morgan. 1999. Postfordism, Union Strategy and the Platonic of Restructuring: The Case of Australia 1980–1996. *Theory and Society* 28: 747–796.

Harvey, M., Steve Quilley, and Hugh Beynon. 2003. *Exploring the Tomato: Transformations of Nature, Society and Economy*. Cheltenham: Ashgate.

Herf, J. 1984. *Reactionary Modernism – Technology, Culture and Politics in Weimar and the Third Reich*. Cambridge: Cambridge University Press.

Manuel, F., and Fritzie. 1979. *Utopian Thought in the Western World*. Oxford: Blackwell.

McMichael, P. 1996. *Development and Social Change*. Pine Forge: Thousand Oaks.

McQueen, H. 1970. *A New Britannia*. Ringwood: Penguin.

McQueen, H. 1979. *The Black Swan of Trespass. The Emergence of Modernist Painting in Australia to 1944*. Sydney: APCOL.

New Zealand Journal of History. 1991. 25 (2). Special issue.

Piore, M., and Charles Sabel. 1984. *The Second Industrial Divide*. New York: Basic Books.

Powell, J.M. 1988. *An Historical Geography of Modern Australia – The Restive Fringe*. Melbourne: Cambridge University Press.

Reich, R. 1991. *The Work of Nations*. New York: Knopf.

Rodgers, D.T. 1998. *Atlantic Crossings, Social Politics in a Progressive Age*. Cambridge MA: Harvard University Press.

Rolfe, M. 1999. Faraway Fordism – The Americanization of Australia and New Zealand During the 1950's and 1960's. *New Zealand Journal of History* 33(1): 65–91.

Smith, B. 1945. *Place, Taste and Tradition*. Sydney: Ure Smith.

Smith, B. 1998. *Modernism's History*. New Haven: Yale University Press.

Taylor, G. 1945. *Australia*. Melbourne: Methuen.

Trotsky, L. 1960. *Literature and Revolution*. Ann Arbor: University of Michigan Press.

Ward, R. 1958. *The Australian Legend*. Melbourne: Oxford University Press.

Chapter 5

Nations and Nationalism:
Australia and New Zealand
(2007)

Co-authored by Lloyd Cox

Australia and New Zealand present a fascinating case, when it comes to nations and nationalism. Both are evidently imperial artefacts, the results of the expansion of the British Empire into the Southland in the eighteenth century. Both are examples of what is best described as settler capitalism, agrarian based primary commodity export economies with British superstructures imposed from above. Both nations therefore displace indigenous peoples, though these indigenous peoples also differ dramatically in culture and organisation across the Tasman (indigenous peoples make up fourteen percent of New Zealanders, and two percent of Australians). Both white cultures look alike, to the outsider, even if New Zealand looks more British. Both share British state institutions, patterns of party organisation and union organisation. Both share imperial commonwealth culture, from cricket to Fabianism. Yet the two experiences are also dramatically different. Australia is a big country, more accurately a small country or society connected by large distances. Only the southlands of Australia are temperate. Two thirds of Australia is arid; its populace hugs the urban edge of the continent. All of New Zealand is green and temperate. Its inhabitants are more widely spread over a much smaller space, though a disproportionate number of them now live around Auckland. Australian history is more clearly artificial, additionally, in the sense that its identity is more often local or regional, at least in terms of everyday life.

The idea of Australia reaches back to Terra Australis Incognita before first settlement in 1788, but its practical identity until Federation in 1901 (and after) is colonial, constituted by the colonial cities of Melbourne, Sydney,

Perth, Adelaide, Brisbane and Hobart. New Zealand, despite the Dutch associations of the name, was later viewed from its Anglo beginnings as Arcadia. Yet the parallel paths of the two nations is also constitutive of their identities. The older Greek image of the Antipodes leads on to the collective identity of Australia and New Zealand as Australasia across the path of the nineteenth century. Australia and New Zealand certainly worked together as part of a larger imperial labour market and labour movement, as well as a shared market for finance and commerce. The earlier arguments for Australian federation, indeed, were arguments for Australasian federation. The Australian Constitution, drafted for 1901, still contains within it a clause leaving open New Zealand as a possible member of the Australian Commonwealth. So these are stories intertwined and distinct, at the same time.

If these are parallel paths, but not quite parallel histories, then they are also stories of separate nations, perhaps most emphatically after World War Two, when nation-building proceeds apace as national developmentalism, and Fordism makes its mark, even if more evidently in Australia than New Zealand (McMichael 1994; Rolfe 1999). Into the nineties, in the face of the new globalisation, both experiences are also described anew as historic settlements, what in the critical literature was referred to as settler capitalism in the new world (Denoon 1987) was now reviewed as the 'Australian Settlement' by Paul Kelly (Kelly 1993), and with a different emphasis, the 'Pakeha Settlement' in New Zealand by James Belich (Belich 1996). In both cases, the image was one of a white man's new world, protected from the ravages of the world system by institutions like arbitration, and able to deliver prosperity on an agrarian production base. As Zygmunt Bauman likes to remind, you only notice something when it fails to work. And so, in these historic cases, did the image of settlement become apparent when it was blown away by the new wave of globalisation.

Australia

The myth of modern Australian history is that Australia's defining attribute is its nationalism. The nation-state Australia is a twentieth century phenomenon, and so is nationalism. Certainly the nation-state becomes a powerful reality in Australia, but this only strikingly so after World War Two, in the period when war, followed by nation-building, the postwar boom and decolonisation all coincide. What is more evident geographically speaking, is that Australia is a land mass or continent, a continent which

in the eyes of the federation fathers a century ago was looking for a nation (Ward 1977). Given its absence of a myth of national foundation, in war or revolution, given its accidental and bureaucratic origins as a penal colony the afterlife of which its instigators apparently gave little thought to, it may actually be more useful to view Australia as an accidental nation. If we begin from the premise that Australia was an accidental nation, then the historiographical and widespread popular sense that Australia is a country of strong nationalism becomes less persuasive. Nationalism in Australia might then be viewed as a more complex phenomenon, politically contingent and periodically enforced upon citizens by their political leaders for electoral reasons or beaten up by the media for sporting events, not least in times of crisis, whether local or global.

To begin to think about the nation in Australia is difficult. To begin to think about Australia is difficult, in terms of the standard liberal or Marxist sensibilities. First, from penal settlement in 1788, the state precedes capital. Second, in a particular cultural sense, labour precedes capital, as bond labour becomes free with the end of transportation, and as capital remains in London, whereas labour, as always, is geographically fixed (though it is also mobile across the Tasman). The kind of nationalism which is then identified as central by historians into the twentieth century is labour nationalism. After its Whig phase, Australian history writing becomes labour history, history from below as befits the image of the land and its popular inflection as downunder.

The most powerful images of labour nationalism in the 1890s are imperial and racially exclusive (McQueen 1970). The image of White Australia finds its enthusiasts across liberal and labour ranks, and this is telling, for the identity of Australia and of Australian nationalism here is in its original form racially defined. Everyday life and loyalty is colonial, defined by the reach of concerns in regional shearing sheds or in the suburbs of Brisbane or the slums of Melbourne, but national identity, when it is presenced, is primarily racial. Indeed, the first legislative act of the new Federal Parliament is to introduce the Immigration Restriction Act in 1901. Australian identity here is white, Anglo, European, not of Asia, neither yellow nor black. The aura of Australia, in this period, was that of A New Britannia in the Southern Seas. New Zealand, more racially pure in its settler population, less tropical in its geographical extremities, still later identified its dream as that of a Better Britain.

This is not to say that labour nationalism ruled, or that its content was absolutely shared by Australia's political elite. For one thing, labour nation-

alism would also happily dispense at least in principle with the aristocratic fops of the political elite. Its socialist dream was often of capitalism without capitalists, as elsewhere in Europe and the New World; and its racism was often moderated by the internationalism of labour and the idea of universal brotherhood. But its mainstream, the labourism that was to dominate both the left and popular culture, was racially exclusivist.

Did the advocates of White Australia then see themselves as Australians? Yes, in this particular register, facing outwards, towards the wider world and not only inwards, or on to the next day and its bread. Yet the presence of imperial consciousness and the images of the New Britannia were such as to qualify this sense irredeemably. In the context of a New Britannia, the citizen (male) would be an Independent Australian Briton. This was confirmed by Federation in 1901, the ordinary impact of which is still subject to dispute. Nation-builders there were, leading up to this event, though their identities were also colonial, for before Federation there was no national capital, and Canberra, an artificial invention built in the shadow of Washington DC and garden city planning, was a city that was never a colony. The city of Canberra thus became identified with the twentieth century project of nation-building in a way that made the two mutually constitutive, at the same time confirming their distance from the everyday life of most citizens in the older and commercial colonial cities. The next significant phase would be marked by the First World War. In the absence of a foundational revolution, the imperial event at Gallipoli became symbolic of Australian nationalism in the context of the imperial heritage. Here the figure of the bronzed, laconic Aussie was born, or constructed. The figure of the ANZAC is expressive of the moment – imperial, Britain in the European theatre of world war; Australian, marked by the pragmatism and comradeship of the wide brown land; and bonded together with the Kiwis, the NZ part of ANZAC.

The Australian state, and the colonial traditions which preceded it, had long been connected with the idea of colonial socialism, or state socialism (Reeves 1902; Eggleston 1932). Australia and New Zealand together, and perhaps especially New Zealand were viewed from the north as the social laboratory of the new world. The institution of Arbitration was constructed in traffic across the Tasman; then in 1938 the Savage Labour Government pioneered global developments in welfare provision in New Zealand 'from the cradle to the grave'. Both the statist tradition and, in a different sense, the practical socialism of the Antipodes was confirmed, momentarily, in the period of reconstruction after World War Two. The significance of the Second World War for the project of nation-building

in Australia cannot be underestimated. For it saw, for example, the first moment at which taxation became a federal prerogative, presuming now that it was the nation rather than the colonies (or then states) which was both the appropriate organisational unit of the state and the desirable carrier of collective identity. If Federation was the first serious political attempt to make a nation-state, then Postwar Reconstruction was its practical sequel and extension in a world where nation-building and rebuilding was now the shared global imperative. The national-development phase of global capitalist development in Australia shared its impulses. Import substitution was consolidated on a grand scale with the development of local Fordism and the shift from car assembly to local car production (Davison 2004). The idea of a National Health Service was mooted in Australia and defeated. In 1944 the Federal Labor Government referenda for the widespread extension of state powers was submitted to the electorate and defeated. The Australian National University was established in 1949, together with a Research School of Social Sciences to guide it and Canberra. National demography became an academic priority and a developmental object, via programmes of Southern European migration to build industry and its suburbs, and to push programs of national development like the Snowy Mountains Hydroelectric Scheme in New South Wales, a national development program which could be compared to the Hoover Dam in the USA.

The result of the postwar boom, and program of national development was the emergence of the period of the so-called 'Lucky Country' into the sixties (Horne 1964). Here the image was of the Australian nation as a consumptive, more than productive culture, where primary export commodity markets could maintain a strong and well-fed largely Anglo population and facilitate its historic shift from the hope of a civic nation into the fun palace of a leisure nation. This was a lazy nationalism, the product of widespread abundance; it remained racially exclusive, though now increasingly European rather than strictly British. One result was that into the sixties the idea, or at least the slogan of the White Australia Policy was abandoned, both by the Labor Party and by the state, though assimilation clearly ruled.

Into the seventies both nation and nationalism took a social democratic turn, marked at government level by the reformist Whitlam moment, 1972–75. This represented a new period of cultural nationalism, perhaps reminiscent of Trudeau in Canada, together with a cosmopolitan inflexion. The Whitlam Government encouraged the development of a national literary canon, not least in the form of film and television, as well as the valorisation of cultural diversity. Against a backdrop of accelerated globalisation, shifts

in diplomatic priorities from Europe and North America to Asia, and immigration trends that diluted the demographic weight of 'white' Australia, the new doctrine and practice of 'multiculturalism' progressively displaced pre-existing uni-cultural narratives of nationhood in most official discourse. While certainly more tolerant of cultural diversity within the nation than its ethnocentric predecessor, this new exercise in civic nationalism was not without its detractors. Many critics of multiculturalism have argued that it conceals the continuation of a hard Anglo ethnic core, dominated by a white Anglo-Celtic elite that defines itself, and is defined by others, as non-ethnic (Hage 2000; Jakubowicz et al. 1984). Elizabeth Povinelli (2002) has similarly argued that multiculturalism called upon Aboriginal Australians to identify with an impossible ideal of 'traditional' cultural authenticity, the logic of which is both conformist and non-conflictual. However, although seeking to domesticate the mobilising power of ethnic identification and grievance within safe cultural parameters, multiculturalism also opened up new spaces for political assertiveness. Indigenous peoples used the new sense of the expanding political sphere or civil society to organise public presence, not least in the form of the Aboriginal Tent Embassy, a self-fabricated space located in the front grounds of Parliament House in Canberra. The image of the black nation could no longer be avoided by the white mainstream.

By the eighties, the Labor Government returned to office, restyled now as the party of state, no longer as the party of the labour movement. The long Labor Decade, 1983–96, saw Australia Labor in tandem with New Zealand Labour anticipate Blair's subsequent New Labour in Britain (Beilharz 1994). This represented the closure of the moment of the project of national development, and the reformation of the nation-state in terms of the globalising project. The return to power of the conservatives, or Liberals under Howard since 1996 has seen the maintenance and acceleration of the processes of economic globalisation together with a formal return to the politics of monoculturalism. In this way, the political achievements of Howard have been to connect back to the populist core of the image of labour nationalism, to refigure this as a middle-class 'battler' ethic, and to connect this to the political economy of deregulation.

New Zealand

Nationalism in New Zealand presents a series of striking contrasts and parallels with its Australian counterpart. The contrasts are perhaps less obvious, especially to the outside observer, but are critical to understanding the

specific form, content and historical trajectory of New Zealand nationalism and nationality. Their genesis can be traced to the decades following the 1860s land wars between Maori and the colonial government, which generated mutually determining pan-Maori and pakeha (white) New Zealand identities. These were the bases for, and manifestations of, two opposing nationalist imaginaries that continue to shape contemporary New Zealand politics. In the late nineteenth century, they both represented proto-nationalisms in search of nations.

In 1854, Canterbury pioneer Thomas Cholmondeley wrote about American precedents for the New Zealand nation, while Governor George Grey told Maori chiefs that one day 'a great nation will occupy these lands' [cited in Sinclair 1986, 1]. It was not until the final decades of that century that the idea took on a more coherent collective expression. If 'nations' are formed not so much by any identifiable empirical property as by nationalist claims themselves, as Craig Calhoun (1997) has argued, then it is clear that Maori and Pakeha nations became gradually sharpening frames of reference during this period. What we might usefully call ' Maorination' came first. The most obvious manifestations were the *Kingitanga* (King Movement) and *Kotahitanga* (Maori Parliament) (Denoon and Mein-Smith 2000, 184–95). Born in the shadows of and as responses to colonial dominance, both sought to encompass particularist tribal claims and identities within a more inclusive 'Maori' framework. Both sought to marry cultural autonomy with political objectives, not least of which was the securing of Maori interests, leadership and sovereignty (*tino rangatira tanga*) in the face of colonial rule, irrespective of tribal affiliation. It is this coupling of culture and politics that marks them out as proto-nationalist. Their ultimate collapse as viable institutions should not blind us to their proto-nationalist character, nor to their enduring legacy for the Maori cultural and political renaissance of the 1970s. They also made a crucial contribution to the formation of a white settler nationalism and identity, against which Maori were increasingly defined and, at least partially, marginalised.

Settler nationalism and its twentieth-century progeny has always been unclear about the status of Maori within its self-proclaimed nation. On the one hand, an assimilationist strain sought to incorporate Maori within narratives of national becoming. In this view, the 1840 Treaty of Waitangi was a unique experiment in cooperation between an indigenous population and European settlers, rather than the imperial fraud that radicals often present it as being. It expresses a compact between, and a founding document of, two peoples who would go on to form one nation. The early

vote for Maori (1876 for male Maori with individual property title), and their physical survival and relative prosperity as compared to indigenous peoples elsewhere, is presented as proof of the enlightened attitude of New Zealand's colonial administration and its desire to incorporate Maori citizens within the new nation. Indeed, one of the arguments put forward against joining the federation with the six other Australasian colonies was that the latter could not be entrusted to uphold the rights of 'our natives' given the savage treatment of their own. On the other hand, white settler nationalism evinced a more straightforward exclusionary vision. This vision was premised on a racialised view of the world, which condescendingly viewed Maori like aborigines as a window into Europe's anthropological past – an unassimilable 'race' on a lower rung of the evolutionary ladder. The new nation would be a nation of and for the white race, as made clear by New Zealand's Immigration Restriction Act of 1899. This excluded those who were not of British or Irish parentage and who could not pass an English language test; this was a 'white New Zealand' policy two years prior to the implementation of its more infamous Australia counterpart. As Denoon and Mein-Smith note, by the end of the nineteenth century in New Zealand, 'the shared idea of "the people" had coalesced and permeated public consciousness so that all who were non-white, non-Christian and non-European in culture were labelled "unassimilable"' (2000, 211).

White settler nationalism was also ambivalent about New Zealand's relationship to Britain. As a British colony peopled largely by English and Scottish settlers and their descendants, notwithstanding the large Maori minority, 'New Zealandness' elicited divided loyalties and contending identities, often within the head and heart of the same settler. Britain remained the mother country amongst early generations of white settlers, including those born in New Zealand. For them, New Zealand promised a Britain of the South Seas, an improved arcadian model to be sure, but one that was still organically tied to, loyal towards and dependent upon the home country. For a time, New Zealand even sought to fashion itself in the imperial image of its British parent, claiming an empire writ small in the South Pacific. Its direct colonial administration of the Cook Islands, Samoa (after the First World War) and other small Pacific Islands, and its continued economic and political dominance of them to this day, represent important episodes in the formation of white New Zealand nationalism. Needless to say, the history of New Zealand's involvement in the South Pacific Islands was also crucial to the emergence of nationalism in the latter, though that story is beyond the scope of this chapter.

Even when the demographic balance shifted in favour of a 'native born' white New Zealand populace in the 1880s, the image of the imperial centre as home continued for many pakehas. New Zealanders generally viewed themselves as 'better Britons', but Britons nonetheless, and this would continue until at least the First World War. But alongside, or perhaps more accurately *within*, this 'better Britonism', was growing a more explicitly separate New Zealand identity. This was reflected in the emergence of a more politically assertive nationalist journalism, the formation of 'New Zealand natives associations' in the 1890's, and the establishment of numerous national organisations. The New Zealand Farmers' Union, the New Zealand Rugby Union, the National Council of Women, the first national political parties and trade unions, and many other national organisations date from this period (Sinclair 1986, 3). They expressed a growing sense of separateness from both Britain and, equally important, the other Australasian colonies.

From the standpoint of the present, it might seem inevitable and natural that New Zealand and Australia should form two separate national states and identities. The 1200 miles separating Sydney from Auckland have themselves been identified as 1200 good reasons for national separateness, a distance which is magnified by the various cultural, geographic and historical differences that national-centred historiography commonly emphasises. But this is to read history backwards. It involves a kind of retrospective nationalism which, through a sleight of hand, transforms what was an historically contingent, could-have-been-otherwise process of national-state formation into an historical necessity, a national destiny, or two. What existed prior to the twentieth century was not 'Australia' and 'New Zealand', but seven British colonies that bore a pattern of family resemblance and, relative to the rest of the world, a high degree of economic, political and cultural traffic between one another, which helped constitute a 'Tasman' or 'Australasian World'. This could just as well have been the basis for the emergence of one rather than two national states and identities.

New Zealand's reasons for not joining the Australian Commonwealth in 1901 have been the subject of extended historical debate (see Fairburn 1970; Sinclair 1987; Belich 2001). It has been suggested by some that the main reasons are economic. The economic crises of the 1890's affected the other Australasian colonies far worse than they did New Zealand, whose relative economic dynamism was said to be an incentive to remain apart. Some commentators have concluded that New Zealand's intensified export trade to Britain since the advent of refrigerated shipping in the 1880's had diminished the importance of access to Australian markets, and thus

diminished the economic incentives to federate. Finally, some nascent New Zealand industries, along with the trade unions, which overwhelmingly opposed federation, were seen to be fearful of competition within the new unitary market that would be formed by the Australian Commonwealth. While such explanations offer important insights into why some constituencies were against federation, they have difficulty in accounting for why these interests prevailed over others that would have clearly benefited from federating, including the powerful farming lobby. A more rounded explanation must take into account New Zealand settler nationalism itself, which impeded and then was consolidated by federation. Apart from the emergence of a pan-Maori identity, what were the other developments that moulded New Zealand's settler nationalism?

New Zealand's transport and communications infrastructure had been transformed from the 1870's, under the stewardship of Julius Vogel. From then on, the rapid growth of a national railway system, the multiplication and improvement of roads, and the proliferation of telegraph lines and postal services, compressed time and space and linked distant localities within and between New Zealand's two main islands. This not only accelerated provincial interdependencies and extended the reach of the colonial state, it gave material and institutional substance to the imagined space of an emerging nation – developments which Livingston (1996) has perceptively described as 'technological nationalism'. Intensified economic and social interconnectedness was coupled with accelerated political centralisation. Up to the period of the land wars, political power and administration had been dispersed across the main provincial centres. The debts incurred and demanded by extended military campaigns undermined the autonomy of the provinces, concentrating power in the hands of an expanding central state apparatus. This apparatus, in conjunction with its imperial overseers, set about forging and perfecting legal and administrative uniformity on every square inch of 'its' territory – a stimulant to and index of institutional nationalisation. From the 1870's, the colonial state also imposed mandatory primary school education for all children, a key instrument of national cultural homogenisation in New Zealand as elsewhere. While Gellner's (1983) claim that nationalism demands and begets the coincidence of cultural and political boundaries is over-generalised, he was surely correct that relative cultural uniformity improves the prospects of initial state formation and consolidation, and that education is one of the key means by which this is accomplished. This was certainly the case in New Zealand, with generations of school children learning a national catechism and mythology

within the classroom, thereby helping to form identities that they would carry with them for life.

The other two factors that were constitutive in the emergence of a white New Zealand nationalism during this period, even though shared with Australia, were institutionalised class compromise in the form of compulsory industrial arbitration, and New Zealand's involvement in war. The 1894 Industrial Conciliation and Arbitration Act (IC&A) represented the key achievement in a line of progressive legislation implemented by the Liberal Government, which gave New Zealand the seeds of a social security system and an international reputation as a social laboratory. The IC&A Act provided a foundation for New Zealand's lengthy twentieth-century attachment to economic nationalism, while also giving workers as citizens more of a stake in the new state. The IC&A Act and other progressive legislation obscured cleavages of class beneath a unifying veneer of community, providing apparent resolution to social antagonisms that remained unresolved. The myth of egalitarianism and a classless society became incorporated into and central features of the very fabric of New Zealand's dominant pakeha nationalism. As in Australia, this myth was enhanced by New Zealand's involvement in war.

Jock Phillips (1996) has identified at least two ANZAC myths. The first is premised on an imperial vision, and commemorates the sacrifices that New Zealanders (and Australians) as 'better Britons' made in defence of and as part of the British Empire. The second is less overtly militaristic, more introspective and focused on the private horrors of individual soldiers whose sacrifices were made on behalf of what was ultimately a foreign power. What both narratives share is a sense of national becoming: in the first vision, New Zealand plays its part as a new nation on the global stage, punching above its weight; in the second, New Zealand loses its pre-national innocence, the blood its soldiers spilled a sacrificial rite of national passage. In the immediate aftermath of the War it was the first vision that was dominant, as reflected in the iconography of the shrines and monuments that mushroomed in New Zealand's towns, cities and rural districts between 1918 and 1922. The ANZAC myth has subsequently been remade and its meaning transformed for new generations, and these same monuments are now interpreted in line with the second vision. They now provide tangible points of reference linking New Zealand's past, present and future, thereby establishing the continuity necessary for the imagining of a national subject.

New Zealand's post-war, nation-building project begins in the 1930's with the election of the first Labour government, and more precisely with

its enactment of the 1938 Social Security Act. The Act contained a raft of progressive policies centred on state subsidisation of health, housing, and education, which laid the main pillars of a recognisably modern welfare state. During and beyond Labour's reign, which ended in 1949, these policies were extended and institutionalised. They developed alongside and as an integral part of a programme of economic nationalism and import substitution, which sought to relieve New Zealand of its heavy reliance on primary production and the importation of manufactured products. Figures like the public servant and economic historian W. B. Sutch (1966, 1972) provided a powerful intellectual rationale for the post-war welfare consensus and its further extension, arguing that economic diversification and the avoidance of foreign control could only be accomplished through tariffs and state intervention into the economy. High consumer prices and heavy state regulation were the prices to be paid to ensure national independence and a more equitable distribution of national income. For a time, New Zealand's welfare state became a source of national pride and identity. Any child from the 1950s or 60s could recite the frequently trumpeted fact that New Zealand enjoyed one of the highest standards of living in the world. But this fact, and the complacent assumptions of the dominant nationalist orthodoxy on which it rested, was beginning to be undermined by internal and external challenges; a resurgent Maori nationalism on the one hand, and the corrosive effects of intensified globalisation on the other.

A Maori nationalist revival was initiated in the late 1960's and intensified over the following two decades. It would, eventually, be realised in the ideology and political practice of 'bi-culturalism', which was in many ways to New Zealand what 'multiculturalism' was to Australia.

In the wake of the Second World War large numbers of Maori had moved from rural to urban areas, and were concentrated in areas of high poverty and relative deprivation. These would in time become a focus for Maori grievances, and sites of cultural re-affirmation. In this context, Donna Awatere's *Maori Sovereignty* (1984) provided both an articulate challenge to the white nationalist orthodoxy, and a militant alternative vision framed by Maori self-determination. The large land rights march in 1975, which spanned the length of the North Island in order to publicise Maori grievances, confirmed the depth of Maori nationalist sentiment. It was followed by a major confrontation at Auckland's Bastion Point in 1978, where hundreds of Maori who had occupied some of the city's most exclusive real estate were physically evicted by a huge police mobilisation. The South African rugby tour of 1981, and the violence that ensued in its wake, further

radicalised Maori youth and sharpened feelings of national marginalisation. Taken together, these events contributed to the reinvigoration of a moribund Waitangi Tribunal that had earlier been set up to address Maori land claims. The co-opting of prominent Maori activists into its bureaucratic machine was simultaneously symptom and cause of the differentiation of Maori nationalism between radical and reformist strains, itself a reflection of increased socio-economic differentiation within the Maori population. This process accelerated after the fourth Labour government came to power in 1984 and immediately set about transforming New Zealand's political economy, allegedly in response to globalisation.

The deregulation of the New Zealand economy, the corporatisation and privatisation of state owned industries, and the hollowing out of welfare provision and entitlement, have had their corollary in a shifting national idiom and sensibility. The cult of individualism and the destructive social logic of unfettered free markets have placed greater strains on the pretensions of nationalism to be a unifying, levelling force. New Zealand's dominant nationalism in the 1980s and 1990s took on all of the trappings of a cynical marketing exercise, packaged and repackaged in Americas Cup extravaganzas and the commercialisation of sport more generally. It also had the odious effect of reanimating a far-right nationalist populism – in the form of Winston Peters' anti-Asian, anti-immigrant New Zealand First party – which appeals directly to the fears and prejudices of a constituency marginalised by globalisation and neo-liberal restructuring. In this it mirrors the development of Pauline Hanson's One Nation party in Australia, though as in Australia the larger dynamics indicate striking social division rather than severe political polarisation.

Conclusion

The emergence, maturation and transformation of New Zealand and Australian identity and nationalism over the long century discussed in this chapter draws out one key fact: the essentially contested nature of the ways that the categories New Zealand and Australia are imagined. This struggle for control over imagination about community in its antipodean context is likely to intensify over the coming years as the communities that they encompass diversify in response to the rapidly changing rhythms of an increasingly globalised world. In both countries, this struggle will also likely continue lock-step, given the respective strength and tradition of the parties to struggle. In New Zealand, the contest will remain more clearly

bicultural; in Australia, it will likely be rather between images of an 'old' and a 'new' Australia (Beilharz 2004).

Looking back at these stories of the rise and renegotiation of antipodean nationbuilding, the conceptual clarity of the idea of the nation-state and of nationalism blurs. These were accidental, or incidental nations imposed, differently, both on indigenous peoples and on convict and settler subjects, who were at best Britons with local accents and markings. The traffic across the Tasman has meant that only more recently has the question of citizenship become more decisive, and yet more indifferent, as more and more antipodeans travel out. As Bauman indicates, you only notice what you have when it's gone. The Australasian experiment was state-dependent, and only latterly more clearly nationalistic. Now it is deregulated, and its nationalisms are less well-rehearsed, even if they are increasingly hostile towards one another. For those who remain, the vicissitudes of settlement continue.

References

Awatere, D. 1984. *Maori Sovereignty*. Auckland: Auckland University Press.

Beilharz, P. 1994. *Transforming Labor*. Melbourne: Cambridge University Press.

Beilharz, P. 2004. Rewriting Australia? *Journal of Sociology* 40(4).

Belich, J. 1996. *Making Peoples: A History of the New Zealanders. From Polynesian Settlement to the End of the Nineteenth Century*. London: Penguin Press.

Belich, J. 2001. *Paradise Reforged: A History of the New Zealanders. From the 1880s to the Year 2000*. London: Penguin Press.

Calhoun, C. 1997. *Nationalism*. Buckingham: Open University Press.

Davison, G. 2004. *Car Wars*. Sydney: Allen & Unwin.

Denoon, D. 1987. *Settler Capitalism*. Oxford: Oxford University Press.

Denoon, D. & Mein-Smith, P. 2000. *A History of Australia, New Zealand and the Pacific*. Oxford: Blackwell.

Eggleston, F. 1932. *State Socialism in Victoria*. London: P.S. King.

Fairburn, M. 1970. New Zealand and the Australasian Federation, 1883–1901: Another View. *New Zealand Journal of History* 4(2).

Gellner, E. 1983. *Nations and Nationalism*. Ithaca: Cornell University Press.

Hage, G. 2000. *White Nation: Fantasies of White Supremacy in a Multicultural Society*. New York: Routledge.

Horne, D. 1964. *The Lucky Country*. Ringwood: Penguin.

Jakubowicz, A., Morrissey, M. & Palser, J. 1984. Ethnicity, Class and Social Policy in Australia. *SWRC Reports and Proceedings* 46.

Livingston, K. T. 1996. *The Wired Nation Continent: The Communications Revolution and Federating Australia*. Melbourne: Melbourne University Press.

McMichael, P. 1994. *Development and Social Change*. London: Sage.

McQueen, H. 1970. *A New Britannia*. Ringwood: Penguin.

Phillips, J. 1996. *A Man's Country? The Image of the Pakeha Male – A History*. Auckland: Auckland University Press.

Povinelli, E. A. 2002. *The Cunning of Recognition: Indigenous Alterities and the Making of Australian Multiculturalism*. Durham: Duke University Press.

Reeves, W.P. 1902. *State Experiments in Australia and New Zealand*. London: Grant Richards.

Rolfe, M. 1999. Faraway Fordism? *New Zealand Journal of History* 33(1).

Sinclair, K. 1986. *The Native Born: The Origins of New Zealand Nationalism*. Massey Memorial Lecture: Massey University.

Sinclair, K., ed. 1987. *Tasman Relations: New Zealand and Australia 1788–1988*. Auckland: Auckland University Press.

Sutch, W.B. 1966. *The Quest for Security in New Zealand*. Wellington: Oxford University Press.

Sutch, W.B. 1972. *Poverty and Progress in New Zealand*. Wellington: Reed.

Ward, R. 1977. *A Nation for a Continent*. Richmond: Heinemann.

Chapter 6

Australia and New Zealand:
Looking Backward, Looking Forward
and the Parting of Ways
(2007)

The trans-Tasman world used to be one story, or at least two stories that were interconnected. Somewhere after the Second World War there was a parting of ways. The national and nationalist narratives which expanded then elsewhere in the world characterised Australasia as well. This parting includes a fascinating story about sociology as a nationalist form, a parting of ways across the Tasman and their tentative reconnection, the latter symbolised not least in the coming New Zealand/Aotearoa-Australia combined Sociology Conference in 2007.

My cue to look back, before looking forward, is Edward Bellamy's famous book of that title published in 1888. Its full title was *Looking Backward from the Year 2000*, so it sets up the optic nicely in terms of past and future. *Looking Backward* takes the form of the classic sleeper wakes utopia. Its subject is transported into the socialist future in Boston as a garden city in the year 2000. Bellamy's book is of far greater sociological than literary import. It became the second biggest selling novel in nineteenth century America, after *Uncle Tom's Cabin*. There were 165 Bellamy Clubs established across the United States in the nineteenth century. The book was also widely influential across the Tasman. *Looking Backward* was important to the thinking of the younger William Pember Reeves. He discussed it in his 1890 Pharos pamphlet on utopia, after he had summarised it in the *Lyttelton Times* in the same year. *Looking Backward* sold like hotcakes in New Zealand. At least two separate editions of Bellamy's book were published in the south island alone, and immediately, one by James Horsburgh in Dunedin, 1891, one by Whitcombe and Tombs

in Christchurch, 1890 (Roth 1962, 232; Kumar 1987). The New Zealand response was breathless.

> 'Sold out again of *Looking Backward*', announced bookseller W. Wildman [!] in the *Auckland Star* of April 19 [1890]. 'Fresh supply of 500 copies will be here in a few days' … In the Dunedin *Evening Star* of April 17, 1890, Joseph Braithwaite, of Braithwaite's Book Arcade, announced: 'I have sold about 5000 copies of this marvellous Socialistic book since I reviewed it in the *Star* about six months ago.' Another thousand copies from England were to arrive at Braithwaite's on April 23. They sold out within two days; but fortunately, another thousand copies were expected on April 20' (Roth 1962, 232).

In Australia, Bellamy's initial influence was northern, located in Brisbane and connected to William Lane. Bellamyism was a kind of period equivalent to Fabianism, popular to the point of radical ubiquity. In Australia, this influence likely peaked into the 1890s. In New Zealand, Bellamyism was presenced at the same time, and indicated, and then revived into the thirties, in Bellamy Clubs via the influence of Alexander Scott. A stronger twentieth century impulse was then subsumed into the politics of the Savage Government (Bowman 1962).

Plainly Australia, and perhaps especially New Zealand, saw itself in utopia (Fairbairn 1989; Sargisson and Tower Sargent 2004). This fitted period sensibilities – motifs of experiment, new beginning, social laboratory, and especially in New Zealand, the utopia of climate and landform, the dream of the green and pleasant land. In New Zealand, as Miles Fairbairn shows, it coincides with claims to both natural and moral superiority of New Zealand and New Zealanders over others. This connects to the symbolic significance in Bellamy of the garden city, and its associated themes of harmony, order and leisure built upon a substrate of material sufficiency (*Thesis Eleven* 2008). More vitally, it signals the period optimism for the possibility of social alternatives, the potential plasticity of social arrangements, relations and institutions, the possibility of social change and the fluidity of conceptual time, where 'back' might be 'forwards' and movement forwards might also include significant components of the past. Contrary to the claim of William Morris, Edward Bellamy was not an 'unmixed modernist' (Beilharz 2004; cf. Beilharz 1992).

Whatever the case, utopianism was a vital trans-Tasman symbol of cultural traffic across the world system and oceans. Then, as now, there was a transnational flow of ideas, people, print, institutions and alliances.

Everybody knows different examples of these processes of trans-Tasman traffic. In music, they are obvious – from Johnny Devlin to Split Enz, Crowded House, via Dinah Lee, The La De Das, Compulsion, Dragon, Sharon O'Neill, Jenny Morris and the Datsuns. Max Merritt did no less than introduce soul music to Australia, and New Zealanders have done better than Australians in cataloguing this, as in the major study by John Dix, *Stranded in Paradise* (Dix 2005).

In politics, the case of Mickey Savage stands out. Born in the Mallee, in north-western Victoria in 1872, he became New Zealand Prime Minister in 1935, leading a Cabinet which included six Australians, five New Zealanders, an Englishman and a Scot. What's remarkable about this is that it was unremarkable – there was no fuss about Aussie invasion, for personnel from either side of the Tasman in this period were viewed as practically interchangeable.

Make your own list: Tom Mann; Truby-King; R.F. Irvine, who returns to our concerns later; Lloyd Ross. The writers, then the actors. Add as you like. Phar Lap; Joh Bjelke Petersen; Fred Dagg; *Suburban Mayhem*; more historians, Freddie Wood, Peter Hempenstall, Pat Grimshaw, sociologists like Mick Borrie. More politicians: between 1893 and 1912 two more New Zealand prime ministers, Seddon and Ward, came from Australia, while Australia's first Labor Prime Minister, Watson, had spent the previous twenty years of his life in New Zealand. Watson was briefly Prime Minister of Australia in 1904, at the same time as an Australian was PM of New Zealand. Et cetera.

As to institutions, Wakefield settlement was common not only to Christchurch and Dunedin, but also to Adelaide via Perth. Arbitration, as contested in its identity as the pavlova, was established by Pember Reeves in New Zealand in 1894, Higgins in Australia in 1904, influenced by the experience of wages boards in Victoria, Wise's experience in NSW and Kingston's experience in Adelaide. As Philippa Mein-Smith argues, this indicates that what Paul Kelly called Australian was in fact an Australasian Settlement (Mein-Smith 2005). The Maritime Strike, of course, was intercolonial, in this sense Australasian, as was the potential ambit of Australian Federation. This was a whole trans-Tasman world, which we have lost, replayed fast forward finally into the 1980s by the matched process of the transformation of Labor parties.

How, then, are we to name or make sense of this process? As Philippa Mein-Smith puts it, Australia and New Zealand are two sovereign states with a shared past but separate memories. The latter observation can be read

in two ways – that there are two sets of stories, or two sets of historians and historiographies. The idea of *Australasia* captures something of the larger story. Plainly it is also a *Pacific* story, a useful, postwar term that includes the influence of the USA and includes water, and others, but marginalises Western Australia in a tandem process to the way New Zealand is usually marginalised by the predominance of the Australian east coast. *Oceania* perhaps captures New Zealand broadly better than Australia, though both have in common the culture of largely English-speaking maritime pacific cities, this again at the expense of the Australian north and west. We could refer back to the image of the social laboratory, or *Two New Britannias*, or two provincial modernisms to connect the experiences. We could call them both *Neo-Europes*, after Alfred Crosby's idea of ecological imperialism. We could think of this in older fashioned terms, as *imperial, commonwealth* or *colonial* history or histories – in Australia, at least, contemporary history is still profoundly colonial, city-based or regional. Or we could call all this *transnational*, though I'm not sure that captures it.

There is a long tradition of established work, like Fry and Olsen's *Common Cause* (1986), which reaches through Sinclair's *Tasman Relations* (1988) to the work of Denoon, Mein-Smith and others, and exemplary comparative labour analysis like that of James Bennett in *Rats and Revolutionaries – Labour Movements in Australia and New Zealand 1890–1940* (2004). In general, it seems that transnationalism is stronger in literature and perhaps history than it is in social sciences. Sometimes transnationalism feels like cultural studies in the weak, culturalist sense, which privileges the text over the state or simply leaves states out.

This process could also, alternatively be called *antipodean*, which has been my ambit claim over the last ten years. Following the example of the cultural historian Bernard Smith, my book *Imagining the Antipodes* follows two core claims – that the Antipodes is a relationship rather than a place (opening a paradox: which Antipodes? whose Antipodes?); and that culture is mediated by traffic rather than emanating from place (Beilharz 1997). The idea of the Antipodes has received a new fillip from the revived enthusiasm of J.G.A. Pocock for the idea in his collection *The Discovery of Islands*, though this is a usage independent of Bernard Smith (Pocock 2005). It also results in David Pearson's enthusiasm for the idea in his essay, 'Connecting the Antipodes' (Pearson 2005).

This curiosity regarding the Antipodes overlaps with the case for settler colonialism, settler capitalism, colonialism and provincialism (Beilharz 2007; Beilharz and Cox 2007). It connects to earlier curiosities regarding

the social laboratory into the twentieth century, this revived as the Great Experiment into the 1980s. It parallels, or complements, the trans-Tasman version of the exceptionalist argument in policy studies (Castles, Gerritsen and Vowles 1996), where Australasia is both different and sometimes leads, in this case with Labor anticipating Blair. It complements the idea of the Australasian Settlement. The point is to connect, or to see the connections and interactions, to recognise but work with and perhaps against the stronger ethnographic tradition – in New Zealand, in Littledene, Caversham, Johnsonville, in Australia, in the community studies tradition, to open up to comparison, to work against academic and methodological nationalism. As Jock Phillips put it, writing about verandahs and fish and chips in 1990, and here addressing historians: we need to understand subcultures, but also supercultures. 'To get beyond the national framework may be the next challenge for cultural historians in New Zealand' (Phillips 2001, 336) – and Australia too, sociologists included.

The question then arises, how did the stories that connected the Tasman become separated in the first place? For this does indeed seem to be the case, that a century ago they were connected or told both separately and together. In Pember Reeves' classics, *Aotearoa The Long White Cloud* (1898) and *State Experiments in Australia and New Zealand* (1902) the stories were told both ways, as narrative and as policy innovation. Albert Métin routinely covered both in *Le Socialisme sans Doctrines* (1901), as did Victor S. Clark in *The Labour Movement in Australasia* (1906). Clark's opening lines made the co-constitution clear:

> The term Australasia is used to include the Commonwealth of Australia and the Colony of New Zealand, lands separated by 1200 miles of water, but intimately connected in social and industrial development ... (Clark 1906, 1)

– co-constituted as producers, labour markets and labour movements, fields of ideas, traditions and innovations, but also combined by empire, masculinism, and racism, through together to Gallipoli.

The two stories here are always connected, as in the Nineteenth Century Series, where R.F. Irvine and O.T.J. Alpers offer *The Progress of New Zealand in the Nineteenth Century* (1902) and T.A. Coghlan and T.T. Ewing survey *The Progress of Australasia in the Nineteenth Century* (1903). Here there are two statistical bases for measuring progress, but related stories of social experiment and advance. Coghlan followed with *Australia and New Zealand 1903–4*. Irvine was a proverbial antipodean – born in the Shetland Islands

1858, educated in New Zealand, migrating from New Zealand in 1891, later to become Professor of Economics at Sydney University. Australia and New Zealand are still connected in the standard Cambridge History of the Empire. Separation, posited by Australian federation in 1901, emerges more clearly especially with World War Two.

In 1940 E.H. McCormick published *Letters and Art in New Zealand* (McCormick 1940). It was part of those thirteen russet coloured volumes that made up the New Zealand Centennial Series – a most valuable period source auspiced by the Department of Internal Affairs, especially when read together with the two illustrated volumes of *Making New Zealand, 1939–40*. McCormick viewed the colonial spirit as the national spirit. The motif of the parting of ways, however, was not new. McCormick traced the emergence of national spirit from the 1890s – only here the separation was more from Britain than Australia. According to McCormick, the national spirit revives in the 30s, after the earlier revival of Anglo enthusiasm in World War One. The period parallel in Australia is to be found in Bernard Smith's *Place, Taste and Tradition* in 1945. Smith's project was to establish the national, but not nationalist style and history of Australian painting. This led later to his writing of the *Antipodean Manifesto* in 1960 (Smith 1945; Beilharz 1997).

McCormick and Smith's earlier works were both shadowed by world affairs, in the war against fascism. This was the same period in which significant journals like *Meanjin* (1942) and *Landfall* (1947) were established. After World War Two the struggle for a national canon becomes more evident, in both cases, in literature, art, later film. It is also apparent in nationalist historiography, in the quest for national identity or character, in Australia, in the work of Manning Clark (6 volumes, 1962–1987) and Russel Ward's *Australian Legend* (1958). In New Zealand, the project was carried by Oliver and Sinclair, until the seismic shift engineered by Jamie Belich. The irony of the postwar process of national canon construction is that it has premodern roots, as in Herder, but comes to fruition after Hitler, where culture is read as place – a dangerous view, as fascism showed. Modernism, on the other hand, leads to abstract international style and empty cosmopolitanism, though its sidestreams turn back to provincialism and regional style. Provincialism triumphs, in some ways, on both sides of the Tasman, as the combination of a false sense of superiority with a heightened anxiety about always missing out on the impulse of real life in the metropoles. Twentieth century nationalism, in other words, is also a response to the different waves of globalisation.

A further emergent contrast here can be seen in two more comparison volumes from 1947. Hartley Grattan edited the *Australia* volume for the

Cambridge University and University of California series. One clear theme here is the coincidence of nationalism and nation-building via the specific instance of Canberra, the city that never dug in because it was not a colony or a port city. Here we are reminded that proposed names for Canberra included Wattle City – Empire City – Aryan City – and Utopia! The general concern in Grattan's volume is with the emergence of national style in art and writing, this dominated by place, literally environment in contrast to the British metropolis. Geography, not traffic, is now presumed to form culture (Grattan 1947).

Belshaw's tandem volume on *New Zealand* follows the same shift from geography to culture, and includes the same self-deprecation of local culture as philistine. It connects pioneer culture to loneliness, nostalgia, romanticism. Place is central, here, and so is place writing. As in Australia, momentarily, the Labor Party is viewed as the nation-builder:

> According to the political slogan adopted by the Labor Party after 1935, New Zealanders were to set about building a nation. To the Labour Party, with its strong anti rural bias, this meant industrialization (Fairburn 1947, 248)

– though in culture, place still rules. Perhaps, given this, we should not be surprised to discover that neither of these two books refers to the other. Place now rules. What is really striking about both these books is that they show the co-constitutive relationship between internationalism and nationalism. Commissioned by the United Nations, they show how clearly internationalism depends on a prior nationalism. Thus, by 1947, the two national stories are mutually exclusive – these are two distinct worlds, two different cultures.

And now? I shall not discuss Belich's two volumes here, partly because the obvious parallel is with Manning Clark in the Australian literature. These two massive projects become some kind of new orthodoxy, partly, again, because of their sheer volume and magisterial extent. Moving towards a conclusion, let me instead compare two smaller books, of modest compass, and more difficult task – the single volume Cambridge concise histories of Australia and New Zealand by Stuart Macintyre and Philippa Mein-Smith. Macintyre's short history of Australia includes New Zealand in index and in text. Macintyre is a frequent visitor to New Zealand, an Australian scholar who takes the connection seriously. His book is the result of the previous waves in historiography, history from below, where the cast of social actors expands in the direction of popular inclusivity, and federation nationalism

is read as racially constructed and gender-bound, while there is also a newer horizon, modernity, beyond capitalism (Macintyre 1999). Mein-Smith's book is riding a new wave, for it is also built within family biography and the Tasman World Marsden project which begins with, or corresponds to transnationalism (Mein-Smith 2005). This also raises the question, especially on the New Zealand side, of asymmetrical relations across the Tasman. Australians more routinely overlook New Zealand, though they also overlook their own peripheries north, south and west. Yet there are so many stories that can be told together, either because they are inseparable or else because the contrast and comparison is enlightening.

I began this survey here in company with Edward Bellamy, looking backward, looking forward. The point about utopia is that it persists, as an orienting device, even after the collapse of communism and social democracy and the absolute pervasion of postmodern irony and consumerist defeatism. We know we can do better, and we know we can do better across the Tasman.

Sociology is impossible without the idea of utopia, understood not as a state of affairs to be realised but as a persistent impulse to reform, towards the goal of the good life as the widely distributed prerequisite of the good polity. The added, antipodean dimension follows – that if to look backward is also to look forward, and vice-versa, then we also need again now to look sideways, at each other, and not only northward.

Acknowledgements

This is a revised version of the closing plenary given to the SAANZ Conference in Waikato, November 2006. I opened and closed the event with music, with a *Rockwiz* segment using two Australian classics from 1971, which the audience were asked unsuccessfully to identify – not a surprising outcome, as these were apparently one-sided. The first was 'Gonna See My Baby Tonight', the La De Das, b. Auckland and biracial. The second was Healing Force, 'Golden Miles', formed in Australia, but a similar composition, including the legendary Charlie Tumahai. The point is evident: some of the greatest achievements of Oz rock are in fact Trans-Tasman, in the fullest sense. I concluded by asking the audience to raise their invisible glasses to the spirit of Charlie Tumahai, and to the prospect of our collaboration in Auckland for the 2007 event.

References

Beilharz, P. 1992. *Labour's Utopias – Bolshevism, Fabianism, Social Democracy*. London: Routledge.

Beilharz, P. 1997. *Imagining the Antipodes – Culture, Theory and the Visual in the Work of Bernard Smith*. Melbourne: Cambridge University Press.

Beilharz, P. 2004. Looking Back: Marx and Bellamy. *The European Legacy* 9(5).

Beilharz, P. 2006. Two New Britannias – Modernism and Modernity Across the Antipodes. *Journal of Australian Cultural History* 25.

Beilharz, P. and Cox, L. 2007. Settler Capitalism Revisited. *Thesis Eleven* 88.

Belshaw, H. ed. 1947. *New Zealand*. Berkeley: University of California Press.

Bennett, J. 2004. *Rats and Revolutionaries – The Labour Movement in Australia and New Zealand 1890–1940*. Otago: University of Otago Press.

Bowman, S. ed. 1962. *Edward Bellamy Abroad: An American Prophet's Influence*. New York: Twayne.

Castles, F., R. Gerritsen and J. Vowles. 1996. *The Great Experiment*. Sydney: Allen & Unwin.

Clark, V.S. 1906. *The Labor Movement in Australasia*. New York: Burt Franklin.

Dix, J. 2005. *Stranded in Paradise. New Zealand Rock and Roll 1955 to the Modern Era*. Ringwood: Penguin.

Fairburn, A.R.P. 1962. Literature and the Arts. In *New Zealand*, edited by H. Belshaw. Berkley: University of California Press.

Fairburn, M. 1989. *The Ideal Society and Its Enemies*. Auckland: Auckland University Press.

Fry, E. ed. 1986. *Common Cause – Essays on Australia and New Zealand*. Sydney: Allen & Unwin.

Grattan, H. ed. 1947. *Australia*. Berkeley: University of California Press.

Kumar, K. 1987. *Utopia and Anti-Utopia in Modern Times*. Oxford: Blackwell.

Macintyre, S. 1999. *A Concise History of Australia*. Melbourne: Cambridge University Press.

McCormick, E.H. 1940. *Letters and Art in New Zealand*. Wellington: Department of Internal Affairs.

Mein-Smith, P. 2005. *A Concise History of New Zealand*. Melbourne: Cambridge University Press.

Pearson, P. 2005. Reconnecting the Antipodes. *Thesis Eleven* 82.

Phillips, J. 2000. Of Verandahs and Fish and Chips … In *The Shaping of History*, edited by J. Binney. Wellington: Bridget Williams.

Pocock, J.G.A. 2005. *The Discovery of Islands – Essays in British History*. Cambridge: Cambridge University Press.

Roth, H. 1962. Bellamy Societies of New Zealand in Bowman. In *Edward Bellamy Abroad*, edited by S. Bowman. New York: Twayne.

Sargisson, L. and L. Tower Sargent. 2004. *Living in Utopia – New Zealand's Intentional Communities*. Aldershot: Ashgate.

Sinclair, K. ed. 1988. *Tasman Relations – New Zealand and Australia, 1788–1988*. Auckland: Auckland University Press.

Smith, B. 1945. *Place, Taste and Tradition*. Sydney: Ure Smith.

Thesis Eleven 92. 2008. Special issue on New Zealand Modernity.

Chapter 7

Australian Settlements
(2008)

What is Australia? And, what is the story of its settlements? Across the path of the twentieth century Australia has too often been imagined as a container, a box, as though its modernity was internally constituted, nation-built on the inside by great leaders from Deakin through Curtin, Menzies and Whitlam. The image of the island continent, then nation state ruled. Of course an earlier historiography insisted on Australia's as an imperial history, and others emphasised a different sense of regionalism, where it was the significance of six colonies and colonial cities that made Australia what it was. But the twentieth century was the century of nationalism, and of nation-building, both in practical terms and ideal.

Since the nineteen eighties the image of the Australian settlement has ruled. Its principal author was Paul Kelly, famously, in *The End of Certainty*, a Keating-like tract setting images of the old, redundant, closed society against the necessity and desirability of the new, globalised Australia. It is now widely acknowledged that Kelly's model was begot of Hancock's 1930 *Australia* (Kelly 1992; Hancock 1930). The latter is by various measures a far superior work. Kelly's book, in contrast, posits or rather names the model. The extent of his influence via *The Australian* newspaper, for which he is a lead writer, conferred a degree of influence on the idea that remained academic for Hancock. Academics and others have now naturalised the idea of the Australian settlement.

But does the idea work? Like others, I have been critical of the content and the politically driven nature of Kelly's recipe, or manifesto. In *Transforming Labor* I opposed its one-sidedness (Beilharz 1994). The Australian settlement only tells us the bad news, which is what serves to limit its scholarly significance. It seems to me, in retrospect, that the idea of the Australian settlement itself needs to be reviewed in terms of its moment and reception.

This was the moment of Australian new labour, before Blair, of corporatism, and the ALP-ACTU Accord. It is this context which already unsettles the idea of settlement, for it makes it necessary to ask who the agents of settlement were, who was seeking to settle whom, or with or for whom? In the 1901 period the actors were social liberals, like Deakin and Higgins, third or middle class parties to the two greater powers of labour and capital. In the Accord period, they were Labor actors like Hawke, and differently Ralph Willis and Laurie Carmichael. There is a long tradition here of the attempt to civilise capitalism, or of the pursuit of social harmony and national development by collaborative means. This taps into the preference of Anglo political philosophy for the idea of the social contract, and the continental postwar political enthusiasm for the notion of social partnership. By the seventies, as I recollect, the British Left's enthusiasm was for a new, radical social contract known as the Alternative Economic Strategic – to simplify, a Swedish model of labour-led collaborative development, with labour and its social democratic intellectuals rather than new liberals driving (Beilharz 1994). In the same moment the Italian Communist Party developed its own tradition of popular frontism from Togliatti to Berlinguer by proposing the Historic Compromise, a kind of non-war version of a war cabinet or government, where traditional enemies might also be included in some social or political settlement. At the same time, again, reformist views in social policy from Gosta Esping-Andersen to Francis Castles developed arguments as to whether there were three, or four global models of welfare capitalism (Castles 1975, 1988; Esping-Andersen 1990). Castles pioneered the explicit case, in his 1975 *The Working Class and Welfare*, that there was an antipodean model of settlement which was quite distinct, radical because of the logic of Higgins' Harvester Act and the tradition of the social laboratory, exceptional, but also, significantly, trans-Tasman, antipodean in the imperial sense, invoking the shared distinctiveness of New Zealand and Australia together. In this way of thinking, there were four models of historical settlement, or welfare policy regimes, minimalist, liberal, Scandinavian and antipodean.

Significantly, these different arguments from labour movement radicals, communists, social democrats and welfare policy analysts occurred in the opening moment of postwar crisis. Each reflected, in different ways, the strength and subsequent erosion into the seventies and eighties of Fordism, the postwar boom, managerial social democracy and the Keynesian welfare state. The postwar settlement indeed after the fact looked like a settlement, a class compromise sharing the Fordist boom of the standardised production

and the explosion of consumer life, suburbia, full employment and civil privatism after the horrible loss and austerity of the Second World War. The so-called Golden Age of capitalism was also the golden age of social democracy and the mainstreaming of the labour movement as a social actor (Sassoon 1996; Eley 2002; Beilharz 2008). The extremity of change from the forties to the sixties could only be equalled by that which was to follow. In policy, as in life in general, don't know what you've got till it's gone. But whatever the case, the idea of historic settlement was one whose time had come and gone.

In this paper I want to pluralise the idea of the Australian settlement, rather than criticise its manifest content, as the alleged carrier of the five policy components of White Australia; Industry Protection; Wage Arbitration; State Paternalism; and Imperial Benevolence (Kelly 1992). More recently, and with playful as well as serious intent, I have suggested that there might be three useful variations on the idea of the Australian settlement (Beilharz and Hogan 2006). The first, the most obvious, is the practical and symbolic act of foundation and invasion itself, 1788. Everybody knows that the original settlement is based on dispossession; perhaps we do not need to be lectured on this, except by the dispossessed themselves. The issue here, at least for those to the left of the Liberals, is not that we do not know about the problem of indigenous peoples, but that we do not know what to do about it. The second settlement is captured in Kelly's moment, Federation, 1901. A third potential settlement, too late, is mooted in the idea of the ALP-ACTU Accord in 1983. This can be viewed as an extension of the 1901 settlement, as an attempt to underwrite 1901 or 1915, BHP (and not only Gallipoli) with a muscular industry policy, the apogee of which is indicated in the 1987 ACTU-TDC Swedish model mission, and its result in *Australia Reconstructed* (Beilharz 1994, Ch.6; ACTU-TDC 1987). The pathos of this last attempted settlement is most apparent in its timing, arriving as it did just as the horse (or dynamo) of globalisation had bolted. With reference to the 1788 settlement, a further, fourth mooted settlement could be symbolically represented by Mabo, and Keating's Redfern Speech, by the stalled moment of reconciliation now again slowly opened up by the Rudd government.

What I am suggesting, then, is that the idea of Australian settlement might usefully be expanded not internally, but pluralised externally. Debate concerning the idea of an Australian settlement has hitherto been characterised by its acceptance of the idea, accompanied by dispute over its specific contents. The power of this situation is indicated, for example, in the recent contribution of Geoff Stokes and the symposium on his views

and Kelly's in the *Australian Journal of Political Science* in 2004 (Stokes 2004; and see Melleuish 1998). Stokes begins by problematising the idea of settlement. It is, as he indicates, a foundational idea. It refers, I would add, to the distinction that Max Lerner (following Michels) makes for the American case, where a myth of foundation coexists with a myth of mission (Beilharz 2001; Lerner 1957). I have argued elsewhere that the Australian case does not fit this American model: we have neither a clear and agreed myth of foundation, where there are various candidates from 1788 to Federation and Gallipoli, nor any agreed myth of mission (Beilharz 2001a). Ours is an accidental or existential nation; we do not know where we are going, and typically we do not care (and this is not altogether a bad thing, as it saves us from the redemptive fantasies of missionary leaders like the second President Bush). More generally, the point might be made that the idea of the Australian Settlement is not an especially good one, but it is now conventional. To connect Kelly's mission to Lerner's distinction, the purpose of *The End of Certainty* was both to establish a myth of foundation, from Federation to Harvester, 1901–1907, and then to juxtapose this distant beginning to a new globalising mission now burst upon us. Kelly was calling out a myth of foundation as a foil for its transcendence.

Stokes sets out to improve Kelly's model by supplementing it. This is a common intellectual and political strategy, that of identifying what has been missed out and putting in a claim for rectification by means of amplification. The first crying absence, for Stokes, is the now controversial issue of Terra Nullius. Stokes claims that this is a foundation myth of Australia; I would rather call it a conceptual precondition of settlement (Stokes 2004, 9). This move on Stokes' part does, however, usefully connect to that sense of Australian Settlement which, in our beginnings, is at once most innocent, or naïve, and most guilty, or responsible. His second big objection is to the absence from Kelly's picture of masculinism. Third, Stokes claims that Australian democracy is underestimated by Kelly. Fourth, the tradition of State developmentalism is truncated by Kelly, shorn of its humanist impulse, rendered too narrowly as heavy handed and paternalistic. The final list indicated by Stokes expands Kelly's five factors to nine: White Australia; Terra Nullius; State Secularism; Masculinism; Australian Democracy; State Developmentalism; Arbitration; Welfare Minimalism; and Imperial Nationalism (Stokes 2004, 20). This is an additive, although it is also a creative response. As Stokes indicates, this idea of settlement needs also to be connected to the idea of the settler society or, I would add, the more radical and comparative concept of settler capitalism (Beilharz

and Cox 2007). This image of settlement also begs the question of 'closer settlement', regional development, decentralisation, soldier settlement, and the tropics, where a whole span of literature from Griffith Taylor's 1950 *Australia* to Warwick Anderson's 2002 *The Cultivation of Whiteness* connects culture to geography, demography, population strategy, science, race, climate and medicine (Taylor 1949; Anderson 2002). But Stokes' concern remains conceptual exclusion. For him, Kelly's five-part scheme is too tight. To go up to nine factors is more historically accurate, he claims.

This may be so, but it also seems to indicate a discursive shift from the criteria of journalism to scholarship or, if you like, from sociology or ideal-types to history, and historiography. And this is exactly to anticipate the nature of Kelly's response to Stokes. If not five, or nine, why not twenty? Kelly understands his own purpose with the idea of Australian Settlement as condensation. Stokes, in Kelly's view, overloads the Settlement framework by expanding it (Kelly 2004, 23–5). As I have suggested here, Stokes' approach is certainly immanent in its logic. It presumes the Australian Settlement to be a good idea, but not quite right, limited because insufficient in detail. Others in the Stokes symposium take distinct additive approaches. For Judith Brett, the missing sixth leg from Kelly's model is the policy settlement between the city and the country (Brett 2004, 27–9). Agriculture (and later extraction) are central to economic and traditionally to ideal or imaginary life in Australia, until the new globalisation of the eighties. This is an important corrective to Stokes' list viewed internally, as is Stuart Macintyre's sense of the political contingencies of the Settlement (Macintyre 2004, 31–3). Viewed from the outside, another approach would be to argue that there is really only one central concept (and institution) to the settlement, which contains or suggests the others, or at the very least is really distinct to other national comparative experience.

This single, central idea is Arbitration. Arbitration and Conciliation are the central symbols not only of Australia, but also of Australian foundation and modernity. To suggest this is to draw trans-Tasman experience closer together than it presently is imagined, for after the Second World War (and especially after the British turn to the European Community) Australian and New Zealand historiographies also become too nationalist, too much obsessed with their own distinction and strength or status as victims of global change. The earlier story is one of parallel and mutually constitutive paths across the Tasman. From 1894 and before with Kingston in Adelaide, to Wellington and Pember Reeves to Higgins in 1904 with the foundation of Conciliation and Arbitration in Australia and 1907 with the Harvester

Judgement, Arbitration is constituted by the cultural traffic that makes the Antipodes both integral and, in this particular sense, exceptional. Macintyre anticipated these kinds of claims in his 1987 paper on Arbitration across the Tasman (Macintyre 1987). They have been given further solidity and nuance by Philippa Mein-Smith and Shaun Goldfinch in their recent comparative and integral trans-Tasman analysis (Goldfinch and Mein-Smith 2006; Beilharz and Cox 2006; Rodgers 1998; Coleman 1987).

How could a single concept condense or suggest so much? Consider Stokes' list. To begin, white Australia is an historic fact, paralleled by less legally explicit regimes such as the White New Zealand policy (Mein-Smith 2005). Shocking as it is to us, as children of the postwar belief in universal human rights, White Australia stands for a kind of Anglo (and Colonial) racism built within the frame of the British Commonwealth before decolonialisation. It reflects the coincidence of period beliefs that nation building strategies were also racialised population development strategies. This is where Imperial Nationalism fits. For labour racism was also necessarily imperial – there is no making sense of imperialism without reference to colonialism (Hyslop 1999; Bonnett 2003; Thompson 2005; Kirk 2003). This should not surprise, let alone outrage us: citizenship the world around and across history is a model of inclusion or social elevation which depends on the exclusion of others. Terra Nullius is again an extreme case, but it is an extreme case of a widespread western belief which runs from Locke through to the socialist tradition, for which the land belongs by right to those who work it. Masculinism, again, is an historic fact, from the Harvester Judgement's familial thinking confirmed in the 1912 Mildura Fruitpickers' Case through to the White Paper on Full Employment. The images of the secular, developmental and democratic all coincide with the new liberal logic of advocates like Higgins, which also indicates masculinism and has as its consequence reliance on regulated markets, a welfare state where national development was hitherto understood as regional development, and so on.

My sense here is that the idea of the Australian Settlement is limited by the role it plays as a proxy theme. Given that we no longer speak of national character, it now represents an attempt to characterise Australian modernity through the first eighty years of the twentieth century as a kind of exceptionalism. With Stokes, the template shifts in the direction of historical specificity, though not far enough to satisfy the historians. After five features comes nine, twenty, a hundred. This argument overlooks the extent to which exceptionalism, if it is an admissible idea at all, is here

antipodean, trans-Tasman. Its reliance upon the cumulative approach to listing risks undermining the status of the single most exceptional significant idea, that of the Arbitration itself. Masculinism, the logic of Terra Nullius and racism are not exceptional, but either universal to this moment of world history and new world history or shared by settler capitalist experiences across Australia, New Zealand, South Africa and Canada, and echoed in the parallel Latin American experience of the twentieth century project of national development.

What then makes, or what made Australia and the Antipodes different? As Allan Martin argued, in a brilliant paper on 'Australia and the Hartz Thesis' delivered in New York in 1969 the 'founding' of Australia continued for three quarters of a century, and across six separate foundations, only two of which were in convict colonies – seven, or more, if we expand the picture to include Auckland, Christchurch, Wellington. A further 'foundation' occurred after gold, in the 1850s (Martin 1973). Yet as Martin reminds, all this foundationalism was nevertheless conducted within a British frame of reference. If we and our New Zealand mates were isolated, we were not insulated (Martin 1973, 124). Thus the Webbs gave more than two cheers for the prospects of Australian democracy, Beatrice cheering louder for New Zealand, and others like Charles Henry Pearson already in 1893 anticipated the idea of a practical state socialism (Martin 1973, 141), the latter only later to be more exhaustively essayed by Pember Reeves in *State Experiments in Australia and New Zealand* and Albert Métin in *Socialisme sous doctrines* (Reeves 1902; Métin 1977). As Martin argues, it was middle class rather than labour actors who were pivotal in this process. Collectivism is not, on his account, immanent to the foundation, but secondary, an enabling device for their own individualism. Australia, therefore (and by extension New Zealand) was more than one fragment, contra Hartz. As Allan Martin puts it, his Australia is not the 'Hartz Australia', and it is not the Beilharz Australia either (Martin 1973, 146; Beilharz 2001a). As Martin argues, more conclusively, the hope or demand is to provide forms of comparison which juxtapose patterns rather than single proposed factors in historical or sociological explanation (Martin 1973, 147).

Allan and Jean Martin understood that comparison, and difference matter. This is why, in their capacity as foundational Professors of History and Sociology respectively at La Trobe University in the mid-sixties they originally eschewed the standard and widespread prejudice that the first, foundational year of the BA should be taught as the local, i.e. Australian national history. Instead, the earliest students at Bundoora began with

Mexico. Forty years after, we are hoping now to start our students within stories about place, time and division that are doubly regional, this both with reference to colonial distinction and with reference to Asia and the Pacific (Beilharz and Hogan 2006). The idea of exceptionalism, after all, begs the question of comparison, and comparativism. More, released from its formulaic definition in the manner of Kelly's claim, the idea of settlement might be pluralised, viewed as potential as well as actual, mooted or projected rather than necessarily consensual, bipartisan or formally institutionalised.

Above I suggested that there might be three or four mooted settlements – 1788, 1901, the Accord in the eighties and Reconciliation. If we were to think of settlement in this way, as contingent and mooted projects of compromise subsequent to 1788, then likely the forties and fifties would emerge as another possible candidate. For the postwar period coincides with the distinct emergence of an Australian modernity only anticipated, and planned for, by Deakin and Higgins. The forties opened with new liberal dreams of reconstruction foreshadowed by Higgins in *A New Province for Law and Order* and by Meredith Atkinson in *The New Social Order* (Higgins 1922; Atkinson 1919). As H.C. Coombs put it in the forties, four central issues were involved. These were full employment; rising standards of living; the need for personal and social development, understood as national development; and the need for national security (Coombs 1944). Full employment would privilege labour, which would eventually pick up the American Fordist model, to consume the products of its own efforts. This would anticipate the emergence of domestic Fordism out of the existing production regime, which was something more like a regime of agricultural Fordism, as in the case of Sunshine Harvester and then International Harvester itself. The mooted new Settlement anticipated by Reconstruction passed, itself sublimated by Menzies and the emergent consumerism and cultural Americanism of consumption into the sixties. The automobile became less the symbol of freedom on the road than of the means to pursue the freedom to shop (Beilharz 2006). As Paul Smyth observes in his contribution to the Stokes symposium, the moment of affluence and the welfare state which follows is something new – it is not apparent in the regime of frugal comfort shepherded by Higgins (Smyth 2004, 40). Yet this new world became the frame for all that we have known subsequently. If Australian modernity was anticipated in 1901 or in Harvester, it was only filled out in the postwar moment, when Australian modernity took the shape that made us, children of the nineteen fifties, and became the frame for all that was to follow. This was where the Lucky Country came from; its

precise configuration or even its existence could not have been obvious in the interwar period.

The results of this settlement, finally, may have looked exceptional to provincials, but were in fact characteristic of the western postwar world. Australian modernity was becoming less exceptional. The image of the Antipodes drifted even further away from the centres, towards more distant horizons, just as globalisation famously compresses time and space. We were no longer insular or isolated, if we ever were. The status of nations was confirmed by the international or world system. The settlement became hesitantly global, breached by the traditionalistic claims of our leaders and our own desires to return to the past. The image of Australia as a nation, and of the National Settlement became clearer as its conditions of existence became weaker. The idea of settlement was announced at the same time as its historic demise. Perhaps, then, it is time again to move on.

References

ACTU-TDC. 1987. *Australia Reconstructed*. Canberra: Australian Government Publishing Service.

Anderson, W. 2002. *The Cultivation of Whiteness: Science, Health and Racial Destiny in Australia*. Melbourne: Melbourne University Press.

Atkinson, M. 1919. *The New Social Order. A Study of Social Reconstruction*. Sydney: WEA.

Beilharz, P. 1994. *Transforming Labor – Labour Tradition and the Labor Decade in Australia*. Melbourne: Cambridge University Press.

Beilharz, P. 2001. Tocqueville in the Antipodes? Middling Through in Australia, Then and Now. *Thesis Eleven* 65.

Beilharz, P. 2001a. Australian Civilization and its Discontents. *Thesis Eleven* 64.

Beilharz, P. 2008. *Socialism and Modernity*. Minneapolis: University of Minnesota.

Beilharz, P. and T. Hogan, eds. 2006. *Sociology – Place, Time and Division*. Melbourne: Oxford University Press.

Beilharz, P. and L. Cox. 2006. Nations and Nationalism in Australia and New Zealand. In *Sage Handbook of Nations and Nationalism*, edited by Delanty, G. and Kumar, K. London: Sage.

Beilharz, P. and L. Cox. 2007. Settler Capitalism Revisited. *Thesis Eleven* 88.

Bonnett, A. 2003. From White to Western: 'Racial Decline' and the Idea of the West in Britain, 1890–1930. *Journal of Historical Sociology* 16(3).

Brett, J. 2004. Response to Stokes. *Australian Journal of Political Science* 39(1).

Castles, F. 1975. *The Working Class and Welfare*. Sydney: Allen & Unwin.

Castles, F. 1988. *Australian Public Policy and Economic Vulnerability*. Sydney: Allen & Unwin.

Coleman, P.J. 1987. *Progressivism and the World of Reform: New Zealand and the Origins of the American Welfare State*. Kansas: Kansas University Press.

Coombs, H.C. 1944. The Economic Aftermath of the War. In *Postwar Reconstruction in Australia*, edited by D.A.S Campbell. Sydney: Australian Publishing.

Eley, G. 2002. *Forging Democracy – The History of the Left in Europe 1850–2000*. Oxford: Oxford University Press.

Esping-Andersen, G. 1990. *The Three Worlds of Welfare Capitalism*. Oxford: Polity.

Goldfinch, S. and P. Mein-Smith. 2006. Compulsory Arbitration and the Australasian Model of State Development: Policy Transfer, Learning and Innovation. *Journal of Policy History* 18(4).

Hancock, K. 1930. *Australia*. London: Benn.

Higgins, H.B. 1922. *A New Province for law and Order*. Sydney: WEA.

Hyslop, J. 1999. The Imperial Working Class Makes Itself "White": White Labourism in Britain, Australia and South Africa Before the First World War. *Journal of Historical Sociology* 12(4).

Kelly, P. 1992. *The End of Certainty*. Sydney: Allen & Unwin.

Kelly, P. 2004. Response to Critics, *AJPS* 39(1).

Kirk, N. 2003. *Comrades and Cousins: Globalization, Workers and Labour Movements in Britain, the USA and Australia*. London: Merlin.

Lerner, M. 1987. *America as a Civilization*. New York: Holt.

Macintyre, S. 1987. Holt and the Establishment of Arbitration – An Australian Perspective. *New Zealand Journal of Industrial Relations* 12.

Macintyre, S. 2004. Response to Stokes. *AJPS*.

Martin, A. 1973. Australia and the Hartz "Fragment" Thesis. *Australian Economic History Review* 13.

Mein-Smith, P. 2005. *Cambridge Concise History of New Zealand*. Melbourne: Cambridge University Press.

Melleuish, G. 1998. *The Packaging of Australia*. Sydney: UNSW Press.

Métin, A. 1977. *Socialism Without Doctrines*. Sydney: APCOL.

Reeves, W.P. 1902. *State Experiments in Australia and New Zealand*. London: Grant Richards.

Rodgers, J.T. 1998. *Atlantic Crossings – Social Politics in a Progressive Age*. Cambridge: Harvard University Press.

Sassoon, D. 1996. *One Hundred years of Socialism*. London, Tauris.

Smyth, P. 2004. Response to Stokes. *AJPS*.

Stokes, G. 2004. The 'Australian Settlement' and Australian Political Thought. *Australian Journal of Political Science* Special Issue 39(1).

Taylor, G. 1949. *Australia: A Study of Warm Environments and their effect on British Settlement*. London: Methuen.

Thompson, A. 2005. *The Empire Strikes Back?* London: Longman.

Chapter 8

Elegies of Australian Communism
(1989)

Is Australian communism dead? The Fairfax and Syme supplement, the *Good Weekend*, a glossy narcissistic weekly magazine of advertising, exotica and high life, is not exactly the place one would expect to see the question discussed. Press treatment of communism in Australia is almost inevitably condescending, if not sneering, alluding accurately to thinning ranks and inaccurately (and unkindly) to geriatric decline. The *Good Weekend*'s analysis did indeed focus upon the numerical decline of Australian communism: 'numbers have slid from 20,000 to 1,800 and most Australians think of the Communist Party (if they think of it at all) as anachronistic and irrelevant' (24 July 1987). No doubt this much is true, especially for those *Age* readers whose stronger impulses would lead them on rather to the forensics of nouveaux rock persons, hot air ballooning and fine cuisine. But how then to explain the apparent anomaly? Why should the communist dinosaur warrant such interest and publicity?

Communism in Australia is indeed in decline, and this would seem to be one reason for the increasing 'safeness' of interest in it. More emphatically, postmodern culture makes anything legitimate – relativism rules, everything is now permissible, at least in cultural terms. One can be a yuppie, a punk, possibly a little bohemian and, yes, one can even be a communist. Everything can be tolerated in the 1980s, because nothing any longer matters. Radical politics become reclassified as a hobby, no better nor worse than entymology or etymology, equally as idiosyncratic as riding on scaled-down trains in the backyard. Readers of the *Good Weekend* can now read further about these fascinating creatures, through the veritable explosion of interest in communist life-and-times, biographies, memoirs, autobiographies and histories.

Australian communists have indeed lived fascinating lives, as the books reviewed here make plain. Yet these writings are also, simultaneously, elegies

of communism, for communists have never sought to be part of a fashion show. Their project was to transform social relations, or to reconstruct social organisation through state planning, to change the conditions of life for everyone, not to be one bazaar item along with all the rest. It is only quite recently that communists have argued for a coalition of the left, and have anticipated their own possible demise as an independent political force. And it is only in this moment that the Australian left has begun to produce a personal literature of any moment.

The foremost symbol and achievement of this literature is Roger Milliss's *Serpent's Tooth* (1984), an autobiographical novel of astonishing power and insight into being an Australian communist. Son of Bruce Milliss, a successful window dresser, Katoomba red and worshipper in the vaticans of Moscow and then Peking, Roger Milliss became a good communist whose central failing was to take too seriously the beliefs of his father, and consequently to reject his father as the communist monolith crumpled and the epicentre of revolution shifted eastward. Roger refused this shift: he was younger, and saw with all the pain of vision that communism's national embodiments each continued to go awfully wrong. Roger failed as a son because he was too loyal, not to his corporeal father so much as to his communist beliefs. For old Milliss had educated the boy well – dialecturing him, in Roger's barbed neologism, using the principles of Dialectical Materialism – quantity into quality, negations negated – to explain the scrambling of eggs for Sunday breakfast, milk and eggs and butter into something new, enculturing the boy into a communist cosmos.

Bruce Milliss was something of a success story; but he chose to become a communist, and suffered deeply for it. Roger's story is also one of torment, as 'the legend and the praxis of his [Bruce's] politics become my own'. The boy heads out letterboxing with electoral missals, grows up in school taunted with *'Get back to Russia, Commo bastard, Milliss, take your old man with you!'* Bruce and Edith work hard in local politics, for Oslo lunch canteens, against tuberculosis, for a local nursery, for Soviet and then Chinese exporters, to stem the tide of Yankee film and to sell tea and trinkets. In 1952 Roger joins the Communist Party and heads, not for China but to Eastern Europe, to see the impending results of the lifting of the dead dictator's hand. But the shadow of the Gulag, cast on the lives of so many ordinary, Soviet citizens, continues to intrude into Roger's own everyday intercourse with these innocent victims of history. The son returns to the foetal shore; father and son argue, bitterly, about the import of it all. Roger beats Bruce Milliss with the accumulating horrors of the

fifties; the old man retreats, *'Look! I'm tired! Why can't you understand? I just don't want to think about these things!'*

Roger Milliss speaks, with striking literary device, of Trotsky, his execution, his own 'shuttered brain'. His father cannot bear to think of these things; Roger is driven into self-analysis, into psychoanalytical frame, grappling with autobiography as the symbiotic integration of vision and blindness. For it is vision and blindness which overdetermine this experience of communism, which seeks to control an alien and hostile world by reading out the painful parts of Stalinism. The expanding optic, in Roger's hands, serves only to cast the experience of communism in constantly starker and more tragic terms. Romantic literary motifs dissolve, not into socialist 'realism' but into interpreted realities, pathos becomes pervasive, also irony, but not cynicism. Roger Milliss continues to meet the Gulag, for example, wherever he goes in Eastern Europe. A Soviet friend's response echoes his father's, when he asks him to speak about the Gulag: *'I just don't want to think about it any more'* ... *'It was all too horrible, I just want to put it out of mind!'* But this is a different desire of forgetting, a desire born of subjection to tyranny rather than partisanship, born of lust for ordinary life and not the fantasies of communist real politik. In this regard Milliss's literary craft takes him closer to the world of Milan Kundera, than to the haughty historiography of great communist writers such as Isaac Deutscher; he writes of the ordinary tragedies of ordinary people rather than of the Shakespearean travails of its incandescent leaders (see Kundera 1984; Beilharz 1987). He reaches into a hitherto unexplored register, in order to begin to address the traumas of being an Australian communist.

And the traumas become deeply personal. Milliss and his father flail each other, in love and with bitterness, over the irreducible point of issue which forever separates them – the question of Stalinism and the status of the Soviet Union. Roger returns from his travels to take up work with the *Tribune*, in league with the enemies of his father, the Aarons group, further betraying him through fulfilling his legacy. The scrambled eggs coalesce dialectically on the flame of Milliss's youth as he closes his ruthless self-examination, issuing into a world with no clear battle lines and a past which haunts rather than guides us.

Milliss's Moscow world was shared by alien others, some voluntary exiles, others not. Bernice Morris belonged to the latter category. Morris was a country girl who came to Melbourne to nurse. She joined the CPA in 1942, little realising how much she and her family would suffer for entering communist ranks. Bernice Morris seems less scarred by this than would be

expected – she lives, still, in hope. So while her book is closest to Milliss's, in this field, in its story-form and in its remarkable, simple yet labyrinthine style, it lives somehow without guilt or at least without remorse. Morris writes plainly, but powerfully, of everyday life across the globe, of her hopes, love, ambitions, and their effective shattering – all but love – by the Petrov witch hunt. She punctuates her narrative with excerpts from her letters to Dave Morris, the communist engineer who unwittingly attracted the gaze of the local secret police: 'The future is for you and me and the fun we'll have building our life together and making history for ourselves ...' (Morris 1988, iv). But that was 1944. Then came what another victim, Ric Throssell, called 'real Kafka country'. Now Bernice lived in a different world. Her young son awoke crying at night, 'Mum, will I be able to get a job when I grow up?' (Morris 1988, 217). Only later would this become possible, after exile in the Soviet Union and China.

Oriel Gray's *Exit Left* (1985) is less tortured than this, though it is equally concerned with ordinary life and sadness. Oriel's father looms large in her life as well, and is badly done by as she takes up the fast life with the New Theatre, where the aptly misnamed 'Fiends of the Soviet Union' determine the spirit of the epoch. The Soviet motif is indeed dominant in this milieu though it is not always clear why this should be so. Gray tells of an Australian novelist who, having visited Russia, returns needing to proselytise for the Future Which Works in all kinds of wonderful ways. At a Waterside Workers' Federation meeting, she was quite carried away. '"And comrades, in the Soviet Union, sexual intercourse is wonderful!" "It's not too bloody bad here, either, lady," said a big wharfie politely from the front row.' Plainly Oriel Gray's register here is the comic rather than the tragic; yet again, the style is reminiscent of Kundera, with his proposal of the radical nature of laughter, itself sufficient to rupture the pompous visage of authority and dogma. For Gray, the point is also one about the nobility of these frail humans; comedy need not be patronising, for these people were not ridiculous.

> They argued and laughed and squabbled and made love. They were inventive, or simple, or hopeful. They were vain, brave, or timid ... They cared. Whatever their mistakes, whatever their naivety, it was better than complacency. They wanted communism, or socialism, for Australia because they believed in it, and they wanted the best for Australia.

They were committed; they belonged to a tradition which provided a project or purpose beyond themselves, as individuals, in a manner which

most readers of the *Good Weekend* would find positively incomprehensible, so fundamental was its altruism.

Oriel Gray's impulse is moral in character – she senses that her fate is to become a bad comrade because she senses the universality of suffering. Towards the close of her final act, Oriel gazes across Sydney harbour, pondering the central contradiction of *The Brothers Karamazov*. Faith becomes a problem for Gray to the extent that it justifies suffering, in religious and political form alike. Cecil Holmes, like Gray, inhabited the world of left culture; the red thread running through his work is not Dostoyevsky but Orwell. *One Man's Way* (Holmes 1986) opens with the Stalin-Ribbentop pact. Holmes is already committed, yet stubbornly independent – 'I suppose it was at this point I erected a tiny compartment in my mind that would permit me private thoughts and reservations but in other respects continuing loyalty to principles.' This small gap in the skull remains a problem for Holmes, who like Koestler's Rubashov fears that its location near the nape may be the very point where the bullet enters. Holmes remembers a conversation with Rupert Lockwood about what might happen to those given to dissent after the revolution. 'He said briefly: "We'd be taken out and shot – or sent to a Gulag in the Centre".'

While Bruce Milliss sold movies and Oriel Gray wrote plays for the revolution which might have come to devour them, Holmes made films at a slightly safer distance – he kept moving, protecting that gap in the skull by taking it with him. The romance of film itself in Holmes's memoirs is heightened by its location; in New York, London, through Eastern Europe, Baghdad, from Broome to Port Hedland and Rabaul to Timor, Indiana Holmes tells an amazing story. Holmes was eventually to leave the Party in order to keep moving, when the Party sought to claim even that little space reserved for private use.

Bill Morrow and Bob Ross, by comparison, never joined the Communist Party. Bill Morrow's life took him from Queensland to Tasmania and back, over a period of struggle close enough to a century in duration. Audrey Johnson's book (1986) tells his story for him, though Bill speaks frequently in it; clearly it is a work of different purpose to the memoirs of Gray or Holmes, let alone the autocritique of Milliss. An early sympathiser of the Wobblies, Morrow, like Holmes and Bruce Milliss, was deeply influenced by Edgar Snow's *Red Star Over China*. Years of organising in the union movement and of labour advocacy in parliament, as well as work in the peace movement, was conducted by the light of this star. While Morrow experienced much in common with party members, he was, however,

external to the fallings-out in international communism which, like others of similar location, he seems to have viewed as unnecessary and avoidable while at the same time he sided with the 'authentic' Chinese.

Amid this earlier atmosphere of what has aptly been called 'depression communism' Edgar Ross throws a biographical line even further back, to his father, Bob Ross (Ross 1988). Bob Ross died in 1931, after an extraordinary life connecting with the genesis of Australian labour radicalism. His politics went back to Barcaldine; the ethos of his era was provided not by the Soviets but by the Wobblies. Yet his sense of strategy was modern enough, he supported the Soviet road for the Soviets, but, like Morrow, located the existing local labour institutions at the core of an Australian way to socialism.

For all the enthusiasm given subsequently to China, it was the Soviet experience which necessarily remained central for Australian communists. David Carter, discussing some of the new books in this field in a recent article in *Meanjin*, has wondered why no one writes memoirs from the position of the 'Stalinists' (Carter 1987). While China may have provided something of a convenient escape clause for local communists, the problem about Stalinism and the Party arguably remains more complicated than Carter allows. For, as Carter rightly acknowledges, Stalinism can be usefully interpreted as a generic category rather than as one limited to the description of the Soviet experience from the late 1920s into the earlier 1950s alone. It is not necessary to confine the use of a category like Stalinism to the analysis of an historically compartmentalised section of Soviet history – Stalinism can equally well be used to explain specifically localised trends within the international communist movement. In this sense the Chinese – and some of the Australians – were as recognisably Stalinist as was the Fearless Leader himself. Certainly local activists, some among them considered here and by Carter, used Stalinism as a category to explain local disorders, notably those combining sectarianism, dogmatism and anti-intellectualism. As Audrey Blake puts it, in her *Proletarian Life*, the camps and the executions are but the end result of these attitudes. Outside of the original phenomenon of high, murderous Stalinism there is another type, characterised by Ronald Tiersky as 'ordinary Stalinism' (Tiersky 1985). The hallmarks of the latter are an absence of any recognisable vision, an enthusiastic blindness towards non-Soviet realities and possibilities and a stubborn refusal of the postmodern explosion into difference which makes communism an indulgence which today is more private than public in nature.

Yet beyond Stalinism, beyond even the Communist Party, its disillusioned devotees often remain deeply devoted to the USSR. The Soviet experience

and its fascist counterpoint loom large on the biographical canvas, shared, for example, by Ralph and Dorothy Gibson. Ralph tells Dorothy's life story in *One Woman's Life* (1980). Dorothy's early enthusiasm for child education led into an enthusiasm for the Soviet experiment – they, after all, were doing what others merely spoke about. Dorothy taught in a school for the children of staff members of the Soviet Embassy and Trade Legation in Hampstead, and visited the Soviet Union in 1934. For Dorothy, this was a vision of the future – 'it all depends on what one sees – whether one sees the relics of the old or the embryo of the new ... one can only judge through Russian eyes'. Viewing the *new* Metro in days of high Stalinism, May 1935, Dorothy spoke of being 'reminded of ancient Athens where people lived in simple homely dwellings but had public buildings of extraordinary beauty and significance'. The period and the blindness are reminiscent of those of the most famous of expeditionaries, Beatrice and Sidney Webb. Dorothy's particular interest in children and in character-building seems to have been the source of an obvious weakness in the 1930s, when Soviet children were touted as the future builders of socialism (see Clark 1977). The partiality of her vision seems in this sense to be more understandably grounded than the almost wild enthusiasms of the Webbs, whose constitutionalism and administrative conception of socialism served at the very least to make them 'ordinary' technocrats.

For amid the inhumanity of much of the Soviet experience, the Gibsons shared a life suggestive of other values, less plainly proletarian than deeply human. Ralph's life of Dorothy Gibson closes with the poignant scene in which the ageing pair read Miles Franklin and Tolstoy aloud to each other. Perhaps it is images such as these which make our writers of such appeal to publishers and to readers? For these, again, are constant, dedicated humans whose lives are structured around goals and not dependent on instant gratification, who know and value tradition, even a tradition we might today choose to reject. These are strong people, with frailties which touch us in different ways. While the Gibsons read to each other in older age, Roger Milliss invokes the sepia tones of his early childhood, middle Australia, mid-century:

> There I am at three years old sprawled on my bottom in the concrete yard with spanner, pliers and oil can helping my brother fix our model motor car, or in floppy sunhat, drooping knickers and inevitable bow tie constructing castles in the sand at Bondi Beach, or striding proudly with my father hand in hand down Market Street, a perfect little manikin in smart tweed overcoat and Tyrol hat, or with a creamcake halfway to and plastered round my mouth on a family picnic ...

And while Milliss's past recollections border on imagination, Audrey Blake remembers with touching candour her first act of love, at fifteen:

> The night I, to use the phrase of the time, "lost my virginity", the gentle, loving young man of seventeen who shared in the deed and I were lying side by side. I was feeling a sense of solid achievement. My periods had been times of acute distress, with cramps causing severe pain, and I was terrified of sexual initiation. Now I felt triumphant, if a bit scared.

In old age, the experience of Australian communists in childhood and youth somehow becomes crystalline.

Sexuality is a major theme of Joyce Stevens' collection, *Taking the Revolution Home* (1987). Stevens combines a long analytical essay with a series of intriguing interviews with communist women such as Grace Scanlon, Joyce Batterham, Edna Ryan, Jess Grant and Gloria Garton. Sexuality emerges not only in its predictable cast within the masculinist culture of the labour movement (and of the Australian culture which it inhabits) but also within the forms of Soviet constructions of sexuality which, ironically, were not unlike what most of us would associate with the DLP: good heterosexual, monogamous and nation-building stuff. In order to explore these matters Stevens follows a literary strategy far removed from that of other writers discussed here, most especially Milliss. She chooses to stop at 1945, the very year in which she joined the CPA, so as to maintain some distance from her project. She also proposes that while the Depression has become a kind of golden age for left and labour historians, the problem remains that even this newer work is too often labour history with the women left out, or, at best, in the margins. The socialist vision, in this sense, has been posited since its inception on a central blindness to gender. Women have been as invisible here as elsewhere. Their hands worked cloth and metal, cooked and scrubbed and made tea for the boy comrades, their legs carried them afar, armed with leaflets and placards as well as with children and groceries; their minds were dedicated to their class and their sex, even though they did not often in those times call themselves feminists, while their hearts and their sexuality were sometimes plundered by the communist men who philandered lightly and moralised heavily, leaving them alone to birth, or forsaking them in the rooms of abortionists with envelopes of banknotes and little else to go by. These were certainly viewed as Party matters, to the extent that authorised abortions were arranged by the aptly titled Control Commission. When Jean Devanny raised questions about sexual double standards in the Party she was expelled. When Joyce Batterham was pregnant with a wanted child,

the 'appropriate' Party authority responded that she and her man ought to be expelled.

Within the more conventionally defined scope of public life, the CPA was ambivalent about equal pay for women, given its commitment to the family wage. The official CPA views on contraception and abortion were little better: as one edict put it, 'It must be kept in mind … that the class struggle cannot be solved through birth control or abortion (or the prohibition of alcoholic beverages) and in the face of this struggle between irreconcilable classes all such minor matters sink into insignificance.' This is not to say that all communist women had to suffer sexual Stalinism. The relationships of the Gibsons and others emerge, for example, from these studies, as what would relatively speaking be called relationships of equals. Sexually active women stepped across the line by declaring their position, as did Devanny. To draw a parallel within socialist history, the situation was analogous to that highlighted by Eduard Bernstein in the German socialist movement. As Ignaz Auer advised Bernstein, it was well and good to be a reformist in practical terms, but not to rock the boat by declaring it publically. So could female sexuality be practised, but not preached within the Australian labour movement. Certainly communist men speak little of sexuality, though this could be a generational trait.

Ralph Gibson's own more recent study, *The People Stand Up* (1983), is not only other-directed in its sense of social injustice in Australia; its arena is the world and its crises from the 1930s on. Gibson's book makes no claim to be autobiographical, yet in a certain sense it is, and profoundly so. For it illustrates in full relief the centrality of world affairs for this leading generation of communists. The people did not, of course, stand up in Australia in any meaningful sense; indeed the very imagery is somewhat more suggestive of the dominant forms of communist dramaturgy than it is of Australian social and political life across the twentieth century. The people stood up, and were mown down, elsewhere, and all this is seen by Gibson, and his introducer, Jack Blake, within the purview of the Russian October.

As Carter observes in his *Meanjin* essay, communist autobiography is bound to be more than usually historical, because of the very fetish-character which communists put upon History. Here, in Gibson's book, the upshot is that it is historical in other places, on other shores. The majority of Gibson's 25 chapters are about people standing up somewhere else. The Reichstag Fire, Egon Kisch (who jumped rather than stood), the building of the Dnieper Dam, La Pasionara, such are the symbols of a world in turmoil. Their significance would be largely lost on a *Good Weekend* audience, which

is more likely to associate the lines 'better to die on your feet than to live on your knees' with Midnight Oil than with the Spanish Civil War. Yet this is its very significance, for reading Gibson's book is like watching old documentary footage, the action overseas interspersed with local vignettes, like that of Noel Counihan speaking from inside a locked cage in the Sydney Road free speech battle, all of which is suggestive of a world we have somehow lost.

In his closing pages, Ralph Gibson writes that his book must finish, as it opened, in Australia. *The People Stand Up* sits on a Moscow-Melbourne axis, the implications of which are never spelled out, perhaps because they themselves are beyond scrutiny, beyond conscious vision. The crisis of Australian communism, in a sense, is that its action has always been played out somewhere else, and when it has been local it has often been seen in the light of other experiences. The perhaps predictable response, that good communists were internationalists and therefore obliged to follow other lights, is somehow less than persuasive. As Russell Jacoby has argued, the left have always been suckers for success, and while this is understandable it has also served to produce the comic spectacle in which the caravan of would-be commissars exemplified by the Fourth International has followed the revolution the world about (Jacoby 1981; see Beilharz 1987). This affinity between orthodox communist and Trotskyist views of history, to speak in their own vocabulary, is no accident, and neither is their shared trajectory into the 1980s.[1] It is this affinity which also helps to explain the reliance of communists such as Gibson on the historical interpretations of writers like Deutscher, who, significantly, described revolutionary history in the twentieth century as 'optimistic tragedy'. It is only for those outside the communist-Trotskyist position that there is little obvious to be optimistic about, except perhaps the practical resilience of ordinary people.

Audrey Blake's *Proletarian Life* (1984) is also fixed upon the Soviet experience. In 1937 the Blakes are in the Soviet Union, in the Lux Hotel, where people have the strange habit of disappearing. Inexplicably, hotel rooms are sealed; their occupants, it is discovered, have departed for the camps. They travel to Italy, Romania, England; then back to Australia. The big question is put to Audrey, 'What about the camps?' The question is asked in public, while Audrey addresses factory workers at lunch, and she cannot answer it. The question seems out of court, for hers was an effective universe.

[1] See, for example, *Joint Statement of the Socialist Party of Australia and the Socialist Workers Party*, Sydney 1984.

It was like the cultural universe of the earlier German Social Democrats, a place where people came together, sang, played sport, argued, engaged in hobbies, all in the light of 1917. Only some disappeared from vision, or at least from their hotel rooms. One evening in 1929, Audrey Blake tells, she attended a talk on the Russian Revolution 'which revealed to me much of the truth of my own existence', the rapacious nature of the capitalist economy and the alternative, provided by the Bolsheviks. Nearly sixty years on, the Soviet Union remains for Blake 'still the bastion', its great merit that it 'has been built without capitalists' (though certainly not without commissars). The Blakes emerge from Audrey's book and Jack's recent writings as the remnants of the loyal Leninist opposition in Australia. The image might seem to jar a little with Jack's earlier and pathbreaking work, *Revolution From Within* (1971), their revolution from within seems now to be located in Gorbachev's grasp, with Gorbachev's implicit slogan of a claimed return to Lenin.

Other communist authors remain completely and happily under Stalin's shadow. Bill Brown's *The Communist Movement and Australia* (1986) is no formal autobiography, yet given the difficulties in disentangling the self and history the distinction between the two forms, history and autobiography, seems less than useful in attempting to make sense of these elegies of communism. Brown's own case is plainly related to his veteran status in the communist movement. According to Brown, the Communist Party was good for forty-odd years from the 1920s to the 1960s. The decline of communism, for Brown, was indeed coincidental with its liberalisation, its opening up to the foreign influences and novelties of the 1960s and 1970s. The declining public image of the Soviet Union was certainly a major issue here, only unjustly so: the capitalist media and forces of reaction from left to right seized unfairly on Khruschev's Secret Speech to the Twentieth Congress of the CPSU in order to discredit the Soviet Union altogether. Given the vulnerability of local communists to such heresies, the cleft opened the way to new and alien ideas, ranging from Trotskyism to Eurocommunism. Brown lays the primary responsibility for this treachery at the clay feet of CPA leadership. The central leadership, particularly in Sydney, developed Maoist sympathies; the Aarons clique simultaneously allowed the entry of the Trojan horse of Trotskyism, occupied by Denis Freney, into its midst. These developments culminated in the decision of the Twenty-Second CPA Congress in 1970 that the Soviet Union was not in fact socialist but *socialist based*, so that the economic basis of socialism had been installed in 1917, but the cultural and political forms still remained in need of some further

development. Given the traditional primacy ascribed to the economic in Marxism, the change was hardly as heretical as Brown and others might have imagined at the time. The dissolution of Trotskyism in Australia and the ongoing rumours of regroupment on more-or-less pro-Soviet grounds make even more clear the substantial agreement here. Brown's own solution involves a return to the 1960s, perhaps even to the 1920s, and in this sense, at least, invites parallels with the last gasps of movements for communist renewal. Socialism remains firmly upon the agenda, in this worldview: what is necessary is party building, the construction of a new Leninist party. He concludes that 'Study of history shows that a path to bring together various genuine forces for socialism was found in the complex conditions of the 1920s. New initiatives are needed to restore a Party united around the principles of scientific socialism.' The message of October remains pinned, miraculously unbloodied, on the portals of history, for some at least. But they are indeed a dying minority who, with ex-Trotskyist Jim Percy, would view its seventieth anniversary as 'the most happy occasion that many of us will live through for some time to come' (*Age* 1987).

Why has communism failed so abysmally to sustain a powerful and independent presence in Australian society? Numerous explanations are possible, and many factors and forces are evidently at play: the strength of the labourist tradition, the flexibility of capitalism's own economic forms (at least until lately), the dominance of the consumerism which was such a significant target for the new left and which now contains it. The major historiographical theme in Australian writing emerges, however, as the irrelevance of the Soviet experience itself. Thus the conclusion to Alastair Davidson's short history of the Communist Party – 'the vicissitudes of CPA history were due to the fact that it thought the Russian revolution was entirely relevant to Australian history. It was not.' (Davidson 1969, 183). Bill Brown expends a good deal of energy in contesting Davidson's history, apparently without realising that Davidson's was a Eurocommunist project rather than one supplied by Yankee gold. Probably Brown would think the distinction slight. The striking thing about Davidson's history, in retrospect, is that it fell short of the very moment when events propelled communism into its deepest phase of re-evaluation. The crystallising events of May 1968 in France and the Prague spring in Czechoslovakia meant that the book ended inconclusively. These developments saw the beginnings of the dissolution of Australian communism; and it was this latter period in which communists began to use literature as a form of dealing with this demise (for earlier accounts see: McEwan 1966; McDonald 1977).

Communists and those interested in communism have long lamented the absence of a new history of the CPA that would take these latter problems into account. Other left groups have meanwhile produced their own accounts (O'Lincoln 1985; Socialist Labour League 1981). Perhaps the prospect of a new history of a more comprehensive kind is simply too daunting; perhaps it is too depressing for younger heads to contemplate, or simply too far away. Other historians have, however, turned their critical attention to the earlier history of the local left, and especially to the regions. Diane Menghetti's *Red North* (1981) paved the way here, and was followed by Jim Moss's work in South Australia and Stuart Macintyre's scrutiny of the West. Jim Moss's major study is part of the South Australia sesquicentenary publishing project; as well we now know, even labour history is now sufficiently re-spectable for celebratory consumption. Clearly the picture of a visible and struggling labour movement is to be preferred to the older historiography, with its numerous blank spaces. But this is also a history compromised by circumstance, for it records a past of industrial militancy now largely lost in clouds of consensus and co-operation. *Sound of Trumpets* is now the music of the Accord; it all seems to serve to make the recent past more distant, the activism further away than it actually is.

Moss explains the history of organised labour in Wakefield's colony as centring on the tension between two trends – a syndicalist tendency, privileging trade unions, and a more conventionally political trend, seeking parliamentary representation and constitutional defences against the ravages of capital. He proposes that the syndicalist trend was more vital in South Australia than elsewhere, yet reformism won out. The predominance of reformism thus explains the marginality of communism, according to Moss, and the postwar boom, the Cold War and Khruschev's speech all contributed further to this marginality. The CPA seems, in this view, to be relatively blameless – it had, after all, long advocated an Australian road to socialism (even if, as Milliss puts it, this was a road in which the familiar local signposts were imposed upon a strange and foreign landscape).[2] The success of reformism, in South Australia as elsewhere, served to illustrate even more forcefully the irrelevance of the conventional communist alternative, necessitating the invention of the 'coalition of the left', where the CPA could

2 Edna Ryan, in Stevens, *Bringing the Revolution Home*, p. 131, tells, for example, of the *Workers Weekly* literally being written for Moscow rather than for the local audience. Joyce Batterham, p. 203, tells a story more quaintly home-grown: in the period of censorship, Lance Sharkey wrote a column in the *Tribune* on how to grow tomatoes: 'everybody was reading it and trying to make out that there was a hidden message in it!'

ride to imagined victory on the coat-tails of the ALP. Moss thus tells us the history of labourism, but with the communists left in, and this, again, is a sign of the times.[3]

Stuart Macintyre deals with these and related issues in his biography of Paddy Troy. The context is the old, pre-Cup Fremantle, itself now little more than a memory. Macintyre manages here to bridge the distance between memoirs and scholarship, partly through the stylistic use of the vernacular. Thus the scenario is set: 'As you travelled into Fremantle, a forest of masts caught your eye. It was a place of movement and noise, enlivened by the unloading of ships and the entertainments offered to sailors and portworkers, a young and vigorous community …' The prose has the tenor of a yarn, the image of travel and entrance something akin to word painting (cf. Macintyre 1980). Documentation becomes ancillary, rather than being the obligatory heavy scaffolding common on academic architraves. *Militant* is not the soul-searching life-of-the-mind kind of biography. Paddy was not your *Good Weekend* type of communist. His times were not our times. Paddy indeed was imprisoned for his communism; he planted his books and papers in the backyard, in 1940 and again in 1949. Where communists today are tolerated and even made interesting, Paddy's lot was different. The authorities in Western Australia's political climate in the 1940s gave him three months hard labour for his belief. Everything was not then permitted.

On Paddy Troy's union office wall was pinned the maxim he took from Ostrovsky: 'All my life, all my strength was given to the finest cause in the world – the fight for liberation of mankind'. (Can we imagine the *Good Weekend*'s photographer orchestrating the frame in order to get the maxim into the picture, behind Troy at the desk? Not quite, somehow.) Troy was a battler, living union life like Bill Morrow, with its ordinary struggles and everyday discriminations, the similarity revealing the essential compatibility between communism and labourism. Like Audrey Blake, Paddy Troy was a product of the Depression. Unemployment was cauterised into his memory, as was the system of body-hire on the docks, men as cattle, at least in the eyes of those above. Proletarian living standards became for him the purpose of his endeavours in life remaining. And then, of course, there was the bonding to the other, the counterpoint, the land of employment – the Soviet Union.

Interestingly, and against the current of some nostalgic views of labour history, Macintyre portrays the period as one where familial bonds were stronger than those of class, at least in everyday life. Reciprocity between

[3] But see also his monograph on communism, *Representation of Discontent*, Melbourne 1983.

Party and individual was in short supply; the Party in Western Australia was conspicuously less than helpful to Paddy's wife and family during his imprisonment. The 1960s brought a new world, as Macintyre observes; individuals became significant to the extent that the other-regarding project of older communists sometimes became difficult to sustain. The me-generation, *Stork*-like figures arrived, revolution in their mouths and Marcuse in their pockets. The old left, forged in the Depression, was faced by the new, born into the affluence of the 1960s and its varied enthusiasms for so-called 'issue-politics'. The mix was volatile, or else simply desolate in outcome – 'Conventional industrial politics were as alien to the reader of Marcuse as Gladstone bags and short-back-and-sides.' Evening shadows were falling on the old left, while the new left ended up working on television, running major publishing houses, working for governments or writing about themselves and their allergies to communism or anything like it.

So what is to be learned from all this? There is much, but little of it easily articulated. What this genre, so new to Australian writing, shows, is the substitution of literature for revolution. It shows something of the problems, as well as the virtues, of radical commitments and leftist traditions, for it shows something of the noble vision of humanity uplifted, along with its lamentable blindness to suffering. It shows the fatal ensnarement of Australian communists within the Jacobin logic whereby people need to have the world improved for them, from above, by those who know better. It shows that the other-mindedness which allowed the Soviet fixation was also suggestive of all other-mindedness at home, a fact which violates the consummate narcissism of the 'good weekend'. It shows the exhaustion of labour's utopia. Finally, these communist elegies show a literary genre which has come of age, at the cost of the combustion of a thousand abandoned hopes. If the next generation should read these lives and expand their visions, in terms at once rational, normative and emotional, then the loss may not seem quite so devastating as it at first appears. The saddening similarity of our own present times to those of the Great Depression already calls upon our memories, and tries our cultural capacity to learn. Communism may no longer be the name given to this project, but it has contributed to it, in positive terms as well as negative, in human terms as well as theoretical. Its passing may, in irony, be its fulfilment.

References

Age. 1987. Lenin's Revolution Turns 70, 2 November.

Beilharz, P. 1987. *Trotsky, Trotskyism and the Transition to Socialism.* London: Croom Helm.

Blake, A. 1984. *A Proletarian Life.* Malmsbury: Kibble.

Blake, J. 1971. *Revolution from Within.* Sydney: Outlook.

Brown, B. 1986. *The Communist Movement and Australia.* Sydney: Australian Labour Movement History Publications.

Carter, D. 1987. History Was on Our Side. *Meanjin* 46: 108–21.

Clark, K. 1977. Utopian Anthropology as a Context for Stalinist Literature. In *Stalinism*, edited by R. Tucker. New York: Transaction Publishers.

Davidson, A. 1969. *The Communist Party of Australia.* Stanford: Hoover Institution Press.

Gibson, R. 1980. *One Woman's Life: A Memoir of Dorothy Gibson.* Sydney: Hale K Iremonger.

Gibson, R. 1983. *The People Stand Up.* Melbourne: Red Rooster.

Gray, O. 1985. *Exit Left: Memoirs of a Scarlet Woman.* Ringwood: Penguin.

Holmes, C. 1986. *One Man's Way.* Ringwood: Penguin.

Jacoby, R. 1981. *Dialectic of Defeat.* New York: Cambridge University Press.

Johnson, A. 1986. *Fly a Rebel Flag: Bill Morrow, 1888–1980.* Ringwood: Penguin.

Kundera, M. 1984. *The Book of Laughter and Forgetting.* London: Faber & Faber.

Macintyre, S. 1980. *Little Moscows: Communism and Working-Class Militancy in Inter-War Britain.* London: Croom Helm.

Macintyre, S. 1984. *Militant: The Life and Times of Paddy Troy.* Sydney: Allen & Unwin.

McEwan, K. 1966. *Once a Jolly Comrade.* Sydney: Jacaranda.

McDonald, G. 1977. *Australia at Stake.* Melbourne: G. McDonald.

Menghetti, D. 1981. *The Red North: The Popular Front in North Queensland.* Townsville: James Cook University of North Queensland.

Millis, R. 1984. *Serpent's Tooth: An Autobiographical Novel.* Ringwood: Penguin.

Morris, B. 1988. *Between the Lines.* Melbourne: Sybylla.

Moss, J. 1985. *Sound of Trumpets: History of the Labour Movement in South Australia.* Adelaide: Wakefield.

O'Lincoln, T. 1985. *Into the Mainstream.* Sydney: Stained Wattle Press.

Ross, E. 1988. *These Things Shall Be! Bob Ross, Socialist Pioneer-His Life and Times.* Sydney: Mulavon.

Socialist Labour League. 1981. *Betrayal: A History of the CPA.* Sydney: Allen Books.

Stevens, J. 1987. *Taking the Revolution Home: Work among Women in the Communist Party of Australia, 1920–1945.* Melbourne: Sybylla.

Tiersky, R. 1985. *Ordinary Stalinism.* Boston: G. Allen & Unwin.

Chapter 9

Revisioning Labor?
(1996)

What is the future of Labor? Marxism, the tradition from which I come, has a lot to answer for as well as its insights. In the thirties, for example, Marxists referred to Labor as a stinking corpse. It was a bad metaphor; the twentieth century has generated enough corpses of its own. Is it time, now, for the union to bury its dead? I don't think so. We are here rather to consider the possibility that Labor might still have a future.

What might it mean to consider revisioning Labor? Today we find ourselves in a vitally important moment, a moment when we must needs talk and argue about the renewal of Labor, and the labour movement. My theme and my question work in this context. My sense is that we need, first of all, to seek to explain recent experience, the extraordinary experience of the long Labor Decade, that we need to *revise* our views of this experience as a precondition for clarifying the predicament we now find ourselves in. But my ambiguity is also studied in another sense: once we might clarify what has gone wrong (and right?) about Labor since 1983, we need also to consider questions of the vision or identity or imagination of Labor. If Labor is to reinvent itself, Labor people need first to clarify its perspectives or recent experience and the status of its collective consciousness. Reinvention begs the question of what cultural stock or repertoire we possess, and what its value lies in, what its strengths, absences and weaknesses are. Reinvention, today, implies invention. So I offer these reflections on the theme `Revisioning Labor?', and I emphasise the interrogative note, for this is a possibility, at present, no more.

As a longstanding friendly critic of the Labor Party I want also to retread some of the paths of criticism which I and others have offered since 1983. In particular I want to reconsider or revisit the themes and arguments of the synthetic survey which I published in 1994, entitled *Transforming Labor*.

However – and this is to anticipate – whatever modifications or revisions I might choose to make to my own views, I want at the very least to insist on the importance of this category, *transformation*, for there are at least three major transformations in which Labor is caught up or has itself brought on. The *first* is the transformation of the labour movement and the Party itself. The *second* involves the transformation, or evaporation of the left. And the *third* is to do with transformations in the global system and western political culture.

Into the eighties the ALP became a party of power, a party of the state rather than a social movement, this at the moment when globalisation itself changes the role of the state (and when states choose to license globalisation). The left, in this scenario, has either gained access of some kind to the state or else, from a different perspective, has disappeared into it. These aspects of transformation are central puzzles for us, today, because as the word *transform* itself suggests, they tease out radical or ruptural senses of change which may not always succeed in escaping the weight of the traditions which form them. *Transformation* can be fundamental or superficial in its content. Labor has both changed, and not; the challenge is to establish the balance, and to argue about the deficit which now shows up in Labor's imagination. The challenge is to open this debate without rancour about betrayal or nostalgia for a phoney past while also eschewing the aggressive confidence that everything had to change, including values like sociability and solidarity.

Thirteen years ago a watershed opened in Australian politics. In those early times around 1983 most on the left were openly cheerful about the prospects of Labor in power. Together with others like Rob Watts and the editors of *Thesis Eleven* I was publically sceptical about the prospects, on occasion at least for the wrong reasons. In any case, by the end of the eighties I had generated a body of criticism, journalism and analysis about what I then called the Labor Decade. As it happened, this pile of papers elicited an offer to write a book, to construct a narrative and an explanation reflecting upon that remarkable experience. It was provisionally entitled *The Labor Decade*, but of course, like many others, I was a cycle out. The Labor Decade eventually took thirteen years; a neat ten if you associate the period with the equally remarkable ascendance of Keating. So I wrote the book three years ago; we awaited the outcome of the 1993 election, and *Transforming Labor—Labour Tradition and The Labor Decade in Australia* was published two years ago, in April 1994. It was launched by Brian Howe and Lindsay Tanner in Melbourne and by Bob Carr in Sydney, but its

message was effectively ignored in the dailies and especially by reviewers in the dailies. Tony Stephens wrote about it in the *Sydney Morning Herald*, as did Geoff Barker in *The Age*; Lindsay Tanner and Race Mathews and others like Simon Marginson received it favourably in the smaller and alternative press, *Overland*, *Island*, and *Frontline*. *Transforming Labor* received no single review in the mainstream press; it was ignored by *Quadrant*, *Arena* and *Eureka Street*.

Mathews said of it that *Transforming Labor* 'establishes Peter Beilharz as Australia's pre-eminent analyst of the nature and purpose of the Labor Party' and was 'required reading for all ALP members and those who have at heart the party's and Australia's well-being'. Tanner, writing from the inside, seemed to think that I'd done as good a job as might be possible from the outside. Marginson responded to the central theses of the book, the tensions and contradictions, but also had the decency to say that its language was sharp and lively and full of humour even if some of it was black. Bob Carr, in launching the book, connected it to Vere Gordon Childe's 1923 classic *How Labor Governs*, a touching parallel and one which helps remind that, after all, even influential books don't get read. Best of all, Chris Wallace-Crabbe wrote me a poem, an experience more moving than any review, however congratulatory, could ever be. But poets are not legislators, for better or worse, and neither legislators nor those writing in the public sphere thought much that *Transforming Labor* mattered despite the best and strenuous labours of some who wanted to use the book to kick start debate. Maybe *Transforming Labor* was too late; or perhaps it was too early.

Why the silence? Maybe my argument, to which I will return, was simply wrong or silly. Maybe, and this is a more significant issue, it was too complicated, for I wanted to argue that the Labor Decade was a profoundly mixed and contradictory experience, one which combined gains and losses. More specifically, my argument was that the Labor Decade was driven by distinct but mixed dynamics of *innovation* and *exhaustion*. By 1993 Labor was electorally exhausted, its credibility partly undermined by Keating's unrelenting emphasis on innovation and change. Hewson and the GST threatened the populace with even more change; the electorate slammed the door in his face, but it was highly mischievous of Keating to turn this niggardly electoral victory by default into a symbolic vote for the True Believers. Believers, as Stuart Macintyre put it, need beliefs; and we are not so clear now what those beliefs are. For both alternative leaders were urging the electorate that they could do it faster, and this was Keating's swansong in 1996. Perhaps there was too much change, or too much talk about it.

Traditions constrain, but they also enable. There is no single Labor tradition, but a multiplicity of traditions in the movement, left and right and centre, communist, Catholic and Fabian and more. There are various true believers, enthusiasts for postwar reconstruction, for the hard class struggle of the Great War before it, for the innovative symbols of Whitlam, healing after the Vietnam War and so on. There are all kinds of autobiographical connections and connotations with which these views are caught up; the experiences of youth here, as elsewhere, are formative. Different actors then summon up distinct images of Labor and the good society, the Golden Age of Chifley, the shared broom of Whitlam and Lance Barnard, the synthetic sobriety of the early Hawke years perhaps. Hawke dressed as Curtin, Keating maybe as Jack Lang; this is part of the way in which Labor actors represent themselves, echoing back to earlier heroes or crises or senses of foundation. And there are, or were, ethical connections here, in the suggestion that Chifley or Curtin or Whitlam got something right, encouraged us to think of and act on ideas like fairness, equity, equality, social justice, at the very least to insist on a deep sense of social obligation and dependence. There were things worth fighting for, notions of positive equality, community responsibility and there were arguments for institutions – from arbitration to Medibank – which went with them. Are these all things we have now left behind? What has happened to the idea that we share responsibility for our fellows who are victims of the shafts of fate, as much as we share in providing others with the possibility of their own good fortune?

The modernisation of the Labor Party and of Australian economic and industrial culture worked against a whole series of sensibilities to do with Labor tradition or labour culture, to the extent that political Labor risked emptying itself out culturally, becoming more fully a party of power than a party associated with the labour movement and its allies or kindred movements. The now widely endorsed idea of a labour settlement, or a lib-lab settlement established around Federation on principles such as White Australia, Arbitration and Protection which had been hegemonic for almost a century was now, into the eighties, being deconstructed partly by the legatees of its authors. Uniquely, apparently, across comparative national experience into the eighties, Australia's welfare state, its social and economic policy were subject to radical restructuring but in our case at the hands of a Labor Government. As Macintyre put it, again, in a different setting in Australia the Labor Party both resisted and absorbed the New Right. The consequences of this process were in some ways significantly different to those, say, in Thatcher's Britain; economic liberalism or economic rationalism

in economic policy was more often accompanied by residual solidarism (or more) in social policy. What in an earlier phase I referred to as *corporatist* or *labourist crisis management* became something more discernibly like *socially concerned deregulation*, this not least of all because the extent to which we could still describe Labor as 'labourist' became more and more puzzling. Evacuating its old traditions through the eighties and into the nineties, there would have to come a point at which Labor culture was no longer recognisably labourist at all. So what then was, or what is it? or what might it be? This is another issue to which I shall return.

The point I want to emphasise here is basic to the argument of *Transforming Labor*. The transformation of Labor is a phenomenon which we encounter in at least two ways. The Labor Decade was a pyrrhic victory in a particular sense, and in both ways, victory in defeat as well as defeat in victory. Labor is both the subject and object of this process, both its author or agent and its victim or beneficiary. Notwithstanding all the well-rehearsed lines about the economic necessity of globalisation and deregulation – there is no alternative – these avenues were opened by political choice. The Federal Labor Governments willed these processes; but they also set in motion, thereby, processes apparently beyond their control and apparently irreversible in their consequences. In politics, of course, nothing is irreversible; yet a broader view of the scope of social action suggests that the weight of history, and traditions and ruptures once established is considerable and constrains polit-ics severely. In Britain you could ask Tony Blair about this; but you could also ask Will Hutton, or Paul Hirst, about the incredible local weight of tradition in both the establishment and the labour movement. In Australia the mid-term situation is apparently more difficult, because of the strategic shifts and transformations which belated processes of economic modernisation indicate. Starting from a weaker economic position, Australia's prospects are bound to remain more vulnerable.

This kind of argument, that the Labor Decade involves both gains and losses, the shedding of some obsolete, masculinist tribal and monocultural baggage as well as some more positive conceptions of, say, economic and social protection as the basis of social solidarity – this kind of argument seems to have been lost in the shouting of applause and damnation for Labor. This is part of a larger cultural problem. It seems to me that one of the major obstacles to public discourse about the future of Australian society lies in the moralism which saturates so-called public debate. If you live in Melbourne you encounter this daily in terms of the latest moral boo-hurrah, Helen Garner and Demidenko ... it goes on and on and on, who's right

and who is wrong. This kind of frame also structures public views of the Labor Decade, which is more routinely presented as all good or evil, all gain or all loss, all innovation or all exhaustion. Argument about Labor divides between boosterism and nostalgia. The best single instance of boosterism, a bestseller in our case, is Paul Kelly's *End of Certainty*. Kelly's argument, to reduce, exactly mirrors Keating's – *before* us, Australia was asleep, backward, pathetic; *we* opened Australia to the world. Let me say, simply, that this kind of rhetoric is both historically misleading and deeply offensive to what we are, and what have been. As I shall explain later, this is *also* one reason why Keating's highroad was electorally rejected so plainly in the 1996 elections. White Australian civilisation was an outpost of British imperialism; its emergence is intimately bound up with the world system. We have always been global and an edge culture, looking out, even obsessively.

To put it bluntly, for Kelly as for Keating world-history starts with us (or at least with them); it's a charming conceit. For the nostalgic, the picture is reversed; the world ends in 1983, or 1986. Nostalgic argument is less vulgar than the boosterist case, I think; there is no single case which exemplifies the nostalgic argument as well as Kelly's does the boosterist case. The clichéd argument from the left has always been constructed in terms of betrayal; who are the true believers? – *we* are, and betrayed routinely by Labor Rats, this time Ec Rats. Probably the most influential book here is Michael Pusey's *Economic Rationalism in Canberra*, also widely read or if not read widely bought and argued about. Let me sidestep the question of Pusey's intention in his book and suggest that it was often received or interpreted as a Whitlamist nostalgia – the seventies were the Golden Years, until the locusts arrived in the SES with Hawke and Keating. A different variation on this theme is John Carroll's endorsement of the sixties in books like *Shutdown!* For Carroll, in effect, the best we achieved was in the Menzies years, under McEwenism, though again I sidestep judgement here as to exact relation between authorial intention and reception. In Kelly's case, by comparison, there is no obvious distinction between intention and interpretation at all – he means us to praise Keating, and the faithful were happy to use *The End of Certainty* to promote the cause. There was no alternative to Keating and deregulation. The electorate begged to differ.

There are other voices raised together with those I am here, somewhat brutally, calling nostalgic; they include figures for whom I have nothing but admiration, such as Hugh Stretton, and other respectable commentators such as B.A. Santamaria. What unites these critics of boosterism is a varying bunch of sensibilities and commitments to the idea of social solidarity.

From varying political perspectives these critics of new Labor agree that the greatest threat of globalisation is to social solidarity. If the old historic settlement is obsolete, so the argument goes, then we need some other form of social contract in order to hold onto (and to extend) the levels of civility and sociability which we have achieved in the past. The problem then must be addressed, whether the imperatives of change are compatible with these established conceptions of social solidarity.

My major concern in this paper, however, is not with the nuances of these particular claims. My immediate purpose is rather to suggest that public debate freezes, or falters, because the construction and reception of these views dichotomises them, as though the choice we face were only between a deadly boring present and an adrenalin future, or alternatively between a comfortable past and a future like *Blade Runner*. This is a misleading way to put the choices we face. The essential attribute of modernity, of the space and attitude we inhabit, is its *ambivalence*. We encounter our lives now as horrific, now as ecstatic, as combinations of positive and negative. We juggle aspects of memory and tradition with challenges presented by anticipations of the future. In all this, we encounter everyday life in ways that are far too complicated and contradictory to allow us properly to take single-mindedly positive or negative stands on the Labor Party or the Labor Decade. Moralising claims about betrayal or the congratulations of boosters both avoid the real puzzle, which is, in effect, to seek to identify what kinds of change or modernisation are necessary and appropriate to particular norms and values such as solidarity or citizenship. For, the original power of Keating's drive – now collapsed – was determined precisely by Keating's identification of change with his own sense of change – no alternative. But there is, of course, always an electoral alternative, even when we think, in conceit, that our values are better than theirs.

The argument of *Transforming Labor*, then, these kinds of claims about pyrrhic victory, about ambivalence and contradiction were lost in the noisier context of imperative demands *for*, or *against*. But perhaps there is a different case, a better way to make sense of all this, outside the shouting, beyond the arguments of *Transforming Labor*. Perhaps there is a more minimalist version of the so-called boosterist appraisal; for as I have indicated, the problem of the weight we want to give to the significance of change remains uncertain. There are those for whom one frame or other of past and imagined Labor traditions, from Curtin to Whitlam, offer the necessary template, and others, perhaps for whom the new age of globalisation needs to be read more soberly in its own terms, for whom the rules of the game

have simply changed. We now find that we are living after abundance, or after the postwar version of abundance, after the long boom. Sure as hell the rules of the game have to change (but again, do they have to change in the way that Labor's key actors decided?). The argument is a familiar one to those on the inside, such as Peter Baldwin; commitment to the old values no longer carries a self-evident set of universal policy prescriptions. Given changes in labour market participation and family patterns, and so on, new means are necessary even to serve 'old' egalitarian ends. These kinds of arguments and issues then feed back in to other disputes concerning the relative achievements of various social policy regimes in cultivating an egalitarian ethos if not an equal society, and they feed in turn into debates over questions such as the presence or absence of an underclass in Australia, as in Travers and Richardson's *Living Decently*, a field again where boosters and nostalgics return, instructing us either that we've never had it so good or else that we should be living in fear of L.A.

A more promising line of argument, potentially, is to inquire into the content of Labor thinking today, and to ask whether it really makes such sense to speak of something like a 'new labourism', a labourism without labourists. Earlier I suggested that the historic compromise or national settlement on which modern Australian civilisation until recently rested might best be described as lib-lab, rather than labour. Labourism has always had its own distinctive identity, in Australia as in Britain; the British party, so far as we can tell, is far less completely disengaged from its own labourist traditions, so that our problems are in some ways, truly different to theirs. At the same time, many of the values embodied in the Australian historic compromise which we can see now, more plainly, after, the fact, were also values of reforming liberalism. So in this regard we might as well ask whether a new labourism is, or ought be, an older liberalism. The older liberalism, that of the *fin-de-siècle*, was of course a *social* liberalism, indicating the sense that social relations precede individuals, rather than the other way around. The issue for socialists here is what the nature of a renewed liberal core for labourism might be, whether its credentials would be closer to those of economic liberalism (economic rationalism) or to those of social liberalism. For in our own lifetimes we have been reminded again how easy is the slide from social liberalism back to economic liberalism, from solidarity back to markets alone. This is one factor which encourages enthusiasms for notions of social market or social partnership; it helps remind us that if the Accord needs rest and recreation, so does talk of social contracts and social reciprocity in general.

Now all of this may seem rather elementary, or obvious, but I am not so sure. My recollection of the 1993 Labor campaign was that its earlier moments of lethargy extended well into its conception or vision of the social. Australians, putatively, were being advantaged by the new Labor initiatives in the world, in Asia and at home, but it was only in the last weeks of the campaign that actors such as Ralph Willis and Barry Jones began to argue that a society was more than an economy, or a market inhabited by hardy and independent (male) individuals. It was as though Labor (in the east? as represented in the media?) had lost the conviction or memory of its own commitment to the values of social solidarity, to institutions like the state or civil society. As I argued elsewhere, in a paper called 'Labor—The New Conservatives?' (answer: no) Keating's verve as Labor leader ascendant often seemed to be caught up exactly with his capacity to manoeuvre images of tradition and present or future together. Keating managed I think more persuasively than any other to talk or connect back into claims about labour tradition while also looking or driving forward. The connection was crucial both electorally and politically. My argument then (in 1993, after the election, given that some suggestions were then afoot that we were entering a Second Labor Decade) was that the possibility of further Labor victories depended in part on these capacities to connect traditions into modernity. In periods of rapid social change, those who claim to rule will be those who work forward but also seem to look back, who can bridge claims about tradition, past and present and identify with claims to the future, modernity and a new order. Labor's pride of place, in that moment, was in its Janus face; and this connection, at that point in time, seemed completely to elude the Coalition, who not only failed to connect to the past but offered little more than a scorched-earth scenario future, L.A. in the Antipodes.

In the 1996 campaign Keating was obviously pushing it uphill; he re-covered some of the language of social solidarity or the 'vision' thing – we are more decent than they – but his capacity to connect traditional claims into the modernising imperative was weak. If in 1993 the Liberals failed to establish a convincing mask or rhetoric connecting them to the past, then this became Labor's flaw in 1996. It is schematic to view it in this way, but in effect the roles were reversed; the Coalition spoke to the past as present, whereas Keating spoke to the future which we do not (or some of us do not) inhabit or which we actually fear. This distinction was apparent for example in the *Australian*'s tabular representation of summary competing leaders' views on election day. While the editorial view of the *Australian* claimed to counsel a vote for neither, its captions captured one key aspect of the difference: 'Vote

for the authors of great change' by Paul Keating, 'Key issues are jobs, taxes and trust', by John Howard. Trust – whatever else we are to make of it, trust and distrust, lies and corruption – as Fukuyama unwittingly shows in his last book is also a symptom of solidarity, not just the non-contractual aspects of contract which Durkheim pointed to. Trust belongs at least as much to labour's vocabulary as anyone else's – maybe more so – where there is a casino economy there can be no trust. Could Keating claim trust? Keating had recovered the language of the 'fair go' and assisting battlers earlier, in 1995, when massaging the welfare lobby, addressing the ACOSS Congress and asking to address the SPRC Conference in Sydney, reminding the profession-al workers in the welfare state (as if they needed that) which side their bread was buttered. Keating's semantic rediscovery of the idea or slogan of social democracy in this setting looks pretty thin. More social democratic than them – sure, and by no means hostile to the idea or mechanisms of welfare. But welfarist in what sense? – more Germanic than British, or American? Maybe, but that's a weak, comparative defence or definition of social democ-racy, which also is a tradition (or traditions) with an ethical core. Historically, Marxist social democracy gave way to Keynesian social democracy, which in turn was transformed into residual welfarism. In the weakest, empirical sense you could associate social democracy today with, say, the social market, but those kinds of claims – interventionist industry policy, social partnership – have not been much voiced since 1987, and *Australia Reconstructed*. More fundamentally, as I have indicated, social democracy is a national project, which Keating's economic initiatives consistently undermined, because the global reach fails to deal with problems on the doorstep.

Revived use of the language of social democracy rests uneasily, however, with the imperatives of globalisation. Social democratic arrangements, like the mechanisms of the welfare state and citizenship as we have known them, belong to the political geography of the nation-state and the national alliance of classes which make them up. Economy rules; you can internationalise economy, but what happens in this process to politics, or to social policy? What happened to the language of labourism in this context, articulated for example by Keating both on the 1993 victory and the ACOSS speech, was that it collapsed back in to the language and morality of Victorian paternalism. 'Looking after' the poor is better than nothing, but it is certainly not part of the language of citizenship or participation. This is the language of subjects, not citizens.

The absence of a more muscular conception of social democracy here led back not to the aging traditional claims about labour mateship or equality

but to the condescension of the worst forms of charity, suggesting the presence of the poor as outsiders or supplicants rather than as citizens. This was exactly the kind of weakness which the opposition could exploit and outmanoeuvre. What it suggests is that having emptied out the various labour traditions or having abandoned the different labour frames generated out of labour traditions, Labor itself now lacks the kind of vocabulary necessary to mobilise popular support.

The journalistic analysis of this deficit especially in Keating's act was widely identified in terms of claims about arrogance or sacrificing the little, local picture to the big, global Asian screen. My sense is that this line of criticism only begins to identify Keating's flaw. To put it in the terms which orient the argument in *Transforming Labor*, Keating's final flaw strategically was in failing to connect past or present and future. To offer an electorate a 'future' is meaningless unless it is a strategy mediated into some cultural sensibilities as to where 'we' have come from and where 'we' presently are. If it is true that Labor has lost or alienated a traditional constituency among working class voters, then it is probably also true that it has gained new support from a new category of middle class voters, entrepreneurs of cultural capital who are, indeed, the globalisers, those whom Robert Reich calls the symbolic analysts in *The Work of Nations*. Of course, you don't need to be middle class to like multiculturalism or the Republic, but the idea of visualising your own future (or that of your children) in Asia rather than in the actually existing outer suburbs may be harder to grasp. Whatever the Coalition Government now chooses exactly to do, it was far more skilful than Labor in reversing Keating's abstract identification of 'future' and 'world' (= Asia). 'Australia' is not only 'then', it is still *now*, for better or worse. Keating's attempt to engage in a kind of rhetorical flip, where time and place are simple and identical, Australia *then*, the world *now*, deeply undermined his own credibility and capacity to connect. The Liberals, finally, were far more skilled not only in electoral spin doctoring but also in reviving and martialling mythologies of the past (the 1950s) against the disruptive, uncertain and threatening brave new global world of the nineties. Keating, not Hewson, was elsewhere.

The argument of *Transforming Labor*, as I mentioned earlier, sought partly to make sense of the peculiar mix of the Labor Decade's experience in terms of arguments about tensions between modernity and memory, change and nostalgia, and between dynamics of innovation and exhaustion. These arguments went largely unheard, I think, because the broader disputes about Labor were conducted in terms of boo-hurrah, singling

out the positive and negative or the gains and losses as though they could be discerned separately. This moralising split was dominant even to the extent that some readers or non-readers of my book viewed it as part of the nostalgic-betrayal camp, this notwithstanding my discussion of the disabling problems to do with nostalgia in the text itself. Certainly the focus of *Transforming Labor* is on the process of cultural evacuation which the Labor Decade involved. The story from 1993 to 1996 doesn't get any happier, and we need to be honest about this at the same time as we are candid about the mixed blessing which what we call 'progress' brings. The first responsibility of intellectuals and critics in this context is to tell the truth, as they see it, from the perspective they inhabit. Neither poets nor intellectuals are legislators, not usually; intellectuals ask questions about problems rather than answering or solving them. If we solve them at all, we seek to solve them socially, but also politically.

Thirteen years ago a watershed opened in Australian politics. We now inhabit a three year interval which is of vital significance. Ours is an interval, a space within which to ask again who we are, where we have come from and where we think we are going. Labor has plainly hit a sense of electoral exhaustion, which has partly been induced by the extent and enthusiasms of its earlier will-to-reform. Innovation itself leads to exhaustion. Our real concern remains twofold. Electoral exhaustion is one problem. I see no good reason why Labor cannot reconstruct and recover office in 1999; it would be a good year to seek to reconnect. But the second problem is arguably more fundamental. Labor today is not only electorally exhausted, it is politically exhausted. Victory in 1999 will be pyrrhic, again, unless some process of political renewal can carry it. Faust, the developer, sold his soul to the devil. The Labor Party has not sold out, in this dramatic way; the problem is elsewhere, in its loss of an ambivalent past and its half-reconciled enthusiasms for a new future which for too many, is too far away. Labor under Keating was perhaps more like the sorcerer's apprentice, unleashing dynamics of change increasingly beyond its control. We may not be able to regain control of the future, into globalisation; reconstructing senses of the past and seeking better to understand the present would be considerable enough immediate an achievement, in any case. Understanding, like senses of control, will always necessarily elude us, or arrive too late; but our nature, and maybe our commitment is ever to seek what is impossible. Perhaps it is this sense which, for the moment, we have lost and need to strive to recover.

I do not argue in *Transforming Labor*, nor do I believe now that the problems we face were generated miraculously since 1983. Half of that book

was devoted to the period before 1981. The problems of the Labor Decade were generated in response to problems preceding it, problems to do with the nature of Australian labour history and culture, and caught up with the particular experience of Australian modernity. We need now to seek a clearer sense of what it is that we are trying to escape, and what remains of value in this legacy. None of this is beyond us, except in the most immediate sense, as results, and prospects. This will take longer than three years, but there is no better place to start than Perth, and no better moment to start than now.

PART TWO:

THINKERS

John Anderson

Chapter 10

John Anderson and the Syndicalist Moment (1993)

Who was John Anderson? Challis Professor of Philosophy at the University of Sydney from 1927 to 1958, Anderson was arguably one of the most influential of local intellectuals in modern Australian history. Yet he wrote little: no single book; he lectured and persuaded at a time when the University on the hill was small and even more exclusive than it now is. An oral tradition, perhaps, more than a written one, Anderson's work has attracted much gossip but little analysis: one major critical exegesis, by Jim Baker, and a lone biography by Brian Kennedy (1995; see also Docker 1974). Andersonianism these days is identified vaguely as a kind of libertarian current which it is typically assumed became naturally right-wing during the Cold War (Baker 1979, 1986). If Anderson's Marxism is acknowledged, in conversation, it is in that patronising strain of Marxism-as-measles, if you're not a socialist before thirty you've no heart, if you are after thirty you've no head. What I want to suggest is that a certain crimson thread runs through Anderson's thinking, a logic of a peculiar kind which is in its genesis caught up with the syndicalist moment. Marxian without being Marxist, in a sense, it often beckons the thinking of Sorel, for it speaks of the ethics of the producers and takes up a position against servility as the central social ill.

Syndicalism obviously had enormous appeal throughout the west not least of all to those with white hands and scarlet fantasies. It is no exaggeration to speak with Christopher Lasch in *The True and Only Heaven* of a syndicalist moment, when parliament was widely discredited even though it had hardly been tried out, when the Wobblies reigned supreme in socialist circles, when Lenin dreamed of a syndicalist utopia in *State and Revolution* and all and sundry – Sorel included – waxed lyrical for the Bolsheviks because they took them also to be syndicalists. Gramsci, Korsch, Rosa Luxemburg and Trotsky all experienced working class spontaneous action and dreamed of

more; Mussolini and others shared their dreams, or at least some of them. This was the moment of the deed, when fascism too, we need remember, was a radical movement, committed to the deed and to direct action. Some of these influences were also apparent in the Antipodes.

Donald Horne gives a nice sense both of later context and of content in what is arguably his finest book, *The Education of Young Donald*. During the years of the second war as earlier Anderson found himself embroiled in controversy, not least of all because of his enthusiasm for James Joyce and Freud. Anderson was conspicuously the first real intellectual the young Donald had come across: he would not stand for the royal anthem, was to be heard encouraging free thinking, denouncing Wordsworth as drivel and introducing this peculiar language, where the ethics of the producer were to be celebrated over those of the consumer (Horne 1968). But more than that, Anderson dared to question the idea of progress, puzzled over the idea of humanism, denied that there was a centre to things, nagged against planning, social engineering and social amelioration. Against these forces were to be pitted the heroes, the producers – scientists, artists and workers (Horne 1968, 214, 221). In raising these issues Anderson thus played the role of the outsider, the oppositionist, the whistle blower; and while the logic of some his arguments may be viewed as conservative, his inflection was always radical.

I

What then was the content of Anderson's social and political theory? He never spelled this out. Unlike, say, G.D.H. Cole, also a youthful syndicalist, he wrote no book entitled *Social Theory*. The best published encapsulation of his views for our purposes is in his brilliant essay of 1943, 'The Servile State'. Anderson did not share the romanticism, nor the harmonism of Hilaire Belloc's 1912 text: but he did view it as an anticipation of later events. By the 1940s, Anderson claimed, the danger of regimentation had increased enormously (Anderson 1962, 328). But if Anderson understood that Belloc's hopes were, technically speaking, reactionary, he also knew well enough to identify Belloc as a radical. Indeed, as he observed, Belloc mirrored Marx in his sense that the perniciousness of modernity consisted in its division of humanity into those who possessed property and those who did not. More like Proudhon, though, Belloc sought to return the proletariat to small holdings; only this would overcome the condition of servility. 'Wage slavery', Anderson suggests, might be an inaccurate description of labour today, yet it

also captures something of the problem. The larger problem, however, concerns the way in which the modern labour movement has become prepared to trade away freedom in return for the promise of security.

Anderson inveighs against the idea that subsistence is prior to culture: he agrees, that is to say, with those radicals from Cole to Pateman for whom the real problem is not poverty but slavery (Anderson 1962, 330; Pateman 1970; 1986). Yet the new servility anticipated in the Welfare State is something which the labour movement aspires to. Now enters his second. Anderson introduces Sorel as authority for the claim that the servile mentality, that of the consumer, emphasising ends, things to be secured, is servile to that of the producer, emphasising activity, a way of life, a morality. The working class is noble because it has the scope to develop the productive spirit, an attitude which can only be retarded by proprietary sentiments. This is a fascinating argument. Earlier, while a self-proclaimed Marxist, Anderson rejected social service as social control. Now, in 'The Servile State' it becomes more readily apparent that the problem with social service is that it seeks to bind Prometheus. Anderson wants to define the working class as an actor, not an other. There can be no stability, no social security, no world without risk, no end to history, no return to harmony. To take socialism as an end is already, for Anderson, to succumb to the outlook of servility.

More, into the forties servility is identified as a widespread economic and political tendency. All states which suppress political opposition and thus all independent enterprise are servile. Here Anderson can be taken to mean by enterprise what today would be associated with the sphere of civil society, rather than market or state. Certainly this sensibility resonates through Anderson's use of the ethic of the producer, which covers roughly the realm not of production, in the economic sense, but of creation. As young Donald was given to understand, the producers were not the proletarians but the scientists, artists and workers. These actors fought for positive rather than negative freedom. Fixation upon freedom 'from' led to the social service, to the servile state.

Anderson thus posits the elements of a sociology of labourism. Planning can, for him, only take the form of the subordination of social life to particular interests. The labour movement has become the standard bearer of these trends: in the name of emancipation, it works steadily toward slavery. The echoes here are deafening, not least of all when Anderson turns his attention to education. As Baker shows, Anderson was a critic of Dawkins *avant la lettre*; the pox he traces to the Utilitarian planners, and back to the

Murray Report (Baker 1979, chs 10–11).[1] There is, in short, for Anderson, a direct opposition between practice and criticism. Any, even attempted subordination of study to other purposes is an attack on study itself; and the principal anti-theoretical attitude at the present time is meliorism, the setting up of betterment as the guide to the conduct of social theory and practice. The student of society should be encouraged not to reform, but to oppose. Servility indicates a failure in responsibility, for it demonstrates a desire to be relieved of troublesome problems. Labourism, in consequence, could only be redeemed if it were oppositional. The name for this kind of Socialism in power, by contrast, was *rationalisation* (Anderson, Cullum and Lycos 1982, 336–39, 124).

II

Anderson set out opposing all monological principles, yet espousing Marxism; he ended up attacking communism as the single most dangerous trend. Was he not then drifting into the position indicated by Hayek? Anderson nowhere to my knowledge discusses Hayek, this notwithstanding the local promotion of *The Road to Serfdom* especially in Sydney, where Dymock's published a cheap local edition in 1944. In order to sense the difference we need to cast back to Anderson's Marxist days. The younger Anderson had a position which Louis Althusser would have envied: he was formally designated Theoretical Adviser to the Communist Party until they fell out, significantly, over a dispute concerning censorship (Baker 1979, 80).

Anderson's Marxism is clearly explained in an unpublished lecture entitled 'The Working Class', circa 1932. Like his predecessor, Francis Anderson, John Anderson was a product of the theoretical culture of Glasgow idealism. His father Alexander was a socialist headmaster and his brother William, Professor of Philosophy in Auckland from 1921 to 1955 identified with the cause of guild socialism (Baker 1979, 79). If Anderson was a pluralist before the thirties, he suppressed this sensibility in order to embrace Marxism. In 'The Working Class' he poses the analytical-political choice: classes, or groups. In either case, he will not start from individuals:

> Social theory does not begin until we recognise that society is not a resultant of the 'wills' of individuals, or a field in which good will and ill will are exercised, but is a *thing* exhibiting definite characteristics, acting in specific ways under specific conditions (Anderson 1932, 1–2).

[1] See also Classicism, chap. 17 in *Studies in Empirical Philosophy*.

Anderson always rejected solidarism, any version of the idea that society represented a single will or purpose or harmony. In his Marxist phase, he proposes that class theory is opposed to solidarism, a position he was later to reject. What was vital now, he argued, was for the militant workers to reject philanthropy and the ethic of altruism. The working class was held down by the State, by claims concerning goodwill, duty and the necessity of one's station. Socialisation, for Anderson, was to be rejected because it was a scheme and not a program of action; rather than being an activity to be undertaken in existing conditions it was posited from above, as a result to be arrived at. Anderson does not here use the language, but the point is Sorel's: the program of socialisation is a utopia, not a myth, a planner's fantasy and not a producers' ethic. Socialisation, that is to say, is to be done to or for workers and not by them; it is a distributive and therefore a *consumptive* theory, neglecting the class war (Anderson 1932, 4–6).

At this point, it becomes possible to offer a provisional explanation of Anderson's life-long connection to the syndicalist moment. Anderson is always opposed to reformism, only he ceases to be a revolutionary. Like Sorel, he rejects political socialism, preferring local activity. Into the forties he substitutes pluralism for Marxism, contingency for revolution; as Baker explains, he adheres to the idea of the producers' ethic, but lets go the sense that it is the labour movement which is the bearer of this ethic (Baker 1979, 67; Anderson 1962, 187). In 'The Working Class', Anderson thinks like Trotsky: he ascribes the producers' ethic to the working class, and the consumers' ethic to the bourgeoisie and its philanthropic lackeys (Anderson 1932, 9). Thus he momentarily defends Soviet planning, defends classes against groups, the right to strike against arbitration, portrays the producers as globally bound together in their struggle against the acquisitive consumers (1932, 10–12, 14, 15). And thus he attacks the ALP not as utilitarian but as capitalist, arguing Marx-like that the real intellectuals must choose and must choose the producers (1932, 16). Plainly Anderson for that moment endorses an heroic conception of the proletariat.

Anderson offers these views in more of a transitional form in a 1936 lecture on 'Social Service'. By the mid-thirties Anderson had become a Trotskyist, of course, because he was an oppositionist. But then he also took sides with the dissidents among the Trotskyists, with intellectuals like Sidney Hook and Max Eastman, with whom he had direct contact in his only trip out of Australia, in 1938. Anderson's views on social service were primarily directed against that now most worn of victim groups – social workers. Philanthropy he decried; social workers lived in its pall, as did kindred

Stalinist bureaucrats. No jokes about light bulbs here – for Anderson the issue is grave, as social workers take up the attitude of the consumer, and here again Sorel is the tag. The logic of the consumer is that of decadent capitalism. So here he argues Nietzsche-like, using Sorel's *Reflections* and *La Ruine du Monde antique* against Christianity as consumptive (Anderson 1936, 5). 'The main point is that social service is directed against unrest and for the maintenance of the existing order, against the independent order of the persons supposed to be benefited and for their continued subservience to the propertied class' (1936, 6).

The Marxist Anderson thus glosses over the nuances of his later view that the proletarian condition is not slavery, just as he is wont to insist that the State has no role other than negative. In later lectures on an only apparently bizarre couple – Bernard Bosanquet and Lenin – Anderson proceeds to analyse these concerns with more care. Here we sense the increasing presence of Freud. Anderson began these 1942 lectures on political theory with the suggestion that social engineering arguments, which viewed politics as the theory of policies, mistakenly presume that we know ourselves and that we know what we are doing. In actuality, however, 'people only to a limited extent know what they are doing, [they] are moved by forces which they may not understand at all' (Anderson 1942, 3–4). Marx and Freud together, for Anderson, provide the insight that there is much about us which we *do not know* and that we can be wrong about our activities (1942, 7). In various places through his writing he sympathises with Croce's sense that we can achieve progress, but reaction is always around the corner.

Theory and policy may thus be bound up, but they are not the same thing, and in this Anderson anticipates his increasing distance from the Marx of the *Theses on Feuerbach*. Here he identifies the similarities between Bosanquet and Lenin: they are both solidarists. Parliament, however, is now important for Anderson, partly because of its basis in argument. Socialism, if it exists, makes sense only as process –'if the working class movement attacks capitalist democracy it may be said to be undermining itself (as it has done), if it destroys capitalism it may be destroying its own freedom'. Bolshevism is servile. Marxism shows its residual idealism in its conception of a final condition, but there is no total solution (Anderson 1942, 51–55). The premise is expanded, coincidentally, in a 1955 lecture on Greek theories of education:

> if we are really to recognise multiplicity, an irreducible variety of things
> and an irreducible variety of characters of any given thing, then we

have to abandon the Socratic conception of harmony, the view that the characters of a thing somehow together make up *one* character, with the corresponding view that things in general somehow make up one thing (Anderson 1955, 20).

Anderson plainly rejected notions of harmony or totality. What then of his relation to Marx? The major published papers on Marx are not especially edifying: they address the Marx/Engels issue, and puzzle through epistemology, defend the idea of activity in the early Marx, introduce Sorel as a leaven, arguing that the factory instils a kind of disinterested activity which assimilates the worker to the scientist, the artist, the warrior. Sorel follows Proudhon, the French syndicalists and Marx in elevating production over consumption (Anderson 1962, 325–7). Among his unpublished papers, there is a condensed series of reflections on Marxism apparently taught in the 1940 Distinction course. What is most striking about these notes is that Anderson evidently both understood the importance of the *Theses on Feuerbach* and was able to identify their flaws. It is the sense of activity in the Theses which attracts Anderson: in the first thesis, for example, the significance of developing the active side against the vacantly contemplative mood of traditional philosophy (Anderson 1940, 22). Yet he also stresses the difference between policy and theory; theory is not politics, even if it is political. Thus the idea of transformative activity attracts: Anderson reads Marx, so to speak, as Sorel, but the exhaustive notion of philosophy as practical repels. Indeed, Anderson refers to Thesis Eleven as the 'last thesis', which may in fact be an appropriate obituary (Anderson 1940, 25). When it comes to the metaphysics regarding the expropriators, Marx simply departs from social science. For Anderson, history is better described in terms of social movements and their activities. The problem with Marx's Hegelianism is that it leads him away from this kind of historicism. Anderson would not have known of Marx's answer to the Victorian questionnaire which requested his strongest dislike but he would have agreed with his answer: servility.

Yet if Anderson never quite became a conservative, nor did he return to the ethical idealism which was Glasgow. In 1941 he gave a series of lectures on T.H. Green's *Principles of Political Obligation* which make this clear. He refers inter alia to Hobhouse's *Metaphysical Theory of the State*, a sure sign of distance from Hegelian thinking (Anderson 1941, 1). The State is not the representative of the general interest, but is itself a particular interest. Green, he charges, takes orderliness as the essence of goodness, failing to realise that the question is not one of order versus disorder but of different kinds of

order. Green is a solidarist, and therefore a quietist: he presumes rebellion to be evil, because of the ideal of consistency. Against Green, Anderson's claim is that

> If we can say that goodness is never *established* in a recognised order but is one tendency having to fight for survival (the good life lived in opposition to *the* world), we have the important point that the opposing forces will be represented in the government just as much as the goods themselves (pp. 8, 10).

The logic of pluralism indicated that even within any particular institution different organisational principles would compete with each other. For Anderson, the division of civil society into different groups offers a latent theory of subsystems. Different rules can regulate each subsystem with no common rules for the whole system. Against this,

> the individualistic point of view is connected with a society in which there has been a considerable loss of freedom ... it substitutes an imaginary freedom in the form of abstract citizenship for a real freedom in the form of devotion to particular cause (pp. 15, 38).

Society had no centre, which was as it should be.

III

Did Anderson then reject his earlier thinking in order to become a cold warrior? The image of cold warrior is arguably misplaced. Anderson's sense was that communism became public enemy number one. Free thought indicated that the only defensible intellectual attitude was critical suspicion toward all current superstition, all systems of consolation, protection or salvation. By 1949 Anderson supported Chifley in the Coal Strike, opposing the ban on the CPA but himself repudiating communism. He refused to allow the Freethought Society to hear the NO Case against the ban (Baker 1979, 128). Baker suggests that this be explained as a 'hardening of the categories' (p. 145). The problem seems rather to consist in closing lines of vision.

Anderson's earlier world seemed open. His favourites were Cézanne and Mozart; he admired Orage and Melville, even Kenneth Grahame, more predictably Dostoyevsky. He was a devastating critic of Fabian utopians such as Shaw and Wells.[2] His collected educational writings make up a volume in

2 See the essays collected together in *Art and Reality*.

their own right (see Phillips 1980). How could it be that he became transfixed upon communism? The capitalism of his own time was evidently less rapacious in its claims than it is in the era of economic rationalism. Anderson saw socialism as oppositional, as compromised by its own advocacy. Even late in his life – as late as 1960 – he admired Guild Socialism as presenting the view of craft, or the producer in society (Anderson, Cullum and Lycos 1982, 242). Easily, too easily had he set upon the notion of a producers' ethic. The narrowing of his later view is in one sense already implicit in this earlier insistence. As has been seen, Anderson did not restrict the idea to the proletariat; the motivating motif was activity rather than production in the workerist or syndicalist sense.

Today we would say that the metaphor cannot stretch; if by production is meant creation, then we ought speak of creation. Anderson evidently rejected the notion of empty activity, action and order almost for its own sake as enthused for example by Shaw (Anderson, Cullum and Lycos 1982, 135; Beilharz 1992, ch. 3). But he was closer to Cole, with his identification of the human as producer-creator, than to the Webbs, who attempted to adjust for difference by speaking of humans as simultaneously producers, consumers and citizens (see Cole 1920; Webb 1920). Anderson does not seem adequately to have entertained the possibility that the syndicalist anthropology was either too narrow, masculinist or premodern. His argument is thus too readily vulnerable to the reading that societies are based on some kind of struggle between the two organisational principles of production and consumption. Thus he wrote in his essay on 'Marxist Ethics' (1937) that the truth of the 'economic interpretation' is that society is production, and that consumption is only incidental to its history' (Anderson 1962, 327).

If we step outside of the circle of his own reasoning, it then becomes possible to question the questioner himself. Anderson seems to associate servitude, servility and service. He plays on the manifold unsavoury connotations of consumption in ways that would have done both Ruskin and Marcuse proud. But even Ruskin, who made so much of the ambiguity in words like 'possession', had more nuanced sensibilities about consumption. The sense that consumption was also a determinant of production was elaborated by Beatrice Webb, in her argument that demand for cheap goods called out sweatshop labour conditions (Beilharz 1992, 73). In our own times, many would argue that the sources of human identity have become even more pluralised and diverse, and certainly some – not only postmodernists – would choose to identify consumption as a positive process. The figure of the flâneur is no longer lonely, these days; it is less controversial than it

once was both to criticise shopping malls and to stroll in them. To modify Bakunin somewhat, the urge to consume can also be a productive act; and somewhat like the firm distinction between mental and manual labour, it may be less than clear precisely what the defining line between production and consumption actually is.

Some of the echoes from the syndicalist moment may thus be hard to hear, today, for the muzak and the squabbling of children. There are other parts of Anderson's voice which are also hard to hear, or to sympathise with. The most obvious of these is arguably Anderson's contempt for the idea of welfare. Anderson's perspective is awkward: he is the secure person taking risks, advocating from the quad that we all live dangerously. One echo here is in the hard distinction suggested by Hannah Arendt, between politics proper and the social question. Arendt's penetrating but frightening view was that the interference of the social into the political meant the end of politics (Arendt 1958). While the argument stings, it is nevertheless somehow difficult to say that it is of this world. Like the ethic of the producers, the purity of politics is gone, like the small, independent university which Anderson knew. Citizens know that they are limited and constrained in their capacity to be active by the limits of the life-chances into which they are born. Anderson knew that humans were interrelated in the beginning; and he did by example serve. It may simply be that the choices are less stark than he imagined. If he was a pragmatist, it may perhaps then be said that he was not, finally, pragmatist enough. Anderson in one place speaks about the desire for unity and the need to recognise and face absolute insecurity (Anderson 1942, 17–18). The choice is too stark: it would surely be more apt to advocate the recognition of contingency. If history is activity in context, then the servile state remains one force among others: if there is, as Anderson thought, no final result, then the future remains more open than he, or the syndicalist moment, could allow. As Sorel would have it, the struggle is more important than victory. Not the arrival, but the journey matters.

Acknowledgements

With thanks to Kenneth Smith and the archivists of the University of Sydney, to Peter Murphy, Brian Kennedy and Alastair Davidson.

References

Anderson, J. 1936. Social Service in *Freethought*. Sydney: University of Sydney Archives.

Anderson, J. 1940. The Nature of Mental Science. Lecture, University of Sydney Archives.

Anderson, J. 1941. Lectures on Green's Principles of Political Obligation. Lecture, University of Sydney Archives.

Anderson, J. 1942. Political Theory. Lecture, University of Sydney Archives.

Anderson, J. 1955. Greek Theories on Education, #2. Lecture, University of Sydney Archives.

Anderson, J. 1962. *Studies in Empirical Philosophy*. Reprint, Sydney: Angus and Robertson.

Anderson, J. c.1932. The Working Class. Lecture, University of Sydney Archives.

Anderson, J., G. Cullum, and K. Lycos, eds. 1982. *Art and Reality. John Anderson on Literature and Aesthetics*. Sydney: Hale and Iremonger.

Arendt, H. 1958. *The Human Condition*. Chicago: Chicago University Press.

Baker, J. 1979. *Anderson's Social Philosophy. The Social Thought and Political Life of Professor John Anderson*. Sydney: Angus and Robertson.

Baker, J. 1986. *Australian Realism. The Systematic Philosophy of John Anderson*. Cambridge: Cambridge University Press.

Beilharz, P. 1992. *Labour's Utopias*. London: Routledge.

Cole, G.D.H. 1920. *Guild Socialism Re-Stated*. London: Parsons.

Docker, J. 1974. *Australian Cultural Elites*. Sydney: Angus and Robertson.

Hayek, F.A. 1944. *The Road to Serfdom*. Sydney: Dymocks's.

Horne, D. 1968. *The Education of Young Donald*. Melbourne: Sun.

Kennedy, B. 1995. *A Passion to Oppose: John Anderson, 1893–1962*. Melbourne: Melbourne University Publishing.

Pateman, C. 1970. *Participation and Democratic Theory*. Cambridge: Cambridge University Press.

Pateman, C. 1986. *The Sexual Contract*. Cambridge: Polity.

Phillips, D.Z., ed. 1980. *Education and Inquiry: John Anderson*. Oxford: Blackwell.

Webb, S. 1920. *A Constitution for the Socialist Commonwealth of Great Britain*. London: Longmans.

Herbert Vere Evatt

Chapter 11

The Young Evatt – Labor's New Liberal (1993)

In 1936 H. V. Evatt published *The King and His Dominion Governors*. Although not yet quite at the height of his achievement upon the world stage, Evatt was already the leading statesman in-the-making, at home and abroad. A figure no less than Harold Laski introduced the volume. The title page of the book testified to Evatt's prestige, as well as indicating something of his own sense of achievement. Evatt presented himself to the world as follows:

> The Honourable Mr Justice HERBERT VERE EVATT, MA, LLD (Sydney), Justice of the High Court of Australia, Sometime Challis Lecturer in the Faculty of Law, Sydney University; Harris Scholar and Wigram Allen Scholar; University Medallist in the Faculty of Law and University Medallist in Philosophy, University of Sydney (Evatt 1936, 1924).

Evatt's cameo tells us something of his self-image; it also signals something of the significance of his student days. Evatt used a similar profile in his electioneering. An undated pamphlet was addressed to the school children of Barton:

> DR HERBERT V. EVATT, P.C., LL.D, D. Litt, K.C., M.H.R. (for Barton) Scholar – Jurist –Statesman – Author – Sportsman

> Most boys and girls have read in history the stories of great men and women in far-off lands and far-off times, but how many know of the great men of our own land and our own time? Read now this short summary of the scholastic record and practical achievements of a great Australian, remembering that in Australia, with due attention to study, this may be achieved by any boy or girl.[1]

[1] From the "Biographical" Evatt Collection, Flinders University of South Australia.

This is followed by a two-page, fine-point, anything but short summary of achievements. A further variation among Evatt's papers is a handbill in mock scroll format, which begins 'Every man is the maker of his own career. The Scholastic Career of Herbert Vere Evatt K.C. M.A. LL.D.'[2]

All this says a great deal about Evatt's sense of education, and of his intellectual origins at the University of Sydney. Evatt was at Sydney in that extraordinary moment when Francis Anderson and Mungo MacCallum propagated the insights and enthusiasms they had imbibed from Edward Caird and Sir Henry Jones, the Glasgow idealists (see Jones and Muirhead 1921; Boucher 1990). Here was an atmosphere where the culture was British but also Germanic, drawing on Goethe, Hegel and Carlyle, taking very seriously across the nascent disciplines the problems of education, citizenship and the good society. And the students were as exceptional as the teachers. Evatt's peers included A. P. Elkin and V. G. Childe and the broader setting came to include figures such as G. V. Portus and Meredith Atkinson, the educators and the educated (see Wise 1989; Gathercole, Irving and Melleuish 1995; Portus 1953; Atkinson 1919; Atkinson 1920; Rowse 1978).[3]

Posterity bestows upon us an Evatt later better known, victorious at the United Nations, having his necktie adjusted by Clement Atlee, frogmarched by Douglas Macarthur, embattled during the Petrov Affair. Behind these later, world-historic images there is then another Evatt, a young Evatt who was a Sydney new liberal even before he took up his pact with the ALP. The purpose of this paper is to examine the writings of the young Evatt in order to establish the nature of his thinking, and to cast light upon its subsequent development into a legal or constitutional mode.

Two notes of context must be sounded before proceeding. The first concerns the new liberal tradition itself, the second, the local setting within which new liberalism flourished.

What does it mean to speak of new liberalism? New liberalism as a doctrine arguably originates in John Stuart Mill's biographical opening

[2] Handbill, "Biographical", Evatt Collection. Evatt's record was indeed illustrious; his only B grade was in German at Fort Street in 1911. His student record also shows a 1917 MA in Logic and Mental Philosophy, "Social and Political Tendencies in Australia", which is evidently missing. H. V. Evatt, Biography 779, Archives, University of Sydney; Conferring of Degrees, 14. 4. 1917, *Senate Minutes*, April 1913–December 1917, pp. 407–8.

[3] The early relationship between Evatt and Childe seems to have been especially close – Evatt wrote to Childe that he regarded him as his political father, and that he was prepared to renounce "bourgeois radicalism". Censor's Precis, Evatt to Childe, 3. 12. 1918, Australian Archives MP 95/1, File 167/57/68. I owe this reference to Terry Irving.

towards socialism in his *Principles of Political Economy*. With the passing of the Victorian period it became more and more evident that the prospects of citizenship were obstructed by impediments to individual development such as class and gender. The obsession of early liberalism with the protection of the individual from the state gave way to a stronger positive sentiment, that the state must need intervene in order to enable individual development. Here, in effect, are to be found very many of the key themes which came to be associated with social democracy after World War Two— the significance of health and of education, the necessity of individual wellbeing as a prerequisite of social participation, the reward of merit, the hope that individual freedom might be constructed positively rather than negatively.

Hobhouse had earlier called this kind of politics liberal socialism (Hobhouse 1911). While he and others remained keen to differentiate the various arguments for social reform, however, the milieu within which new liberalism emerged involved a catholicity of claims and a plurality of actors. There were family connections, in both senses, between reformers, Christians, social workers and researchers, Toynbee Hall, the Fabian Society, and the Charity Organisation Society, all of which were drawn together by what Beatrice Webb called 'the class consciousness of sin' (Webb 1979, 182, 207). While these actors have long attracted the interest of historians however, it is only relatively recently that theorists have puzzled more thoroughly over the content of their ideas. Only under the yoke of Thatcherism has new liberalism been recognised as the most powerful of intellectual forces in British history for the first half of the century. As Michael Freeden puts it, the new liberalism became caught up in the most deceptively pyrrhic of defeats; the institutional form of liberalism expired at the very moment when its ideological influence was most pervasive, in the confluence of policy across Keynes, Beveridge, Fabianism and the Atlee Government (Freeden 1986, 371; 1978). Thus new liberalism continues to elude critical scrutiny, even though it offers a valuable tradition for radicals today.

And the local setting? The Australian path of development offers an only slightly paler imitation of the British, for Australia had its own traditions of colonial liberalism. They are clearly evident in the efforts of local figures such as David Syme in the public sphere and H. B. Higgins in the law (see Macintyre 1991). Despite the renewed academic interest in new liberalism, however, most work to date has been governed by the need for recovery rather than explanation, and this in Britain and Australia alike. Freeden, for example, identifies the key characteristic of British new liberalism as its collectivist rendition of the evolutionary thinking which was so vital

to nineteenth century sociology (see Freeden 1986, 1978; Burrow 1970; Beilharz 1991). But there has emerged no more elaborate political typology of new liberalism, its conceptual contours or internal shifts and differences.

In Australia new liberalism has been presented as a kind of ether which constitutes all mainstream political discourse (see Rowse 1978; Bourke 1987; Melleuish 1989; Roe 1984; Docker 1974).[4] But there is more to the story than this. What the Australian experience suggests, it will here be proposed via Evatt, is a bifurcation between educational and legal impulses. New liberalism comes to take two quite distinct, though related turns, one towards community, the other towards constitutionalism and nation-building. The educational stream, identifying with the values of *Bildungsprozess*, rests on values such as locality and the public sphere; it is best expressed in experiences such as those of the Workers' Educational Association in Britain and Australia, and across the oceans has had as its beacon the towering figure of John Dewey. The legal current, by contrast, rests on values such as rights and justice within the framework of constitutional law. In Australia its clearest innovation was arbitration, and its best slogan was that provided by Higgins' hope that ours was 'a new province for law and order' (Higgins 1922). Higgins' book, which Evatt much admired, was to be published in the WEA series, usefully reminding us of the various fusions and intersections between the currents. The legal current nevertheless becomes dominant within Australian Labor thinking, arguably until the ascendancy of Whitlam who, of course, was an educator aspirant as well as a legislator (see Beilharz 1989). The educational current informs Labor thinking through the activities of the WEA intellectuals among others, some of whom later become active in the Australian Institute of Political Science, but the orientation to community largely lies dormant until the 1960s. Between these periods the educational legacy can be traced through the work of figures such as H. C. Coombs, but the dominant concern comes rather to be seen as that of constitutional obstacles to ALP policy.

Evatt's attraction to law, and his sense of affinity with Higgins describes a trajectory towards the legal current within new liberalism. In the work of the young Evatt, however, we find indications of the two streams running together. The world of the young Evatt was more cultural than legal. Evatt won prizes for some very fine pieces of writing. They were 'The 'Play Within the Play' in Elizabethan Drama' (Wentworth Medal, 1913), 'The Possibility

4 Rowse exaggerates the unmediated influence of Green and underestimates the
 radicalism in new liberalism.

of a Standard of Merit in Literature' (Wentworth Medal, 1914) and best known, the eventually published political essay 'Liberalism in Australia' (Beauchamp Prize, 1915).

In his literary essays Evatt is more generally given to definition than to historical argument, as is the case in the essay on Liberalism. In 'The Play Within the Play' (1913) he is less concerned initially with the device in the strong sense, as it is exemplified say in Hamlet's mousetrap, than he is with the more general issue of subplotting and representation. The use of the subplot, according to the young Evatt, is a staging device, a gesture in self-reference. The play within the play directs the attention of the audience to the fiction which is presented as the main plot. The audience watches the other audience on the stage. This then refers the audience back to life itself, for the internal reference signals that the main plot is also a play within the larger play of life. What this suggests, according to Evatt, is the arrival of dramatic self-consciousness. He illustrates this well by quoting Tieck's 'Die Verkehrte Welt'.

> Scaramouch is riding through the forest on his donkey; a thunderstorm suddenly comes on. One naturally expects him to take shelter. Not at all, 'where the deuce does this come from?' he cries, 'There's not a word about it in my part. What absurd Nonsense! My donkey and I are getting soaked. Machinist! Machinist! Hi! in the devil's name, stop it'. The machinist enters and excuses himself, explains that the audience (consisting of actors) had expressed a desire 'for stage thunder, and that he had consequently met their wishes.' Scaramouch entreats the audience to change its mind, but to no purpose, thunder they will have. 'What, in a sedate, historical play?' It thunders again; 'Its a very simple matter' says the Machinist 'you blow a little pounded colophony through the flame; that makes the lightning; and at the same moment, an iron ball is rolled overhead, and there you have the thunder' (Evatt 1913, 35).

Evatt makes clear his own disapproval of this playfulness – it is lawless, and his life was of course governed by respect for law.

These issues become clearer in 'The Possibility of a Standard of Merit in Literature', where we find Evatt discussing the issue of the necessity of judgement, or what today's philosophers would call the debate between objectivism and relativism. Evatt's journey is guided by Kant's *Critique of Judgement*; it necessarily comes upon questions about the relationship between reason and imagination in modern culture. Ought we to criticise, or

create? If we criticise, what then happens to the authentic voice of literature? The logic of Evatt's case is that criticise we must, but his is no merely mechanical defence of tradition or of canon (1913, 15). The problem, as he sees it, is the question what basis there is for judgement in an epoch which sounds rather like our own, where 'the flag of literary anarchy is almost flauntingly displayed' (Evatt 1914, 19). Evatt displays his own classicism in his rejection of Macaulay's assertion that English literature now overtowers earlier world literature. For Evatt this claim merely signals the contemporary reign of mediocrity. He prefers Goethe's plea, that the task is barely yet begun. He shows the influence of his teachers in indicating an attachment to *Sartor Resartus*, which he rightly calls a work of greatness unrecognised.

Now Evatt turns to the question of the author's role in interpretation. He praises Aristotle, 'It is in the exercise of our faculties that our experience lies', and concludes that 'we must make a study of great works from the point of view of the artist himself '.But more, 'criticism must not only interpret [use the authorial view, PB] but judge'. Evatt turns here frontally to embrace Tradition, but with the logic of a barrister …

> the very fact that the writer is, at the present, engaged in the construction of an essay which … must come under the superbly broad classification of 'literature', and that such essay is competitive – shows that – for the purposes of the University of Sydney – a standard of merit in literature does actually obtain (Evatt 1914, 29).

Here special pleading and appeal to precedent are bound up in one, in a sleight of hand anticipating Evatt's later indifference to the substantive issue involved in Bentham's *Plea for the Constitution* in his own paper 'The Legal Foundations of New South Wales' (Evatt 1938; cf. Bentham 1843).[5] To distance ourselves from the sense that the real is the rational, as we denizens of the 1990s are likely wont to do, is not, however, to dismiss tradition. Evatt proceeds to put his views less objectionably by quoting Landor, 'We admire by tradition' (Evatt 1914, 32). What Evatt avoids is the defence of tradition with reference to the norms and values it embodies, a course easily open to him via Carlyle or Goethe. He defends tradition in literature rather as precedent. The slide into formal logic, even when practised in aesthetics, culminates in Evatt's call for an arbiter, an authority in an Academy which ought to deliberate upon such vexed questions as he discusses. 'Personally,

[5] In *Rum Rebellion* Evatt seems to distance himself from Bentham because of Macarthur's reliance on his views.

I subscribe with enthusiasm to the verdict of Tradition and Posterity, as mediated through this Supreme Court of Literature' (p. 51).

Evatt is at his best in *Liberalism in Australia* (1918). It is an essay expressive of that moment when liberals could not sufficiently muster their own political forces, and looked upon labour with reservation. The scope of Evatt's canvas, again, is expansive. The survey opens with comparisons between the situation in Britain and in Australia. While Australia lacks an aristocracy, and hence a conservative party proper there is, all the same, a division of temperament between progress and tradition. Note the contrast between Evatt's stance in politics and that in aesthetics; in the former, he sides with progress, in the latter, with tradition. The British liberals were obliged to battle against obstacles, against the Corn Laws, in defence of Chartism; Australian liberalism, by comparison, may have 'languished at times for want of foes to conquer'. This is a distinct problem, for as Evatt notes, liberalism is progressive in a reactive kind of way – it sets out to remove hindrances which society places in the way of individual self-development. Evatt does not here countenance the stronger kind of argument, for which liberalism, if it is not to be merely reactive but pro-active, actually demands a positive, educational project rather than a negative, juridical stance. Australian liberalism did, for Evatt, have its historic tasks, but they were primarily to struggle against the convict past and the squattocracy, against 'irresponsible government' (p. 3). The transition to democratic forms could also, of course, be viewed more agnostically, as a transition from status to contract, but the young Evatt's view is more optimistic than this; he sketches out a process of advance which is in some ways reminiscent of Sidney Webb's description of evolutionary progress in *Towards Social Democracy* (1916; see also Maine 1890; Marshall 1950).

Where Webb traces the trend toward communal provision and municipal socialism, Evatt charts the onward march of representative democracy. Evatt suggests that convictism had to be opposed because of its negative effects upon character formation, an argument with resonances in the views of Sir Henry Jones, Alfred Marshall and Beatrice Potter (Evatt 1918; Jones 1909; Potter 1891, 228). But more, no government can endure permanently half slave, half free (Evatt 1918, 11). Now Evatt pauses to acknowledge the role of W. C. Wentworth, whom he views as a 'Liberal socialist', at least in the beginning (Jones 1909; Potter 1891, 228). In sympathy with Fabians and new liberals alike, he observes the presence in the local setting of arguments concerning the unearned increment, or the social or community role in the process of producing wealth (Evatt 1918, 31). His choice of authorities

throughout is as befits the new liberal – Carlyle, T. H. Green, Sir Henry Jones, Hobson, Lloyd George, the young Churchill.[6] In sympathy with their concerns, Evatt dedicates a chapter to Liberalism and National Education. He laments that educational concerns, in Australia, came late; irresponsible government and convictism took up all the energies of the local liberals (Evatt 1918, 42). The WEA is held up as an exemplar in both the local and British experiences; Evatt laments, in passing, the relative absence of the locality as an active realm within Australian education.

The ALP looms large, by contrast, yet Evatt shares the concerns of other *fin-de-siècle* liberals from Bryce to Deakin about the power of the party machine. In explicit sympathy with Webb, Evatt proposes that the party form is necessary, but that it produces corresponding problems. He has less doubts than Deakin, however, for he proceeds to endorse the identification of new liberalism with the principle of 'state interference', and it is the parties, of course, which do the interfering. Liberalism has one ideal, he states, the 'provision of external means for inner moral development'. 'The only unchangeable eternal principle to which a sound political philosophy can hold is the idea of moral development' (Evatt 1918, 54). Policies and strategies may change; liberalism takes up such means as it must, protectionist in one setting, free trade in another, in order to pursue these ends.

Like most reformers of his epoch, Evatt regards the extent of the Australian social achievement as already offering a landmark of progress in the form of 'socialism without doctrines'. He anticipates later arguments such as those of Eggleston and Duncan, that by their various enactments the Australian states are on their way to a greater measure of labour legislation than anywhere else in the world (Evatt 1918, 56; see Eggleston 1932; Duncan 1934). But if there is something of a global trend at work here, which Australia is simply leading, then this nevertheless remains a sober business, for liberalism sets itself apart from 'German theoretical socialism' (Evatt 1918, 59). Evatt turns now to attack the pledge, rejecting the claim to precedent ironically put by Hughes on the grounds that appeal ought rather be to right and to validity. Even if the pledge is widely practised elsewhere, this is still no recommendation. Nor is the pledge 'moral, expedient and necessary' as claimed. At this point Evatt breaks later ranks to side with Deakin, for it is his firm conviction that the party system ultimately violates

[6] It is interesting to note that while Evatt rarely marked his own books, his personal copies of Green's *Principles of Political Obligation* (1913) and his *Prolegomena* (1906) are heavily annotated. His Green, along with Marx, Mill and Keynes are in the Evatt Collection at Flinders.

the principle of representation (p. 59). He also cuts down the other stick with which labour opponents were later to beat him, in rejecting the principle of preference to unionists.

Evatt's views on the Labor Party are evidently ambivalent. The ALP, he pronounces, today takes its stand 'on what is termed 'evolutionary' socialism', or what we might call German practical socialism (pp. 60–61).

> Socialism represents so many aspects and embraces so many concept-ions and ideas that it is something to all men and something different to each point of view … [it is] an extravagant expression of that modern movement of thought which exalts the importance of material and economic interests at the expense of intellectual moral and religious principles (p. 63).

The new liberalism knows better. In Sydney or in Glasgow, it eschews the socialism of the stomach, and exalts rather the spirit. Thus Evatt refers to Green, and to the claim that social evolution concerns the struggle between the good of the people and the alien dogma of class interest (p. 78) Little wonder that Evatt would not yet embrace the Labor Party, for it is indeed a class party in both word and deed, and the politics of class is bound to collide with the claims of citizenship.

Evatt proceeds to repeat the view common to new liberals and idealists that individualism and collectivism effectively merge in theory and in practice. 'The whole tendency of modern politics to-day is towards the multiplication of the collective functions of society, and Liberalism is largely responsible for that tendency' (p. 73). The language summoned up by Evatt is that which infuses British thinking after Spencer, that of organism and function – 'democracy is founded not merely on the private interest of the individual, but also on the function of the individual as a member of the community'. For Evatt this illustrates Hegel's 'objective freedom', liberty realised in the state (p. 74). Did Evatt then elevate the State, as Hegel and Bosanquet did, or did he take sides with their English critics, such as Hobhouse or the pluralists, like Cole? At this stage of his life Evatt was not a vehement statist. In fact the logic of his thinking throughout his life was perhaps more constitutionalist than statist. Evatt later admired Holman's practical statism, but more as a sign of earthly achievement than as a matter of principle. Even then, the early Holman himself preferred Morris to Bellamy (p. 21). Evatt himself later took his own distance from the axiom that the extent of state activity was an accurate measure of progress in applying the radical programme. And while he sought the expansion of constitutional powers in

the forties, the nationalisation of banks was Chifley's great enthusiasm, not Evatt's.

Evatt proceeds, in *Liberalism*, to attack Bosanquet, who would in fact have agreed with at least part of his argument, for the differences were by no means as complete as has sometimes been imagined (McBriar 1987). The flaw in Bosanquet's case is a practical one, concerning the consequences of charity. Bosanquet proposes that small subventions demoralise the souls of the poor; large subventions are a different matter. The case is absurd, Evatt claims, but it is also asocial – as though Booth and Rowntree had never drawn breath, or poverty lines. 'If smallness is the real objection to the pension there is a very obvious remedy' (Evatt 1918, 75). The problem with Bosanquet's view is that it rests on the premise of the monad, it denies both spiritual and social solidarity. It reveals both a lack of feeling and a lack of logic – 'such critics as he are a valuable adjunct to the Liberal movement'. Against this, Evatt echoes the thinking of Justice Higgins: 'Liberalism claims ... that every citizen should have full means of earning as much material support as experience proves to be the necessary basis of a healthy civilised existence'. Again, it could be objected that Bosanquet in principle would agree; the difference, now, is that Evatt explicitly introduces the image later associated with social democracy, of equalising the running race against fate. The state needs to be active; the shift beyond contractualism is one from a negative to a positive theory of the state, from the conception of humans as means to one of them as ends.

> The result is the idea that material wealth exists for the sake of the moral development of man, not man for the sake of material wealth; and Liberalism does its best to provide the external conditions for more efficient and fuller lives (Evatt 1918, 75–6).

Evatt quotes Higgins to reinforce the point, and then proceeds: 'the great aim is to secure conditions which are necessary to the fulfilment of man's vocation as a moral being, and the work of developing the perfect character in himself and others'. Along with these echoes of Fichte and Goethe Evatt speaks against paternalism, if not against patriarchy.

But none of this is suggestive of socialism of the stomach. Evatt in fact sides with Churchill – 'Socialism attacks capital, Liberalism attacks monopoly' – and adds to it the safety net of a national minimum, leaving open the quest-ion of maximum aspirations. Yet if the Antipodes had an easier struggle than the British, they nevertheless provide an exemplar. 'Liberalism in Australia is the spirit of Liberalism taking its time to reveal itself, and teaching its

adherents in the rest of the world its new possibilities in practice, and even its new implications in theory' (Evatt 1918, 77). The values of Glasgow idealism echo throughout these pages, as Evatt quotes Jones in closing (Evatt 1918; see also Boucher 1990). Later in life, Evatt was to argue a variation of this view in his study of Holman. The logic of idealism remained with him. 'The history of parliamentary socialism in Australia, is the history of socialism attempting to realise itself 'practically', or, in other words, within the forms and framework of a capitalist society' (Evatt 1942a, 4).

Whatever else one might say on Evatt's arguments concerning liberalism, his essay represents an extraordinary achievement. In assembling these cases on literature or on liberalism as politics Evatt was barely yet twenty. His achievement is awesome, the breadth of his youthful knowledge intimidating. The motifs of new liberalism developed elsewhere by more mature minds are all there – individual and social development, organic evolution, *Bildung* as the end, state activity as the means, elevation of humanity the aspiration. Yet the democratic, educative impulse is also countered by the negative, reactive or legal appeal to tradition and to authority as values in themselves. Despite the contradictions, though, the young Evatt has a project, a positive vision of the good society. The course of his subsequent thinking was to take up the legal theme, to return to the defensive cast which Evatt had described as a defining attribute of nineteenth century liberalism, pitted against injustice rather than presenting a project in the stronger sense. In other words, Evatt's project becomes constricted, from these larger, more ambitious hopes, to those of a more minimal and defensive civil libertarianism; it eschews the pursuit of social democracy, and instead attacks such acts of injustice as present themselves.

By the thirties Evatt's optic has closed down, closer to that of classical liberalism than the new liberalism. The legal mind becomes more concerned with matters of technical detail than with fundamentals. Thus Evatt's teleological premise in the *Liberalism* essay, that the colonies could not continue on half slave, half free, led him away from serious consideration of the anomalies raised by Bentham. And thus his detailed consideration of the case of the Tolpuddle Martyrs was to focus attention upon the carriage of injustice within the law via the political misuse of the 1797 Act, rather than on the morality of time or place (Evatt 1937, 59). Yet Evatt clearly held freedom high, if now 'freedom from' more than 'freedom to'. For here he also recognises the tenuous nature of rights:

> Unless trade unionists throughout the world are always ready to
> sacrifice their personal interests, their safety, or even their lives for the

amelioration of the lot of the poor, their elaborate organization may perish overnight in a holocaust of terror and force or in the slower process of legal repression (Evatt 1937, 128).

These are words that could have come from the pen of a Marxist fleeing Frankfurt. But even as Evatt glanced into the impending horrors of the slaughterhouse, he was able nevertheless to conclude that the case of the Tolpuddle Martyrs represented 'the very coronation of injustice, and yet there was no technical breach of the law' (Evatt 1937, 128–9). The note of sobriety returns, however, as Evatt takes the point that it was politics, and not justice, which led to the pardons. And then the line swings again, as he closes on a positive note – the pardons were, finally, obtained, and the extreme punishment was thereby mitigated (Evatt 1937, 130). Faith could be placed in arbiters after all.

Evatt's sense of the new province for law and order was less triumphalist than that of Justice Higgins. Becalming the struggle between the classes was not his primary vocation. What then became of Evatt's new liberalism? Whence the spirit, whence the prospect of social elevation? There is one element of Evatt's thinking which always runs from spirit to letter, and culminates in that particular letter to Molotov. The defensive, civil libertarian motif remains clear enough into the forties and fifties; Doc Evatt is always there to save the day.

The preoccupation with law seems effectively to marginalise the hope of community and to minimise the pursuit of *Bildung*. Evatt could see this in others, if not in himself –as he wrote in his study of Holman, the lawyer's frequent failure was to appreciate that the main function of a parliamentarian was not to explain what is, but to describe what ought to be (Evatt 1942a, 564). Commonsense would suggest that Evatt learned the limits of his youthful hopes, sensibly directing his capacities where they were likely to be most effective. By the time he wrote *Australian Labour Leader* Evatt was ready to entertain the possibility raised earlier by his friend Childe, that such victories as labour tasted were all likely to go sour. His conclusion was more formally open than Childe's:

Political Labour's struggle towards socialism is dependent upon Mill's hypothesis that mankind shall continue to improve. At times the condition seems to be impossible of achievement. Then black despair suggests that the struggle for humankind avails nought. But victory may be at hand only if courageous leadership and loyal devotion remain (Evatt 1942a, 574).

..adition – were they enough to overcome the dialectic

Into the later years of Evatt's life, his sense seemed no longer to be that social obstacles to development could be removed by reforming governments but more that the establishment placed political obstacles all around, and larded them with the rewards of corruption. In this sense he remained both idealist and hatchet man. Even his boldest arguments in favour of temporary alterations to the Constitution fell back on to the American tradition associated with Brandeis and Holmes and expressed symbolically in Roosevelt's 'Four Freedoms', two negative freedoms and two positive, but civil freedoms (see Evatt 1942b, 83–5; Evatt n.d., 39–41). Certainly, on these grounds, he was duty bound to defend the rights of Communists. But Evatt was also to raise, for us if not directly for himself, the question of the compromised relationship between liberalism and democracy. Yet if the positive spiritual impulse of new liberalism weakens in Evatt's path towards Petrov, or is sublimated into his enthusiasm for the United Nations, the interest in drama remains constant. Clearly Evatt viewed the lives of others, such as Bligh, as tragedy, and came more and more to view the stage local or larger as dominated by deceit and suspicion, their stories cloaked and concealed, told by idiots of various persuasions and signifying nothing (Evatt 1965, 143). Law offered a shield against such a world. And even when Evatt sought the extension of the law, the power of which he also feared, he called upon the rhetoric of theatre to put his claim. Like Lloyd Ross and W. G. K. Duncan, he saw the choice starkly as 'to plan or not to plan – that is the question' (Evatt 1942b, 7; cf. Duncan 1934).

Probably it is the tendency of new liberalism to lapse back into older habits which explains why some radicals expect so little of it. When besieged, sometimes even when ascendant, liberalism returns too easily to the negative freedoms or material premises of those such as Beveridge who straddled the centuries (see Beveridge 1944; Harris 1977). Evatt, in his own way, also straddled the centuries, as do we ourselves. Liberalism remains with us, for all its weaknesses; as fundamental as it is to Labor thinking, it is difficult nevertheless not to wonder whether its strengths have yet been tapped. In Evatt's case the strengths, too, often remain unrecognised, for he did not sacrifice his ideals; the problem was rather that he failed, albeit in a hostile setting, to make them sufficiently evident. Thus must we return to our roots.

References

Atkinson, M. 1919. *The New Social Order*. Melbourne: WEA.

Atkinson, M., ed. 1920. *Australia: Economic and Political Studies*. Melbourne: Macmillan.

Beilharz, P. 1989. The Labourist Tradition and the Reforming Imagination. In *Welfare Essays – Historical Sociology*, edited by R. Kennedy. Sydney: Macmillan.

Beilharz, P. 1991. *Labour's Utopias: Bolshevism, Fabianism, Social Democracy*. London: Routledge.

Bentham, J. 1843. A Plea for the Constitution in *Works* IV, edited by J. Bowring. Edinburgh: William Tait.

Beveridge, W. 1944. *Full Employment in a Free Society*. London: Allen & Unwin.

Boucher, D. 1990. Practical Hegelianism: Henry Jones's Lecture. *Journal of the History of Ideas* 51(3): 423–452.

Bourke, H. 1987. Social Scientists as Intellectuals: From the First World War to the Depression. *Intellectual Movements and Australian Society*, edited by B. Head and J. Walter. Melbourne: Oxford University Press.

Burrow, J.W. 1970. *Evolution and Society*. London: Cambridge University Press.

Docker, J. 1974. *Australian Cultural Elites*. Sydney: Angus and Robertson.

Duncan, W.G.K. 1934. *National Economic Planning*. Sydney: Angus and Robertson /A1PS.

Eggleston, F.W. 1932. *State Socialism in Victoria*. London: P. S. King.

Evatt, H.V. 1913. The 'Play Within the Play' in Elizabethan Drama. Wentworth Medal for English, Fisher Library. University of Sydney.

Evatt, H.V. 1914. The Possibility of a Standard of Merit in Literature. Wentworth Medal for English, Fisher Library. University of Sydney.

Evatt, H.V. 1918. *Liberalism in Australia. An Historical Sketch of Australian Politics Down to the Year 1915*. Sydney: Law Book Company.

Evatt, H.V. 1924. Certain Aspects of the Royal Prerogative: A Study in Constitutional Law. LL.D diss., University of Sydney.

Evatt, H.V. 1936. *The King and His Dominion Governors, A Study of the Reserve Powers of the Crown in Great Britain and the Dominions*. London: Oxford University Press.

Evatt, H.V. 1937. *Injustice Within the Law. A Study of the Case of the Dorsetshire Labourers*. Sydney: Law Book Company.

Evatt, H.V. 1938. Legal Foundations of New South Wales. *Australian Law Journal* 11, 18.

Evatt, H.V. 1942a. *Australian Labour Leader & The Story of W. A. Holman and the Labour Movement*. Sydney: Angus and Robertson.

Evatt, H.V. 1942b. *Postwar Reconstruction. A Case for Greater Commonwealth Powers*. Canberra.

Evatt, H.V. 1965. *Rum Rebellion: a study of the overthrow of Governor Bligh by John Macarthur and the New South Wales Corps*. Sydney: Angus and Robertson.

Evatt, H.V. n.d. *Postwar Reconstruction. Temporary Alterations of the Constitution*. Canberra.

Freeden, M. 1978. *The New Liberalism*. Oxford: Oxford University Press.

Freeden, M. 1986. *Liberalism Divided*. Oxford: Oxford University Press.

Gathercole, P., T. Irving and G. Melleuish, eds. 1995. *Childe and Australia: Archaeology, Politics and Ideas*. St Lucia: University of Queensland Press.

Harris, J. 1977. *William Beveridge*. Oxford: Oxford University Press.

Higgins, H.B. 1922. *A New Province for Law and Order*. Sydney: WEA.

Hobhouse, L.T. 1911. *Liberalism*. London: Oxford University Press.

Jones, H. 1909. *Idealism as a Practical Creed*. Glasgow: Maclehose.

Jones, H., and J. H. Muirhead. 1921. *The Life and Philosophy of Edward Caird*. Glasgow: Maclehose.

Macintyre, S. 1991. *A Colonial Liberalism.* Melbourne: Oxford University Press.

Maine, H.S. 1890. *Ancient Law.* London: John Murray.

Marshall, T.H. 1950. *Citizenship and Social Class.* Cambridge: Cambridge University Press.

McBriar, M. 1987. *An Edwardian Mixed Doubles: The Bosanquets versus the Webbs: A Study in British Social Policy, 1890–1929.* London: Oxford University Press.

Melleuish, G. 1989. Liberal Intellectuals in Early Twentieth Century Australia. *Australian Journal of Politics and History* 35(1): 1–12.

Portus, G.V. 1953. *Happy Highways.* Melbourne: Melbourne University Press.

Potter, B. 1891. *The Co-operative Movement in Great Britain.* London: Swan Sonnenschein.

Roe, M. 1984. *Nine Progressive Intellectuals.* St Lucia: University of Queensland Press.

Rowse, T. 1978. *Australian Liberalism and National Character.* Malmsbury: Kibble.

Webb, B. 1979. *My Apprenticeship.* Cambridge: Cambridge University Press.

Webb, S. 1916. *Towards Social Democracy.* London: Fabian Society.

Wise, T. 1989. *The Self-Made Anthropologist. A Life A. P. Elkin.* Sydney: Allen & Unwin.

Vere Gordon Childe

Chapter 12

Vere Gordon Childe and Social Theory
(1995)

What was Childe's contribution to social and political theory? *How Labour Governs* (1923) is widely recognised as at least a minor classic in Australian political sociology. Yet Childe has long had an ambivalent status as a social theorist. His prominence is accompanied by a sense that Childe was implicitly following Michels, i.e. telling us what we already knew: that nothing much could ever be expected of political parties when it came to arguments for socialism. Following the recent work of T. H. Irving, I seek in this paper to inquire into these two related issues – the question of Childe as sociologist of the party, and the question of Childe as social theorist. How does *How Labour Governs* stand viewed in the context of work such as Michels' *Political Parties* (1915), Ostrogorski's *Democracy and the Organisation of Political Parties* (1902), Hans Müller's *Der Klassenkampf in der deutschen Sozialdemokratie* (1892), and how does his work relate to that of other socialists such as Lenin, Cole and Gramsci? Second, how does Childe's work emerge from such a contextualisation in terms of social theory itself? Was Childe a significant thinker? Does his work represent something of an enduring legacy? In order to present this case, I need firstly to establish some sense of the nascent sociology of the party as it appeared especially in the hands of Michels (and Weber), for whom the central problem was the mass political party exemplified in the institution of the German Social Democratic Party. The logic of this argument is that organisation itself militates against the achievement of socialism. Here Müller's case is also important, not only because he wrote the first sociology of the party and focussed also upon the SPD, but also because his logic seems to anticipate that of Childe. Where Michels viewed the problem of the party as a problem of the state, Müller viewed it as a problem of class composition. He argued, like Childe, that the mass party has a dual character, which corresponds

eschewed the general philosophy of history which for Michels doomed all socialist experiment in advance. While Childe wrote his study in a self-sufficient way, without reference to any of these other minor classics, he did not refer explicitly, either, to Cole or to Webb. Contextually, however, the affinity with parts of Fabianism was there, because while the mass party was one major problem for Childe, there was also another: that of Syndicalism. *How Labour Governs* is better read as a work which sits between these problems. If we shift, then, to the broader question of the status of Childe's book as social theory, it becomes apparent that the specificity of his political argument is also suggestive of its status as social theory. For Childe retained a sense of the open-ended nature of history, a position which was not available to thinkers such as Michels, but which is actually far more useful to us today.

Who was Vere Gordon Childe? The most common answer to this question would be that he was an Australian prehistorian who also wrote a book about the Labor Party. This kind of characterisation is basically accurate, with the minor proviso that the book was about labour politics, and not just about the Australian Labor Party.

How should we read Gordon Childe? This question is more difficult to answer, except with the platitude that his work can be read in many different ways; most obviously, as a prehistorian and as a political thinker or historian. In this paper I want to puzzle over the question of Childe's status as a political sociologist and as a social theorist. But why 'puzzle'? There is a strong lineage in western culture which views clarity and simplicity as the real virtues of social theory. The argument probably starts somewhere around Plato, and culminates, for us, in analytical philosophy. Its appeal is seductive. Yet it distracts us from the task of taking seriously all those traditions and thinkers that are uncertain and complex. This puts us in a bind, for the most interesting thinkers are often exactly those over whom we must puzzle, whose work is incomplete, if not contradictory.

Gordon Childe is an attractive thinker because he belongs in this category. This is the task of puzzling which I set myself in this paper. The larger puzzle consists in the relationship between Childe's archaeology and his politics, or more loosely put, in the question of Childe's relation to Marxism. The

smaller puzzle taken on here concerns the question of the theoretical status of his central political work, *How Labour Governs*. In the first section of this paper I discuss the sociology of the party around the time when Childe wrote *How Labour Governs*. My purpose is not to convert Childe into a sociologist of the party, but to read *How Labour Governs* as a contribution to that project, so I begin by establishing something of the scaffolding, built up by Müller, Ostrogorski, and Weber, and especially by Michels, that makes up the sociology of the party. In the second part of the paper I offer a reading of Childe's book as a sociology of the party. In the third part, I offer some tentative reflections on the status of Childe's thinking in broader terms of social theory.

The Sociology of the Party

The first observation which ought to be made about the sociology of the party is that there is really no such thing. Sociology of the party has always been, and remains, an unfulfilled project. Like the theory of citizenship, courtesy T. H. Marshall, the sociology of the party had its founding manifestoes – most strikingly, Michels' *Political Parties* – and relatively little by way of substance that followed. Certainly there were more-or-less explicit theories of the party in Lenin, in Gramsci, and more recently in critiques of the new class, and in theories of labourism, corporatism and social democracy (see Lenin 1975; Gramsci 1971; Gouldner 1979; Miliband 1961; Panitch 1986; Przeworski 1986). Probably it is fair to suggest that the prospect of a sociology of the party eventually disappeared into political science via Duverger, McKenzie and Kircheimer or else via Roth and others into historical sociology, which remains obsessed with matters of the state (see Jaensch 1989; Evans, Ruschemeyer and Skocpol 1985). In more general terms, the concerns of a sociology of the party have simply been subsumed to those of government. The purpose of the party – to win (or seize) state power – has meant that its own dynamics have been submerged in the concern with the state. This is less than universally helpful, partly because it overlooks the significance of opposition, partly because it eliminates from vision the extent to which parties operate as part of civil society, or as social movements, which they also to some varying extent are (Beilharz and Murphy 1991).

In any case, the state of the art in sociology of the party in Australia directly reflects the global phenomenon – with Childe, too, we have a founding document, but little in the way of a substantive tradition to follow. Like Michels' work, Childe's was an historically specific response to the

...ved up to their nostra as to make future scholarly work redundant.

Michels' is usually taken to be the pioneering work on parties. There is, however, one important political precedent, Hans Müller's *Der Klassenkampf in der deutschen Sozialdemokratie*, and one leading analytical account which precedes Michels, Ostrogorski's (Müller 1892; Ostrogorski 1964; Ostrogorski 1902). Müller's book was a polemic directed against the elders in the German Social Democratic Party, the paradigm case and historical exemplar of the mass left party. His view was that the SPD had gone rotten under Bismarck's anti-socialist laws, because these laws actually effected a transformation in the class composition of the party. Earlier leaders had been proletarians all. Under the anti-socialist laws many of them actually became petty bourgeois. Before Bismarck's laws, they worked as proletarians (more likely, as craft-labourers) for capitalists. Under these laws, they found themselves blackbanned; unable to secure positions as labourers. So they set up shops, or small enterprises of their own, and thus emerged the patrician inn-keeper culture which finally came to dominate the SPD into the twenties. Müller, of course, could not have anticipated the extent of the latter development, but it can easily be extrapolated from the logic of his argument. That logic is signalled clearly enough in the title of his work – the problem concerns the class struggle in the SPD, that between proletarians and unions on the one side and petty-bourgeois and leaders on the other. Müller's argument is suggestive of anything but a metaphorical or ironical use of the slogan of class struggle. The struggle in the SPD for him was not like a class struggle, it was a class struggle. Here Müller formulated a theme which becomes resonant throughout the histories of later socialisms. It is the theme of workerism: proletarian good, petty bourgeois bad; the view which found its formal apogee in Trotsky's *Defence of Marxism* (and himself) as correct because it possessed appropriated and authorised proletarian credentials.

Müller set out from the proposition, which would have pleased Marx well enough, that it was necessary to make a fundamental distinction between what the party said and what it did. Contrary to the enthusiasm for the revolutionary half of the Erfurt Programme, Müller insisted that programmes tell us nothing about the character or essence of a party. The

problem is that the mass of the party does not see itself in them – and why? Because in the party there are more people who are uneducated than educated (Müller 1892, 10, 12). Class analysis explains this. There are three classes, and logically there should be three parties. Only the working class is revolutionary; the petty bourgeoisie is anti-capitalist, but reformist, and this is where the mess begins. Cigarmakers, it appears, have been the downfall of the party – there is not now a single wage-labourer in the Reichstag. The SPD was a proletarian party, but with petty bourgeois representatives (Müller 1892, 16, 20). Under illegality, the parliamentarians lose their allowances and become entrepreneurs. This places them in a paternal relationship to workers. The leaders become deproletarianised, in terms of their habits, sense of place, and patterns of everyday life. In any case, parliamentary activity, in the 'talking-shop', is a petty bourgeois predilection, compared to the realm of real politics or mass activity (Müller 1892, 21).

Müller's argument was at the same time crude and nuanced – crude in its premises, yet nuanced in its sense of process. For his view was not that there was an influx of petty bourgeois, like a middle-class 'Lenin-levy', but rather that the class membership of the leaders was actually transformed, without anyone so much as noticing. At the same time, the case is not persuasive, for there is something sociologically naive about its logic – it is as though divisions of labour are abnormal rather than normal, as though the priests had not prefigured the process somewhat earlier. Müller was evidently an enthusiast for the one-class utopia of labour. Thus he proceeded to restate the case for revolution, and not for evolutionary pamphlets à la Kautsky. The revolution, however, must now begin in the party, between the revolutionary proletarians and the opportunistic petty bourgeoisie. Presumably this will result in the end of electoralism, although electoralism was a result of petty bourgeoisification and not self-evidently its cause (Müller 1892, 22–3, 76).

Müller's argument and many variations and independent derivations of it can be found throughout subsequent discussion. Certainly the rise of the middle class and the sociology of professional power reflects this (see Beilharz 1985; Larson 1977). Müller even alluded to some of these possibilities when he identified education as a key variable, only then to subsume it in the class struggle. The sociology of the party took on quite a different direction in the hands of Ostrogorski. Like Weber, Ostrogorski viewed capitalism or class as one major analytical variable in the explanation of politics, but be also viewed politics as a site of struggle in its own terms. It had its own sets of spoils, and it developed its own electoral and financial dynamics. Machine politics involved corruption and the power of class, but it was also

good rather than a participatory culture (Ostrogorski 1902, 624).

Ostrogorski set out to explain two major experiences of party formation, those in England and in America. Like Halévy, he brought to his book the clarity of vision possessed by the outsider. Evidently he influenced Weber, who visited the United States in 1904. Ostrogorski surveyed the entire history of party political activity in England and America. He approached his task with the self-conception of the social scientist, yet the message which finally ensues was little more optimistic than Michels'. But Ostrogorski's pessimism was of a different kind. It related more directly to the concerns expressed by leading scholars such as Lord Bryce, regarding the ways in which party voting and its attendant mechanisms were antithetical to the growth of an active and independent citizenry (pp. ix–xiv). Whereas Bryce, like his local follower Alfred Deakin, viewed parties as generally problematical in that they complicated and potentially obstructed the relation between state and citizen, other thinkers such as Durkheim and the Webbs viewed the absence of such mediation as the problem. Ostrogorski, for his part, identified the particular institution of the caucus as the central problem, but like Weber he located this concern within a modern vista where machine politics and mass culture were the broader negative trends.

The striking difference between Ostrogorski's orientation and those of the other thinkers sketched here is the absence of socialism from the picture. Ostrogorski set out to explain the party form which was dominant in the Anglo experience, and in the period before the emergence of the British Labour Party. His story thus focused on the transformation of clubs into parties in England, and on the forms of brokerage and patron-client relations in America. Caucus emerged as a problem because it massified politics – its dynamics militated against independent and critical thinking, and facilitated the dominance of the wire-pullers. This reflects broader trends towards the privatisation of civic life. Before the apparently progressive repeal of the paper duty in 1860, the individual worker in Ostrogorski's romanticised world-image could not afford a newspaper, so the whole workshop subscribed, one worker read out aloud, all discussed the issues and each learned. It was a civic process. Now each individual buys the *Sun*, and takes what he likes from it. Plainly Ostrogorski was alert to the problems of the other agencies which

came to stand between individual and state, such as the mass media itself, and was already anticipating the alienating effects of such developments. More, just as politics becomes an act of consumption, so does consumption – not least of alcohol in workingmen's clubs – stand in for politics. Failing to aspire to the Aristotelian condition of the *zoon politikon*, parties seek to appeal to the animal side of men. Self-interest thus becomes the currency of political life as such, for politicians and followers alike (pp. 177, 193, 196).

By its very logic and operation, then, the caucus 'bids fair to set up a government by machine instead of a responsible government by human beings'. As society was separated from politics, so was politics separated from principle. The party becomes an end rather than a means (pp. 304, 331). These problems became heightened when he turned to the American experience. Where the English had grappled with the old corruption only to disappear under the weight of the caucus, the Americans had produced the paradigmatic instance of machine politics in cities such as New York. His detailed narrative again reached back to origins; his argument effectively extends de Tocqueville's hopes and fears for American democracy, more notably the latter. The general thrust of the argument is not difficult to anticipate – mechanical politics overpower democracy; the party, designed as an instrument for the purpose of facilitating democracy, itself comes to dominate the process. The successful politician is not he who reads Aristotle, but he who has the numbers. Like Weber, Ostrogorski had a specific interest in the personality-type which is encouraged by this state of affairs, and found little cause for joy in the results. The TV figure of Boss Hogg leaves the stills of the *Dukes of Hazzard* and glowers in the margin of Ostrogorski's text, for this kind of corruption and dealing out of the spoils is by no means limited to ethnic brokerage in the cities. The American experience thus represents a more pure type of the problem of the political party (p. 367).

Ostrogorski's focus upon the Anglo-American experience obviously precluded the mass labour or social democratic party from his purview. The implications of the argument for labour were, however, clear, as clear as those of Michels, for whom the SPD was the exemplar and not the exception. Ostrogorski's general conclusions apply to the political party form as such – 'It would, in truth, be difficult to find in the history of human societies a more pathetic drama than this ruin of so many generous aspirations, of so many noble efforts, of such high promise and expectations' (p. 608). He alluded here to the idea of eternal recurrence, and returned to the general theme of the loss of the individual within the fibres of mass democracy. His case finally lapses into a psychology of sorts, where the 'fundamental

...ay and spurning the very idea of legislation, with the difference that Ostrogorski offered a way out – the replacement of parties by 'special organisations, limited to particular objects' (pp. 630–1, 634–5, 637, 658). Such an arrangement would serve to rekindle the beacon of citizenship. Michels, by comparison, offered us no such recipe of salvation.

The *locus classicus* in the field of sociology of the party remains Michels' *Political Parties*. Michels' *magnum opus* itself is rarely read: what we usually get is its clichéd reduction, 'who says organisation says oligarchy'. His text, needless to say, contained something more than this. It contained a theory of organisation, located within a theory of modern culture. Michels started out from the premise that democracy is inconceivable without organisation. Organisation is vital to modernity, as it is the weapon of the weak in their struggle with the strong. 'It is only by combination to form a structural aggregate that the proletarians can acquire the faculty of political resistance and attain to a social dignity ... Yet this politically necessary principle of organisation ... brings other dangers in its train. We escape Scylla only to dash ourselves on Charybdis. Organisation is, in fact, the source from which the conservative currents flow over the plain of democracy, occasioning these disastrous floods and rendering the plain unrecognizable' (Michels 1915, 25–6). Direct government is impossible; consequently representation is necessary. Parties like the SPD establish schools, but these create working class elites. Thus every party or professional union becomes divided into a minority of directors, and a majority of directed. This is part of a broader trend, whereby all organisational forms, small or large, encourage differentiation of organs and of functions (pp. 36–38).

In the organisational life of the SPD the key sign of transformation was the replacement of the voluntary contact or *Vertrauensmann* (some were women) by professional paid staff (p. 41). The party now mimics the military organisation, in rhetoric at least, from Fabianism to Kautsky's war of attrition to Lenin's vanguard party (and Gramsci's war of position). Michels attempted to underpin this with a psychology of what he called the need for leadership felt by the masses and here he signalled as proof the mass reverence for icons – 'Karl Marx buttons' and, perhaps more understandably, 'Karl Marx liqueurs', which the masses consumed in ritual at meetings (p. 73). Notwithstanding these happy relations, there also ensued 'the struggle between

the leaders and the masses' (p. 166). Unlike Müller, Michels did not view this as the drama of the class struggle on the smaller stage. Michels portrayed the conflict rather as one given to occasional revolt, doomed to failure in any revolutionary sense. The more vital struggle was that between the leaders themselves. Certainly there was a process of psychological metamorphosis among the leaders. The revolutionary fundament in Michels became more evident in his proposition that often, in fact, 'reformism is no more than the theoretical expression of the scepticism of the disillusioned, of the outwearied, of those who have lost their faith; it is the socialism of non-socialists with a socialist past' (pp. 177, 217, 225).

While this suggestion is both witty and withering, it solved the problem falsely, as it simply installed its own definition of revolutionary socialism as authentic (and unargued). Michels was, of course, attracted to Syndicalism throughout his life; it was one theme which was continuous from his socialist origins to his trajectory into Mussolini's fascism. This was something of a bind for Michels, for as a radical intellectual he also admitted the necessity of middle-class ideas in the transformation of the proletarian movement into an explicitly socialist movement. Workers are 'naturally' socialist, it is 'in the blood'; intellectuals *become* socialists, and consequently bring the evangelical spirit to their leadership claims. The sum total of these combined processes is the *embourgeoisement* of the working class party. Leadership becomes petty bourgeois, as does the orientation of electoral activity, and the party also produces its own petty bourgeois officialdom (pp. 250–1, 261, 282–5). As Michels proposed, via Parvus, the SPD thus not only took in petty bourgeois members, it also generated a petty bourgeois stratum in its own right. Here, but without reference to Müller, Michels identified a third path of petty bourgeoisification, the way in which radicals were defined as subversives under Bismarck's laws and subsequently became small entrepreneurs. By his time of writing, the striking form of such activity was, however, less the cigarmaker than the *Parteibudiger*, the tavern-keepers who hosted socialist activity under the guise of recreation (pp. 285, 297, 298).

The problem is even more fundamental, however, for Michels' proposition was that every individual member of the working class cherished the hope of rising into a higher social sphere. Petty bourgeois forces seemed ubiquitous. Syndicalism emerged as a prophylactic, but it too was plagued by the necessity of organisation and representation, so that it misidentified the problem as electoralism. More generally, there was also the problem that the unions do not represent the populace, and cannot be democratic political organs in this sense either. Finally Michels turns to the explicit enunciation of his 'iron law

especially if you want to argue about culture, identity or art history, for that is where Smith's essential position regarding the necessity of cultural traffic is spelled out.

The arguments of *Place, Taste and Tradition* already anticipate *European Vision* by insisting that we are antipodean – if you want to understand Australian culture, you need to begin by looking elsewhere, because identity results from cultural contact and contestation, even as this is mediated by imperialism and colonialism. To put it differently, Smith's art history seems too often to have been read as art history rather than global history or the history of imperialism, as if we were Australians rather than antipodeans.

There are other reasons that we have been slow to recognise the importance of Smith's work. As Smith's own project makes plain, there is a price to be paid for working in the periphery, even as there are advantages to that sense of distance. We tend to look elsewhere for our theory. We look to the centres, to the French or to the American version of French fries. In another sense, we have been slow to register the importance of Smith's work theoretically because we have (in different ways) lived with its production. My case in *Imagining the Antipodes* is that we have only just caught up with Smith, partly because he was ahead of us (and Said, and the rest), partly because it is only now possible to read his world serially, as we did, say, Marx in the seventies.

So where have we come from? Smith's sense is that we are less Australians than antipodeans. But what does this mean? The image is classical, referring to the other of the antique centre. To be antipodean is literally to have the feet elsewhere. Yet culture is not the product of place. We do not emit culture, immaculately, and nor does landscape. All cultures known to us result from processes of fabrication, in which humans create from a stock of cultural images and artifacts borrowed from other places and times. To be antipodean is therefore to be both European and not, both European and more. Identity, in this way of thinking, is neither given by place nor by genetic endowment, nor even by the combination of the two, which would merely make of us 'independent Australian Britons'. There is, in short, no such thing as national character, and this is just as well, for arguments concerning national character all too readily beget hatred and racism. Culture is not a modular phenomenon given us by national citizenship, blood, language or place of birth. It is not essential, or fixed, but processual, and relatively open.

Smith's argument, already in *Place, Taste and Tradition*, was that Australian art and European experience were mutually constitutive. You couldn't understand one without the other. Except that Smith's insistence on this asymmetrical reciprocity between centre and periphery was flattened, in

its reception, into the more conventional, unilateral theorem of cultural imperialism. On Smith's account, however, the culture of the victims of imperialism also profoundly affected that of the dominant powers. If culture is not the authentic emission or outpouring of place or soul, if it is artificial and constructed rather than given by God or nature, then phenomena such as Orientalism, Japonisme and Chinoiserie perhaps appear in a different light.

In the forties, when he was forming his intellectual identity, Bernard Smith spent time reading Marx and Spengler, Sorokin and Toynbee. His early encounters with surrealism were formative, not least of all because, while he was immediately immersed in the cultural apocalypse of war, he was also attracted to the anticipation of surrealism in Bosch, Goya and Piranesi. Smith's project works comparatively, by anticipation, in terms of precedents. He was much compelled by Toynbee's proposition, in his *Study of History*, that all cultures recycle, summoning up images of the past, archaistically or, reaching forward, futuristically.

What we call culture, then, is a hybrid or amalgam of past, present and future. National cultures routinely borrow or invent pasts as well as futures; more importantly, they borrow from other cultures or their images of them. Moderns thus cultivate primitivism partly because of the incapacity of modernity to generate a modernist consciousness sufficient to sustain itself. Futurisms, on the other hand, conjure up imaginary possibilities of mechanical, industrial futures, not least of all in sharper situations of uneven development. Futurism, or constructivism, emerge most emphatically therefore not in the United States but in Italy and Russia. So modernist art and literature can emerge unexpectedly in the peripheries, just as Australian culture can be parodied with the throwaway that it was postmodern before it was modern. As I have suggested in a book entitled *Transforming Labor*, the irony is rather that we became modern without fully becoming industrial.

When we think through the work of Bernard Smith, these kinds of issues begin to make sense. For in this way of thinking, we can presume that modern societies are nevertheless deeply traditionalist. This is not only the case for, say, France or England. Even New World societies such as the United States powerfully combine pastoral myths with those of Fordism and progressivism.

The point is that no peoples known to us are culturally self-sufficient. Picasso's use of African motifs is the rule, if you like, not the exception, though in Smith's work it is probably the work of the Mexican muralists that makes the most of cultural hybridity. All of which indicates, in turn, that we should

not have been so surprised by the postmodern, for it represents (among other things) an attack on modernism, a reprise of earlier forms and sensibilities like Dada, and a capacity to generate innovation through recycling. Smith, indeed, had used the word postmodern already in discussing Australian art in 1945; Toynbee had used it in the forties in broader, civilisational register. Even postmodernism, in this sense, was predictable.

Yet, if culture or identity is generated in this way, processually, through traffic, what about cultural imperialism? One consequence of Smith's Marxism is precisely that he thinks through the prism of civilisations in a world system based on power and violence. But this is the interpretative frame. It does not tell us the content of particular, local stories or experience, nor does it begin to anticipate how it is that the empire bites back. For in the conventional trope of cultural imperialism, as in the set-piece image of bourgeois ideology, culture is imagined to flow one way, down, from the intellectual heights of the metropolitan centres to the dumb, below-the-belt regions where the dirty bits dwell. Even in a sophisticated book like Said's *Orientalism*, the subaltern does not yet speak; and that, after all, was the main reason Said wrote its sequel, *Culture and Imperialism*, to redress the balance. Smith, for his part, anticipated all this in *European Vision and the South Pacific*. Here the radical commonsense is that Europe (Cook, Banks) ruined the South Pacific, but this, for Smith, can only be part of the story.

The European encounter with the Pacific also radically destabilised the metropolitan experience of the English Enlightenment. Controversies over extraordinary phenomena such as the kangaroo and the platypus violated the existing and hegemonic systems of classification in Europe. Radical intellectuals in Australia apparently fell over themselves, spilling their coffee in excitement, when Foucault discovered this kind of thing in Borges' Chinese encyclopedia (in *The Order of Things*). So why should they bother reading about exploration and colonialism in the South Pacific? The temptation in the conduct of much of what passes for social theory, after all, is to find a theorem which explains everything, plugs up those embarrassing holes caused by the poking fingers of curiosity. Social theory has become so caught up with Answers, or Positions, that it has little time for questions, for curiosity.

That people interested in social theory should feel compelled to look elsewhere is, however, an expectation entirely consistent with the logic of Smith's project. Like art history, social theory cannot escape the idea of the avant-garde. For intellectual taste rests on notions of distinction, and many are the pressures to seek value in the other, the exotic, the distant.

The idea of vision was another pioneered by Smith, before ways of seeing and notions of the gaze became compulsory. *European Vision* rested on the idea that perception frames knowledge; we see in terms of what we know already, we assimilate unknown into known, as the earliest white landscape painters managed to render the southland in distinctly English, picturesque or romantic, gothic registers.

In this regard, as in the fatality of European contact with the Pacific, however, the message of Smith's book was taken to be singular, as though for example the idiotic English only saw what was in their heads. The story Smith wanted to tell, again, was more negotiative and processual, indicating how it was that the invaders were also educated by the process, manufacturing a new mythology about uniquely Australian light, transforming moving waters from blue to brown and so on. For Smith, art, like culture, resulted from the traffic between peoples; there was no such thing as Australian or French or English art, except inasmuch as we ourselves actively constructed them as notional styles. Cultures are not essences that make themselves appear, so much as they are contingent results of processes manoeuvred by actors at once open and closed, curious and dominant by disposition.

These kinds of concerns held together *European Vision and the South Pacific*, but they cannot possibly encapsulate the pleasures of that text. You need to read it, look at the pictures, in the second, quarto edition of 1985. For the story is in the detail, as well. My suggestion is that it is the starting point for those who might be curious, partly because of its own brilliance, partly because it is the theoretical frame which holds up the much misunderstood *Antipodean Manifesto* and the more conventional, but too easily conventionalised text of *Australian Painting*. *European Vision* is also the constitutive echo of *Place, Taste and Tradition*. It is literally its other, its other half, for *Place, Taste and Tradition* begins exactly where *European Vision* heads, the centres, working on the fundamentally Smithian (or it could be Freudian) hunch that the truth or meaning of a problem will always be found where you least expect it.

My sense is that Smith's work is useful to think with, that it travels, that as it recycles other views we should follow him by recycling it in turn. He carries his Marxism loosely, like a string bag, reforming all kinds of insights and wisdoms that (like Marxism itself) come from elsewhere. Reading through Bernard Smith's published works, then his papers, over three years as I researched *Imagining the Antipodes*, I came to the conclusion that Smith's was a project of astonishing consistency, a kind of patchwork quilt veering towards curiosity rather than seeming to close it off. The consistency of the work is held together, I think, by these kinds of sensibilities indicating that

cultures recycle, remember or reinvent back, anticipate forwards, combine laterally. As in Hegel's now infamous image of the master and slave, and the burgeoning literature on alterity, Smith's curiosity focussed on, among other things, how it is that the global centres depend upon the subordination of the peripheries, perhaps not in economic ways so much as culturally. Modernism, in a sense, has an empty heart, especially as we face the new millennium; and nostalgia drives us backwards in our minds, more than forward. So the German and Nordic tourists you bump into have no time for Melbourne or Fremantle or Juan Davila or Roy and H G; it's the centre they lust after, the primeval, that which they imagine they can encounter authentically, without impediment or subtitles to get in the way.

Bernard Smith's work, in comparison, wants to puzzle about how it is that we as moderns or postmoderns construct the primitive as our imagined other. Who are we? Where are we going? What this line of thinking suggests is that modern consciousness labours under its own fear of insufficiency, hungry for supplements, unable to affirm finally the material civilisation that we inhabit, homeless, in this luxurious sense. It's not that we feel ill at ease in Australia but that we feel awash, homeless in the modern epoch. But home, to follow Smith (or to follow Agnes Heller) can only now be imagined as artificial, as is culture. Home, like culture, is not given to us at birth; and moderns remain deeply traditionalistic, again, in their manifest inability to make peace with this fate.

Again, at this point, it is worth inquiring as to whence these neuroses came. Do most people, most of the time, really feel so deeply disturbed about identity as existential angst? There is, I think, something deeply romantic about modern culture (I have argued this elsewhere, in a book called *Postmodern Socialism*). Certainly this is sympathetic with Smith's way of interpreting the world, as if we back into the future, facing the past rather than embracing what might lie ahead of us. At the same time, it is difficult not to detect some sense that what we now call hybridity is simply a fact of life, that most people most of the time carry multiple sources of identity without feeling too burdened by this, perhaps even celebrating it.

As Bernard Smith would put it, the point about being antipodean is less one about singularity of place, of origin, than it is one of process, or relationship. To be antipodean is, by definition, to have more than one source of identity, even if neither of them are apparently of our own choosing. We did not choose British imperialism as an agency of invasion or settlement, nor (but in a different way) did we exactly choose American cultural imperialism after the Second World War. My own people did not ask to be dragged

halfway around the world to Australia as its consequence. Do they now feel homeless? Not so far as I can tell, because they know that home, like Kafka's crustacean shell, is something you also carry with you, and they remember the past with sufficient clarity to avoid fantasies about returning to it. Better to inhabit the present, even if that involves playing along with the idiocies of the powerful when they intrude into our lives.

Bernard Smith reversed Cook's journey in 1948, knocking on the door of the Courtauld Institute to tell Anthony Blunt that he wanted to conduct research into art in Australia. Blunt effectively showed him the door, informing him that he would not encourage research into what did not exist. Like Smith, we need to persist against both the arrogance of power and the chauvinism of the oppressed, for our identity consists of both. After all, the idea of being somewhere safely at home in the world is not only illusory, it is in one sense dangerous. All of us need some sense of comfort, but the idea of feeling at home in the world was not available even to Anthony Blunt. We carry the other within us, even if that is not the full extent of the matter when it comes to the world of difference.

In his book *Night Letters*, Robert Dessaix writes in this vein that one of the advantages of being Australian elsewhere is that you are a kind of blank to people, and so of little interest until they have written on you. Europe takes little notice of us, unless to plunder or posit us as exotic when in fact we are all too disarmingly like them. 'We remain a kind of Estonia of the South Seas', he writes, 'not a wholly unsatisfactory state of affairs.' To imagine being Australian in this way is, I think very largely sympathetic with the spirit of Bernard Smith's work. Being cast as antipodean, we find ourselves in need of the recognition of the dominant other. But having been named thus may well be the extent of our recognition. The only consolation is that we know who we are, even if no one elsewhere will listen. We know who we are, at least enough to carry on. We have the satisfaction of knowing, when we bow obsequiously before our masters, that our people, behind us, can share the gesture we make with two fingers. Identity shows even in silence; there is virtue in both of them. As for the work of imagination, that lies before us as surely as oceans of opacity surround the extremities.

References

Beilharz, P. 1994a. *Postmodern Socialism – Romanticism, City and State*. Melbourne: Melbourne University Press.

Beilharz, P. 1994b. *Transforming Labor – Labour Tradition and the Labor Decade in Australia*. Melbourne: Cambridge University Press.

Beilharz, P. 1997. *Imagining the Antipodes – Theory, Culture and the Visual in the Work of Bernard Smith*. Melbourne: Cambridge University Press.

Burn, I., N. Lendon, C. Merewether, A. Stephen. 1988. *The Necessity of Australian Art: An Essay About Interpretation*. Sydney: Power Institute.

Dessaix, R. 1997. *Night Letters: A Journey Through Switzerland and Italy*. New York: A Wyatt Book for St. Martin's Press.

Drew, P. 1994. *The Coast Dwellers: Australians Living on the Edge*. Ringwood, Victoria : Penguin Books Australia.

Foucault, M. 1970. *The Order of Things: An Archaeology of the Human Sciences*. New York: Pantheon Books.

Haese, R. 1981. *Rebels and Precursors: The revolutionary years of Australian art*. Ringwood, Victoria: Allen Lane.

Said, E. 1978. *Orientalism*. New York: Vintage Books.

Said, E. 1993. *Culture and Imperialism*. New York: Knopf.

Smith, B. 1945. *Place, Taste and Tradition*. Sydney: Ure Smith.

Smith, B. 1960. *European Vision and the South Pacific*. Oxford: Clarendon Press.

Smith, B. 1962. *Australian Painting, 1788–1960*. Melbourne: Oxford University Press.

Smith, B. 1975. *The Antipodean Manifesto: Essays in Art and History*. Melbourne: Oxford University Press.

Tacey, D. 1995. *Edge of the Sacred: Transformation in Australia*. North Blackburn, Victoria: HarperCollinsPublishers.

Toynbee, A. 1934–1961. *A Study of History*, 12 vols. Oxford: Oxford University Press.

Willis, A-M. 1993. *Illusions of Identity: The Art of Nation*. Sydney : Hale & Iremonger.

Chapter 16

The Portrait of the Art Historian as a Young Man
(2002)

Bernard Smith and Robert Hughes have dominated Australian art history and criticism for a long time. No wonder they have their enemies. I have met Robert Hughes only once, at the launch of *American Visions* (1997) at Readings bookstore in Carlton. I told him I thought it was a great book, and an especially good television series. I gave him a copy of my book on Bernard Smith, *Imagining the Antipodes*, published in the same year. In his gruff but amicable manner, he said to me, 'You must have known Bernard for a long time.' I replied that I hadn't; we had opened a relationship in 1993, when I'd approached Bernard with the idea of a book on his work.

I think I can now claim a special relationship with Bernard Smith. Perhaps it is an intersection, more than a matter of lives along parallel paths. I came to Smith not only late but also across other fields. I had the advantage, I think, of not being an art critic, neither his student nor his competitor or opponent. I have, of course, come upon many who claim to know him and his work better than I do. I was unaware, on beginning, that there were others who had special claims to authority on Smith, which they had, however, never acted upon. As the nastier reviews of *Imagining the Antipodes* appeared, it became more apparent to me that I was a poacher among others who had purchased licences but failed to exercise them.

Others always know better.

We are still learning about Bernard Smith. We will learn a great deal more when Patricia Anderson's biography is published, and when others turn to the work of detailed research and interpretation that will confirm my book as what it claims to be, a first book about Bernard Smith. Meanwhile, he is also still writing. In *A Pavane for Another Time* he tells more of his 'establishment' phase in the 1940s than we have readily known before. He has painstakingly revisited his own papers, those that I also worked through

over three years of Fridays at his home in Fitzroy, where from time to time I came upon things I thought too personal or private to warrant discussion in my book. My concern was with his ideas. Perhaps, indeed, he tells us more than we need to know, at least about sex. In *A Pavane for Another Time* we meet another Bernard Smith, the boy from the bush who goes to London, to the Courtauld Institute. This book is a sequel to *The Boy Adeodatus* (1984), but it is a very different kind of book. Twenty years after *Adeodatus*, Smith's style is less given to choreography, more documentary and ruminative in form. It befits Smith's present moment in life. This is an important book, and we are fortunate to have it. It maintains the historian's discretion of *Adeodatus* in sticking well clear of the present. This is consistent with Smith's lifelong sympathy with Hegel. Smith has always been fond of Hegel's Owl of Minerva – with the idea that wisdom arrives at the end of the day (or else, just too late).

The central chronological frame for *Pavane* is the 1940s, particularly the years he spent away on the Continent and in England, in the crucible of Western art collections and their scholarship. This was not only his journey out. It was a confirmation of how European his formation had already been. Smith's Sydney, into the days of the Second World War, was already European. The people with whom he mixed, in and around the Communist Party, were often escapees from the crises on the other side. Spain, Germany and Poland and the Soviet Union were perpetually present, politically and culturally in the Sydney of his day. Smith's first great work on Australian painting, *Place, Taste and Tradition* (1945) was in this context an accident; while everybody else in the Teachers' Branch of the Communist Party was tied to Europe and its art or politics, Smith alone rose to the challenge of filling the antipodean gap. He began by giving lectures on Australian art. The gesture was vital, but, as he notes in opening *Pavane*, the price of this achievement has been considerable. He has been corralled as 'Australian', with the result that his most significant recent book *Modernism's History* (1998), has fallen down the back of the metropolitan fridge.

Several Australian reviewers of *Modernism's History* imagined Smith to be poaching. By what right, with what authority, could he claim to speak now at the end of his career, about international art? The book suffered a similar predicament in its metropolitan reception. It arrived at the same time as several other obituaries for modernism. Why value the view of an outsider over or against those of the cosmo specialists at the centres? How, in the eyes of the transatlantic art mafia, could an outsider like Smith have the authority to speak on world art? How could an Australian – or one who had not, like

Robert Hughes, long expatriated himself – be expected to know anything about the centres? The contempt of silence that greeted *Modernism's History* reflects the older, imperial sensibility for which the Antipodes is a place ineluctably down under rather than one of dynamic interchange and complex relationships between peripheries and centres constructed through cultural traffic. The irony is that Smith and his mates in the forties knew more about European art than about Australian art. He spent years teaching about metropolitan art on his return, not least at the University of Melbourne. His lectures on the subject, full of powerful insights, are also there among his papers in Fitzroy.

What he did while at the Courtauld Institute in one sense represented a step back from *Place, Taste and Tradition*. His interest now was in the earliest European ideas about the Southern Hemisphere. As he wrote in a letter to Lindsay Gordon on 23 November 1949, 'I am becoming convinced that the conception of Paradise, Utopia and "working man's Paradise" in the Southern Land is one of the central historical ideas running through Australian literature, art and politics.' The antipodean optic was opened, a decade before *The Antipodean Manifesto* in 1959 or *European Vision and the South Pacific* in 1960. The whole point about Europe and its Antipodes was obvious: the two were inseparable. To learn about one was simultaneously to puzzle over the other.

That Smith became known as an authority on Australia was against his intention. I think this is one reason he has played down his achievement as a Cook scholar; he does not want to be viewed as an Australianist. The great achievement of *European Vision and the South Pacific* was precisely to insist on the inextricable nature of those series of places and ideas. Australian art could never be self-sufficient, any more than French or English art could be. Cultural innovation and movement results rather from traffic, in people and ideas. *European Vision and the South Pacific* was ahead of its time in paying attention to this traffic. In the nuance of its argument about European perception and the experience of the voyagers, that book is closer to our times, to the revived interest in so-called primitivism, the 'noble savage' and the representation of the other. It is both an anticipation and a precursive qualification of Edward Said's rather one dimensional analysis of so-called orientalism. Smith would insist that the processes whereby Western sensibilities replenish their jaded appetites for the exotic with japonisme, chinoiserie, and romanticisms of other contrived provenance, are part of a much larger, more complicated, and ongoing series of transactions between the various cultures concerned. His own focus (or one such) is on the Pacific

as an intellectual laboratory of empirical experiment. The experiences of Cook and Banks and their painters affected indigenous peoples, but plainly also had an impact upon the centres of Enlightenment. It was (partly at least) with New South Wales in mind that Bentham envisaged his panopticon which in turn, as it happens, provided a springboard for and provocation for Foucault's insights in our own day.

Smith's personal discovery of the *European* 'other' ended on 1 January 1951, when the *Otranto* docked back in Sydney. His East European encounters had put an end to his residual commitment to the Communist Party. Smith told Sam Lewis, head of the Teachers' Branch of the party, that he would rather live in Australia under Menzies than in Czechoslovakia under Gottwald. The rest of his formal career was yet to begin: teaching at Melbourne University from 1956, establishing the Power Institute at Sydney University in 1960, retiring back to Melbourne to write – and paint.

After *European Vision* there came *Australian Painting*. Those who grew up with or alongside Bernard Smith did not have my advantage as a come-lately, to read the collected works sequentially, as one would Marx or Gramsci. Those who read the books on Australian painting seem often to have imagined either that Smith viewed Australian art as derivative of European art, or else, after the publication of the *Antipodean Manifesto*, as a plea for cultural nationalism. But his views have never been as narrow or simple or categorical or mutually exclusive. Read contextually and serially, Smith's work suggests, rather, that it is as impossible to speak of European artistic traditions without antipodean art as it is the other way around.

If Smith's fate has been to be placed as an Australianist, the great significance of *A Pavane for Another Time* is to act as a corrective to this view. Indeed, it is difficult not to believe that, after a career both of recognition as well as misrecognition, Bernard Smith is engaging here in a resolute attempt to fashion, or at least inform anew the subsequent reception of his earlier work.

The prompt here has been the veil of silence drawn over his global study of modern art, *Modernism's History*. Smith still insists on being heard, even as antipodeans remain sidelined, stuck in the sideshows of global culture. We should be thankful that he returned to Australia, has stayed and has continued always to write. While in one sense *A Pavane for Another Time* might be read as memoir, a time slice and a further work of acknowledgement and confession to his first wife, Kate, in terms of the reception of his ideas it might also be seen as an attempt to put Hegel to the test. It's a gift from the Owl of Minerva.

References

Beilharz, P. 1997. *Imagining the Antipodes: Theory, Culture and the Visual in the Work of Bernard Smith*. Melbourne: Cambridge University Press.

Hughes, R. 1997. *American Visions: The Epic History of Art in America*. New York: Alfred A. Knopf.

Smith, B. 1945. *Place, Taste and Tradition*. Sydney: Ure Smith.

Smith, B. 1960. *European Vision and the South Pacific*. Oxford: Clarendon Press.

Smith, B. 1962. *Australian Painting, 1788–1960*. Melbourne: Oxford University Press.

Smith, B. 1975. *The Antipodean Manifesto: Essays in Art and History*. Melbourne: Oxford University Press.

Smith, B. 1984. *The Boy Adeodatus – Portrait of a Lucky Young Bastard*. Ringwood: Penguin.

Smith, B. 1998. *Modernism's History: A Study in Twentieth-Century Art and Ideas*. Sydney: UNSW Press.

Smith, B. 2002. *A Pavane for Another Time*. Melbourne: Macmillan Art Publishing.

Chapter 17

Bernard Smith: Taking a Distance
(2013)

One of Bernard Smith's key sensibilities concerned the idea of distance: taking a distance, letting the dust settle, sitting with the owl of Minerva, at the sunset, seeking to make sense of the world after the fact. Now that he has gone, it is a good time to seek to take some distance on Bernard Smith's work. What did he come to say? What did he set out to achieve? Why, in this context, was he so insistent and persistent in his Marxism?

Bernard Smith was a Marxist. Five words: what might they mean? In earlier encounters with Bernard's work, I have used different metaphors to suggest the nature of his relationship to Marxism, to Marx in particular: that his Marxism was like a string bag, formed by the objects or other ideas or facts that he chose to accommodate into it; that he wore his Marxism not like the iron cage in Max Weber's *Protestant Ethic*, but like a light cloak, as a badge or a kite rather than as a compass (Beilharz 1997, 1996a, 1996b). The parallels in the history of Marxism might be scholars like Eric Hobsbawm, or outside it, Fernand Braudel. Other Marxist resonances might include Raymond Williams, he who famously asked what it was that a thinker or writer had come to say, and Jack Lindsay, of whom more anon.

Bernard Smith insisted upon his Marxism, across the path of his life. But were his politics those of a Marxist? Yes, and no. Mainly no: he was an oppositionist. His object was less to change the world than to stop it getting worse. He was an anti-Nazi communist, initially, a forties rather than a thirties or depression communist. The dominant motif of his forties politics was that of civil liberties. The triggers for his radicalization were to be found, however, in the late thirties. Its triggers were Spain, the Spanish Civil War, and the rise of Hitler. Its symbolic icons were Guernica, the place and the painting; and Hitler's 1937 Degenerate Art Exhibition in Munich. He was not a primarily political, let alone redemptive personality. As he wrote in

third person, reflecting back at a distance on his life in the first volume of his autobiography, *The Boy Adeodatus*, 'Bernard was not interested in politics [at his one teacher school in Murraguldrie, out back of Wagga]; but politics was becoming interested in him' (Smith 1984, 236).

Later in life, his politics were still reactive: in the struggle against the overdevelopment of inner-city Sydney and Melbourne, against the forgetting of genocide against Australia's indigenous people in *The Spectre of Truganini*. His positive politics were cultural. They famously took the form of a manifesto, itself both a positive and negative text, in the 1959 *Antipodean Manifesto*; and they were crowned in the greatest monument to his life, the RAKA Awards. Sometimes the tenor of his politics was straightforwardly and period liberal democratic, as in his 1986 urging in 'The Writer and the Bomb' that the best immediate step was to write to your Member of Parliament (Smith 1988, 66). His brief encounter with what passed for actually-existing socialism in the late 40's made his preferences clear – given the hypothetical choice between living in Gottwald's East Germany and Menzies' conservative Australia, Australia ruled (Smith 2002).

He had attended the University of Sydney, BA incomplete: was he then an Andersonian? Andersonian scepticism dominated the Sydney Left, along with communism; Anderson, indeed, had at one stage occupied the position of Theoretical Advisor to the Communist Party of Australia (Beilharz 1993). Anderson's position notoriously was described as a will not to reform, which was the role of the servile state, but to oppose (Kennedy 1995). Unlike Anderson, Smith was not a contrarian; nor was he ever a Trotskyist. He was an oppositionist, indeed, but never a revolutionary. Smith was never an enthusiast for Bolshevism – why? Precisely because Bolshevism, like Jacobism, seeks to force history, or else to leap over it (Beilharz 1987).

The question remains: what kind of Marxism was this? Let us step sideways, and ask the obvious philological question: what did he read? By the eighties, when some of his most sophisticated encounters with Marx were published, he had read everything: the *1844 Manuscripts*, the *Grundrisse*, *Capital*, *Theories of Surplus Value*. As the 1986 essay 'Marx and Aesthetic Value' shows, Bernard Smith's Marxism worked at a significant level of theoretical sophistication (Smith 1988, ch. 13). But what did he read when he was young? and how did he escape the dead hand of Dialectical Materialism, the standard fare of his formative period in the thirties and forties?

This question begs another: what was the available Marx in that formative period, anyway? Marx's translation history is famously patchy, and in the English language, late. What did the young Bernard Smith have available

to him from Marx's project? The *1844 Manuscripts* were published in German in 1932, and coincidentally in English and American translations by Bottomore and Struik respectively in 1964. This meant that the message of Marxist humanism was repressed through the history of Marxism-Leninism, but was available for the rising generation of 1968. *The German Ideology* was published in German in 1932, and in English in 1938. *Capital* Volume 1 appeared in German in 1867 and in English in 1887. Its more popular editions appeared with the Modern Library, in New York in 1906 (the version used by Smith) and later in popular editions with Charles H. Kerr in Chicago and Dona Torr in London. The *Grundrisse* was first fully translated into English in 1973. The Introduction to the *Grundrisse*, notable for its fragment on the universality of Greek art, appeared earlier, in the 1904 Kerr edition of Marx's 1859 *Critique of Political Economy*, and was therefore in principle available to Smith, as were odd texts such as Francis Klingender's 1947 *Art and The Industrial Revolution*, appreciated by Smith but positioned by him as 'too narrow' in its orthodoxy (Smith 1988, 35). He had read *The German Ideology* and *The Theses on Feuerbach*, Engels' *Origin of the Family, the State and Private Property*. Like others of his generation, however, Smith imbibed a theoretically sophisticated Marxism from the work of others who understood philosophy and read German, such as Max Eastman and especially Sidney Hook, particularly Hook's *Hegel to Marx*, which focussed on the young Marx and the young Hegelians, Ruge, Bauer and Feuerbach. He spent serious time with Spengler's *Decline of the West*, and *Man and Technics*, and Toynbee's *A Study of History*, as well as the kindred civilization analysis of Sorokin (Beilharz 1997, 9–10). Smith's thinking itself became civilizational, committed to the fundamental sense that western culture recycled motifs such as those of progressivism and romanticism.

Smith explains further in the essay 'History as Criticism' (1983). In writing his first great work on Australian painting, *Place, Taste and Tradition* (1945)

> I read everything I could then get hold of in English by Marx, Engels, Lenin and Stalin. [My interest was] Marxian rather than marxist because although I wrote the book within the broad guidelines of historical materialism there were also considerable countervailing influences in the work, such as a voracious interest in Toynbee as each of his green volumes appeared, and a fascination with Heinrich Wölflin's account of art in terms of style. Nor did I attempt to write the book within the terminology of marxism: proletariat and bourgeoisie, base and superstructure [etc] … I believe that my marxian vantage point

provided a better perspective on the development of Australian art than MacDonald and Lindsay's organic nationalism. It also provided more aesthetic space within which it was possible to revalue colonial and modern work. (Smith 1988, 73)

The alignment of concepts is characteristic of Smith's way of thinking: Marxian; colonial; modern, modernism, each term necessary to locate and make sense of the others.

In addition to Marx, Toynbee, Spengler, Hook, Sorokin, there was another proxy Marx figure here: Jack Lindsay. This filament connects Smith to Brisbane, where Smith later delivered the major text *Australian Painting Today* as the 1961 Macrossan Lectures, and links further back to the Marxism of Vere Gordon Childe, an important source and anchor for the Marxism of Jack Lindsay (Beilharz 1995). Smith was later to dedicate a major collection of essays to Jack Lindsay; earlier, his 1988 essays *The Death of the Artist as Hero* directly echoed Lindsay's *Death of the Hero*, 1960. Smith's collected essays were dedicated to the memory of Norman and Lionel Lindsay 'in appeasement' and to Jack Lindsay 'in gratitude'.

Its preface identifies Lindsay's *Short History of Culture* (1939) as an important influence in Smith's own intellectual formation. The scope of Lindsay's *Short History of Culture* was prehistorical, or historical in a prehistorical sense: and thereby hangs a tale. For one serious bond between Lindsay and Smith was the idea that history was not present, but past: you needed some distance on history in order to make sense of the world.

Lindsay's reputation was always somewhat obscure: an Anglophile Marxist from Brisbane, with early Nietzschean leanings or longings, he became a scribbler. He wrote too much, at least 153 books up to the age of 83, almost three a year, more than many people are capable of reading. In the period of his English exile, he took up solidarity with the Historians' Group of the CPGB. The CPGB Historians Group anticipated the view from below which became so popular into the sixties and seventies. It also followed interests in material history, the history of technology and of things, and Lindsay also wrote in these fields. He remained a humanist and a vitalist, and he defended a kind of open Marxism, more easily recognisable to us today as a cultural Marxism. His sympathies connected to Ernst Bloch and to Gramsci. The affinities between Smith, Lindsay and the GPGB Historians are apparent: their Marx was the Marx of *The Eighteenth Brumaire*.

The sense of distance or detachment also echoes in Marx, even in his most active and politically committed phases. As his most recent biographer,

Mary Gabriel, writes in *Love and Capital*, Marx was always notoriously late for significant historic events. The *Communist Manifesto* was published too late to impact upon the 1848 Revolutions. *The Civil War in France*, planned to coincide with the Paris Commune, appeared after its fall. Most famous of all was Marx's 1851 prediction that *Capital* would be ready for the Crystal Palace; it took another 16 years (Gabriel 2011, 514). Politics, and history, always got in the way.

Bernard Smith chose to be late, as well as committed. For the early Smith, the Smith of *Place, Taste and Tradition* (1945), politics mattered because they were unavoidable: poets and painters were dying in Spain. His early politics were antinationalist, antinativist (Smith 1988, ch. 6). He was intuitively indisposed to take seriously the kind of Herder-wisdom for which culture is only ever particular, and springs as it were from the ground. This predilection became clearer in his masterwork *European Vision and the South Pacific* (1960), where culture appeared not from any originary place but rather emerged from the dialectics of cultural traffic as it extended across the world system. But *Place, Taste and Tradition* was also an emphatically positioned document: it lacked the cooler scholarly detachment of *European Vision*. A similar distance opened between the politics of anti-fascism in *Place, Taste and Tradition* and the absolute centrality of period style and periodization in *Australian Painting* (1962). Periodization, by definition, can only be applied *ex post facto*, when the owl has flown. Time matters, then, for Smith, and we cannot force it. But there is also, as he recognised, a division of labour that holds up intellectual activity. Historians, for example, were themselves artists and producers rather than actors on the world stage (Smith 1988, 85). Smith was not given to refer to Max Weber, though Kant was certainly within his frame; the idea of spheres of interest and competence was fundamental to his work.

Bernard Smith was a traditionalist. Marxism was his tradition; but traditions face the past. Like Weber, he believed that we chose our gods, our traditions, as we had to serve them. Art, as he was given to say, 'has a history'. Art history has a history. Unlike some other postwar Marxists like Paul Sweezy, then, Smith did not embrace the idea of the 'present as history'. His epistemology was not presentist, and certainly not predictive. He liked to sit with the Owl of Minerva, but he did not endorse Hegel's enthusiasm for the idea of *philosophy* of history, where the author became the end of the story. In this particular sense, and against the current of Marxism-Leninism, he was not a Marxist. He was not a triumphalist; his mood was rather with the spirit of Gramsci, for whom left to itself history would always work out well for the other side, not for those of us who stayed facing left. What this

suggests, perhaps, is the presence in his work of a Marxism of irony, if not a Marxism of the tragic.

With the Marx of the *Eighteenth Brumaire*, where there are ghosts, and we are creatures given to repetition rather than to progress, Smith is also here with Freud. Freud's presence is probably most apparent in *The Spectre of Truganini*, where it is forgetting, rather than rationality or progress which is the leitmotif. In this way, of course, it is Freud rather than Marx who is the really radical or even revolutionary thinker of modernity. If we can never be masters in our own house, then the entire fantasy of the project of the rational domination of the world begins to crumble. We arrive too late, too late perhaps even to understand, let alone to exercise the project of rational mastery.

Smith's Marxism is that of *The Eighteenth Brumaire*, not that of *Thesis Eleven*. As he puts his view with simple eloquence in 'History and the Architect' (1982) 'As I speak my words flow into the past' (Smith 1988, 89). This historicist sensibility also informs the strong distinction he wanted to maintain between art history and art criticism. Criticism is of the present, and is often therefore ephemeral: in the present, it is increasingly likely that we will get it wrong. This remains the strongest single difference between his own project, for example, and that of a critic like Robert Hughes. It also helps to explain his distance, his literal disinterest, from so much of what these days goes to make up contemporary art, which for him we could like or dislike but could not get a distance on.

Is this not, then, a tragic view of history, and if so, how does it connect to Marx, Marxism, historical materialism? As I have tried to suggest here, the echoes with Marx and with the idea of a project of historical materialism are substantive. Perhaps the most obvious textual or aesthetic symbol which suggests itself here by way of connect is Walter Benjamin's Angel of History. Smith's view is ironic, because those who think they have understood or even believe that they control the world have surely deluded themselves. Wisdom, in this way of thinking, will always, necessarily, be retrospective. Yet Smith also is wont to insist on the empirical temper in his work. As he puts it, big thematic questions: the sacred versus the secular, the competing needs of science and tradition, the national versus the international are *empirical* matters (Smith 1988, 88). And this, after all, is also the spirit of *European Vision*: where it is experiment, effort, mistake and sometimes insight as well as blindness that drive us on, however we stumble.

The tension between the ideographic and the nomothetic remains unresolved, necessarily, both in Smith's work and elsewhere. Likely it is just

another of these matters requiring empirical response. Whatever the case, the message is clear. Historians do not change the world; they wait. But they might change the way we think, and as we think, so we are. This is another key insight discovered, or argued, in *European Vision and the South Pacific*. We are involved, and detached, all at the same time.

This image of detachment brings us closer to the theme of isolation, which Bernard Smith sets out to disentangle in his 1961 Macrossan Lectures.

Distance, and isolation, have long been standard default themes in antipodean historiography. In this, it may be useful to connect Smith to other Australian writings. Elsewhere I have observed that there are significant connections between Smith's work and that of Russel Ward in *The Australian Legend*. The two had been mates together at the fledging Australian National University, but there are also lines of thought which connect them, for example on romanticism (Beilharz 1997). When it comes to distance and isolation, the more obvious connection is with Geoffrey Blainey, though to the best of my knowledge their paths did not cross in this way.

The significance of Blainey's contribution to Australian historiography has been blurred by political controversy over the question of immigration in the early 80's. Signal among his many works, and like better known for its title than for its message, is *The Tyranny of Distance*, 1966. This is an extraordinary work in its own right, not least because it manages to enliven what is in fact a transport history as a key optic on white Australian life. For the colonies and cities that went to make up Australia first had to be connected, by traffic literal as well as cultural. Modern Australian history was therefore also the history of its transport technologies, their uptake and transformation. The Blainey thesis is brilliant. It does not, contrary to popular sensibility, suggest that the 'essence' of Australia consists in its being far away from the centres. What it implies, rather, is that 'Australia' is constituted by the traffic in between the cities and regions and other maritime regions. In this its themes are directly aligned or at least sympathetic with those of Bernard Smith.

The Tyranny of Distance does associate the themes of isolation and distance, though they are not in fact the same. Both themes do however imply that culture happens through movement or cultural traffic, both by ground and especially via the maritimes. Isolation, for Blainey, is the original colonial condition. He dedicates a whole chapter to the condition. His conclusion is entitled 'Antipodes Adrift'. Smith's 'The Myth of Isolation' takes on the challenge. It is a major contribution to the discussion of the provincialism

question (Beilharz 2006). The cliché is that Australia is indeed too far away, irrelevant and provincial. Yet there are signs of recognition, and they are warming; proceed with caution. 'For the quality of a culture is best judged, in the long run, by informed critics separated from it both in time and space ...' (Smith 1988, 217). All the same, it may be best, Smith tells us, to let these matters settle in any case; a later generation will make better sense of this belated recognition of the place of Australian painting on the world stage. The irony is telling. While the English have discovered Australian painting, in the 1962 Whitechapel show, local critics are so completely habituated to bleating about our isolation as to find themselves now lost in the confusion. Smith does not use the phrase, but the issue is what A.A. Phillips in 1959 called The Cultural Cringe. Smith's claim is that we may, in Australia, indeed be distant, but not isolated. His sentiment echoes Gauguin's: we need to know where we came from, have some idea of where we are going, and not be haunted by the fear of isolation (Smith 1988, 219).

Culture is constituted through movement, through traffic (Beilharz 1997). 'Our European-based culture came to us in small transportable things that could be carried in ships, such as minds and books' (Smith 1988, 98). In contrast to Hughes' argument in the Whitechapel document, this raises the possibility that we might be isolated in space but not in time. Spain happened for Bernard Smith in the backblocks of Wagga, in Murraguldrie, a one-teacher school amidst *pinus radiata* and not much else. It happened via radio and by letter: there was mail three times a week, and frequent letters from Lindsay Gordon, from whom Smith tells us he learned so much.

Smith lists his reservations about the idea of isolation. First, it rankles because it suggests exceptionalism; and Smith is interested in particulars, but perhaps especially in patterns. Exceptionalism suggests exoticism, a trope which conceals at least as much as it reveals. Second, isolation suggests definition by absence, or lack. The motif of isolation misses the point of intelligence, interpretation or action. What at first sight seems to be isolation, often turns out to be a process of selection and rejection.

At the beginning ... This process of selection and rejection is not apparent to any extent. That is not surprising. Our colonial painters, despite the time and distance from Europe, were certainly not isolated from the European tradition, for most of them were English and identified themselves with their homeland all their lives ... Colonial

artists were European artists in Australia. There was no essential isolation in the colonial situation, for, despite the distance, ideas and styles come through. (Smith 1988, 223)

As Smith explained, colonial painting in Australia was essentially a branch of English painting: which is not to say that it was merely derivative, but precisely to acknowledge the fact that it was colonial, i.e. here and there, peripheral and central at the very same time. Culture results from a concatenation of forces, environment, different European aesthetic movements, politics and social forces. The links with Europe were never broken – there was a constant coming and going of personnel, ideas and techniques and tools. And none of this was empty mimicry.

> Acceptance without question is the essence of provincialism: the colonial painters accepted picturesque and romantic conventions without question. An indigenous tradition, on the other hand, not only assimilates, it also rejects. Indeed it must exercise choice if it is going to be more than a pale imitation of the metropolitan culture of which it is affiliated. (Smith 1988, 225)

The only sense of isolation worth worrying about, for Bernard Smith, was isolationist politics, the kind of exceptionalism which in culture calls for an Australian painting or music or letters as though it can come only out of the ground or environment. What made culture live, in contrast, was the extent to which it rather resulted from the blend of innovation and tradition (Smith 1988, 228).

So why did metropolitan critics choose this moment to discover Australian art? Contrary to the argument of the Whitechapel document, the modern movement since 1900 was largely correlated to the Renaissance tradition, and was stimulated rather by exotic art from Catalonia or Africa, Japan or the South Sea. 'With the expansion of European culture over the globe it is the exotic frontier cultures which have to a large extent determined taste and much of the movement of style.' The presenting issue, now, would likely less be isolation, or exceptionalism, than the iron grip of modern primitivism (Smith 1988, 229).

Only the first of Smith's two Macrossan Lectures was republished as 'The Myth of Isolation'. The first lecture was overwhelmingly more powerful, pertinent, and prescient: it has provided the substance for much of the foregoing analysis. The second lecture was entitled 'The Rebirth of Australian Painting'. It was a theoretical survey, and indeed periodization of

the art scenes in Melbourne and Sydney, with reference to time and place. The other peripheries of the peripheries – Brisbane, Perth, Adelaide and so on – remained invisible, as did New Zealand in Smith's work (see also, across the Tasman, the parallel publication by Sinclair (1961)). Perhaps they were gaps for others to fill in, or fill out; perhaps these were more serious oversights. But he was there first, and it seems unfair to have expected a great deal more of Bernard Smith, considering the extraordinary nature of his achievement.

His final diagnostic was telling, and it backed into and moderated the more strident tenor of the *Antipodean Manifesto*.

> But if Australia is to continue to produce an art of international standing it will be, I believe, an art that emerges from Australian experience and gives a critical edge to it; an art that both celebrates and scarifies our beliefs and traditions; diverse in its interests … while allowing the adherents of no doctrine to posture as an elect called by history to create the only true art of their time; an art which combines tolerance with a lively clash of conflicting opinion, an art contemptuous neither of ideas nor of intuition in the creative process, an art which at its best can rise above the interests and limitations of the nation and the self … (Smith 1962, 32)

Bernard Smith was a Marxist. Five words, which say a lot, and yet leave a great deal yet to be resolved. I began this exercise, seeking to take some distance on Smith's work, with those five words. Let me close with six: 'He was an historian, after all' (Beilharz 1997, 28). Or five: 'He was an historian, after …'

Now that we are after Bernard Smith, it is truly time to sit with the Owl of Minerva, looking back in order to look forward.

References

Beilharz, P. 1987. *Trotsky, Trotskyism and the Transition to Socialism*. London: Croom Helm.

Beilharz, P. 1993. John Anderson and the Syndicalist Moment. *Political Theory Newsletter* 5.

Beilharz, P. 1995. Vere Gordon Childe and Social Theory. In *Childe and Australia: Archaeology, Politics and Ideas*, edited by T. Irving, G. Melleuish and P. Gathercole. St. Lucia: Queensland University Press.

Beilharz, P. 1996a. On the Importance of Being Antipodean and the Consistency of Being Bernard. *Voices* (Summer).

Beilharz, P. 1996b. Place, Taste and Identity. *Art Monthly Australia* (August).

Beilharz, P. 1997. *Imagining the Antipodes – Theory, Culture and the Visual in the Work of Bernard Smith*. Melbourne: Cambridge University Press.

Beilharz, P. 2006. Robert Hughes and the Provincialism Problem. In *Reflected Light – La Trobe Essays*, edited by P. Beilharz and R. Manne. Melbourne: Blackink.

Gabriel, M. 2011. *Love and Capital – Karl and Jenny Marx*. New York: Little Brown.

Kennedy, B. 1995. *A Passion to Oppose – John Anderson, Philosopher*. Melbourne: Melbourne University Press.

Sinclair, K., ed. 1961. *Distance Looks Our Way. The Effects of Remoteness on New Zealand*. Auckland, University of Auckland.

Smith, B. 1962. *Australian Painting Today*. St. Lucia: University of Queensland Press.

Smith, B. 1984. *The Boy Adeodatus – Portrait of a Lucky Young Bastard*. Ringwood: Penguin.

Smith, B. 1988. *The Death of the Artist as Hero*, Melbourne: Oxford University Press.

Smith, B. 2002. *A Pavane for Another Time*. Melbourne: Macmillan.

Robert Hughes

Chapter 18

Robert Hughes and the Provincialism Problem (2006)

I

Everybody knows, loves, hates Robert Hughes. We love him because he is eminent, global; perhaps because he is like us, or some of us. We may not speak like him, but when we hear his voice we recognise it. We hate him because he left, because he left Australia in the sixties and yet insists that he remains connected to us, and might even know something about us or our place.

On the closing page of his first book, *The Art of Australia* (1966) Hughes claimed in exit to quote an unnamed painter who, he states, said to him then 'The fact is, you can't begin to grow up until you've left the place!' The temptation for us, in our shared sense of injury, is to read this as an act of ventriloquism, as though Hughes is hiding from or playing with us, as though this is his own view. Australia is an awful place; you have to flee, you'd be stupid to stay. A more useful way to approach this issue is to generalise it. Some of us have a strong need to leave; but this is a need to leave home, wherever it may be. Travel expands the mind; to live elsewhere is to be compelled to confront difference in a way that can enable you to read the conventions of everyday life at home as though they, too, are peculiar, at least arbitrary or incidental.

Robert Hughes had good reason to leave. The medium of his activity, paint, painting is as he is given to remark beyond reproduction, even with megapixels. Bernard Smith, in contrast, could leave for England in the forties and return, for his archives were largely antipodean, and his texts, both those he read and those he wrote, were readily transmissible. His via media was print. For Hughes, the art critic, you have to be able to smell the

paint, get up close to the pictures themselves. You had to seek out the wealth of culture in the centres, even if, as Hughes also is given to insist, those centres began to decline and pluralise at the very moment of his arrival in New York in 1970.

In this paper I revisit Hughes' writing in order to address, again, some of these problems, which often go under the title of provincialism or the provincialism problem. The idea of Provincialism, famously, cuts both ways – it is both a condition, or a geography, and a stigma, or a culture; it can even be made into a virtue, or a politics. My sense is that Hughes has profoundly suggestive things to say about provincialism. He may, later, have spat at the Antipodes in pain and anger, but his way of thinking about the provincial, not least with reference to Australia and to Barcelona, is evocative in the extreme.

But let's begin at the beginning, with provincialism itself. The immediate associations are evident. The victim of isolation and detachment, convict settlement and harsh climate, Australia is the arse-end of the earth, Europe's Antipodes, the rude bits, down under, the place the imperials send their detritus, dispose of cretinous relations in Oscar Wilde or Virginia Woolf, a laughing stock, crude, unrefined. Ours is a backwater, the sticks, the paddocks and fields which feed only the baser appetites of imperial desire in the north. The provinces are insular, as we are, vulgar, narrow, self-absorbed, idiotic, parochial, closed, dependent, infantile. Ours is parallel to what Marx called the idiocy of real life – idiotic because closed, self-referential, or just too far away.

Give this house of cards a conceptual poke, and it collapses. This was exactly Bernard Smith's gesture, when he observed in 1962 that provincialism was also a metropolitan phenomenon. Like the New York gallery worker who was nonplussed by me – 'Oh, you have art in Australia?' Manhattan is notoriously buzzy, but it is also prone to self-absorption; even Brooklyn is made to look like the sticks, let alone Chicago or Boston, Ohio or Iowa. Without the stigma, perhaps, Manhattan is also insular, so that we might, again, generalise, and wonder here about the cognitive limits of the fields available to be known by humans. Even my own city, perhaps especially my own city, Melbourne, is one I really do not know, though I can navigate it reasonably successfully without a map, or without thinking. This is to speak of the limits of knowledge anthropologically, to value habit, the local, the vernacular. There are, in fact, significant cultural limits to our spheres of reference, and these are also environmental. Think only of university cultures – all different, all constituted around different local enthusiasms and

theoretical preferences. Many aspects of our everyday lives do indeed seem to be acted out in microclimates. To speak of the phenomenon differently, in the language of psychoanalysis, it might alternatively be said that provincialism is another word for narcissism, self- love or self-absorption. Provincialism turns inward, away from other worlds, hopes, fears.

The issue of provincialism, in the case of the Antipodes, is plainly imperial, and this is a constant theme in Hughes' work. Provinces, in the sense of physical geography, do not choose themselves; they are constituted as provincial by the world system. The language of empires and colonies later gave way in the seventies to standard talk about centres and peripheries. Here, again, the implications of this nomenclature were multiple – the centres were not only geographical, but based on claims to culture and power, money and violence as well as galleries, museums and opera. Cultures of the periphery were bound to be inferior, cheap copies of the real European, then American, then international-style modernist thing.

Art historians like Bernard Smith, and critics like Robert Hughes, have always known this to be a nonsense. The point, put too crudely, is rather that the centres feed on the peripheries. Picasso and African art, Gauguin and Tahiti, Matisse and Morocco, Australian actors in Los Angeles – now, Australian art critics in New York then – we all know the stories, even if we do not sufficiently contemplate what they mean, that culture is mobile, that great things happen in the centres because they are magnets of money and opportunity, power and influence. There are simply more gigs in Manhattan than in Melbourne (though sometimes I wonder).

In nineteenth century Australia it simply made sense that we were provincial, of British dominion, and this persists into Federation. Leading Australians like H.B. Higgins sought what they imagined as a New Province for Law and Order. Canberra later becomes the utopian symbol of this national project. Only by the sixties does national culture, and national chauvinism, insinuate itself into teaching curricula. Arthur Phillips famously anticipated the issues in 'The Cultural Cringe' in 1958. Were we as good as our masters? By their own criteria, never. Either, as Phillips understood, they make us feel inferior ('oh, you have art in Australia?') or we do it for ourselves (the best is always made in England, then America). Phillips' vernacular typology captured the essential ingredients. He differentiated between what he called Cringe Direct and Cringe Inverted. Cringe Direct is explicit – we cower before the other. Cringe Inverted always bites back, even when no offence has been committed. Cringe Inverted reverses the earlier prejudice; the best is always local, whether cultural or natural. It results in the arrogance of

nativism or cultural chauvinism, a prejudice in no way morally superior to the haughtiness of our superiors in London, New York or Paris. This is something we should stand against. Phillips' diagnosis retains a charming period sense that attitude is like bearing, or stature, how we (as Australians) hold or carry ourselves. His conclusion was that the Cringe was a bigger problem than isolation, and that the solution to Cringe was not the Strut, but a 'relaxed erectness of carriage'. Provincialism, its enemy, could also be a complex. Provincials could only too easily lurch from an unwarranted sense of superiority to a horrible anxiety that we were always missing out. Whatever the case, the politics of inversion never achieves more than reversal.

The intellectual dimensions of these anxieties ran, and run deep. Phillips was writing in the same moment that McAuley penned 'The End of Modernity'. At least since D.H. Lawrence left *Kangaroo* here in 1923, Australian intellectuals had been searching for genius loci, for the spirit of place that made us special or exceptional in the face of European decline and the rise of mechanical civilisation in America. Romanticism, a powerfully European cultural impulse, was translated into the primitivism of place. We in the Antipodes were not the city, but the bush, later the desert or the beach. The great contribution of Bernard Smith, in this setting, was to insist that Australian identity was neither just cultural (European) or environmental (local), but both, constituted by the traffic between places and the influence of those places on localities and other places.

In 'The Myth of Isolation' (1962) Smith took up these provincial perennials. Were the provinces merely the waiting rooms of history, where nothing was fated to happen, the eternal sticks to the northern big smoke? Smith defines the irony of the moment as one in which local artists discover that it is their difference rather than their derivation which makes them interesting to the centres. Historically, the problem later has precisely been provincialism, the desire to keep up with the international Joneses by second guessing northern tastes. Smith connects this to what he calls the myth of isolation. We may be physically distant from the cities of the centres, but our cultures have been co-constituted through the empires. To put it differently, what we call Australian culture ('oh, you have art in Australia'?) is constituted by cultural traffic, literally by the routine intercourse and maritime contact which was formally opened in 1770. Here Smith engages with Hughes, and in particular contests the claim that Australian painting might be defined by an absence – the absence of the Renaissance tradition, where it now (in the sixties) offers a presence in which the landscape of gum tree painting is broken by deserts and

banditti, bushrangers. Smith dislikes this approach, for it smells, he says, of exceptionalism.

Any hint of the Jindyworobaks makes Bernard Smith twitch. He is opposed to the need to make any culture especially unique, whether to seek especially to value or to devalue it. Smith's alternative explanation is to say that what appears at first sight to be isolation or ignorance might turn out, rather, to be a process of selection and rejection. Artists have their prejudices, or blindnesses as well as insights; they are also operators, and they have historical repertoires on which to draw. In any case, negative definition is always unwittingly confessional. The colonial artists were European artists in Australia. The first school of Australian painting was neither just the environmental result of heat and eucalypt; French *plein air* painting, Whistler, impressionism and *art nouveau* were also there. As Smith argues, the secret is in the mix, and it is this which makes it ineffable. Acceptance of the metropolitan culture without question, he says, is the essence of provincialism. With the expansion of European culture over the globe it is the exotic frontier cultures which have to a large extent determined taste and the movement of style. For us, as those positioned externally as provincials by the centres, the resonances miss our actual location and experience. And here Smith agrees with Hughes, that to think of Australia as a *jardin exotique* is a fashionable way of missing the point, for to its painters Australia is not an exotic garden; it is the place where we live.

At this point, in 1962, Hughes was still living in Australia; Smith has travelled out ten years earlier, but returned and has always worked here. As Smith put it elsewhere, on the occasion of the 1956 Olympics, Australian intellectuals were migratory birds, as ours is a migratory culture. But then, they all are.

Bernard Smith's student, Terry Smith, picked up on these issues in 1974, when he was living in New York, before returning to Sydney to direct the Power Institute and relocating, again, to Pittsburgh, migrating, as we differently do, responding to push and to pull. Terry Smith's paper reads more like a manifesto, if for a lost cause. 'The Provincialism Problem' seems here to consume us. Terry Smith's prose was as clear as it was powerful. To identify provincialism as a problem in this way was to beg the question of its definition. Smith defined it as an attitude, with a history and geography of its own. He wrote that 'Provincialism appears primarily as an attitude of subservience to an externally imposed hierarchy of cultural values. It is not simply the product of a colonialist history; nor is it merely a function of geographic location'. The phrasing echoes that of Marx, as it opens the first

volume of *Capital* (1867): 'The wealth of societies in which the capitalist mode of production prevails appears as an immense collection of commodities', and Terry Smith, like Bernard before him, was indeed a Marxist, for whom imperialism was a first historical principle, as capital was the first concept. Terry followed Bernard in insisting that provincialism was, however, also universal. The projection of the New York art world upon every other scene was itself also provincial, this both in centre and in periphery. The problem is, as Terry Smith argues, that we can all see this, on a moment's reflection, and know it is culturally relative or constructed, yet it is also real. Distinctions like metropolitan versus provincial still prevail, even after we expose or denounce them as arbitrary or stigmatic.

The development of Australian art, for Terry Smith in the seventies, is typified by variations on the theme of dependence. Inasmuch as the centres behave as though they are the leaders, the natural culture heroes, so do we then follow. The resulting tensions are beyond resolution; either we seek creatively to adapt, or we go local, seeking to make good, original art right here. Provincialism does not escape from this bind, but expresses it through the obsession with local identity. Who are we, in the provinces? Not you, in the centres. But please, can we play with you? New York, in this understanding, becomes a kind of brand name, a place or an image which authorises work as implicitly avant-garde. The logic of provincialism, as Bernard Smith also knew, then worked by relay. In order for, say, an art historian to receive recognition at home, it would first have to be granted overseas and then fed back. Centres like New York then depend vitally on the input of foreign artists. But this will always involve the politics of the one way mirror, to use an image a Dutch sociologist once used with me; we can see them, but they never see us, except more recently in Hollywood speaking tongues. Cultural creation works through cultural traffic, but cultural transmission of the avant-garde is one-way; Australians know Jackson Pollock but New Yorkers will not know Sidney Nolan, let alone Gordon Bennett ('oh, you have art in Australia?'). But here, for Terry Smith in 1974, there was no apparent exit: '*As the situation stands, the provincial artist cannot choose not to be provincial.*' Expatriation results in assimilation, followed by return home to proselytise for antipodean artists. There are, of course, provincial or regional artists in the USA, as well; but turning our backs on provincialism will not make it go away.

Is there then, no escaping these hard choices, avant-garde or dependency, metropolitanism or provincialism, cosmopolitanism or introspection, internationalism versus regionalism, universal or particular, Paris or the bush? Or

to put it differently, thirty years after Terry Smith's essay, is provincialism always such a bad thing? Is provincialism necessarily a problem?

Some signs suggest a shift in the available perspectives on these matters. An influential postcolonial critic like Dipesh Chakrabarty, himself a commuter, can now call for what he advocates as *Provincializing Europe* (2004). Provincial cuisine, provincial or place based writing, Tuscany, Provence, Tim Winton, Stefano di Pieri, all the hip signs of consumption point out, away. The romantic critique of modernity has always pointed out, and back, away from the metropolis and its cities, even as these fantasies and consuming desires gobble up our early evenings in television and novel. Even the cop shows have left Manhattan.

Long have moderns lusted for the past. Karl Marx, and differently Ferdinand Tönnies, harboured implicit or explicit desires to return to the community-image of the world before capitalism, before modernity. Oswald Spengler marked this way with his *Decline of the West* (1922). Martin Heidegger rearticulated this sensibility into the thirties, where wisdom and balance come of isolation or solitude; cities corrupt, distract, overstimulate, generate herd mentalities, stimulate outer rather than inner direction. Yet this desire also evokes the lust for an authenticity we never knew. Put differently, again, in our times praise for the particular has been pitted against the abstract universalism of Enlightenment. What makes me real, in this way of thinking, is local, vernacular, that which grounds me, or puts my ear to the earth, which is small, modest and silent rather than bustling, restless and insatiable. The appeal of this view is as evident as is its danger. It is the argument for roots. As another antipodean in New York, Ken Wark, used to say, however, these days we have aerials, not roots. The limit of Wark's aphorism is also apparent. Not everyone can afford aerials, or voluntary mobility; and there remains a sense in which place, as we choose it, is constitutive of those senses of home or belonging which are the apparent precondition of love, loyalty, of the capacity to care for the locale and to engage in civic and political activity.

Another line into this labyrinth, then, would be to think of the pastoral rather than the provincial. Love of the pastoral is as British as it is German, and this British lineage has always been powerfully evident in the Antipodes, even more so in New Zealand. New Zealand is the green and pleasant land, Ruskin, Tolkien. Australian pastoralism is distinct, known, as in Streeton's 'Golden Summers'; these are different tectonic plates. Arguably all moderns, metropolitans included, still have elements of the pastoral in their minds. That is what Frederick Olmsted set out to achieve, in Central Park and else-

where, not the garden city but the city in the garden. As Raymond Williams reminds us in *The Country and the City* (1973), these are very powerful words, county and city, both in fact brimming with ambivalence or contradiction. If we are in the city, we remain, in this field, somehow not of it. Modernity brings with it a sense of alienation. We become addicted to the stimuli, but they never quite satisfy us. In result, we become romantic again, nostalgic for times imagined if not remembered, and seek out the provincial, now to consume it, as diners or tourists, in passive rather than active mode.

II

This was never the case for Robert Hughes, who set out to consume modernity even if he started in Italy and England before settling in New York. The young Hughes set out to conquer world culture. He already knew some of it; he knew about the pastoral, about antiquity and not only about modern painting. This he makes most apparent when, on television shows like *American Visions*, he looks straight down the barrel of the camera, sunburnt and tieless, to feed you some allusion to Cincinnatus in American period painting. The newest world civilisation, that of the United States, of course drank deep of Roman and classical antiquity as it invented its own republican traditions. Hughes knows all this, and this is what enables the mastery of his televisual control and capacity to condense across cultures and epochs.

But if he looks Australian, and appearances deceive, then surely Hughes is the kind of bitter expat and empty cosmopolitan who fled in despair; you can't begin to grow up until you've left the place. The detail of all those years of criticism in the *Time* magazine columns suggest something else, a sense of detail and engagement as befits his trade and his commitment. Was Hughes ever, then, provincial, and what does his writing tell us about the provincialism problem? My suggestion here is that Hughes' work throws significant light on provincialism, because of the self-consciousness of his path and because of its doubly antipodean basis, one foot in the Antipodes as we know them, one foot (or his heart) in Barcelona. To begin with his beginning, Hughes tells us something of these issues in *The Art of Australia*.

The Art of Australia is a young man's book, completed before he was twenty-five, and published in Australia in 1965, by which time Hughes was in Italy, painting and discovering other worlds. The young man knew his purpose. It was supplementary to Bernard Smith's, from *Place, Taste and Tradition* (1945) to *European Vision and the South Pacific* (1960) and

Australian Painting (1962). Bernard Smith always stopped short of the present; that was his own art, or craft, that of the historian, for which distance and detachment are vital. This is the fundamental methodological and stylistic difference between Smith and Hughes. Smith is, as he says, a cultural historian with a primary interest in the visual. Hughes is an art critic, a writer rather than a scholar, though the depth of his work is clearly scholarly, or civilisational in scope. But the critic is in and of the present, reactive, in the moment, in the gallery or the studio; the energy is different, and the result reads with the distinction of the tradition more like Carlyle than Ruskin. Hughes stamps his critic's foot. When he sees crap, he says so.

So Hughes' purpose in *The Art of Australia* was to update Smith, and he achieves his result. The work is more descriptive and analytical than sweeping and sociological in the way a later project like *American Visions* is. Yet a sociological residue remains, as Hughes understands. As he writes in opening, 'the most interesting issue raised by Australian painting is the complex, partly sociological, issue of its pendant relationship to the European tradition, both old and new. A history of Australian art should be written in terms of its overseas prototypes'. Hughes' use of language, occasionally florid over the path of his work, is invariably evocative. Pendant could be illustrious, or simply in suspension. Certainly Hughes is right that a nationalist history of Australian painting would never work; this indeed, is one of the few limits to the more recent separation of the Australian collection from European work in the newer arrangements in Melbourne's two national galleries. As you follow the trajectory of colonial painting, from Glover through to Fred Williams in the Potter Gallery, you get a clear sense of movement, attraction and distance, but no sense of the cultural traffic and precedents which helped enable Australian painting. Hughes tell us here, in 1965, that he himself eschews the prototypes out of ignorance; what we need here, he says, is a scholarly sequel to Bernard Smith's *European Vision* for the period since 1880. Now prototype is too hard a word, but it fits the period. The point, rather, following Smith in 'The Myth of Isolation', was that culture works through selection and adaptation, so that what would be called for here rather would be some kind of comparative history of colonial art, say, across settlers capitalisms, Australia, New Zealand, South Africa, Canada, or the South American experiences across the Pacific.

But the young man already knows his terrain, and so deals in opening his book with the provincialism problem. At this point, he deals with it mentally. Ours is a provincial culture, constituted as such by the waves of

world history. The question for Hughes, in the wake of Smith, would be to study what uses this provincial culture finds for the art it produces in period circumstances of sixties conservatism and high economic boom. What Hughes still characterises here as Australia's lamentable isolation from the mainstream is, he says, diminishing by 1969, when he closes the preface to the second edition of the book.

Hughes opens his tour by acknowledging the significance of Smith's work, while setting his own against it. I have written extensively about Smith's work, for example in *Imagining the Antipodes* (1997), and am working towards a future project which will more fully catalogue Hughes' achievement, which will necessarily involve sorting out their interrelations. For the moment, I will only say that it seems to me on early encounter that *The Art of Australia* may be less set against Smith's work than the subliminal rivalry between the two men set in Sydney in the sixties, might at first suggest. Hughes sets out, like Smith, to work within the relationships between art and environment. Like Smith, he has an instructive scepticism towards bullshit, nationalism included. He has no patience for the you-beaut cultural heromaking which enthrones Streeton, Lambert, Dobell and Drysdale in the pantheon. The results of this desire, as Hughes characteristically puts it, are hilarious; but the desire says much more about us, or them, then, than it does about the paintings.

In self-reflective register, he continues, he had imagined later in the fifties that Australian painting was purely a product of isolation, and that this isolation had conferred some mysterious vitality upon it. But this was before he travelled out, to Italy. The limit of Australian experience, in this period, is in the limits of its Galleries, apart from the National Gallery of Victoria. Apart from the NGV, Australian galleries are 'provincial to a fault', both in space and time. Each individual art work is presented as though it were a relic, revered but not understood, all aura, or awe, no context or history.

One difference of emphasis between Hughes and Smith is already apparent, or at least suggested here. Hughes' emphasis is on the gallery as the site of the appreciation, or consumption of art. This is the figure or persona we know so well, standing in front of a picture on TV, or eliciting a similar presence in his magazine columns. Smith's emphasis, as in 'The Myth of Isolation', is on the creation or production of the images, on the painters rather than the public. It is a fitting approach for a Marxist, which Hughes never was, though the question of patronage becomes more and more palpable, for example, by *American Visions*; and perhaps this was inevitable as Hughes' view shifted to the Hudson, where money shouts, and patronage

is everything, even if the art becomes entropic in result. It's a long way to the top, and a longer way from Joshua Reynolds to Jeff Koons.

So Hughes begins *The Art of Australia* with this fundamental curiosity about the relationship of Australian painting to Europe, and his sentiments anticipate those later followed through in Smith's *Modernisms's History* (1998), where the stories of the peripheries would always necessarily also tell us something of the stories of the centres. For Hughes, in *The Art of Australia*, no other country in the modern world provides so good a laboratory for the study of foreign schemata on a provincial culture as Australia.

The text of *The Art of Australia* opens, of course, in Botany Bay, and here we see a pattern in Hughes' work; most of that to which he returns is first posited in passing. The contemporary reader is immediately transported to *The Fatal Shore* (1987), though in the fibre of Hughes' own project, there are also echoes into *Heaven and Hell in Western Art,* his wonderful and unjustly neglected book of 1968. For there are demons in the European imagination, and they are also transported to Botany Bay, as it is the Antipodes from which they hail. Here we have antipodean creatures, with the feet facing elsewhere, but we also meet Goya, a doppelganger who will return later.

Where there is hell, there is heaven. Hughes deals with the images of the Antipodes as arcadia. As he puts it, the vision of arcadia in the Antipodes, despite its croaking, stinging and gargling inhabitants, was not easily to be put down. Early painters, like Augustus Earle, combined romanticism, frontier lore and topography in their work. Hughes' language becomes harsher as he proceeds. The lineaments of colonial art, he concludes, are patchy. 'No country in the West during the nineteenth century, with the possible exception of Patagonia, was less endowed with talent'. This is the magisterial voice of the critic in the making. Hughes' young tongue is lacerative. But what is often missed, as we provincials recoil from the severity of the judgement, is that the certainty of its delivery also invites dissent or disagreement ('sez who?'). Hughes possesses authority, which invites dissent.

Hughes' judgement, at this point, was that in consequence there was little in the history of Australian art between 1788 and 1885 that would interest an historian (take that! Dr Smith!) *except* the way that painters accommodated environment and European forms. The young Hughes did not resile from identifying Australian painting negatively, by its absence – the problem here was that there was no Australian Delacroix.

After 1880 things picked up. In 1883 four young Australians were on a walking tour up north – not in Italy, but in Spain. Spain: outside Madrid, not yet Barcelona. In Spain, they got the gossip from Paris, on Gerôme. They

adapted and selected, especially their leading light, Tom Roberts. Such is the way of cultural traffic. Provincialism however persisted, later in Norman Lindsay, who suffered to an appalling degree from provincialism in time as well as space. Some painters disappeared into the bush; others fled out, like Albert Tucker in 1947: 'I am a refugee from Australian culture'. Those who stayed in the cities just copped it sweet, following perhaps what Max Harris called the Camus streak, playing along, avoiding grand gestures. Some simply copped provincialism, while others struggled against it, or fled to the centres. Still provincialism prevailed. Hughes quotes Jacques Barzun, to the effect that it is the provincial belief in centre and extremity that makes Paris and London rule; only the adventurous travelled out and sideways. Provincialism looks up and down, not sideways.

Hughes dances around *The Antipodean Manifesto*, Bernard Smith's 1959 choreography with the Boyds, Perceval, Pugh, Black, Dickerson and Blackman. Often then taken to be advocacy of a national, and figurative tradition against the abstraction of international style, the *Manifesto* viewed in retrospect was unable to escape from period standoffs between Sydney and Melbourne and abstraction and realism in its reception. The remaining point was that the antipodean was less an Australian, than a figure caught in between, or a migratory bird. Like Smith, Hughes was unhappy with the false choice between Dobell's portraiture and empty abstraction. The line out, for Hughes, was apparent in Ian Fairweather's work, or in Brett Whiteley's. An image of Whiteley's made the cover of the second edition of *The Art of Australia*, indicative both of results and of beginnings. Whitely had also travelled out, and shared something of Hughes' cultural universe, where America was the background image, even as the British rock invasion opened the next brilliant phase of cultural traffic. Their soundtrack was Dylan, and Cream; its icon, momentarily, was Jagger, rather than Marilyn Monroe, but never quite Warhol. *Gimme Shelter* then became an island.

The Art of Australia seems, necessarily, to become more reportive the closer it gets to its own present. Its personnel seems busier, sweatier, their paintings wet and dripping, disallowing the kind of critical distance that Bernard Smith insisted upon. Yet Hughes was bound, in conclusion, to seek to make sense of it all, or at least of the present and its impasse. Or was it an impasse? For Hughes also succeeds in conveying the sense by the end of the sixties that new movement is discernable, in centre and in periphery. Historically, the tendency has been to think regionally and to seek out *genius loci*; and like Smith, Robert Hughes twitches at the kind of interwar nationalism which looks to land and soil for inspiration, whether

in Germany or in Australia. Hughes complains that Australians tend to presume that place has some kind of special influence over art and culture, even if it is weaker than this kind of nazi or chauvinist enthusiasm. Problem is, as Hughes concludes, the nature of this influence is never defined; and yet, we continue to feel it, now perhaps more than ever, as we revalue nature over culture in what is again a significantly provincial turn (culture we lack, but have we got nature!)

Now, towards the end of the sixties, Hughes anticipates globalisation, or at least something like it. Now we live in what he calls a linear culture, where images are mechanically reproduced and globally transmitted, to the extent that it may henceforth be pointless to speak of isolated cultural pockets where regional styles may develop in nostalgically admired purity. Australian painting, on this way of thinking, should really be conceived as painting in Australia; the whole possibility of national style is placed under question. Hughes' anticipations look prophetic, forty years later; the only difference in what we watch today is that while globalism indeed undermines the nation it also strengthens it, in different ways, and regionalism in turn thrives, both within and across nations. As for the painters themselves, Hughes' sense in 1965 is that they remain caught within D.H. Lawrence's problematic, in *Kangaroo*. 'They are afflicted with a sense of inferiority – of being constantly left behind; and their occasional truculence about decadent Europe is their obvious mask'. They still carry Phillips' Cultural Cringe, in both forms; they lust after the unattainable, and they despise it. To ignore this problem, and paint as if nothing existed north of Cape York or east of Christchurch is to succumb at once to provincialism, as he puts it. But painters need not feel or carry the responsibility to articulate national identity or collective imagination. Hughes slips behind the screen, together with the black swan of trespass: 'I had read in books that art was not easy / But nobody told me that the mind repeats / In its ignorance the vision of others'.

Twenty years later he was back in Sydney, researching *The Fatal Shore*. That book became an airport bookshop blockbuster, one of the few books about Australia in my experience known to most of my friends overseas, though again it is much more than that. By 1987 Hughes' style is ripe, visual and as shocking as its object is, thick with mobile adjectives whose purpose it is to catch this place or what the convicts and their governors might have seen in it two hundred years earlier. This first colony, of course, is a province, a little bit of England caricatured by its relocation in the land of weird melancholy. For its opponents at one remove, like Jeremy Bentham, transportation was a

way to evacuate British refuse. As for the earliest painters, their heads were elsewhere, or at least their habits and templates were too pastoral to register the specificities around Botany Bay. Cultural traffic worked its way, as when for example the invaders gave back to the indigenes a word they thought was theirs, but was actually introduced: Kangaroo. D.H. Lawrence unwittingly reproduced the gesture by giving back to Australians the provincialism they had also invented.

More powerfully, for those of us who come after Freud, Hughes describes the experience for Europe as its geographical unconscious. The Antipodes served as the other of Empire, never as the equal or balance of the centre except in the most antique sense, as object to its subject. This was to play out as the great antipodean time lag. Yet Australian democracy also supplanted its Gulag. Australians were capable of innovative democracy, but less so of original cultural creation. Some, like Samuel Sidney, dreamed of the Antipodes in the nineteenth century as arcadia, as a way out of modernity. Hughes charts rather the political arrival of modernity via democracy, together with its maintenance of a culture that remains provincial. The broader theme worked by Hughes here is that which is so central later to *American Visions*. It is the question of foundations, of the myths within which peoples or their leaders constructed modern cultures, puritan yet hedonistic in America, the convict stain, then the egalitarianism of gold in Australia. The Australian encounter with the continent was different. The Americans went west with the same enthusiasm that took them elsewhere, whereas the Australians hugged the coastline, and themselves, stuck to the east, stayed with Camus rather than travelling with Tocqueville. 'In Australian terms' he writes with gut-wrenching personal prophecy in *The Fatal Shore*, 'to go west was to die and the space itself was the jail'.

In the nineteenth century, each new proclamation of renewal or Australian arrival enclosed a longing for amnesia, Hughes wrote, or at least for nostalgia, for images of the other's past, Arcadia, the green and pleasant land. Ours was, he said, at first a chronicle of provincial misery, a minor episode in English imperial policy, best forgotten. What was distant in time and space was real; what was close had been sublimated into the substance of bad social dreams, this at least for our superiors and educators. It was, finally, the sea which imprisoned us; but there were always ways out, means of traffic both individual and cultural as the tyranny of distance became navigable by those with the means, first the sailboat and steamer, then the Constellation and the 747.

Australia, thus, has always been Robert Hughes' Antipodes. He was both antipodean, to end living the majority of his years in New York, with Australia as his other referent, and metropolitan. There is a third leg here, for Hughes, and it is chosen in Barcelona.

These days the image of Barcelona is cool, hip, a third way, away from well-trod centres. It was not so long ago that Barcelona was viewed in the centres as was Barry McKenzie. Manuel, in *Fawlty Towers*, comes from Barcelona, and we – here in league with the British – laughed, as though it were self-evidently funny or hopeless. Hughes discovered Barcelona, as Italy, definitionally as an innocent; all he had on Italy was de Chirico on a postcard. Barcelona he has come to love enough to write on thrice: *Barcelona* (1992); *Barcelona – The Great Enchantress* (2004); and in between, the biography that precedes his autobiography, *Goya* (2003).

The first volume of the trilogy, *Barcelona*, maps it out. In its preface, the optic opens again with provincialism – this time, with somebody else's. The vista for *Barcelona* opens with a sense of postimperial shift. Hughes anticipates that the coming decade, the nineties, will see the winding up of a model of cultural activity that served modernism so well. It is, in fact, an older model, inherited from papal Rome and then Paris at its height. It rests on the idea of the central city dictating its norms to the provinces and colonies. Probably the last city to assume this role, according to Hughes, was New York, circa 1925–1975. Barcelona, on this view, was plainly provincial, and this would echo 'on a none-too-subliminal level, with the fact that I am a provincial, an Australian'. But more. This is Catalan. Australian is not quite a dialect; and with a few exceptions from the west, Australia has no specific tradition of proud separatism.

Hughes tells us that he fell in love with Barcelona in 1966. He talks us through history, city emergence and design, decline and recovery. The contrast with New York, a city he then viewed in civilisational terms as entropic, is striking. Barcelona is a metropolis; it has long been an intensely provincial place as well. Regionalism can strut, as well as cringe. Hughes the historian cannot help himself. What began in his head as a city architecture guidebook is soon back with the Romans. Which is, of course, where the story of provincialism begins, with the Romans in Provence, and in Catalunya. The spirit of this provincialism was less proudly independent, and more emphatically egalitarian, with a touch of Camus. Thus the famous and unique oath of allegiance sworn by Catalans and Aragonese to the Spanish monarch in Madrid : 'We, who are as good as you, swear to you, who are no

better than us, to accept you as our king and sovereign lord, provided you observe all our liberties and laws – but if not, not'.

Hughes' love of Barcelona runs deep. He also loves Gaudi, and la Sagrada Familia, but he is at pains to avoid tokenising the place, as in the Opera House to Sydney. Instead he traverses a contested culture of experimentalism, *modernisme*, tradition, and catholicism, socialism, class struggle, planning and chaos. Catalan modernism, in result, is that wonderful hybrid closer to Art Nouveau than to Bauhaus. This is the context in which Gaudi arrives. Hughes describes Gaudi's architecture as the delayed baroque that Barcelona never had. But it is in the detail of his analysis that Hughes reminds us of his earliest interest in architecture, and it is in the sense of wonderment that Hughes best conveys the fantastic impossibility of these nevertheless highly tactile traditionalist experiments. Gaudi is both a regionalist and an essentialist; there is nothing here of international style. And this is its brilliance.

Hughes closes Barcelona with the line from Maragall, which becomes the prompt for his return in 2004 – 'Our Barcelona, the great enchantress!' He returns in the little book called just that, *Barcelona – The Great Enchantress*. Much has changed, in those twelve years. He has fought off the black dog, with *American Visions* in 1996. Hughes has almost been killed, in his Northwest Australian car accident of 1999. This would be enough to stop most, but writing works as his Jacob's ladder. And the register becomes more personal, if not confessional, in these little books like *The Enchantress* and his book on fishing and nature, *A Jerk On One End* (1999).

The narrative returns to 1966, to first sighting, but only momentarily. It shifts rapidly to Barcelona as the site of Hughes' third wedding, to the painter Doris Downes. Third time lucky was in the third city. And the echo, again, is with Sydney rather than Manhattan, for Barcelona also has the vitality of provincialism. Hughes remembers the oath of allegiance sworn by the Catalans and Aragonese to the Spanish monarch in Madrid, and views it as an admirable template for modern marriage. If not, not. Hughes' description of the wedding is touching, if not moving. And the stretch and pace of the book is incredible, not least in this more closely personal register. Hughes speaks with feeling of love, of food and markets, of dance, of Catalan submarines; there is an 'I want' here which is refreshingly direct after a decade of 'I want to argue' as the dominant voice in postmodern criticism.

Yet the provincialism problem also persists. Hughes observes that one response to provincialism, an internal response, is to adopt a personal centre

as an alternative – New York, London, Paris. America appealed to Hughes rather than Britain as a way to side step the awful cringe. But as Hughes says here, to sign up with the USA, for an Australian, might also be an act of colonial capitulation (though it might also mean anything else, including choosing where you want to die). Hughes would rather be an adoptive or short-stay Catalan instead. Plainly Barcelona was a relief from New York, less suffocating, less given to endless ratification and starfucking. Yet Barcelona had a long settled history, was a province rather than a colony as, say Sydney was: these are not the same story. The legacy of Barcelona, looking out, is that a strong regional culture is not fated to be provincial, in Spain or anywhere else.

The power of Hughes' own voice, in closing this little scan, is in its directness. Hughes refuses tribalism. His view is sympathetic with that of Agnes Heller, that (within limits, and given good fortune) we can choose ourselves. To choose Barcelona, or Melbourne, is to embrace it with some sense of comfort. Melbourne, for me, is not New York; it is the place I was born, and where I have chosen to stay, to work, to live. I do not have to love it, though I might choose to. Nor do I have to feel shame for it. It is simply my city. For his part, Hughes insists on the right to choose what he loves, cities included. Identity, here, is not traditional or prescriptive: it is modern, and optional. And it is less than obsessive, demanding endless justification. Life is too short.

The exit from Barcelona is, again, touching, a plain little story, the couple watching the Catalan national dance, the *Sardona*, from their hotel window. The dance is stately, minimal, democratic, spontaneous. Hughes knows how to watch. He has the voice and the eye. And he has other companions. His life has been ghosted by various figures, but the one he persists with is the last in this survey: Goya. Hughes' *Goya* is dedicated to Doris Downes, and her sons, and laments the loss of his own son, Danton. The pain goes on, for it now includes Hughes' own, after that near-fatal car crash, and the dozen operations that followed. The extent of Hughes' suffering is difficult to fathom. Only it can explain his lapse into the bitter language of provincialism, as his Acknowledgements proceed to blast Western Australia ('West Australian justice is to justice what West Australian culture is to culture'). Hughes' experience in Western Australia was Hell. It took him closer than he had been before to the pain, fear and despair that would more fully open Goya's lifeworld to him.

Hughes' writerly frame in introducing Goya is at once historical and cultural. Provinces, like empires, are historically formed; Spain was once

the world. The horror that Goya painted evoked a world unknown to white Australians, even Catholics like Hughes in the sixties. In America, in contrast, the pain of Vietnam bit deeper, reaching back into earlier fundamental splits like those of the American Civil War. But the roots go back further. Goya was also a provincial. The Spanish Enlightenment was slow to emerge; it had significant enemies. Provincialism is, as Hughes hints, as much to do with time as with place or space; provincials feel as though they are behind. As Johannes Fabian argues in *Time and the Other*, the world leaders in the centres place themselves ahead of provincials and others in time, therefore in history, but also in the present. Whether rich and conservative or avant garde and radical, the leaders of the west see themselves as bearing the spearhead of time as progress. To suffer censorship, for example, whether in Madrid or in Melbourne across those centuries, was to be held back, pronounced backward, to be placed backwards in time.

Yet from the provinces, prophets also come. Sometimes they cultivate the local mythology, the Spanish majo or macho, or maja, the natural and vulgar voice against the refined and artificial. Goya, like Hughes, innovates but is vernacular in voice. Like Gaudi, to follow, there was something strikingly distinct in the result. Hughes shares Goya's fascination with the grotesque and the macabre; remember only the visuals in *Heaven and Hell in Western Art*, as scary as anything in Tarantino, scarier even for the absence of the photographic clarity of film. More, the artistic image appeals endlessly, empirical, sceptical, seeking to enlighten, to illustrate but fully aware of the monsters that come with the sleep of reason, the *caprichos* adding captions themselves elusive or else full of paradox. Goya is provincial and modern at the same time. Like Hughes, he takes to exile, this time to Bordeaux via Paris. Goya suffers a stroke, which paralyses the right side of his body, the same side which Hughes shatters in the car crash. So the sleep of reason brings Goya to Hughes, in the chaos, and Hughes travels through to the other side with Goya as his psychic companion.

Hughes' local reception, in the meantime, had been marred by the TV series *Return to the Fatal Shore*. The title was good humoured; the series had to build around his accident. If the result was disappointing, we should hardly be surprised. The magisterial presence of *American Visions* is not there. The themes suggested seem reminiscent of earlier, provincial days, wowserism and class; this was the kind of stuff that made some Australians feel that he no longer knew us. Nevertheless, the local response to Hughes was often cruel, unable to see his pain. Most appalling of all, a West Australian performer purchased the squashed metal cube of the car wreck

in order to present it garnished with green cans as the most vindictive art work imaginable in the Antipodes. Even Beckett, in his gloom, would do no more than alliterate critic with cretin. To set out to crucify the critic symbolically in this way was beyond awful. Goya had Saturn devouring his son. We had rather set out to cut up the messenger. Art had become payback.

If modernity is about speed, then provincialism is anxiety about missing out. What Hughes forces upon us is something we already know, but often fail to recognise. The centres suffer from an abundance of riches. We, who live further away, are sometimes compelled to innovate not ex nihilo, but with what comes to hand. Innovation comes also of distance, of other circumstances. The anxiety of missing out, after all, comes of the fear of being in the wrong place. But there is no right place. Cultural innovation happens everywhere, anywhere. These days, even as the global rush to the urban edge becomes pluralised to that of various world cities, the hinterlands risk dropping off the canvas. The provincialism problem persists. If Robert Hughes is ahead of us, it may be to do with the quality of his provincial insight, rather than the fact that he left us behind. We should celebrate him, and his achievement.

Is provincialism, then, always a problem? Perhaps Terry Smith's 1974 maxim still stands: we have no choice but to be provincial. This has its advantages, if we also think like migratory creatures. There is no especial privilege in being outsiders; anyway, here is no outside to the world-system. The perspective of the provincial might still expand the horizon. The issue here is rather that the relationship between centre and periphery is generally constructed internally, as master to slave, or oedipally, as father (or mother) to child. The limit of provincial vision, in consequence, is that it is unilateral. In terms of perspective, the peripheral vision of provincialism remains underdeveloped. There is light outside the provincial tunnel. Other optics, traditions and possibilities for creation might open, if we look sideways.

Chapter 19

Placing Robert Hughes:
A Promissory Note
(2013)

Who was Robert Hughes?

By repute he was Australia's greatest art critic, and the world's. Hughes was born in Sydney in 1938 and died in New York, his adopted home, in 2012. He was the first great Australian expatriate of his generation to go to the New World, to Manhattan and to *Time Magazine* rather than to London and the *TLS* or the BBC. He was a stunning, playful, sarcastic and insightful writer: *The Art of Australia* (1970, after a false earlier start); *Heaven and Hell in Western Art* (1968); *The Shock of the New* (1981); *The Fatal Shore* (1987); *Nothing if Not Critical* (1990); *Barcelona* (1992); *The Culture of Complaint* (1993); *American Visions* (1997); *A Jerk on One End* (1999); *Goya* (2006); *Things I Didn't Know*, an autobiography (2006); *Barcelona: The Great Enchantress* (2007); and *Rome* (2011). Then there are the artist studies, of Lucian Freud, Auerbach, Lancely and Donald Friend. But perhaps his most powerful presence was televisual, something of an irony considering is contempt for the modern medium of dumbing-down: *The Shock of the New* and *American Visions*, both television series that begat books, as well as occasional performances on Speer, Gaudi, 'Return to You Beaut Country', 'Return to the Fatal Shore'; there was a constant sense of return to Australia, the place he initially had to flee.

This was a life of extraordinary achievement. Hughes was a journalist with a strong grasp on classical culture and art history, the combined product of his own talent and precociousness and a Jesuit schooling. But if he was a writer, and a brilliant stylist (occasionally given to excess, a *leitmotif* of his life) he was also a performer. When you watch *Shock of the New* or *American Visions* you can see a certain wickedness or at least mischief, a sense of power

and pleasure in the things you (or he) can do with words – assess, tease, judge, connect, condense, praise, poke, skewer.

Hughes was one of Australia's greatest intellectuals. This needs to be said and said loudly, clearly. For in the sad path of decline that followed his near-fatal car accident near Broome in 1999, Hughes became (at least in Australia) the object of contempt rather than of sympathy or sufficient recognition. The appalling apogee of this contempt, perhaps unsurprisingly itself took artistic form. Artist Danius Kesminas bought the metal cube which was all that was left from Hughes' car crash, festooned it with detritus, and presented it in Perth – as a work of art (*The Australian*, 1/2/2001). Unfortunately the critic was not at this moment of his tragedy able to put the piece in its place. My suggestion here, in this modest gesture of parting recognition of Hughes, is that the extent of his achievement has been diminished in Australia because of the power of the nationalist tradition which he walked away from. In walking away from 'us', Hughes' exit for Europe and America was seen, pathetically, as an act of treachery or betrayal. He was, in fact, rather like Bernard Smith (who chose, alternatively, to spend most of his life in Australia) an *antipodean*, a cosmopolitan always connected to more than one place, working in the cultural traffic between Sydney, Manhattan and Barcelona (his last love).

The local obituaries of Hughes indicated something of the awkwardness in his reception in Australia. It was as though we could not take in the extent of his canvas, as Bobby Huge, and instead needed to reduce him to a local larrikin, back slapping, hail-fellow-well-met, rather than an intellectual of cosmopolitan breadth and capacity. And it was as though he had only written one book, the big book about '*us*', about the convict origins of Australia, *The Fatal Shore*. A kind of narcissistic reduction follows, in which some of his greatest written work – from *Heaven and Hell in Western Art* to *Nothing if Not Critical*, and his finest performance, in *The Shock of the New* and *American Visions*, is simply elided or overshadowed.

Damien Murphy, in the *Age* (8/8/12), remembered Hughes as critic, raconteur, fisherman, shooter, historian, memoirist, educator, author of *The Fatal Shore*. Hemingway? Larger than life? Multi-faceted, indeed. Marxists could see in this the stuff of Fourier, and *The German Ideology*: Hughes was each, huntsman, herdsman, fisherman, critic. John MacDonald, again in the *Age* (8/8/12) also emphasised the larger than life, the power of the 'well turned one liner', 'a man's man and a ladies' man' (not quite a well turned one liner), as possessing 'astonishing eloquence' and (getting

closer) 'as one of Australia's [!?] finest writers'. Matthew Westwood, in *The Australian* (8/8/12), presented him as a giant of the arts. Sebastian Smee, in *The Australian* that same day, presented him (interestingly) as a democrat, who helped make art more popular (a useful approach, given the frequent popular response that he was a snob, because as an art critic he necessarily believed in a hierarchy of value). Patricia Maunder's obituary in the *Age* (8/8/12) had Hughes as an 'eloquent, witty art critic never far from controversy' – the latter, indeed, because Hughes was good at playing the contrarian. Stephen Romei described him as a 'Big man who took a hammer to ivory towers' (*The Australian*, 8/8/12), though his iconoclasm was more often directed against the charlatans in the temple of art. Peter Craven (to whose views we will return) had him 'first and last, [as] an art critic and writer, a stylist without peer' (*The Australian*, 8/8/12) – the greatest writer of non-fiction in Australian history (sic) but also as a dazzling presenter and performer. Craven shares enough of Hughes' formative culture to recognise that if he sometimes behaved like a jerk on the line, he also knew that this was a corrective position, to take up the 'cultural strut' rather than the 'cultural cringe'.

The Australian's editorials got closer, recognising Hughes as 'a true internationalist', the most eminent practitioner of his craft (8/8/12). Hughes 'stayed away from Australia too long and in the latter decades appeared unaware of how much we had changed'. The 'we' is indicative, though this is of course the aspirant voice of the nation, via its sole daily national newspaper. But the judgement also has clout; *Beyond the Fatal Shore*, the post-accident series (2000) itself also shattered by the event, started off badly, repeating the clichés of Hughes' childhood, so that it could honestly be said, sadly, that when it came to Australia Hughes no longer knew what he was talking about. Finally, Richard Woodward, in *The Australian* three days later, reported again that Hughes was an iconoclast, an impossible act to follow, a writer of significant performative qualities (11/8/12). Writing from New York, Woodward's Hughes looked European, more than Australian. 'He could summon up apt quotation to illuminate a Rothko painting, early or late; and when he delivered summary judgements on Marinetti's violent fantasies or Le Corbusier's megalomania, his relaxed cadences and half-smile only twisted the knife deeper' (Woodward pays Hughes the highest tribute, by mimicking his own style). The latter was an image also employed by Christopher Allen in *The Australian* – Hughes 'a leopard among jackals'; he liked to skewer his black beasts, such as Julian Schnabel (8/8/12).

Some obituarists were plainly moved by Hughes' parting, Craven among them. Few among them, or earlier, managed to capture Hughes naked, so to speak. Tim Flannery did, writing in *The Monthly* of the boozy, generous evening he found himself sharing with Hughes *in situ* in Soho, Hughes emerging late at night naked with whisky and two shot glasses (September 2012). Cathy Lumby, a close friend (but not lover) portrayed Hughes not so unsartorially, but as chef and *bon vivant*, struggling with life and his accident and as with Flannery, supporting, mentoring, urging on (*Age*, 7/10/06).

The international obituaries, indicatively, saw Hughes as a long term visiting cosmopolitan with an antipodean inflection. *The New York Times* saluted Hughes as 'the eloquent, combative art critic and historian who lived with operatic flair and wrote with a sense of authority that owed more to Zola or to Ruskin than to his own century' (6/8/12). The *Guardian* couldn't resist the imperial attraction, describing Hughes as the art critic version of Crocodile Dundee ('Now that's what I call a review!') yet as writing the English of Shakespeare, Milton, Macaulay – and Dame Edna Everage (7/8/12). So much the better for *The New York Times*. For its view was anticipated earlier by Christopher Hitchens in *Vanity Fair* (May 1997). Hitchens, another contrarian, paralleled Hughes with de Tocqueville, the perception of the gifted outsider. 'He has made amateurism professional. Even better: he is the marsupial critic'.

There are some interesting, if predictable dynamics of appropriation or possession here. The global authorities see Hughes as one of theirs, marked perhaps by some antipodean birthmarks, but a citizen of the world. The Australians stretch, often, in this direction, though the residual sense is that he was 'one of us' who stepped away, whose redemption was caught up with the singularly powerful gesture of acknowledgement and return in *The Fatal Shore*. *The Fatal Shore* was a major event, a fact attested to not only by its own achievement but also by its reception. It remains the airport blockbuster that tourists read, indicating something of the power of the scribe and his capacity to capture, condense and impose a highly problematical 'Gulag' narrative, the result of which not only addresses the origins of white Australia in convictism but establishes this moment by default as the secret of the place, even now. This, even though this gesture in effect displaces or marginalises the other major foundational story: that of the dispossession of the Indigenous peoples by the convicts and then the settlers. Who are we, or were we, on this account of convictism? Convicts,

victims not perpetrators, not invaders but the inheritors of the British poor, escapees from Bentham's panopticon.

The reception of the book, like its girth and style, were appropriately magisterial. Academic commonsense – gossip in the corridors – had it that academics hated Hughes most because he had stolen their thunder – he had done serious archive work, but worse, he could *write*. Some of the major reviews suggest something rather more positive, less conditional. Bernard Smith, Australia's leading art historian, heaped praise on the younger man who had sometimes – as in *Art of Australia* – dined at his expense. Smith was sufficiently generous to describe *The Fatal Shore* as a classic. 'Of course the book is not without faults, but the faults will have to be weighed against the scale of its achievement' (Smith, 1988: 59). Hughes claimed novelty for his work: Smith, the (art) historian, proceeded to set it in context. Others were to make the parallel explicit: it was with Edward Thompson's *Making of the English Working Class*. Hughes set the convicts up, so to say, to speak for themselves. 'This has been achieved', Smith wrote, 'this evocation of the past, largely by the brilliance of the writing: irony and paradox, dialogue and metaphor are each employed with telling effect to keep the narrative sparkling' (1988: 62–3). To name another association implicit in Smith's review, Hughes was brilliant, not least in terms of place-writing: his capacity to evoke nature and landscape through words that are pictures is sublime. For Smith, who also was schooled in the earlier classics, this writing was as good as Michelet.

The view of Australia's leading narrative historian, Manning Clark, was no less generous. Clark seems to identify with Hughes, here understood as a writer whose gift is in the capacity to plumb the depths of the human condition. Unfussed by academic pretence, Hughes is able to write history although it were literature, Dostoyevsky rather than Dry-as-dust (Clark 1987).

Australia's leading rising historian, Stuart Macintyre, added the echo of Gibbon to that of Michelet and Dostoyevsky. *The Fatal Shore* was, as Macintyre indicated, a crossover book, part scholarly, part popular.

> Consider the full measure of Hughes' achievement. The story of convict transportation spans eighty years. It moves from Georgian Britain to more than a dozen places of settlement on both sides of the Australian continent and out into the Pacific. Its complex institutions were devised and modified by a host of administrators. The origins, experiences and responses of the 160,000 victims defy the most

elaborate taxonomy. The book evades none of these complexities, yet not once in six hundred pages does it strain the reader's attention (Macintyre, 1987: 244).

Hughes delights in the riches of language – he sends us running to the dictionary. 'If a rhetorical flight threatens to lull the reader's vigilance, he punctures it with a sharp monosyllabic thrust', as in prisoners beneath the deck 'crusted with salt, shit and vomit' (244). Macintyre is interested in the substance of the case, but also in issues of voice, as above, and audience, which he understands is the jet-age traveller and consumer of foreign cultures. Hughes, of course, is smart enough to know that he is writing for (at least) two audiences, one internal, one external. Too many Australians likely think he is writing for us alone, or that he should be. For Macintyre, this is a strength – *The Fatal Shore* becomes big picture, imperial history. 'Nothing is assumed, not even a bush fire. All is seen anew and explained for the armchair traveller', (246), or for the person next to you in 34B.

'Travel literature, of course, has a tendency towards hyperbole' (246), the ripping yarn. Excesses ensue, not least, for Macintyre, the too easily affected identification of Botany Bay with the Gulag. Hughes is open, as Macintyre indicates, to the revisionist views associated with J B Hirst for which it is not convictism but the development of democracy which is the foundational moment of white Australian history. Yet the overwhelming logic of *The Fatal Shore* is to follow that kind of Hartzian path, where the moment of first foundation explains or determines the real nature of the Australian fragment. Once convict, always convict.

Others also praised *The Fatal Shore*. David Malouf, whose own culture and insight as a social thinker are not always acknowledged, essayed the book in *The New York Review*. The quality of his thinking, stimulated by Hughes, is palpable:

> As befits a colony that was intended to exist in two places, a real geographical Antipodes and at the same time an Antipodes of the mind, everything that occurred in early New South Wales seems double and ambiguous: yet what was eventually worked out, in the pragmatic English way ... was a 'system' that in Hughes' words 'was by far the most successful form of rehabilitation that had ever been tried in English, American, or European history' (Malouf, 1987: 3).

So this is antipodean history, but it is also part of global history; and it inevitably has its cultural or psychohistory. Was this then a model for the

Gulag? Probably not, rather a model of Terror. There is no overwhelming need to Read History Back, unless we choose to. But Terror, and Hell, are serious connections for Hughes and Malouf, who surely remembers that the younger Hughes cut his teeth with a book called *Heaven and Hell in Western Art*. At the least, Malouf understood that Hughes was telling a hell of a story.

> He works, that is, like a writer, putting us inside what he writes as a dramatist might. He understands that the story in history, if we are to experience the thing fully, is as important as the mere recounting of events (Malouf, 1987: 5).

Some of the response to *The Fatal Shore* was more ambivalent. Eric Rolls discussed the book as 'fiction with the accuracy and argument of non-fiction, it is non-fiction with the intelligence and imagination of fiction' (Rolls, 1987: 87), but complained of its carelessness. 'Hughes makes too many unforgivable blunders. He has a chronic inability to copy anything down correctly' (88). Was it then a work of art? Graeme Newman thought so, reviewing *The Fatal Shore* in *Law and Social Inquiry* (1988). He described the book as a work of art, contrasting human waste and wasted lives against a landscape itself beautiful, at least to those with enough time or patience to look carefully at it. Others themselves as different as John Carroll and Alastair Davidson agreed that Hughes had got it wrong, at least when it came to the foundational argument concerning convictism. What was remarkable was less the persistence of the stain than its supersession, as indicated by J B Hirst (Carroll, 1987; Davidson, 1987). Clive James, his fellow expatriate, wrote in *The New Yorker* that the book was redemptive, both of its subjects and of the landscape within which the story is enacted. Hughes is a stylist, for James, like the poet Peter Porter, for whom the rapacious appetite for words speaks less in the register of 'Look how much I've read', than 'Look how much there is to read' (23/3/87: 98).

How, then, should we assess the contribution of this clever expatriate? The critical literature on Hughes is sparse, but engaging. The earliest instalment, originally published in *Thesis Eleven* in 1993, is Ian Britain's 'The Nostalgia of the Critic: Postmodernism and the Unbalancing of Robert Hughes' (Britain, 1993), the earlier version then developed and extended in Britain's *Once An Australian* (1997). Like Craven, Britain can understand Hughes because he knows enough (has read enough) to hear the resonances. Britain observes the stylistic mannerisms ('usages at once bold and exact; the combination of punchy rhetoric with fluent cadences') (Britain, 1993:

68). He works three different cultural figures to place Robert Hughes. The first is the persona of Iago, Shakespeare's villain and the echo of his brilliant collection of essays, *Nothing If Not Critical*. The association is itself visual; as Britain cheekily observes, Hughes can look on his cover jackets like a scowling gargoyle. The second figure whose voice Britain hears loudly in Hughes is Ruskin: 'when art is set in its true and serviceable course, it moves under the luminous attraction of pleasure on the one side, and with a stout moral purpose ... on the other' (Britain, 1993: 75). But more, for Ruskin the question of balance is crucial: all important questions can equally well elicit positive and negative answers (and this is the balance which Britain sees receding in Hughes' writing into the nineties, where the motif shifts too easily to complaint). The third figure, according to Britain, is that of Cyril Connolly, 'whose potpouri of aphorisms on love and art, *The Unquiet Grave*, Hughes recalls exulting in at the age of sixteen' (Britain, 1993: 71). From Connolly and Ruskin, Hughes takes on the serious sense of the necessity of a hierarchy of values in art. Not all art is equal: and it is important to say so, even if noses are put out of joint in the process. This is, indeed, the work of the art critic: to judge, to justify, where necessary to provoke. Art is about argument.

For me, the strongest echo here remains Ruskin, 'a violent illiberal', equally opposed to Toryism and Communism. Liberalism, of course, means different things across the Atlantic, and across the last two centuries. Hughes' temper often seems rather to be like that of the radical tory, here reminiscent not only of the truculent Ruskin but also of the dyspeptic Carlyle, for indeed Hughes writes like the Thunderer, and is much exercised by the job of deciphering signs of the times. The sympathy with Carlyle is more than substantive; it is also stylistic, in the rolling prose and its onomatopoeiaic ring. Hughes echoes Carlyle in his consideration, for example, of the category of the sublime, though he also echoes contemporary scholars such as David Nye in this. When he complains about American culture, his voice seems to chime in with that of Christopher Lasch. Britain recognises that the connection with Iago is more loose than the echo of Ruskin, as is appropriate with the image of the joker/critic/*sotto voce* tongue-in-cheek trickster of *Othello*. The most powerful point of Britain's enthusiasm to back the influence of Iago is that it throws into full relief the extent to which Hughes is an actor, a performer. Occasionally this does involve verbal violence, as when he skewers Baudrillard or Schnabel. The world's a stage, and the blood is fake. But for Britain, the risk is that even before the sadder pathos of the car

accident Hughes' critical spleen risks the loss of Ruskin's gently romantic dialectic of negative and positive.

Andrew Riemer offers a personal analytic in his study *Hughes* (2001). Riemer tracks Hughes from their shared early days at the University of Sydney. Riemer chooses different motifs than Britain: primarily they are religious, Catholic, bound up with hell and the image, self-endorsed by a youthful Hughes, of Bob as the Devil. Hughes hated school, even though it was also a source of salvation for the later 'baby critic'. For he was taught about European culture, and about art, postcards of de Chirico. He learned rhetoric from the Jesuits, and came to view art as the substitute for religion: little wonder that it was so hard for him to accept postmodernism, or the death of his god.

Many of his local readers quote Hughes from *The Fatal Shore*. Riemer shows the genius at work, in contrast, on Mondrian in *The Shock of the New*: 'No view of Mondrian is more misleading than the idea that he was a detached formalist, working towards a purely aesthetic harmony' (Riemer, 2001: 24). Even Mondrian needed God. In the late Mondrian, 'The paintings are incorruptible. These are the real rudiments of Paradise, the building blocks of a system that has no relationship at all to our bodies, except through the ocular perception of colour' (Hughes in Riemer, 2001: 26). Similarly on Gaudi, in Barcelona. Even though Hughes takes his distance from the uncorrupted premodernism of Gaudi, the high priest of modernism allows that Gaudi is redeemed by his moral and aesthetic seriousness (Riemer, 2001: 29). And in *Heaven and Hell in Western Art*, as Riemer observes, Hughes exercises the virtuoso voice of the Courtauld and Warburg Institutes, ending, nevertheless, in vernacular voice with an image of Batman. The reference is not obvious, but it works. The juxtaposition is typical.

Riemer knows his subject well. As a young man: 'possessing of, or possessed by an impatient energy, opinionated assurance, ambition bordering on hubris and, above all, a seemingly irresistible desire to offend' (Riemer, 2001: 36). Words like flamboyance and eccentricity fit neatly. More, he views Hughes' Americanism as a kind of modernism, or Europeanism. European modernism no longer existed, in Europe, but its legacy did after World War Two in Manhattan. The modernism that he loved in Europe was closer to the dawn of the twentieth century, too far removed now by time and by place, yet this, indeed, was the shock of the new.

As Riemer shows, *The Shock of the New* embraces technology and design with the same enthusiasm as the higher aesthetic. He loves the gallery, but

he is also keen to get out of it, into the streets, chasing the machines of modernity.

Riemer's gentle suggestion is that Hughes let his own disappointment settle in before the accident, somewhere say between *Culture of Complaint* (1993) and *American Visions* (1997). *American Visions* is nevertheless presented, touchingly, as 'a love-letter to America'. As Hughes tells us, he is interested in interpreting Americans through the things they make. He loves Jefferson, Monticello, as well as he does the Chrysler Building or Hopper. Perhaps Hughes' misfortune (fortune) was to hit Manhattan, too, too late, as it slid into Reaganism and the New Empire. Riemer writes, it seems sadly, that the 'tone of these [later] pieces is almost valedictory: perhaps the fifty-year-old critic had seen the best of his time' (Riemer, 2001: 95). Lampoon and invective are the kinds of words that come to mind for Riemer here: he picks Hughes' cadence with a subtle brilliance, suggesting that for the later Hughes nothing much at all was praiseworthy any longer. We know that Hughes was depressed at this stage; it happens, and it shows. Riemer is a brilliant stylist in his own terms; but as with his other gifted interpreters, the resultant style in engagement with Hughes seems evocative of some kind of momentary fusion of vocabulary, 'Eventually', he writes, 'we succumb to spiritual or intellectual desiccation: everything around us seems decayed, debased, racked by folly and venality' (Riemer, 2001: 108). This is the world of Iago, the Moor and Desdemona transported to the Hudson. But this is also the tragedy of culture, and of modern mid-life. As Hughes speaks it in his video *Goya – Crazy Like an Artist*, 'we dream of a great late style, but few of us achieve it'. As in one of Goya's late images, Hughes ends up as a man on sticks.

Riemer tucks *The Fatal Shore* neatly into this context. It was a settling of accounts; and perhaps Manhattan, after all, was disappointing as well. *The Fatal Shore* was Hell, which was the absence of God. But in America, in *American Visions*, Hughes detected the power of the sublime, whether in nature or in industry, in Cole or in Sheeler. This is still, it seems to me, Hughes at the height of his powers: synoptic, authoritative, clear, powerful, a wicked glint in the eye, a sad or mischievous inflection in intonation.

But after the accident, and especially in *Beyond the Fatal Shore*, Hughes loses it; Australia is placed in the past, with some qualification, and looks like a Place without Art, or much culture apart from hedonism and leftover established religion. As Riemer shows, however, Hughes is always ever European, at the same time: never just English, or misplaced (Irish), but an antipodean in Manhattan. 'At heart Hughes has always been and remains

European', strung to his Irish and Jesuit roots, their gaze firmly focussed on Continental Europe. Maybe he was the last, or the lost European. For he was in love with a world that was lost.

Riemer remembers Hughes' early years, from contact, though his text covers his life's work, anticipating its decline yet celebrating his consistency and his command of both ideas and the words that Hughes has carry them. In *Robert Hughes – The Australian Years*, Patricia Anderson sticks to the formative experience. Yet Anderson starts, too, in Europe, with Hughes and Goya.

Hughes came to associate with Goya, late in life. Early, he was influenced by cosmopolitan locals like Alan Moorehead, whose *Fatal Impact* anticipated *The Fatal Shore*. But there are other dimensions of Hughes here, even more fascinating. Hughes willingly participated in the rewriting of his life that made his own visual art too brief an episode. In fact, as Anderson shows, this cartoonist fond of the image of the Devil as a signoff was also viewed as a youthful painter of significance. Hughes was a youthful expressionist. Elwyn Lynn, premier established critic of that time in the sixties wrote of one Hughes painting, *Summer Landscape*, that it 'was an extraordinarily effective summary of a season in a few simple shapes'. And James Gleeson, the most influential and striking of Australian surrealist painters, wrote of other Hughes images, after he had shifted to figurative painting that he 'must now be considered among the best young painters in the country' (Anderson, 2009: 208). He shifted into religious painting; one of his oils was purchased by the National Gallery of Canada.

Were these then perhaps his best years? Plainly he was prodigious, but then this is also a common path, from the construction of visual images to the use of word-pictures. Hughes longed for aesthetic delight, but he also revelled in being out the front of the room, and he soon became the cowboy of the scene, via New York, now astride a Honda Four, tasselled coat, long hair, raving about Jagger and the Stones not only as a sound but as a phenomenon: the sexy man out the front, music soundtrack by Dylan, J J Cale and Cream. This would be hard stuff to leave behind.

Two last glimpses offer further insight into Hughes, these both in the form of the interview. Peter Craven and Michael Heyward interviewed Hughes in *Scripsi*, (4/4: 1987). This was, then, the moment of *The Fatal Shore*. Beginning here, Hughes explains that while his work echoes an invisible association (E P Thompson), he connects it with narrative, and Carlyle as well as with voice and sympathy for the subaltern. 'I do admire Braudel but quite frankly I don't have the scholarship. I couldn't possibly pretend

to be a scholar of Braudel's capabilities' (Craven and Heyward, 1987: 69). The conversation turns to purgatory and the life of the expatriate, but more powerfully to questions of style. Does he overwrite? Sometimes, he confesses: 'I have a natural tendency to be florid: it is my conversational tendency and my written tendency too' (81). Sometimes, he seems to be saying, he simply cannot help himself: his life-long love affair is with words and images. (But who, in later life, he seems to be asking, is listening? New York is Babel.)

The question of style, finally, is further pursued in conversation with Robert Dessaix, another master with words, though perhaps given more to a personal minimalism. As Dessaix says in introduction, it's Hughesually, 'usually less the argument that wins you over in Hughes' books (in my experience) than the language: rich, physical and somehow both fastidious and pungent at the same time. It's the language that packs the wallop' (Dessaix, 1998: 52). Hughes responds by stating that he is a writer, rather than an intellectual, and genuflects (as is frequently the case) to Orwell's strictures on style. He claims to be a journalist, still, in terms of self-identity, and registers *American Visions* as a secondary text – 'It doesn't even have footnotes or a bibliography' (Dessaix, 1998: 57). But he also responds positively to Dessaix's cue that his work is in, and on, performance.

Dessaix's most pungent comment is an aside, in a footnote.

> An analysis of Robert Hughes' written style confirms his point about 'concreteness': his vocabulary and syntax are both calculated to excite his readers to pay attention and to reveal his own emotions rather than to demonstrate his mastery of or allegiance to a particular ideology and its codes (unlike much academic writing). His verbs tend to be physical ('beat', 'shear', 'bawl', 'tar', 'grind', 'jam', 'starve' and so on) as does a high proportion of his adjectives ('goatish', 'mushy', 'vivid'), his text being peppered with colourful, often colloquial nouns ('gadzookery', 'claptrap', 'thuggishness', 'quack', 'duffer'). The effect is to invite the reader into his world as a curious equal rather than to lecture, intimidate or silence the reader (Dessaix, 1998: 60, n. 9).

Dessaix understands that the temper of Hughes' writing is democratic, but also that it is part of a complicated and considered strategy of performance. The common charge of elitism against Hughes is largely misplaced. His work is an invitation to disagree, within the tradition sometimes still called agonism. If he sometimes lost his footing, or his way later in life, then we should be sufficiently generous to accept that. His importance as a writer, in Australia and elsewhere, is too great to belittle.

The critical literature on Robert Hughes' work – that which takes him seriously as an intellectual – is small, but it is suggestive. Along with modest contributions like my own, taking up the question of provincialism (Beilharz, 2006), it is a beginning. But this beginning needs more work if it is to fulfill the promise of Hughes' own work. Hughes was the great art critic of the twentieth century because he combined text and context, artwork and history, with style in word and image. My sense is that he needs to be registered seriously in his own right in this way, but also as a worthy complement to Bernard Smith. Leading his generation, he turned to America and to the twentieth century. Ergo my purpose in this contribution here, to mourn, to pay tribute, and to leave as a modest offering this small essay, as a promissory note.

References

Anderson P (2009) *Robert Hughes. The Australian Years*. Sydney: Pandora.

Beilharz, P. 2006. Robert Hughes and the Provincialism Problem. In *Reflected Light – La Trobe Essays*, edited by P. Beilharz and R. Manne. Melbourne: Blackink.

Britain, I. 1993. The Nostalgia of the Critic: Postmodernism and the Unbalancing of Robert Hughes. *Thesis Eleven* 34.

Britain, I. 1997. *Once An Australian*. Melbourne: Oxford.

Carroll, J. 1987. Australian Foundation. *Quadrant* May.

Clark, C. M. H. 1987. Robert Hughes and the Greatest Show on Earth. *Scripsi* 4 (4).

Craven, P., M. Heyward. 1987. 'Interview' *Scripsi* 4 (4).

Davidson, A. 1987. The Fatal Shore. *Thesis Eleven* 18 (19).

Dessaix, R. 1998. Robert Hughes. In *Speaking Their Minds*, edited by R Dessaix. Sydney: ABC.

Hughes, R. 1968. *Heaven and Hell in Western Art*. New York: Stein and Day.

Hughes, R. 1970. *The Art of Australia*. Harmondsworth: Penguin.

Hughes, R. 1981. *The Shock of the New*. New York: Knopf.

Hughes, R. 1987. *The Fatal Shore*. Melbourne: Harper Collins.

Hughes, R. 1990. *Nothing if Not Critical*. New York: Alfred A. Knopf.

Hughes, R. 1992. *Barcelona*. London : Harvill, 1992.

Hughes, R. 1993. *The Culture of Complaint: The Fraying of America*. New York: Oxford University Press.

Hughes, R. 1997. *American Visions: The Epic History of Art in America*. New York: Alfred A. Knopf.

Hughes, R. 1999. *A Jerk on One End: Reflections of a Mediocre Fisherman*. New York: Ballantine Publishing Group.

Hughes, R. 2006. *Goya*. New York: Alfred A. Knopf.

Hughes, R. 2006. *Things I Didn't Know: A Memoir*. New York: Alfred A. Knopf

Hughes, R. 2007. *Barcelona: The Great Enchantress*. Washington, D.C.: National Geographic Society.

Hughes, R. 2011. *Rome*. New York: Alfred A. Knopf.

Macintyre, S. 1987. Hughes and the Historians. *Meanjin* 2.

Malouf, D. 1987. House of the Dead: *The Fatal Shore* by David Malouf. *The New York Review of Books* 34 (March 12) (4): 3.

Marx, K., F. Engels, C. Arthur. 1970. *The German Ideology*. New York: International Publishers.

Newman, G. 1988. Punishment and Social Practice: On Hughes's *The Fatal Shore* Review Essay. In *Law and Social Inquiry* 13 (Spring) (2): 337.

Riemer, A. 2001. *Hughes*. Sydney: Duffy and Snellgrove.

Smith, B. 1987. 'The Fatal Subject'. *Scripsi* 4 (4).

Thompson, E. 1963. *Making of the English Working Class*. New York: Pantheon Books.

George Seddon

Chapter 20

George Seddon and Karl Marx –
Nature and Second Nature
(2003)

Why should we read Seddon and Marx together? For a start, they are both polymaths, however differently placed; cosmopolitans and locals in different times and places, wondering, both, about our worlds. I align them here with some reflections gathered under the title Nature and Second Nature. To anticipate, let me emphasise that my purpose is not to dichotomise, that is to say that my purpose is not to read Seddon for Nature, and Marx for Second Nature, but rather to align the two in this setting, where we seek inter alia to bring together Seddon's work and the project of Thesis Eleven. I take my purpose therefore to be, to wonder about how we think those terms, nature and second nature, and to begin to move beyond the single-minded split between nature and second nature, or nature and culture. For the problem in much recent argument regarding nature and culture is that the split values one term over the other, not least in the Antipodes, where the nature/culture split is especially appealing, given the contrast between the concrete urban edge, and desert or landscape. So I start from a sense of the need for a better way to think this, which might, for example, invoke a third term, especially in the postmarxist culture we inhabit in Thesis Eleven, where categories like Theory and Practice threaten to work much as culture/nature splits do – one swallows the other up, or else the two remain unconnected.

What might such a third term be? Practically, culture and nature are bridged by *experience*. Geographically, culture and nature are bridged by *suburbia*. What connects nature and philosophy in a different optic, might be *architecture*. Ought we then return to the Greeks? *Techne* might also be a possible third term; but all this only makes critical sense after the fact, as in Arendt in *The Human Condition*. The problem with techne, for us, is a

modern problem. The relationship between theory, praxis and techne only becomes apparent after the Industrial Revolution. We can never really know the Greeks qua Greeks, only via their interlocutors, and within our own cultural horizons.

To express the problem in different terms: in terms of Western Intellectual History, the cultural turn into the second half of the twentieth century transforms nature into image or representation. Nature becomes a floating signifier, and Theory becomes its surrogate. We encounter the clever discoverers of the idea that there is no such thing as nature, even though we live in it, just as we still inhabit a world of things. The ecological turn, in turn, romanticises nature often as image or metaphor, where Nature is Divinity, Providence, Harmony. But 'nature' is not just an image of the urban other, it is a collective noun for species, ecosystems, contexts. Nature has a referent, but not an essence. The sense of place that draws us together here has to do with experience, not essence. Meantime, culture is not only genetically linked but ontologically continuous with nature, most evidently as cultivation, or agriculture. None of which is to say anything new, but merely to wonder about how we name and classify our worlds. To align Seddon and Marx is to open any number of possible perspectives, but one of them, plainly, is geography. As Braudel put it twenty years ago 'ecology' is among other things a contemporary code-word for 'geography'.

So, as ever, we face problems of how to think about being in the world – this world, here now, in Fremantle or in Melbourne – and how to do this without creating conceptual prisons that obscure the nature of these worlds for us.

So much by way of prefatory remarks. Let me proceed to my subject. I first met George Seddon (on paper) rather recently; my loss. I got the knowledge from Trevor Hogan, the cultural messenger from Western Australia. I think my own discovery was gratuitous, coincidental. In 1996 I read Seddon's essay on the Australian backyard. The same year my family and I spent a week in Perth, looking. We visited the Gallery, among other places. It was a peculiar encounter. There was a memoir for the painter Ian Burn on show, including a spooky seventies video with a young Terry Smith in New York City: I didn't feel comfortable. It's not impossible I was hungover. In the Gallery shop I lingered over a book called *Swan Song* but, feeling contrary, I left the book, only to make a special trip back later. Like most intellectuals I guess, it is my habit to study a place before I go there. What *Swan Song* afforded was something more like a song line.

I had just finished my book on Bernard Smith, *Imagining The Antipodes*. I suppose that I was more open then than before to receiving Seddon's work. There were symbolic connections, too: Seddon's Swan-visual was the Port Jackson Painter's image; there was a coincidence of naming and recognition. That Swan is Bernard Smith's bookplate image. George and I met in a session on Bernard's work – or on images of Australia? – at the 1997 Melbourne Writers Festival; and then there was *Landprints*. It became clear to me that George's work intrigued because of its focus on place, but not in a romantic sense, more like the idea or third term of *habitat* in the work of Zygmunt Bauman (to which I will return later).

Let us enter through the Australian backyard, as a synoptic image of Seddon at work. Those of you who know the essay will remember it as direct, descriptive in voice, reminiscent without being nostalgic. Its procedure is serial – it opens as follows:

> When I was young in the 1930's, and for several decades on either side, the function of the typical Australian backyard in the cities and country towns could be known easily from a list of its contents. (Seddon 1994, 22)

There follows just such a list, and its smells – the chooks, the outdoor lavatory dunny, Velvet soap, Reckitts blue dye, the ubiquitous lemon tree. This is the backyard of my parents, in the Eastern suburbs of Melbourne via Stuttgart and Haifa, and it is the backyard of the house we bought in 1984 in Northcote. Seddon traces some of these regional and ethnic variations – it is a beautiful piece of writing as well as a sepia print. There are all the things here that we associate with the Professor of Things in General. There is a linguistic excursus on the history of the word 'yard'; Geoffrey Hamlyn gets a guernsey, there is a fascinating passage on the classic quarter-acre = 100 links or one chain, and a lovely moment that opens as follows: 'In Perth, there was a fine debate in council in 1876 on pigs' (Seddon 1994, 29). The point I want to make is more powerful, and substantive. Seddon's linguistic or material self-consciousness undergirds the whole argument. The argument, hidden in part by choko vines and obscured by the equally ubiquitous fig-tree, is I think as follows: The backyard is 3 things, the field of 3 activities: it is: 1. an economy, 2. 'nature', i.e. predominantly rural and 3. it is a culture, and this in two significant, different respects. It is part of a culture of self-sufficiency, *and* it is a culture of tidiness and order, both understood in the sense of culture as *activity*. So, to repeat, there is under Seddon's list of contents

an unfolding sense of the plural or multiple *functions* of this space we call the backyard, economic, natural and cultural, where culture is a practice rather than a series of empty if evocative representations or names like Victa lawnmowers and Vacola preserving jars. Seddon's essay therefore is an achievement like the best of anthropology: for its moves make the backyard exotic or distantiated as well as familiar, and the result if like the anthropologist's best sticky question: well, what *is* a market – an economy or a culture?

But if the backyard is economy, nature, and culture, it is also history or has a history, as Seddon observes when he introduces the theme of gardening as order, where gardening becomes a struggle against nature or at least for a particular, manicured conception of socialised nature. As Seddon expresses it, the mania for tidiness also represents a discourse with the environment and closer to our own times, gardening becomes a conspicuous element in consumer culture. So that you could imagine a parallel text to Bernard Smith's *European Vision and the South Pacific* where it was the garden, rather than the painting, through which historic paths into the Antipodes might be tracked.

The sensibilities shown in this essay are evident in various papers gathered in *Swan Song* and *Landprints*. Let me survey some of these before turning to Marx. I think there are five things at least that strike me about reading Seddon's work. *First*, it is cultured; he knows the echoes in other people's discussions and traditions; as soon as you hear a resonance, he names it. Seddon knows how to think comparatively. *Second*, it is visual, whether implicitly or explicitly. Its senses of place are visually evocative. The writing is sensual. *Third*, it shows an ongoing capacity to combine particularity and generality, or to be suggestive and substantive at the same time. *Fourth*, it combines a practical skepticism towards academic bullshit with a deep commitment to intellectual activity. *Fifth*, the voice is inclusive, vernacular, in the best sense, as in the observation that the banished personal pronoun is now creeping back, 'even in doctoral theses, I rather like it'. The voice invites, as well as it educates, and connects.

But as Hegel said of Scholasticus, in order to swim you need to get into the water, and it is in the fine texture of Seddon's writing that you see the point, as when he observes, for example, that what pleases us aesthetically is as often artefactual as 'natural'. Seddon wants to respect nature without demonising culture. Humans despair, but they also im- prove. The perspective involved in Seddon's work is as gentle as it is radical. 'Australia is not a big country; agricultural Australia is about the

size of France. It is a rather small country with huge distances' (Seddon 1995, 70). And so on, and so forth ! only the author can do better than me at this, so enough, or else read Seddon yourself, read Seddon on Rottnest and hop on the ferry – go.

To summarise: the local markings and flavours of Seddon's work are apparent. What is peculiar to his work, and which in my mind places him uniquely in the same space as Bernard Smith is that (give or take Marx) Seddon thinks the Antipodes (and in this case, the Antipodes of Western Australia) comparatively, in terms of new world experience, and within the conceptual frames of thinking which we have learned to dichotomise as romanticism and enlightenment, frames here combined (Beilharz 1997). He knows that if Australian civilisation is different to European or American, then this has something to do with the Pleistocene, and not just with the laconic tradition of popular culture; with images of the bush greenhide and stringybark. He knows that romanticism is a deeply compromised tradition, for its love of nature is contrived and urban. He knows that the rationalist current of Enlightenment thinking too readily is allowed to overpower experience. And he knows that while humans need to respect trees, we are not trees ourselves; we do not have 'roots' except in a self-constructed, imaginary sense – and these, as it happens, are sensibilities that cross over from *Swan Song* to *Landprints*.

Romantics value specificity over generality, ergo the centrality of sense of place which so many moderns share. Yet it is mobility which sets our species apart, though we seem even in postmodern times reluctant to identify ourselves with movement in our antipodean case, between hemispheres rather than with place, or places, instead recreating places, simulating heritage in our own images of what is authentically Melbourne, Sydney or Fremantle. All the same, these are our landprints. It is a peculiarity of the Antipodes in its abstract sense that it was to serve not only as the imaginary refuse dump of Europe but also as its utopian escape hatch, as Seddon relates in discussion of de Foigny. The Antipodes were just that, the backyard of Europe, a place where the junk nestled with local dreams as well as those of outsiders. Whatever else the Antipodes might be, the idea mainly involves projection, not least that involving the 'pathetic fallacy', where we project human values and emotions onto landscape. We moderns still find it difficult to think outside of animism, or anthropocentrism. The implication of all this is apparent, even if little else is: we humans have difficulty thinking about what it is that is proper to ourselves, and what is specific to nature, let alone what goes in between.

Historically, we mate the natural with the supernatural, nature with the unnatural, with the cultural, or else with the artificial. Seddon connects the third and fourth antonyms, the cultural and the artificial, when in *Landprints* he extends discussion to the order/disorder dichotomy. Here the point is that simple one, often made today conversationally about the production of video-documentaries, that the hand which holds the camera magically retains its invisibility. We work hard, some of us, to make our gardens look relaxed and comfortable. Artifice is abundant and ubiquitous. It is this, incidentally, which makes the western antipodean images of Richard Woldendorp so powerful: you cannot help but see his hand in the photographs, a fact which proves Seddon and Ruskin both at the same time (Winton and Woldendorp 2000).

Seddon's sense is that within or alongside these classificatory frames and the Eurocentric residues of thinking about genus and species, there have also been three persistent Northern European dreams of place, epitomised by images of the Mediterranean, the Pacific, and the wild nature of the jungle. What these tropes have in common with some varieties of contemporary pastoral is precisely their projection, or imagism – here there are simply too many floating signifiers, as in the redemptive melancholy of Charles Reich, where the city must be rebuilt as the country. Seddon does not refer here to Faust, or to Spengler's *Decline of the West*, though the connection may be suggestive. The point is that we need to know nature as contemplation, and not only as instrument, or to put it differently, that we might be able to know nature practically without viewing it merely as a means of transformation. Here we meet the problem of limits, and the intellectual obstacle thus raised is not the Enlightenment, where reason struggles endlessly with experience, but the spirit of Faust, where to know is only ever, to act – to rebuild the world. To connect to Marx, to whose work I shall turn in a moment, this is, to anticipate, via the figure of Trotsky, the way in which Marxism as productivism becomes part of the instrumental culture which the young Marx set out to criticise. The connection to Spengler here is different, for *The Decline of the West* conceptually separates nature from culture only to elevate nature over culture. Parenthetically, this might also indicate the possibility that the idea of civilisation could be a possible third term, or even stand for third nature.

The political issue of this concern in Seddon's work results in a practical, rather than magical ecology. We should not despoil the land, not because it has rights of its own, but because our own rights are merely custodial. This

is the language of English ethical socialism, of Richard Tawney and after. And if we are shifting in the direction of socialism, perhaps it is time to introduce Karl Marx.

I first met Karl Marx (on paper) thirty years ago, in fifth form, when I tried, not for the last time, to read *Das Kapital*. The encounter was unproductive; I returned to rock and roll instead. Between 1972 and 1975 I educated myself in Marxism, and into the later seventies I was led through the labyrinth by two brilliant teachers, Alastair Davidson and Zawar Hanfi. In 1980 I got as close as I ever will to meeting Marx. I discovered, after the fact, that I had been led by the hidden hand of destiny to his seat in the Old Reading Room of the British Library, G7. If it is true, as we often hear said, that the brains of some are located in their arses, then this was as close as a young Marxist could get to kissing the pope's ring. Perhaps it was this which finally resulted in the birth of *Thesis Eleven* a year later.

So what does Marx have to say about nature, and second nature? The textual basis of our encounter is almost entirely with manuscripts unpublished during Marx's lifetime, across the *Paris Manuscripts*, the *German Ideology* and the *Grundrisse*, with an aftereffect in the first volume of *Capital*. So there is also some work of interpretation here, as with the scattered observations across Seddon's writing. If reading Seddon theoretically is like interpreting landscape for geology, looking for clues as in the Backyard essay, reading Marx on nature is difficult for other reasons. Marx is more theoretically explicit, but his views on nature and second nature are suggestive and ambiguous. Two opening observations and some background before we enter that labyrinth. First, nature is central for Marx, even if as precondition, for his is a naturalism, even if the focus shifts across the nineteenth century to capitalism naturalised, i.e. second nature. Second, the concept of second nature is in principle historical, and ambiguous in application in Marx's work. It is a concept to be used or filled, rather than a concept like, say, commodity, which is rich in conceptual determinations. Second nature is an historical concept which itself has a patchy history. Hegel posits the idea of second nature; Adorno plays with it; Bauman returns to it; Marx thinks with it, without ever working it up.

In the interim, between Marx and us, western Marxism turns away from nature, to embrace culture. Our traditions within critical Marxism turn away from nature, because of the need to shift away from positivism and away from the dogma of Dialectical Materialism, towards history.

Engels formulates the principles of dialectics as universal. Infamously, there are claimed to be three such laws, the transformation of quantity into quality; the interpenetration of opposites, and the negation of the negation. The only principle carried through critical theory is the refusal of identity-thinking. Marxism's difficulty with nature, however, is not only a post Marxian predicament. There are obviously unresolved tensions in Marx's work, between the attraction to natural science and strong truth claims, and the incipient defense of *Geisteswissenschaft*. Marx is caught somewhere between Darwin and Dilthey. After Engels, the Darwinians rule, especially Kautsky. Critical Marxists then turn away from nature in the face of Diamat, Stalinism, Lysenko. Orthodox Marxism, following Trotsky, becomes the mirror or production; Department One of the economy rules. The economic logic of Trotsky and Preobrazhensky and then Stalin is industrialising; agriculture is an embarrassment compared to the high romance of American productive forces shod with Bolshevik nails. More sensitive minds, like Gramsci's, turn away from nature in sympathy with the modesty of Vico, where we as in a footnote in *Capital* can only claim really to know what is human, though it is characteristic of Gramsci's thinking that, as a boy from the periphery, he knows the importance of agriculture and uneven development. Into our own times, you could count on one hand the Marxists who take food seriously as a production item rather than a consumption item. It must surely be a sign of our times that critical theory is interested in food only as dining out or as style, not as work or production. In Gramsci, in any case, history is valued both because we make it and because we do so within limits. Only that degree of modesty in Gramsci, qua Vico, subsequently becomes counterproductive, as culture has swallowed up nature conceptually in critical theory as surely as capital chews up nature in actuality, and all we have left is representations, even as nature suffers under the weight of modernity's obsession with the pursuit of rational mastery.

The prehistory of this present is Marx's own work. I think there are four obvious texts, the *Paris Manuscripts*, 1844; the *German Ideology*, 1845, the *Grundrisse*, 1857/8, and *Capital* volume one, 1867. Nature is the ground of much of this thinking, and second nature emerges slowly out of it. In the *Paris Manuscripts* nature and history become coextensive. Marx writes, for example that

> The nature which develops in human history – the genesis of human
> society – is man's real nature; hence nature as it develops through

industry, even though in an estranged form, is true anthropological nature (Marx 1844, 303).

Or with a slightly different emphasis:

History itself is a real part of natural history, of nature developing into man. Natural science will in time incorporate into itself the science of man, just as the science of man will incorporate into itself natural science: there will be one science (Marx 1844, 303).

In these early writings, then, the first object of human culture is nature. The senses open us up into the world. Creativity and richness in needs become the differentia specifica of human animals.

Much of the *Paris Manuscripts*, of course, consists in the philosophical critique of political economy. Capitalism involves the analytical shift away from landed to moveable property. Private property is the result of the alienation of labour, not the other way around. Private property or capital is therefore an alienation of natural property. Alienation famously involves alienation from species-being (*Gattungswesen*), whereby Marx introduces the notion of inorganic nature. Marx plays with the idea that nature is the inorganic body of humans, inorganic in the sense that it is the direct extension or precondition of human existence. We live in nature, which means that nature is in some sense our body, as differently later in Freud, where culture is prosthetic. Humans do not secrete culture, they create it; we create, we generate abundance, and at the same time inequality. 'Man is directly a natural being', Marx writes, endowed with vital powers, therefore active, creative, yet at the same time natural, corporeal, sensuous and therefore suffering, like other animals and plants. 'To be sensuous is to suffer', he says, 'but man is not merely a natural being: he is a human natural being, that is to say, he is a being for himself' (Marx 1844, 276, 336).

Humanity is therefore both natural and historical. Humans are distinguished by language, production, more powerfully, by consciousness, creativity, culture, which cuts both ways; for this is also the text where Marx spits at the 'pestilential breath of civilization'. Architects raise utopia and dystopia in their imaginations, where bees merely labour.

The *German Ideology*, a year on, contains some more hints in this direction, though we can only wonder what Marx might really have achieved if he had not wasted so much time tilting at windmills. The *German Ideology* opens with a naturalistic parable, the story of the German

philosopher whose life mission was to destroy the idea of gravity, as if it were the illusion of gravity that made us drown. In the space of a year, now in collaboration with Engels, we can detect here a slight anthropological shift. Nature is slowly being pushed away, both by the path of capitalist development and by its critic. Here Marx confidently announces, after the earlier combination of history and nature, that it is history which rules. 'We know only a single science, the science of history' (Marx 1845, 28). The sentiment could be Vico, or it could be Montesquieu. The shift of emphasis toward anthropology is also anthropocentric. History is civilisation, the process of shifting away from nature. History is the history of the production of needs. Nature becomes a capitalist artefact. Yet for Marx at this stage, context remains fundamental, for the *German Ideology* is also the text where, in effect, he defines essence as nature. The essence of the fish, he tells us, is its being, water, the condition of which in turn depends on the development of industrialisation. Essence is existence is history, is nature.

By the time we reach the *Grundrisse*, the frame of reference has moved on, though there is a sense in which the text combines the concerns of the *Paris Manuscripts* and the *German Ideology*, the philosophical critique of political economy and the science of history. The matters that concern us now have to do with the forms which precede capitalist production. Marx's premise here is that the reign of capital depends on a severance from nature. The wage-labour/capital relation depends on releasing the worker from the soil as his *natural workshop*. Precapitalist or for that matter premodern property forms depend on community relations that are naturally grown, *Naturwüchsig* (Marx 1857/8, 471). Subsistence nature is the inorganic nature of humans, whereas wage labour is the product of *history*. So here Marx addresses two basic facts of modernity, geographical and social mobility, migration and movement, but with the twist that these are seen not only as the history of progress towards a human being rich in needs, but also as an ontological separation from nature. For precapitalist property means belonging to a community, and by means of the relationship to this community, belonging to the land and soil, to the earth as the individual's organic property. The emergence of capital as moveable property therefore rests upon the transcendence of another form of property. Second nature, here, is capital as *private* property, where property becomes the other (Marx 1857/8, 492).

The ambiguity in Marx's thinking is apparent. Of course there are residual aspects of romanticism at work here. Yet on balance, Marx's

own sympathy is with the process he is describing, where capitalism is prehistory, and industrialism is the precondition of socialism understood as the pursuit of the richness in needs. Second nature is not inferior to nature, for Marx, except inasmuch as it retains its capitalist markings. By the more openly romantic norms and values of the *Paris Manuscripts* industrialisation is plainly an abomination, and this is part of Marx that never leaves us; even in *Capital* he still fulminates against the idea of the division of labour. Yet the procession of his work, culminating in the only text considered here actually published under Marx's authority, is clearly toward the goal of rational mastery of a socialist kind. The concerns of the section of the *Grundrisse* on Precapitalist Economic Formations returns in *Capital* One as the problem of the So-Called Primitive Accumulation. The primitive accumulation of capital is primarily the primitive accumulation of capitalist relations. These are achieved through violence against peasants and nature in the process that we now know as the compulsory making of the working class. Second nature is formed here as capitalist nature, via the profusion of commodity relations and the phenomenon of commodity fetishism. The greatest achievement of capitalist culture is the naturalisation or universalisation of capitalist relations. And so Marx concludes, in a far more powerful insight than the dialectical hocus-pocus that prefigures socialist revolution in Chapter 32, that

> The advance of capitalist production develops a working class which by education, tradition, habit, looks upon the conditions of that mode of production as self-evident laws of Nature (Marx 1867, 726).

So what does this add up to, this incipient concept of second nature in Marx? The idea of second nature itself has become naturalised in vernacular usage; doubtless it has other histories which I am unaware of. There is to my knowledge very little commentary on the idea in the Marx reception literature. Alfred Schmidt, in his *Concept of Nature in Marx*, offers a skeletal summary, characterising Hegel's as a position where nature is blind and second nature manifests reason or objective spirit. As Schmidt observes, Marx's twist on this is to insist that second nature also becomes unconscious, or blind (Schmidt 1972). The 'second' nature is still the first, though in a different sense we might add that second nature is potentially transitional. Marx, in any case, seeks to subject capitalism to the same logical critique as Hegel applies to first nature, for it is beyond planning, control or human power. As Horkheimer and Adorno put it in *Dialectic of Enlightenment*, 'Civilization is the victory of society over

nature which changes everything into pure nature' (Horkheimer and Adorno 1944, 186).

Schmidt assembles this argument in the same moment that Habermas is puzzling, relatedly, over what it would mean to begin to move towards a rational society. The particular admixture of what we call romanticism and rationalism is striking, and never without its redemptive motivation. Those were the sixties. Karl Korsch reflected on the issues in a less happy time, thirty years earlier. In his 1936 study *Karl Marx*, which remains one of the best books on Marx, Korsch addresses the way in which Marx's work often seems to be framed by the coordinates of *Naturwüchsigkeit* and the 'social laws of nature'. Korsch observes that for Marx *Naturwüchsigkeit* was primarily a negative value, though Korsch would not in his moment have had access to the *Grundrisse*, where Marx's ambivalence is more apparent. Korsch refers mainly to the *German Ideology* and to *Capital*, connecting the idea of the naturally grown to 'natural' divisions of labour, species being, the state, law, language and race as apparently immutable. Naturally-grown relations represent the challenge, for Marx, for they are open to change. Similarly with 'social law of nature', which refer to the wisdoms of political economy turned into eternal truths, when they themselves are historical products. As Korsch puts it, Marx, to the contrary of romanticism and political economy 'applies both terms for the purpose of extending the realm of history and society, ie. of a conscious social action against the so-called eternal necessities of an altogether inaccessible "realm of nature"' (Korsch 1936, 193). From this, it would follow logically or serially that Marx's project is the idea of socialism understood as third nature, though here Marx would fall into the same pattern he himself claimed to discern in Hegel; if second nature is perpetually reshaped, there may be nothing beyond second nature. Marx's sense of historical movement cannot escape from its own telos. Simone Weil wrote in the thirties in *Oppression and Liberty* that it was only during the last century that it came to be realised that society itself is a force of nature, as kind as the others, as dangerous for us if we fail to succeed in mastering it (Weil 1958, 20). The German philosopher who believed that we needed only to eliminate the idea of gravity in order to prevent drowning was indeed a fool, a man with a lost cause. Weil's argument, like Marx's, indicates that the case is indeed different when it comes to belief in the immutability of second nature.

This is, finally, the sense given to the idea of second nature by Zygmunt Bauman. In Bauman's work the idea of second nature could cover not only

something like consumer consciousness but also loyalty to the Führer; each, different regime, whether here economic or political, works hard at seeking to naturalise itself. Textually speaking, Bauman centres on the idea of second nature in *Towards a Critical Sociology*, published in 1976. There he argues that the arrival of sociology coincides with the realisation of second nature. Nature is the name we give to excess, to that which resists our desire to change the world; therefore 'nature' is the byproduct of culture. Society is second nature. Second nature is therefore enabling and protective as well as conformising and constraining. We can wear it as a light cloak, even though it often seems a casing as hard as steel. Second nature may not permeate the very essence of our being; as Marx says in *Capital*, alongside the claim that capitalism generates a working class which sees capital as second nature, it is really only the dull compulsions of everyday life that see us apparently kneeling at the foot of the fetish, when we are in fact only following the sole repertoire available to us, believe or not. We mouth the words as the fetish speaks; the space remains to change all this, only we do not know how to exercise it. Whatever the case, the point is that second nature is contingent; unlike the blanket-fog dominant ideology thesis enthusiastically dispensed by Marxists in the sixties, it still offers room to move (Bauman 1976; Beilharz 2000).

If I wheel towards Bauman's work as I begin to close, it is not only because these are fields where I have more recently laboured, but also because I suspect that the sympathies there might be more suggestive, finally, than those between Seddon and Marx. Bauman's is not a primarily ecological or geographical (Braudel) project, but it may well be more open to nature and to second nature than much else available to us in Critical Theory. This much is already evident in the way that Bauman suggests habitat as a more useful alternative to 'society'. The other associations are apparent, in thinking about weeds, gardens, limits; it is no accident that Jim Scott uses Bauman as a pivot for his own work on forestry in *Seeing Like A State* (Scott 1998). Once again, we can but wonder how the critical insights of Foucault could be lavished so indulgently on the traditional habits of law and medicine while exemplary modernist activities like agriculture and architecture remain somehow at the edge of scrutiny. More generally, it seems to me that Seddon and Bauman share something of the necessary discomfort with the intellectual position, where we know that we need to know but we also know that the prostheses of understanding too readily get in our way. As intellectuals we know that we too readily substitute explananda for explanandum or in this case, second nature for

nature. Intellectuals arguably have a characteristic gift for the fetishism which they attribute to the others.

To close on a different, though I think continuous note. Twenty years ago we founded Thesis Eleven under Marx's banner, publically wearing our commitment to the thesis on Feuerbach which in English translation reads: 'The philosophers have only *interpreted* the world in various ways; the point, however is to *change* it'. In our heads we have written variations on that theme ever since; the point is better to interpret the world, for it changes, and so on. The Sydney philosopher John Anderson used to refer to the Eleventh Thesis as the last thesis, and yes, amen, there is a sense now in which we inhabit a world not only after manifestoes, but also after theses. But if, hypothetically, we were launching *Thesis Eleven* again today or tomorrow, in the company of George Seddon and in the spirit of his work, perhaps we would call it *Thesis Eight*, and repeat, together with Marx, that

> Social life is essentially practical. All mysteries which mislead theory
> into mysticism find their rational solution in human practice and in the
> comprehension of this practice (Marx 1845b, 5).

Seddon's compass points in the same direction, even if his bearings are different. It also thus, points out, across hemispheres and across boundaries. This may be one sense in which our projects coincide, one journey we can share together across these expanses of nature and second nature. There are footprints to follow.

References

Bauman, Z. 1976. *Towards a Critical Sociology*. London: Routledge.

Beilharz, P. 1997. *Imagining the Antipodes. Culture, Theory and the Visual in the Work of Bernard Smith*. Cambridge: Cambridge University Press.

Beilharz, P. 2000. *Zygmunt Bauman—Dialectic of Modernity*. London: Sage.

Horkheimer, M. and T. Adorno. [1945] 1972. *Dialectic of Enlightenment*. Reprint, London: Verso.

Korsch, K. 1936. *Karl Marx*. New York: Russell and Russell.

Marx, K. [1844] 1975. Economic and Philosophical Manuscripts. In *Collected Works*, edited by K. Marx and F. Engels. Vol. 3. London: Lawrence and Wishart.

Marx, K. [1845b] 1976. Theses on Feuerbach. In *Collected Works*, edited by K. Marx and F. Engels. Vol. 5. London: Lawrence and Wishart.

Marx, K. [1857/8] 1973. *Grundrisse*. London: Allen Lane.

Marx, K. 1867. *Capital*. Vol. 1. Moscow: Progress.

Marx, K. and F. Engels [1845a] 1976. The German Ideology. In *Collected Works*, edited by K. Marx and F. Engels. Vol. 5. London: Lawrence and Wishart.

Schmidt, A. 1972. *The Concept of Nature in Marx*. London: New Left Books.

Scott, J. 1998. *Seeing Like a State*. New Haven: Yale University Press.

Seddon, G. 1994. The Backyard in *Australian Popular Culture*, edited by I. Craven. Melbourne: Cambridge University Press.

Seddon, G. 1995. *Swan Song: Reflections on Perth and Western Australia*. Nedlands: University of Western Australia Press.

Seddon, G. 1997. *Landprints: Reflections on Place and Landscape*. Melbourne: Cambridge University Press.

Weil, S. 1958. *Oppression and Liberty*. London: Routledge.

Winton, T. and R. Woldendorp. 2000. *Down to Earth – Australian Landscapes*. Fremantle: Fremantle Arts Centre Press.

Hugh Stretton

Chapter 21

Hugh Stretton – Social Democracy in Australia (1994)

I

Hugh Stretton is widely recognised as Australia's leading social democratic thinker. My concern in this paper is to establish what this kind of claim might mean and my purpose is therefore dual, both to establish the physiognomy of and the echoes in Stretton's thought and at the same time to clarify what it means to speak of social democracy in Australia. Elsewhere, in books like *Labour's Utopias – Bolshevism, Fabianism, Social Democracy* I have argued that social democracy is best understood in the stream of classical Marxism associated with the German Social Democrats until the Great War. This is a tradition which follows Marx, in that it both affirms and denies bourgeois civilisation. On this basis, what we encounter comparatively as reformism in Australia is either closer to labourism or to social liberalism. At the same time there is a recognisably English tradition which runs from the Social Democratic Federation to Tawney and communitarianism or ethical socialism, which provides a powerful and significant vocabulary the limit of which, however, is often thought to be increasingly apparent today in its monoculturalism and its residual medievalism. These are some of the kinds of resonances I want to listen out for. For the purposes of the task at hand, I shall focus upon Stretton's central 1976 work, *Capitalism, Socialism and the Environment*. This approach will enable me to pursue *inter alia* the question of affirmation and denial, valorisation and critique as criteria for the social democratic assessment of white Australian civilisation.

Who is Hugh Stretton? The bibliography tells the story, but only part of it, for Stretton's life path has been extraordinarily active in the political and administrative spheres. His books and essays tell only some of the story, in

the manner we might associate with other pragmatic reformers and activists. Like Keynes and Titmuss, Beveridge and Tawney in the English tradition, the writings serve as signposts rather than monuments. The most important works are the following: *Capitalism, Socialism and the Environment* (1976), *Housing and Government* (1974), *Ideas for Australian Cities* (1973), *Political Essays* (1986), *The Political Sciences* (1969), *Urban Planning in Rich and Poor Countries* (1978), and most recently *Public Goods, Public Enterprise, Public Choice* (1994, together with Lionel Orchard). Stretton's contribution has been variously assessed by the contributors to *Markets, Morals and Public Policy* (Orchard and Dare 1989) and his profile sketched by Mark Thomas' *Australians in Mind*. His path takes him from Melbourne and its university, where he read Tawney, whose work he had first encountered at school, then to Oxford and Balliol, where he read Hobson. Stretton subsequently studied at Princeton and has taught at Balliol, Smith College, and the University of Adelaide, where he was Professor of History from 1954 to 1968 when he stepped down to the position of Reader. A practising reformer, he served for many years as Deputy Chairman of the South Australian Housing Trust. Stretton is best placed, biographically, with those other reformers who have been concerned to identify social problems, establish their nature and identify means for their rectification. His name belongs together with that of Coombs in the Australian register, though the balance may be gently complementary. Coombs writes, in a sense, after the fact; Stretton's concern is more with the way the agenda is formed in the first place. His is a life both scholarly and political in the tradition associated with Max Weber's famous imperative that we ought seek only to combine passion and perspective, knowledge and politics.

How then to place Stretton? Let us begin with some context regarding talk about social democracy. What might it mean to be a social democrat in Australia? I have already implied that it might mean something more English than German – pragmatic, given to interpretation after the fact and to viewing theory as a tool rather than a good in itself. Indeed, it might well be argued on logical grounds by razor sharp minds that there is no social democratic tradition in Australia, except by default, as in case that there is no sociology in Australia, only sociologists. The 'social laboratory' of the previous *fin-de-siècle* was the result of practical reforming purpose, but it also had various visionary aspects. Australian paths of reform and reconstruction occurred largely at the hands of groups and individual actors whom the Americans would call liberals, or the British would call social liberals. They were interventionists, committed to ideas of social protection

and security, the commonwealth, regulation, later the welfare state. The dominant political culture in Australian cities and suburbs, however, was arguably closer to labourism than liberalism in the muscular, civic sense. From the 1890s to the 1980s labour culture arguably had a disproportionate influence in Australia, partly because of the relative absence of a modernist, industrialising bourgeoisie (Beilharz 1994a).

The term social democracy nevertheless became something of a catch-all after the Second World War, and as I have indicated, the English also used the term early, into the 1880s, as a description of their own position. As the Swedish Social Democrats articulated this stand, its hope and purpose was to shift from political and social rights to economic democracy, in a path of progressive and radical reform not unlike that later anticipated by T.H. Marshall for Britain in *Citizenship and Social Class*. Less favourably located, Richard Tawney imagined the same kind of process already in 1929, in *Equality*.

In sociological terms, however, what makes social democracy an important tradition is its essential ambivalence regarding modernity. Social democrats are both modernists and romantics at the same time. They encounter contemporary Western civilisation as a matter of gains and losses, and they feel strongly about both. Both on the continent and in Britain, socialists from the 1820s on were horrified by the destructive power of industrialism and yet attracted by the prospects it potentially held open, of free time, of possible abundance, for the good life in public and in private spheres. One strong distinction between this common European lineage and the antipodean story is apparent. Australia encountered no industrial revolution, in the strong sense, until the Second World War. The Australian labour movement and bourgeoisie have tended to imagine their good society as suburban more than urban, romantic and pastoral more than modernist and metropolitan. Ours was a modernity without modernism, at least in the boosterist, American sense. The fundamental ambivalence towards modernity which we find in Marx and classical Marxism, in Carlyle, Morris, and Tawney is less conspicuously present in mainstream Australian political culture. Its modernists are few and far between, and, like Elton Mayo or Meredith Atkinson, are largely ignored, driven away or eclipsed and forgotten. Social democracy in Australia, I shall argue, *is* necessarily in this way something of a category by default, because its leading thinkers, like Hugh Stretton, exercise a different take on these medieval and modernising currents which together form European social democracy. What this raises, substantively, is the question of the

relationship between liberalism and social democracy, for it may well be at the end of the day that (in those American and British senses of the word) Hugh Stretton is Australia's *liberal* thinker, and if sociology and liberalism are mutually constitutive, then this opens questions of Stretton's project as a sociology.

The significant issue which follows on from this, is not whether liberalism is good or evil, but how well it can conceptualise social bonds and whether it can cope with the kinds of change we now experience accelerating in modernity under categories such as 'globalisation'. I shall suggest that the apparent limit in Stretton's thought is to do with his sense that *more stays the same today than changes*. What is increasingly unclear, as we approach the new millennium, however is the extent to which processes of accelerating change threaten to undo or simply bypass traditional ways of thinking, social democracy and liberalism included.

To foreshadow: Stretton argues (or at least one of his three voices does) in *Capitalism, Socialism and the Environment* that 'As the twenty-first century opens, most daily life is much as it has been for three generations past ...' (Stretton 1976, 52). While this is likely both an accurate description of the lives of the two-thirds world, and a useful anthropological reminder of the universality of the human condition, it may be less than sociologically useful or politically enabling when it comes to living now in the centres. It risks missing, I suggest, the extent to which change and even the *sense* of change is formative of metropolitan culture into the 1990s (Touraine 1992).

II

Stretton's major work, in this context, is *Capitalism, Socialism and the Environment*. The fields covered by the book are expansive and generous. Its tenor owes more to Tawney than to Marx. So, for example, in talking of ecology, there are the practical notions associated with Tawney and Schumacher, ideas of stewardship and living simply; a style which, like Tawney's, is distinct, hectoring, polemical; and Stretton's morals are probably most like those of Tawney, associated with ethical socialism, the desirable priority of will over necessity, politics over economics, reform over inequity, planning over chaos.

The style of the book is striking. It is addressed to the 'general reader', not to the tired inhabitants of the academy. It has a practical 'what is to be done?' orientation. It plays on notions of commonsense, which notoriously

can cut both ways. Like Tawney, it is simultaneously plain speaking and impatient; and it is concrete, yet abstract (there is only one reference to a reformist called Allende, and none at all to Whitlam or his project in Australia, though *per contra* it would also be suggested that, though there is only one reference in the text to John Stuart Mill, the whole book is about Mill, and in this sense, also, about Whitlam). The strategy chosen by Stretton is novel. The book rests on three scenarios, three possible utopias (or dystopias). In this sense, then, the book is highly intellectual, a thought-experiment about choices regarding the future which in principle are open to us. The three possible scenarios can be characterised as following: first: bad news; next: news ok but could be better; finally: better news after worse. Or to express them symbolically, the first scenario is that in Thomas Hobbes' *Leviathan*, a future risking life, nasty, short, brutal; the second is a kind of commonsense Americanism, or managerial sociology, 'business as usual', and the third imagines a kind of strife which leads to a new way out, to the discovery and confirmation of a socialism of a sensible, conservative kind. A conservative socialism – the oxymoron works, because it invites.

Stretton's strategy, then, in *Capitalism, Socialism and the Environment*, offers a kind of radical twist on that in traditional socialist writing on utopia – it is, in a way, Morris' *News From Nowhere* with a three-dimensional optic. Forsaking the Rip Van Winkle-Sleeper Wakes genre, Stretton offers three *possible* outcomes. *Capitalism, Socialism and the Environment* is a thought-experiment like Morris, but it is modern, and contingent – it is, in fact, open ended, it defers, finally, to the popular will rather than to Victorian images of necessity or evolution. Taste its flavour, in summary. Stretton writes:

> Most capacities for love develop (or don't) in childhood; the largest quantity of human co-operation occurs within and between households; co-operation there is the pattern, and has to be the continuing basis, for co-operation anywhere else. To put it in the most shocking possible language, socialism should cease to be the factory-floor and chicken battery party, and become the hearth and home, do-it-yourself party (Stretton 1976, 206).

Good news for Tony Blair, even for Eric Blair, though it is also evocative perhaps of the BBC-TV image of *The Good Life*. Enough to make you wonder why, here, there are only two alternative scenarios. But Stretton warns us, he is out to shock; though his tenor is not that of Jeremiah, he conspicuously enjoys provocation, and views it as an insufficiently exercised

part of intellectual vocabulary in Australia. We are too polite. Nevertheless, under the provocation there is also a firmity of sentiment. The connotations of Stretton's utopia are apparent – green, and local, more like Tönnies, communitarian, than highly modernist or functionalist like Durkheim, not city, or at least not metropolis, not Manhattan or Sydney today, Adelaide, not Amsterdam.

Mere medievalism, some would spit, and they have. As I have argued elsewhere, however, in books like *Postmodern Socialism* and *Transforming Labor*, the split between country and city in Australian intellectual debate is too easily choreographed, and often is, as though it were a replay of the American spat between Lewis Mumford and Jane Jacobs, the pastoral versus Greenwich Village. Stretton is not the suburbanite or patriarch he is sometimes cast as (Beilharz 1994, 85–9). His claim is rather that Australian cities are specific, different, both urban and suburban. His claims are less provincial, I think, than they are governed by a particular sense of the specificity of place. A Melbourne boy self-transplanted to Adelaide via other parts, he is attracted to order, likely more so than modernists or postmodernists of my generation, for whom Jacobs got it right, and New York remains powerfully magnetic, compelling in its chaos. This, even, if Jacobs' village also disappeared, in time, driving her to Toronto, a workable city which urbanist snobs love to hate – too much like Melbourne. The substantive issue remains, again, how well this sentiment in Stretton's work travels. Certainly it can be argued that the second and third generations in Stretton's earlier vignette feel distinctly different about place, taste and traditions, that musician Paul Kelly's path from Adelaide to Melbourne to Sydney and to America and back, nowhere, now there, is more typical than not, whether as actuality, now, or as desire. So this is the question which needs to be puzzled over, at the end of the day – what talk about community, and place, and scale and belonging might now mean, and whether liberalism or social democracy can sufficiently begin to address them.

III

What, then, are the resonances in Stretton's case? As I have indicated, they suggest for me a fascinating mix of local and other, of experience and reading, of pragmatic attraction and moral utility. It is easy, too easy, to detect in Stretton's voice the case for organicism, *backyardism*, medievalism, in short that kind of tory radicalism which goes back to Carlyle, the thunderer, and forward to Robert Hughes, the complainer. But this is, I think, both to miss

the point and the content of Stretton's work. Its content aligns far more readily with Tawney, Keynes, Coombs, for Stretton's is really a fabianism of a kind. And it is Coombs who is really Stretton's hero or at least this is what he told me when I asked him. Now to mention fabianism is only apparently to introduce a new category, for fabianism like labourism and liberalism can also be viewed as a kind of reformer's Gladstone bag, and we need always to remember that these categories are far too readily fixed, treated as exclusive after the fact when they were not, in their moment. In the practical work of reforming politics not least of all, reformists work together, whether Christian like Beveridge, socialist like Tawney, revolutionary like Morris or Cole, utilitarian like the Webbs, and so on. But there is, I think, something British or at least English about this. This fabianism of a kind rests on a clearly local sense of the place of the middle class and the civil service and the old Oxbridge tradition, Politics/Philosophy/Economics. As in Tawney, it values norms such as service. Stretton's work and its moralism thus anticipates neatly more recent missiles such as Michael Pusey's *Economic Rationalism in Canberra*. Though we might also wonder – with due respect to Michael – why and how his book, a masterpiece of political timing, has come to dominate this field to the effective exclusion of all other arguments, including those like Stretton's.

More routinely, the resonances in Stretton's work are in liberalism from Mill to Rawls. This is an aspect of his project, again, which is often missed: Stretton's work is less romantic, or less pastoral than liberal. To the extent that it is romantic, as I have indicated, Stretton's politics are to do with a romanticism of *place* rather than time. Stretton is not arguing, implicitly or explicitly, for a return to a previous imagined state of affairs. He is arguing for a vital sense of place, and for its intelligent conservation against the always acidic bite of modernism. In different terms, Stretton is arguing for Australian social democracy as intelligent suburbanism (bearing always in mind that in Australia, at least, cities and suburbs are notoriously difficult to separate). Then there are the echoes with liberal feminism, the striking sensitivity to matters of the home as domestic economy, sympathies with the later work of Marilyn Waring, sympathies in advance with the work of Alec Nove, setting the idea of feasible socialism against the bad collectivism of battery-hens, leninesque post-office or barracks utopias.

Yet Stretton's work is not that of a weberian Marxist – in the sense of classical or German Social Democracy, not least of all because it is not the work of a Marxist. Stretton shows no more interest in or sympathy for Marx than does a conservative solidarist like my colleague John Carroll. The

sympathies in Stretton's work are more like those of Durkheim. Stretton places great store on values like civility (notwithstanding his dislike of polite indifference), even more: on decency, prudence, interdependence, and his politics rest on the idea of the good expert, the moral professional (*Age*, 17 October 1988; Stretton 1993). Again, though this kind of commonsense might be described as English (or Scottish) it is also perhaps French, as is exemplified in the echoes in the case of Pusey. It is underwritten, it seems to me, by the commitment to simplicity, to the home or the private sphere as well as to the life of the polis or city, but it is not organicist, in the way say that Mumford is. In fact, Stretton chooses to lambast organicism explicitly, in *Ideas for Australian Cities* (Stretton 1973, 279–84), where he also develops a defense of the suburbs and the household in terms of the *producers'* ethic, where the home thrives less as a locus of consumption than as a site of creation. And in this, it ought to be recognised, whatever view one finally takes of the suburbs, Stretton pioneers the realist recognition that Australians are, actually, in a peculiar way suburban whether we like it or not. While others through the sixties from Barry Humphries to Robert Hughes promoted the sneering denial of this cultural fact, Stretton simply spoke it.

This situation again serves to bring into focus something of Stretton's sense of purpose. His model of intellectual activity is as circuit breaker; he knows that there are wrong paths taken, mistakes in policy and politics made which could be rectified. He denies the denials of those like Humphries who pour scorn on the way that we live. In his important work on *The Political Sciences* he chastises the C. Wright Mills of *The Power Elite*, a disabling work, while praising the positive, in the image of *The Sociological Imagination* (Stretton 1969, 266–67). In other words, his is a pioneering argument for an example of the public intellectual, for he values public work over Germanic critique. And this is why he values the personal, attacks corruption, moralises, is angry. Stretton less often thinks culturally, or civilisationally; he thinks in terms of politics, accident, contingency. As he put it in a famous line, anticipating the transformation of Labor in the eighties, 'how different history might have been had the Willis faction won Treasury' (*Age*, 19 January 1989) – no question mark. Or in his contribution to the *Daedalus* symposium, Stretton's brief is not problems of Australian culture, but 'The Quality of Leading Australians' (Graubard 1985). Stretton presumes that politics retains a certain elasticity, even when we forget it. As a public moralist, he starts not from 'is' statements, but from 'ought' (Stretton and Orchard 1994, 1). Will, here, is given more

power than context; possibilities remain open, in principle, even for Labor Governments (Stretton 1993).

IV

Social democracy, I have suggested, is an intriguing tradition because of its ambivalence towards modernity. Though Marx is often caricatured as a ruthless moderniser, there is also a fundamental romanticism in his thinking, which in turn informs classical Marxism, the Marxism of the Second International. Marxism becomes boosterism with the Bolsheviks (via Kautsky) for obvious reasons – the Russians need to industrialise. The British, by comparison, industrialise earliest, and their central social critics, from Ruskin to Jeremy Seabrook, never quite recover from the shock. But they also recognise that medievalism, in the manner of Belloc and Chesterton, simply will not any longer work. Social democratic culture, then, originates as both critical and affirmative of the world. The German Social Democrats were always Weberian Marxists, while the English were sufficiently sensible to seek the combination of modernity and community, even if the images of community and culture remain relatively prescriptive and simple in both streams. Thus when Stretton writes in *Ideas for Australian Cities* that the left should henceforth be intelligently conservative, we have to wonder about the contrary sense, that no-one today can any longer be just conservative; change, now, is at such a norm as stability, and complexity militates against simplicity both of question and answer (Stretton 1973, 150, 170, 282).

As the bite or relevance of social democracy recedes, as social democratic practice becomes mainstream and increasingly administrative after World War Two, its aura also becomes different, alternatively more given to the affirmation of bourgeois civilisation – third way as first way – or else more nostalgic for imagined pasts. Questions of the past now becoming more pressing, not less. Significantly, arguments about what white Australians have achieved are conducted more often by local, or longitudinal analysis than by comparative or transnational criteria. Thus Michael Pusey defends the image of the 70s and John Carroll the 60s, others the 50s. Hugh Stretton in a sense defends neither 60s or 70s and in a sense both, for commonsense tells us that Australians are basically good at what they do, and should continue at it. The problem today is whether this kind of argument can or will be heard in Canberra, where the will to modernise and globalise (after a fashion) has been let loose. Social democracy, or liberal politics, may then

differ variously, as they imagine communities constructed of groups, or individuals first, but they are both tied to images of national sovereignty which may be evaporating before our eyes (see Beilharz 1994b, 1993; Sassen 1994; Hirst and Thompson 1992). The image of Australia as a governable unit is increasingly unsettled, elsewhere, dispersed, uneasy. We feel uncertain, cut loose, buffeted by cynicism and narcissism.

To put this into different perspective, we can also view change as a virtue even while recognising its profoundly unsettling and disruptive character. In *Capitalism, Socialism and the Environment*, Stretton writes that change is a *cost* of achieving better equality, freedom and social cohesion (Stretton 1976, 150). But change is also a benefit, an imperative, and more than either, it is a *fact*. Speaking to Mark Thomas, Stretton suggested that the world might be divided into two types of people: those who remembered their childhood and thought that, above everything, they wanted that sort of upbringing for their children; and those who, recalling childhood, insisted that their children would never go through what they had suffered (Thomas 1989, 96). Today, increasingly, it is difficult to suspect that people worrying about children would feel a sufficient sense of control to anticipate either of these possibilities. Our hopes for our children today are probably more minimalist, hopes for patterns of resilience rather than for *this* path or *that*.

So where does this leave us? It leaves me in awe of the achievement of Hugh Stretton, wondering, perhaps, about matters of change, complexity, density and difference, puzzling about the twentieth century and modernity as a period of losses as well as gains now lost, wondering whether social democracy might stretch into the new century, or whether the social democratic moment has passed. In a similar, limited mood, it might leave us wondering whether sociology has missed its moment, except that the need for sociology remains so central. Even so, the social democratic, fabian or liberal currents are only ever part of the story of sociology, Australian and elsewhere. As I suggested earlier, change is a challenge as well as a loss. My own sense is that we have rich traditions and precedents to draw upon if we wish to revive or reinvent the project of Australian sociology; this is hardly a matter of creation *ex nihilo*. Perhaps the process of creation or recreation is already underway, and we are part of it; perhaps it will simply remain for others, later, to discern our flaws, as well as to appraise our contribution.

References

Beilharz, P. 1992. *Labour's Utopias – Bolshevism, Fabianism, Social Democracy*. London: Routledge.

Beilharz, P. 1994a. *Transforming Labor – Labour Tradition and the Labour Decade in Australia*. Sydney: Cambridge University Press.

Beilharz, P. 1994b. *Postmodern Socialism – Romanticism, City and State*. Melbourne: Melbourne University Press.

Beilharz, P. 1994c. 'Socialism after Communism – Liberalism?' Paper to Conference on History of European Ideas, Graz.

Graubard, S., ed. 1985. *Australia: The Daedalus Symposium*. Sydney: Angus and Robertson.

Hirst, P. and G. Thompson. 1992. The Problem of Globalization. *Economy and Society* 21: 4.

Marshall, T.H. 1950. *Citizenship and Social Class*. Cambridge: Cambridge University Press.

Orchard, L. and R. Dare. 1989. *Markets, Morals and Public Policy*. Sydney: Federation.

Pusey, M. 1991. *Economic Rationalism in Canberra*. Sydney: Cambridge University Press.

Sassen, S. 1994. *Cities in a World Economy*. Thousand Oaks: Sage/Pine Forge.

Stretton, H. 1969. *The Political Sciences*. London: Routledge.

Stretton, H. 1973. *Ideas for Australian Cities*. Melbourne: Georgian House.

Stretton, H. 1976. *Capitalism, Socialism and the Environment*. Sydney: Cambridge University Press.

Stretton, H. 1993. *Whodunnit* to Social Democracy? Murray Smith Lecture, Melbourne, 9 June.

Stretton, H., and L. Orchard. 1994. *Public Goods, Public Enterprise, Public Choice*. Melbourne: Macmillan.

Tawney, R.H., ed. 1964. *Equality*. London: Unwin.

Thomas, M. 1989. *Australians in Mind*. Sydney: Hale and Iremonger.

Touraine, A. 1992. Is Sociology Still the Study of Society? In *Between Totalitarianism and Postmodernity*, edited by P. Beilharz, G. Robinson, J. Rundell. Boston: MIT Press.

Jean Martin

Chapter 22

Jean Craig and the Factory Girls:
Jean Martin's Industrial Sociology, 1947–50
(2008)

Jean Martin, née Craig, was not always a multiculturalist. In fact, what is striking reading back through her work before the seventies is how distant her interests are from the multiculturalism which she came to be identified with after *The Migrant Presence* (1978). Certainly her work is marked by a persistent interest in movement and migration, though her earliest work develops these themes internally, with reference to the rural emigration of young women to Sydney (Butlin Papers, P 130/49/1). There is no strong presence of ethnicity as a theme in her earlier work, though she plainly drank deep of these issues in her time in the city and districts and neighbourhoods in Chicago and from the culture of its great university in 1947–48.

Last year, at the Canberra TASA Conference, I indicated that one key question to ask of Jean Craig's Chicago experience was, what difference did it make to her already existing Durkheimian sensibilities, acquired in collaborating with A P Elkin? (Beilharz 2009). An equally difficult, and interesting question is, how did she come to ethnicity as a core issue for her Australian National University PhD on displaced persons in New South Wales, with Nadel, submitted in 1954? There is no significant prehistory for this interest. Her earlier competence and curiosity is in everyday life conditions for farmers and soldier settlers and their families in northern New South Wales. Then, after her year in Chicago, Jean Martin takes a serious turn into industrial sociology and some of its central thinkers: Durkheim, Mayo and Warner. This is the subject of the present paper. First, I foreshadow some of Craig's theoretical interests in the field. Second, I summarise some of the pertinent themes and issues of her Sydney factory fieldwork and its implications.

I

What was she reading? In Lent Term 1950 Jean Craig taught a seminar on industrial sociology at the University of Sydney. The course notes in her papers indicate a deep engagement with the core materials. They focus on Durkheim and Mayo, though the role of Warner should not be underestimated. She worked with Warner at Chicago, and he was a major carrier of cultural and intellectual traffic between Australia and the USA but also a significant collaborator of Mayo's. Mayo's work and Warner's are both scattered with cross-references to each other's work.

Craig's notes are clear and systematic. She begins with Durkheim. Social solidarity is central both for social reproduction and for individual development. No sooner has she begun the exposition of Durkheim, however, than she breaks to observe that the Mayo group tend to allow the former social factors to elide the latter individual dimensions (N 132/59: 1). Solidarity has some kind of magic; it cannot be externally induced, or lowered onto social relations from above, by the state. The challenge, of course, is for occupational groups to develop this solidarity in lieu of the traditional or earlier territorial and kinship divisions. The Mayo group adopts the idea of *anomie* to deal with concrete work symptoms such as high labour turnover, absenteeism, low productivity, and workfloor conflict (N 132/59: 3). The Mayo group, however, take high productivity as the opposite of *anomie*, which is difficult because (as her subsequent research shows) high productivity often goes together with isolation rather than solidarity. As Craig observes, Mayo operates with a thin reading of Durkheim. Mayo values harmony, more than solidarity, and argues as though there are relatively simple and dichotomous relations between past (good) and present (bad) and smaller and larger levels of social organisation (ditto). Mayo does not make it clear that anomic labour is abnormal. In other words, Mayo projects his own nostalgia onto Durkheim.

Craig's reading of Mayo is suggestive. Some of his major works, written in the midst of the world crises of the 30s and 40s, certainly fit the scenario of the decline of the West, even if his inspiration is Pareto rather than Spengler.

Those who know Mayo's writings will likely agree. His *locus classicus*, *The Human Problems of an Industrial Civilization* (1933), occasionally reads more like a fireside chat than a serious work of sociology. His essays string together related but loosely connected themes, from the study of fatigue and monotony to the Hawthorne Experiment at the Western Electric Company in Chicago. The famous paradox of that study was that the group subject

to scrutiny worked better and were happier under the spotlight than not. And, to modify earlier judgement, Mayo insists that this is not a situation of return, but rather a new industrial milieu (Mayo 1933: 71). Whatever the case, one implication of the Hawthorne work was that it was the interview process and that of therapeutic scrutiny which became significant, as though it were the magic itself.

The irony in Mayo's is that it is also anti-modernist, in ways that Durkheim's thinking plainly is not. Anomie seems simply to be a function of modernisation, or rampant economic development (Mayo 1933: 131). And as Craig observes, Mayo seems to see social disintegration as a function of scale. Indeed, he refers to Warner's *Yankee City* study of a small New England town in distinct contrast, then and now so to speak, with the case of Chicago (Mayo 1933: 133). Yankee City, Mayo claims, is an 'undamaged' New England community (1933: 136). But that is not the finding of Warner at all.

The sequel to this book was entitled *The Social Problems of an Industrial Civilization* (1945). Emerging from the second world war, Mayo's scenario was no more cheerful, even if the fireside tenor was more earnest and the scope of the work more panoramic. Here Mayo elaborates what becomes a core distinction for him, that between the *established* (traditional) and *adaptive* (modern) society. The problem remains Durkheim's: how to mediate individual interests via the group, though as Mayo argues, this is also a spontaneous tendency, as shown in the Hawthorne Experiments: given the chance, humans will prefer to cooperate. The general theorem is that material civilization has outstripped cultural capacity. The talking cure becomes a key to good industrial relations. Work pathologies can thus be defused by 'talking it off'.

Whatever the elective affinities between Mayo and Warner, their priorities and conclusions differ. Craig was indeed interested in psychology, but her approach was more analytical and less prescriptive. Her way of working was closer to that practised by Warner and his team.

The text of Warner's taught by Jean Craig in Lent 1950 was Warner and Low, *The Social System of the Modern Factory* (1947). This volume of the *Yankee City* series focuses on the 1933 General Strike in the local shoe industry. Warner's story concerns the capitalization of the industry, its elision of community roots and ties, the introduction of absentee ownership, interstate and national competition, and the destruction of craft identities and job paths. The emergence of industrial struggle coincides with the establishment of the mass worker. Workers are isolated at work; the General

Strike gives them solidarity, after they are denied the earlier, work-related identity politics of the American Dream. Warner's work can also be read in terms of the before/after of tradition/modernity, but his image of the present is not only one of loss. What Mayo's group got from the experience of experiment, Warner's got from the strike. In other words, Warner's logic is closer to Durkheim's than Mayo's is. The prospect of industrial solidarity offers something new; individual responses to change can be irrational, but this is suggestive rather of a new form of rationality.

This brings Jean Craig to her most important addition, the idea of the primary group. Here she refers to Cooley, but the immediate inspiration for her fieldwork seems to have been Shils. The primary group here is evidently the work group, though likely in her later work it becomes the ethnic group. Primary groups have solidarity; strong patterns of identification, high and complex levels of interaction; their members have common tasks or goals. The group has some degree of autonomy, even if it has little control over externally imposed rules; and it is small, small enough to allow the above features to operate (Craig 1950: 5). Size is not the only, or clearly defining issue, however. Craig refers, in contrast, to Sol Tax's observation that impersonal relationships may also characterise small societies. She connects this to Simmel's observations, underworked by subsequent sociologists, regarding pair and triad (1950: 6). Though she does not use our language, Craig is also referring here to the politics of recognition. Individuals have certain basic needs for affection, security, recognition or response from others. 'It is only within the primary group relationships that these needs can be adequately fulfilled' (Craig 1950: 7). But this is the site of conformism, as well as fulfilment. And here she steps sideways into psychoanalysis, the family and beyond, and refers to Carl Rogers, whose lectures she also attended at Chicago. Here the immediate family situation matters more than images or memories of the past. Therapy comes into play alongside the family as a significant primary group.

Consequently, and here Craig's frame of reference turns again to the Warner group: 'The primary group functions to regulate the interaction of individuals engaged in "co-operative" enterprises' (1950: 8). Craig concludes that, for Mayo at least, social conflict in industry is connected especially to 'defective communication' (1950: 9), particularly up the line. The failure to satisfy the needs of workers generates neuroses and obsessive thinking. For Mayo, technology outpaces social relations, but well-informed elites can nevertheless steer society towards equilibrium. Craig's attitude to Mayo here is respectful, yet critical. Mayo's thinking rests on a harmonism and a kind

of programmatic economism which rests uneasily with a more desperate sense of the decline of the west, especially in his earlier work.

II

After Jean Craig left Chicago she remained in correspondence with Shils, not least regarding the significance of primary groups (NLA, MS 7912, Box 8: 3: '10th Dec. 1948, Saw Mr Shils about this', 13th Dec; Craig to Florence Harding, in our possession, 22/7/52, 'Can you please procure me a copy of Shils' new book on primary groups?'). And she began a major project into the working lives of women in the David Jones underwear factory in Sydney. This resulted in a major, three-part study which was never published. Her archives contain a grumpy referee's report advising against publication, this notwithstanding the fact that the field was almost completely new and the project pioneering (Butlin, N 132/60).

Another document in Craig's papers (NLA, MS 7912, Box 8) bridges the project. It is entitled 'Proposed Research on Industry: Shils Lectures on Primary Groups'. There are hypotheticals regarding the possibility of such research. Should I take a job in the factory? How best exactly to proceed? First casual interviews, annual reports? Small group interviews? A factory with predominantly men or women employees? Nationalised, co-operative or private? One with a harmonious industrial history or a record of dispute? (Mayo and Warner had taken quite different cases here.) Did factory experiences develop 'democratic traits'? What conclusions would be drawn from such research regarding personality? And so on.

The three part paper covers The Role of the Fellow Worker; A Study of Norms in a Factory; and The Employee Role (Craig 1, 2, 3). The research base is in fieldwork in a department of 120 machine operators, all women, working on fourteen different machines. Only the manager and repair mechanics were male. Thirty six operators, or 35% of machinists were interviewed. Questions used were of the following kind: 'What would you call a good worker?' or 'What sort of person do you best like to work with?' The substance of Craig's findings deal with how it is that the operatives look out for each other, while playing along with the demands and expectations of their superiors. Patterns of loyalty are horizontal rather than vertical. Information can be shared sideways, but not generally up the line. Solidarity works entirely within the primary group; it does not pertain to the factory or to the division of labour as such. Information might be passed up the line if it is directly advantageous to another worker, but

not if it might harm them. There are some exceptions. Repeated theft of personal property on the floor can be reported, but not by including the name of the culprit, rather reporting the offence alone. More, if an operator works next to another whom she objects to because of dirtiness, swearing or some other personal characteristic, she may ask to be moved to another bench, but she should not state to the supervisor specifically the reasons why she wishes to be moved (Craig 1: 7). Codes of honour work among those who are equals. Finally, there are some ambiguities faced by the floor-girls, who are employed as operators but who mediate between operators and supervisors. Floor-girls provide intelligence to supervisors and to departmental managers above them. Some kinds of grievances can thus be relayed up the line by the floor-girls, preserving anonymity for the operatives below them.

The rules of these games that people play are immediately apparent to us, whether in terms of our childhood school experience or in terms of more sophisticated kinds of peasant cunning. Power relations are crucially mediated via the delivery or withholding of intelligence or information. Nor does it surprise us that there are stigmata attached to deviants. The most common form of deviance is 'crawling'. Only the infringement is named: crawling is a violation, loyalty or solidarity is not named as the norm or positive term. When it comes to work behaviour, the most important expectation is that the fellow worker should take a fair share of 'good' and 'bad' work. 'Good' work is connected to bonuses, or is easy, or satisfying. 'Sharking', taking all the good work, is also subject to stigma. The general expectation that operators will work slow when being timed also extends throughout the whole group (Craig 1: 10). Work expectations are also mediated by primary groups on the floor; some set their own quotas, resisting the individual appeal of going for that bonus.

Some of these women were working fourteen hours a day. Little wonder there were issues with productivity or absenteeism. Workers therefore cover each other; their loyalties are to fellow workers, not up the line or to the firm. There are limits to the extent of the primary work group, however. Sociability tends to end when the whistle blows. Moral judgements are nevertheless employed towards each other. Girls are typed as 'good' and 'bad' in terms of the way they talk about sex; given the practical separation of work and social life, the girls do not actually know about each others' activity, only about their reputations. These tend to divide along class lines of respectability. Here the influence of Warner can be detected, for unlike Mayo, he relied on a six-class layer cake model of the American class system

(Warner 1949). She is also keen to emphasise that when it comes to class, this is how the girls see themselves (Craig 1:15).

Fellow worker expectations also operate at a higher social level. They promote competition and the value of self-improvement through money; not through aspiration to proceed on up the line, for there are almost no opportunities to do so (1:17). This confirms the findings of Warner and Low in *The Social System of the Modern Factory* (1947).

The second instalment of Craig's three-piece shifts more explicitly into norms between workers and management. Some of the material in the second and third parts repeats that in the first. Floor-girls, for example, might act as mediators, but only in very particular circumstances, such as those involving the repeated theft of private property from operatives. Perhaps the most interesting observation here concerns the absence of floor-wide norms. Thus, for example, many operators hold that, with the exception of the requirement that one should work slowly when being timed, they should be free to work as hard as they wish, unhampered by any limitation imposed by the work group. But a minority of operators follow the opposite expectation, namely that output should not exceed a commonly agreed upon norm (Craig 2: 3).

Craig's expectations are more modest than Mayo's. She concludes that the norms followed by operators serve to protect them from managers, to preserve their practical autonomy and their levels of reward and wellbeing. More, they generate enough harmony to allow the business of the firm to go on. 'Mrs F', the departmental manager, has also read Mayo, and thinks of the factory girls in terms of the possibility of disturbed personality alongside the more elementary issues of mere disobedience (Craig 2:6). Mrs F knows that the world is changing, that labour shortages have cultural effects in the workplace, and that Human Relations has already had an effect. But she is indifferent to the workers' own norms. She prefers those who 'keep to themselves' over those who pursue sociability. She shares the distinction between 'rough' and 'respectable' girls, and like those on the floor associates this distinction with that of class. She also worries about the 'irrationality' of some individual operators (Craig 2: 9). She sees her girls as individuals, not as members of groups. But her expectations do not rule, at least not on the floor.

The third instalment, on 'The Employee Role', focuses further upon Mrs F. Mrs F would like to impose her expectations upon the culture of the factory, but knows that such an expectation would be unrealistic. She becomes more strongly involved in matters only when levels of output are visibly affected.

She works as a kind of psychological juggler, for example, trying to match a pair of girls who work well together or to fix a problem when one goes on holidays and the other claims she cannot work with any of the other girls (Craig 3: 2). She knows that quality matters, but is prepared to accept certain aspects of the decline of quality in production. She has to accept and work with the realization that she and her workers have fundamentally different senses of purpose. Hers are corporate; their loyalties are to the primary group.

Craig's conclusion is that (while she does not use the phrase) there is a class struggle over information which both limits productivity and yet makes the very conduct of business possible. This struggle coincides with sufficient practical cooperation to make production possible.

The theme of sociology of knowledge is a significant undercurrent in Craig's work. Earlier, in her Chicago period, she spends a great deal of time carefully reading Mannheim. Later, *The Migrant Presence* still follows this interest in knowledge and its politics. Craig shared the period enthusiasm of the forties for the idea and necessity of planning. She does not seem to have shared Mayo's sense of despair, coupled with his let out clause that all this could be fixed if only we could teach our leaders well. The temper of her industrial sociology accords more closely with the Warner group's work in *Yankee City*, and its methodological commitment to something we would now call an anthropology of modernity.

References

Beilharz, P. 2009. Miss Craig Goes to Chicago or Jean Martin Finds Australian Sociology, TASA Conference Proceedings, Australian National University, December.

Craig, J. 1950. Unpublished documents. The Role of the Fellow Worker; The Employee Role; and A Study of Social Norms in a Factory. Noel Butlin Archives, Australian National University, N132/60.

Mayo, E. 1933/1960. *The Human Problems of an Industrial Civilization*. New York: Viking.

Mayo, E. 1945. *The Social Problems of an Industrial Civilization*. Boston: Harvard.

Trahair, R. C. S. 2005. *Elton Mayo: The Humanist Temper*. New Jersey: Transaction.

Warner, M. 1988. *W. Lloyd Warner – Social Anthropologist*. New York: Publishing Centre for Cultural Resources.

Warner, W. L. and J. L. Low. 1947. *The Social System of the Modern Factory*. New Haven: Yale.

Warner, W. L., M. Beeker and K. Eells. 1949. *Social Class in America*. Chicago: SRA.

Chapter 23

Miss Craig Goes to Chicago:
Jean Martin Finds Australian Sociology
(2009)

Jean Craig was born in Melbourne in 1923 and grew up in Sydney, where she died in 1979. She took a BA at Sydney, working with A.P. Elkin, one of the founding fathers of Australian anthropology; and she, in turn, as Jean Martin became the founding mother of Australian sociology in the establishment process of the discipline in the sixties. By the age of twenty-two she was completing on her MA with Elkin. Its subject was rural life in northern New South Wales. Subsequent early research included a major report on two soldier settlements in NSW (1946), this conducted via Elkin and the Postwar Reconstruction Unit of the Federal Government. By 1947 she and her best mate, Florence Harding had decided to study sociology in the US. At this point there were no doctoral programs offered in Australia. They wrote to Dollard, at Yale, whose work they admired; and to Chicago. Chicago picked up. She spent the academic year 47–8 and then some working with the cream of the crop – Lloyd Warner, Robert Redfield, Wirth, Blumer, Burgess, Carl Rogers, William H. Whyte. The two women enrolled in a coursework Ph.D. program with the Committee of Human Development.

Together with Florence Harding Jean Craig conducted fieldwork in Hegewisch, a German-Polish precinct on the south side. Returning home via the UK and Europe, she took further lectures at the LSE by Laski, Firth and Shils. She remained in contact with Shils when, back in Sydney, she took up casework in industrial sociology, now working on and in a clothing factory associated with the retailer David Jones in Sydney and the Lustre hosiery factory, with reference to the usual issues of labour turnover, morale and absenteeism. In these years Jean Craig developed an interest in migration, initially in internal migration, for example, of youth and especially young women exiting country for city. In the absence of Durkheimian community

building, country life stifled, women especially. Women would seek income, independence and meaning, but also ego identity and recognition increasingly in paid work, in an Australia which had always been heavily urbanised in terms of population distribution. Girls left for the city, where they often didn't fit.

From 1949 the establishment of the Australian National University in Canberra as a national research institution meant that local Ph.D. work became possible within Australia. Jean worked with Siegfried Nadel now on displaced persons, and submitted in 1954. The result was a thick socio-logical enterprise, both more dense and more robust than her Sydney MA, which was loosely constructed though entirely comprehensive in narrative form. Now married to historian Allan Martin, Jean followed the pattern of his appointments until her first real job took her straight to the top. Her first significant academic appointment was as foundation Professor of Sociology at La Trobe University, where Allan Martin was simultaneously appointed Foundation Professor of History, and the two disciplines were closely worked together, following the inspiration of the Sussex model. Jean Martin produced many papers, and at least one hallmark book, *The Migrant Presence*, as well as the major Adelaide study on migrant networks, *Community and Identity* (1972), which established her as a major force in defence of the emergent idea of multiculturalism. Her most enduring effect otherwise, in addition to teaching, mentoring and institution building, was evident in her work on commissions and reports, including the pathbreaking *Henderson Commission of Inquiry into Poverty* (1975), the Karmel Report's Commonwealth Schools *Commission of Inquiry* on the educational needs of girls and women (1974), her *Survey of the Educational Experiences of Children of non-English-speaking Origin* (1972) and her contribution to *Who Cares? Family Problems, Community Links and Helping Services* (1977).

Various challenges face us (Sheila Shaver, Trevor Hogan and myself) as intellectual biographers of Jean Martin. One is simply to periodise her work. Another is to seek to explain its changes, shifts and transitions. As I have already intimated, there is a significant shift from the tenor of her early work to that of her Ph.D.; and it would be tempting to view this as the direct result of her time and experience in Chicago. The earlier work, the 1945 MA on rural sociology, and the 1946 research project on soldier settlement, already, however show clear and powerful Durkheimian sensibilities, which can be attributed to Elkin's influence, but also to the two-way traffic between Australian anthropology and the metropolis.

Australia was attractive to anthropologists because of the example of aboriginal culture, as mediated by Spencer and Gillen via Durkheim's *Elementary Forms*. Radcliffe-Brown notoriously took Lloyd Warner along on his expedition to Australia; and Warner famously insisted throughout his life that his subsequent sociology was an attempt to apply the knowledge base of his fieldwork with the Murngin people finally crystallised in *A Black Civilization* (1937) to the organisational and cultural life of American modernity, as in Newburyport, Mass., or Yankee City. Jean Martin's undeclared position was exactly the same: to seek to legitimate anthropology as sociology, or was it the other way around? This was also Elkin's ambit: an anthropologist of aboriginal culture and religion, he was an ordained Anglican minister and the founder of the short-lived Australian Institute of Sociology at Sydney and editor of its progressivist journal *Social Horizons*. Elkin became Professor of Anthropology at Sydney in 1934, after Radcliffe-Brown and Raymond Firth, working a double shift as Rector of his country parish in the country area where he encouraged Jean Craig to research. The ambit of Warner, Elkin and Craig/Martin is nevertheless apparent: whether construed as 'moderns' or 'traditionals', Australian blacks and whites live in communities that fulfil similar needs and functions. We are more like each other than we might at first care to think. (But to anticipate later developments into the seventies: if community is the local group, what happens to this premise when we introduce the idea of multiculturalism?)

Jean Craig's early research focussed powerfully on the material life of dirt poor whites, as well as those who fared marginally better in farming, dairy and fruit. She worked as research assistant for Elkin's books on *Citizenship for the Aborigines* (1944) and *Aboriginal Men of High Degree* (1946), though Jean never wrote on aboriginal culture; all her work on displaced people and migrants was focussed on newer immigrants, from the Baltic states after World War Two to her pioneering work on the Vietnamese refugees to Australia consequent on war's end in 1975.

Jean worked earlier at the Australian National University for Mick Borrie (from 1951) who was then researching his pioneering book *Italians and Germans in Australia*. Academic sociology was born in Australia in the fifties as demography. The traditional obsession of the white invaders from 1788 had been with 'peopling a nation', filling up the 'empty' spaces, making the stolen deserts bloom. Aborigines were rendered invisible in this process because they were viewed as one of the oldest peoples, a 'dying race'. Sociology became the study of white or whiter Australians, and cities; anthropology took on the original inhabitants, who for long were not viewed

as modern or urban (though that they of course also were). From 1952 to 1954 Craig worked on the assimilation of displaced persons in a large rural town in NSW close to Canberra. Her subsequent work was that of the journeywoman; lectures and short courses or class and culture, tropical communities, social work, etc, follow-up work on her Ph.D., resulting in *Refugee Settlers* (1965).

Evidence scattered throughout Jean Martin's papers held at the National Library, Canberra, and the Butlin Library, Australian National University, as well as in her Chicago notebooks (communicated to us by Bill Martin, now in our possession) make it clear that her daily sociological thinking when it came, say, to class was as much influenced by the Warner study as her thinking about race was influenced by Dollard's *Caste and Class in a Southern Town*. There were more crossovers, of course. Her industrial sociology was influenced by the work of the Australian born and trained Elton Mayo, who had earlier taken on Warner at Harvard from 1929 to 1935. Warner was beginning his work on Newburyport at the same time as Mayo was working on Hawthorne. Warner's multivolume study of Yankee City significantly ended on a Durkheimian, rather than conventionally American-Weberian note. The largest volume of all, and in some ways the most innovative was *The Living and the Dead* (1959). Less well known, Warner also entertained the idea of conducting research into white Australian society, as well as Chicago and Yankee City and alongside *A Black Civilization* (Elkin to Hole, 22/10/47, University of Sydney Archives; Hole to Elkin, 4/10/47, idem). While Mayo had no such known plans of return, his interest in trauma, like Warner's in death and memory, places them in the centre of anticipations of the newer American cultural sociology. One wonders, indeed, perhaps especially as an outsider, about the relative indifference of North American scholars to Warner (cf. Warner, 1988) and Mayo (cf. Trahair 1984) as well as to maverick Marxists like C.L.R. James in *American Civilization* (1950).

Is there, then, a clear sense in which Jean Craig changes after she visits and works in Chicago? The answer to this question is yes, though it remains at present difficult precisely to define. Craig was already thinking like Durkheim before she left Australia. The report that she wrote for Elkin under the auspices of Postwar Reconstruction was already more ambitious than her MA. There she addressed Elkin's theorem that societies depended on five Durkheimian factors for their coherence: where the 'essential principles of social organisation are continuity with the past, contiguity, kinship, social expression and a common hope for the future' (Craig 1946, 2). At the

conclusion of the study she adds a sixth: common occupation; which does not itself have general validity, but reinstates the centrality of economic bonds, as in the *Division of Labour in Society* (p.249). Craig has made the point earlier, in 'A Study of Rural Emigrants in Casino and Sydney', focussing on country women, girls and delinquents. Work is the key agent of assimilation, via the primary group, the employment group; and this is what takes Jean Craig into industrial sociology, even though she is essentially making it up for herself. Assimilation, in any case, can work through modern mechanisms like work, and not only through the institutions of tradition.

By the early-middle seventies Jean Martin was a pioneer of what she, like others, called multiculturalism. One of our other central tasks for this project is seeking to determine exactly what this meant. The logic of her earlier argument, just alluded to, is that inclusion rather than assimilation as a conformism is a social fact in modern societies. Multiculturalism is, in her view, a sociological fact: communities work as networks in different ways, intersected by class and ethnicity and gender. Networking is in any case also a social fact.

In this regard a nation state like Australia might be viewed as a community of communities, at least when the Federal, State and local state authorities consciously follow policies whose purpose is to encourage these networks, for it is they through which social life is already routinely mediated. The American postwar experience was doubtless one key horizon for this way of thinking. But there is no enthusiasm here, in Martin's work, for the theory or practice of strong assimilation. What is implied is rather a weaker politics of coexistence, based less on an overarching ideological unity or a strong identity politics than on a practical sense of ordinary trust as mediated through the culture of economic life. Even the most apparently bland tracts of suburbia, in this way of thinking, were criss-crossed by networks of support and action.

Thrown together by the accidents of world history, the peoples called and made into Australians by their state simply had to get on together. But this could also become a case of necessity into virtue, so that Martin's eventual argument in *The Migrant Presence* was for a robust cultural pluralism or 'structural pluralism'. Multiculturalism, in this way of thinking, became another way of recognising and encouraging pluralism. Where ethnic groups became significant actors in civil society, in a polity characterised by a strong state tradition, multiculturalism was a social fact. The nation-state would then operate as a network of networks, many of which were also necessarily transnational. But this is to take us beyond Jean Martin's times, through the

challenge of establishing the distinction between what she achieved and the nature of the situation which we now face persists.

The broad sweep of Jean Martin's work thus crosses various curiosities concerning individuals, primary groups and their integration. Ethnic groups, factory groups work as little publics, or at least they can do; work groups are the more potentially democratic. Underlying this sociology is a strong sense that is closer to Durkheim than Renan: solidarity is less ideological than practical. Trust is mediated as much by the ordinary commerce of everyday life as it is by spiritual bonding. We do not have to love each other to live together.

Doubtless Miss Craig's time in Chicago confirmed these sensibilities, at the very least. The detail of the case will have to be laid out with much more care as the span of our book opens out. I am grateful for the opportunity to share something of these lines of inquiry with you.

References

Craig, J. 1945. Some Aspects of Life in Selected Areas of Rural New South Wales. Master's thesis, Sydney University, Anthropology.

Craig, J. 1946. Report of a Survey of Two Soldier Settlements in NSW, Sydney University/Department of Postwar Reconstruction.

Craig, J. 1955. Assimilation of European Migrants: A Study in Role Assumption and Fulfillment. PhD thesis, Australian National University, Anthropology/Sociology.

Martin, J. 1965. *Refugee Settlers*. Canberra: ANU Press.

Martin, J. 1972. *Community and Identity*. Canberra: ANU Press.

Martin, J. 1978. *The Migrant Presence*. Sydney: Allen & Unwin.

Trahair, R. 1984. *The Humanist Temper: The Life and Work of Elton Mayo*. New Brunswick: Transaction.

Warner, M.H. 1988. *W. Lloyd Warner – Social Anthropologist*. New York: Publishing Centre for Cultural Resources.

Peter Carey

Chapter 24

From Sociology to Culture, Via Media –
Some Thoughts from the Antipodes
(2009)

Ladies and gentlemen, or as Tristan Smith would say, 'Meneer and Madam,' thank you for indulging me. I shall offer you some introductory remarks concerning the Antipodes, with reference to Bernard Smith and J.G.A. Pocock, and then read and comment on the voices of two contemporary antipodean writers, Nick Perry, from New Zealand, and the expatriate Australian writer Peter Carey, who lives down the road, towards Soho.

Why talk about the Antipodes as a way to characterise writing or media in Australia and New Zealand?

The idea of the Antipodes is, of course, classical – having the feet elsewhere, sometimes backwards, monsters from the south. It is revived into the modern age in terms of *terra australis incognita*, the unknown south land. In the wake of British expedition and invasion it becomes actualised as Australasia, Australia and New Zealand. In this period the image becomes more appropriately geographical – the other point on the globe, the opposite to that constituted by the centres. Into the nineteenth and twentieth centuries the image is, by turn, celebratory and stigmatic. Othering works both ways. Australasia is constructed as paradise, but also as hell, and here there is also some bifurcation between Australia and New Zealand, again for geographical reasons. New Zealand is the green and pastoral land, and even its indigenous people are valorised by Europeans, even as they are dispossessed. Australia is in contrast brown and dry, with convict origins and indigenous peoples who are viewed as less than Greek warriors and therefore primitivised.

The image of the Antipodes is revived locally in the 1960s in Australia. Its generalised stigma is reversed. The mobilising concepts of the idea of the Antipodes are apparent – north/south is up/down, cerebral/visceral, cultural

or civilised versus natural, mind versus the dirty bits. Its inversion by the victims down under involves the reversal of these values. We, down under, give you, our superiors, the finger. The new world blows raspberries at the old world, at Europe, and then even at America as it becomes the centre of empire and the culture industry. We all love Mickey Mouse, but he also becomes the symbol of mediocrity and empire.

In 1960 a more nuanced image of being antipodean is generated by the Australian cultural historian Bernard Smith. As I have tried to show in my study of his work, *Imagining the Antipodes*, Smith makes at least two radical claims (Beilharz 1997). The first is that the Antipodes is a relationship rather than a place. The second is that culture moves reciprocally and not only from centre to periphery: culture is constituted through cultural traffic. More recently, this argument has been joined from the other side of the Pacific and the Tasman by J.G.A. Pocock, best known in America in the history of ideas, and himself raised in New Zealand. As Pocock puts it, New Zealand history sees peoples in motion, histories transversing distance, identities never quite at home. An archipelago in the southern ocean, it views Britain as another archipelago. The strong point of distinction between Smith and Pocock here is locational. Pocock's image of the Antipodes is insular, literally, and archipelic (Pocock 2003). Smith's is different because Australia is different, a dry land mass, a continent. Both Australia and New Zealand are distant from the centres, but not isolated: they are constituted by maritime traffic and trade, and both look out, and very often north, rather than necessarily in, at their own provincial navels. Both are Neo-Britains in the southern seas.

In Australian sociology, Smith's arguments have been mediated primarily by me, in *Imagining the Antipodes*, by me and my colleague Trevor Hogan into a text called *Place, Time and Division* (Beilharz and Hogan 2006), and by my students and others around the journal *Thesis Eleven*. In media studies, the image of the Antipodes has been used by thinkers like McKenzie Wark, but most explicitly by New Zealander Nick Perry. For the rest of my time, I want to introduce you to Perry and in closing, to the independent application of some of these ideas by the Australian-American writer Peter Carey. Both, as you will see, have a signal relationship to Mickey Mouse.

Nick Perry's most important contribution here is in the idea of 'antipodean camp'. It's a broad idea, which echoes out through Australiana movies like *Priscilla, Queen of the Desert*, where suburban cowboys are also gay. First clue: *The Rocky Horror Picture Show* was written by a New Zealander.

Second, where else would a former conservative Prime Minister – Sir Robert Muldoon – have been keen to act as MC for the *Rocky Horror Show*, an even more symbolic act given the habit of local audiences to join in, to emulate the action as it unfolds on the screen?

Even more powerfully, where else would a Prime Minister in office – Labor Prime Minister David Lange – agree to a meet and greet with Mickey Mouse?

> *The Rocky Horror Picture Show*, the matter of fact willingness of an ex-Prime Minister to act as its MC (Master of Ceremonies) and to subsequently appear, complete with the appropriate cloak and make-up, as Count Robula, (the host for the horror movie on late-night television) are all instances of 'antipodean camp'. Are these utterly marginal differences or central signs of the times? Politics/business as usual or institutional cross-dressing? The same familiar fetishisms or is something rather strange afoot? Another recent New Zealand Prime Minister did it somewhat differently than his conservative predecessor – and did it whilst in office. For example, as the head of a Labour Government, David Lange warmly welcomed Mickey Mouse to his prime-ministerial suite. Faced with the cooling of official diplomatic relations with America as a result of his government's ban on nuclear ship visits, he was photographed in an anti-nuclear 'Nukebuster' tee-shirt whose design was inspired by the then topical 'Ghostbusters' motif. In an appearance on breakfast-time American television he observed that, 'I've been four times to Disneyland, but never to the White House' going on to (accurately) point out that invitations to the latter location had none the less been extended 'to all sorts of hoods' (Perry 1998, 10).

The attendant photograph almost mimics its historic precedent – Eisenstein shaking a smaller Mickey's white gloved hand in a famous 1930 Hollywood photo opportunity. The message is clear – nobody cares about New Zealand, or even, the imperial powers hold New Zealand beneath contempt – ergo the attitude of antipodean camp, the politics of inversion, the politics of the finger. Perry connects this to James Scott's fine study, *Domination and the Arts of Resistance*. 'When the great lord passes by, the wise peasant bows deeply and silently farts'.

Peter Carey is no sociologist, and yet, of course, he is. The most pertinent work here is *The Unusual Life of Tristan Smith*, 1994. Let me speak in his voice – Smith's, and Carey's:

My name is Tristan Smith. I was born in Chemin Rouge in Efica – which is to say as much to you, I bet, as if I declared I was from the moon.

And yet if you are going to make much sense of me, you have to know a little of my country, a country so unimportant that you are already confusing the name with Ithaca or Africa, a name so unmemorable it could only have been born of a committee, although it remains, nonetheless, the home of nearly three million of the earth's people, and they, like you, have no small opinion of themselves, have artists and poets who are pleased to criticise its shortcomings and celebrate its charms, who return home to the eighteen little islands between the tropic of Capricorn and the 30th parallel, convinced that their windswept coastline is the most beautiful on earth. Like 98 per cent of the planet's population, we Eficans may be justly accused of being provincial, parochial, and these qualities are sometimes magnified by your habit of hearing 'Ithaca' when we say 'Efica'.

If I say 'Voorstand' to you, that is a different story entirely. You are a citizen of Voorstand. You hold the red passport with the phases of the moon embossed in gold. You stand with your hand over your heart when the Great Song is played, you daily watch new images of your armies in the vids and zines. How can I make you know what it is like to be from Efica – abandoned, self-doubting, yet so wilful that if you visit Chemin Rouge tomorrow morning we will tell you that the year is 426 and you must write your cheques accordingly.

If you were my students I would direct you to read *Efica: From Penal Colony to Welfare State*, *The Caves of Democracy*, and Volume 3 of Wilbur's *The Dyer's Cauldron*. But you are not my students and I have no choice but to juggle and tap-dance before you, begging you please sit in your seats while I have you understand exactly why my heart is breaking. (Carey 1994, 3)

So begins the story. Tristan Smith is an antipodean, more than an outsider again. He is born deformed, as Carey says, like a snail without a shell, to a theatrical mother from the centre who has settled in the periphery. The book is brilliant – Efica could be New Zealand or Australia, but it could be anywhere in Africa, any other settler capitalist location – it could be in the South Pacific, could be French or Dutch, British or American in its hegemon. Carey constructs an entire lifeworld in a novel that is also

historical, has its own vernacular (even, charmingly, for the genitalia) and a scholarly apparatus as well as a vocab list to make the study scholarly, to give it the power and aura of an alternative world view. Footnotes explain that this is how we antipodeans see things, and why.

Tristan Smith is born deformed and pathetic – until he meets Mickey Mouse, or the Efican variant thereof, Bruder Mouse. Tristan Smith repeatedly apologises for his antipodean manners, the periphery shouting at the centre. But we are also of you, even if you cannot see us. And if we are really ambitious, we can only leave, betray our country of origins, sell out, move north – which is exactly what Carey does, moving from Australia to Manhattan, or this, at least, is the way wounded Australians at home like to see it.

Efica has an elaborate history of independent circus work, derived of its hegemon in Voorstand, but different, not least in that no live animals are used, only symbolic characters like Bruder Mouse – and Oncle Duck. The Eficans are northern people who have been abandoned in the south. They have more than the usual share of identity issues. 'What are we?' We're just sort of 'here'! Eficans are losers, and proud of it:

> In the Voorstand Sirkus, there is no pity. A man falls, he dies. This, you would say, is the point – the reason a Sirkus star is rich is because of the risk he takes.

> But when we Eficans watch the Voorstand Sirkus we do not watch like you. We watch with our mouths open, oohing and aahing and applauding just as you do, but we watch like Eficans, identifying with the lost, the fallen, the abandoned. When a performer falls, *c'est moi*, *c'est moi*.

> Our heroes are the lost, the drowned, the injured, a habit of mind that makes our epic poetry emotionally repellent to you, but let me tell you, Meneer, Madam, if you are ever sick whilst visiting Efica you will quickly appreciate the point of view. If you come to the Mater Hospital with no money, no insurance, even if you stink of piss and have no lips – you will not be sent away, not even if you beg to be. (Carey 1994, 36)

Yet Tristan Smith's life line is as the mouse. Its suit, in the form of a simi, a cyborg, offers him both a body, a carapace, and a face, a mask, and in this way he becomes an unexpected star in the centre, in New York – in Voorstand. Yet political intrigue frames the whole story: Tristan's mother is murdered, and his minders turn out to include CIA-equivalents who are

rigging the Efican elections, a reference no doubt to Allende but also to the Australian Prime Minister's Dismissal of 1975 (notwithstanding the fact that no Australian Prime Minister has yet met with Mickey Mouse). That is the paradox, Carey says: we are important enough for you to bring down our government, but you have never heard of us. In the New Zealand case, referring back to the Prime Minister and Mickey, the background context is the sinking of the Greenpeace vessel The Rainbow Warrior by French commandos in Auckland Harbour in 1985. Sovereignty, like cultural dependence, has long been a serious issue for the Antipodes.

Tristan Smith manages to become a celebrity as Bruder Mouse, and even to get laid – though as Bruder Mouse, not as himself, the snail without a shell. His great sexual conquest is as Bruder Mouse but he screws the Empire all the same. Framed, exposed, he becomes a fugitive, yet the story has an open ending: for this is the prelude, the beginning of his young life.

Perhaps this is less antipodean camp than antipodean tragedy. It nevertheless suggests several outcomes. First, in a small population like Australia or New Zealand with a less developed intellectual division of labour than the USA, we do well to learn from others who are not sociologists or do not look like sociologists. This is, I think, a message of universal import. Interesting things can become apparent where the borders are more porous. One disadvantage of working in American sociology, in the heart of the world-system, is to be located exactly in its strength, its number and high degree of specialisation. Working in a smaller setting, like the Antipodes, means you have to know about more, to explore, to make it up, to improvise. Second, therefore, those who are interested in the history of culture need to be open to the fields of history and cultural studies. The specificity and difference of history is a kind of natural antidote to the temptation to generality and abstraction in mainstream sociology. Grand claims can be usefully qualified by the outsider's question of 'so wot?' or the complaint, 'not where I come from!' Third, social life is deeply performative, as I have performed for you today, and to use the voices of others in the process – to read, to repeat, to act out – can achieve a sense of profundity alongside, if not beyond interpretation and formal criticism. The mask and the voice are powerful – this is the mouse, this is not a mouse, this is us, this is you – this is all of us.

References

Beilharz, P. 1997. *Imagining the Antipodes – Culture, Theory and the Visual in the Work of Bernard Smith.* Melbourne: Cambridge University Press.

Beilharz, P., and T. Hogan, eds. 2006. *Sociology – Place, Time and Division.* Melbourne: Oxford University Press.

Carey, P. 1994. *The Unusual Life of Tristan Smith.* Brisbane: University of Queensland Press.

Perry, N. 1998. Antipodean Camp. In *Hyperreality and Global Culture.* London: Routledge.

Pocock, J.G.A. 2003. The Antipodean Perception. In *The Discovery of Islands – Essays in British History.* Cambridge: Cambridge University Press.

Index